king

Washington

A guide to the
tural landmarks of
he Evergreen State

Greg Vaughn

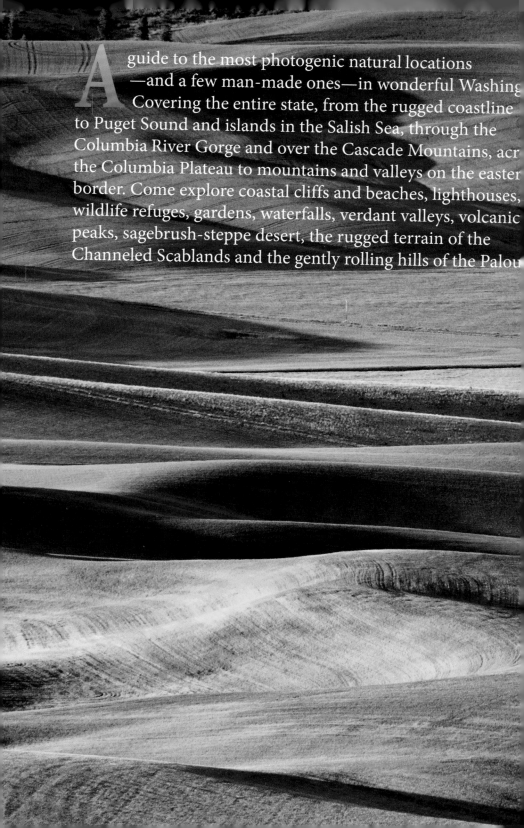

A guide to the most photogenic natural locations —and a few man-made ones—in wonderful Washing Covering the entire state, from the rugged coastline to Puget Sound and islands in the Salish Sea, through the Columbia River Gorge and over the Cascade Mountains, acr the Columbia Plateau to mountains and valleys on the easter border. Come explore coastal cliffs and beaches, lighthouses, wildlife refuges, gardens, waterfalls, verdant valleys, volcanic peaks, sagebrush-steppe desert, the rugged terrain of the Channeled Scablands and the gently rolling hills of the Palou

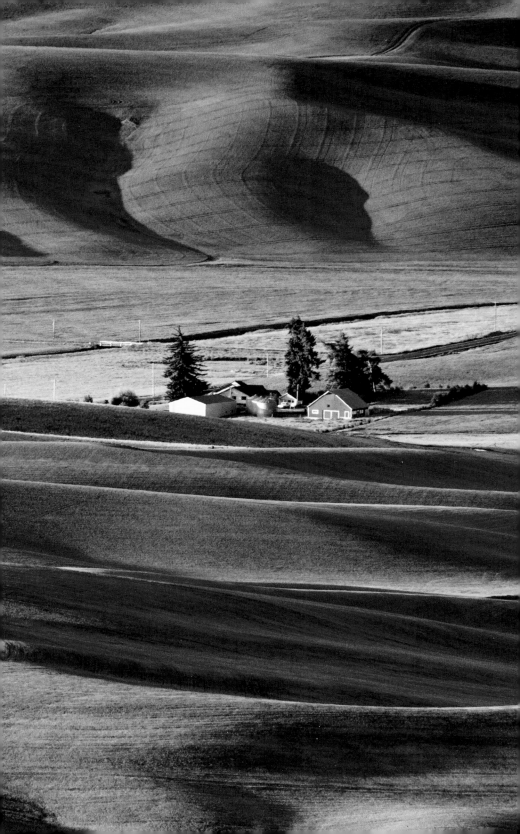

PHOTOGRAPHING WASHINGTON
A Guide to the Natural Landmarks of the Evergreen State

Published by PhotoTripUSA Publishing
An imprint of

GRAPHIE
INTERNATIONAL, INC.
8780 19th Street, Suite 199
Alta Loma, CA 91701, USA

Text & photography Copyright © 2013 by Greg Vaughn, except as noted

Executive Editor & Publisher: Laurent Martrès
Book & Cover Design: Sioux Bally-Maloof, Heartstone Arts
Layout: Greg Vaughn & Laurent Martrès

Cover photo: Mount Rainier from Glacier View Overlook
Title page photo: Wildflowers on Tronsen Ridge & view to the Stuart Range
Previous pages: Palouse wheat fields from Steptoe Butte

Printed in China

Important notice: Some of the locations described in this book require travel through remote areas, which may not always be safe. Travel at your own risk and always check conditions locally before venturing out. The author and publisher decline all responsibility if you get lost, stranded, injured, or otherwise suffer any kind of mishap as a result of following the advice and descriptions in this book. Furthermore, the information contained herein may have become outdated by the time you read it; the author and publisher assume no responsibility for outdated information, errors, and omissions.

Publisher's Cataloging-in-Publication

Vaughn, Greg.
Photographing Washington : a guide to the natural landmarks of the Evergreen State / Greg Vaughn.
p. cm.
Includes bibliographical references and index.
ISBN 978-0-916189-19-8

1. Travel photography--Washington (State)
2. Landscape photography--Washington (State) 3. Landscapes --Washington (State) 4. Washington (State)--Description and travel. 5. Washington (State)--Guidebooks.
I. Title.

TR790.V38 2013 778.9'9917970444
 QBI13-600025

Acknowledgements

First and foremost, I would like to express my gratitude to Laurent Martrès, publisher, friend, and fellow photographer, for giving me the opportunity to do this book, for encouragement as it took shape, his infinite patience and his dedication to producing top quality books and photographs.

I am indebted to fellow photographers Don Geyer, Alan Bauer, Tom Kirkendall, and Vicky Spring, all of whom are also guidebook authors, for generously sharing their knowledge of their home state, and to retired National Park Naturalist Ron Warfield for contributing his expertise and wealth of knowledge about Mount Rainier. Ron provided all of the text and photos for the Westside Viewpoints section in the chapter on Mount Rainier National Park.

Special thanks to Terry Donnelly, Mary Liz Austin and David M. Cobb, outstanding photographers and good friends whom I called upon repeatedly in the course of researching this book. Thanks also to Sally Foster for a number of excellent suggestions for improving both location coverage and my grammar.

Grateful thanks to Roni Freund and Mike Steele of Lake Chelan, and to the Lake Chelan Boat Company, for help in getting to Stehekin. And a big shout out to trail guide and hiking buddy Jill "Little Dragon" Sazanami, who got me up, down and back on some amazing trails.

This book, and my career as a photographer, would not be possible without the continual support of my wife and sons. Finally, I dedicate this book to my parents, who instilled in me a love of travel and the outdoors, and whose love and support I've always known I could count on, no matter where I wandered.

Contributing photographers

Many thanks to the photographers who generously contributed to this book. Please visit their websites for more of their excellent photography at a look at their offerings for fine art prints.

Don Geyer - www.mountainscenes.com
Alan Bauer - www.alanbauer.com
Sean Bagshaw - www.outdoorexposurephoto.com
Laurent Martrès - www.martres.com
David M. Cobb - www.dmcobbphoto.com
Kevin McNeal - www.kevinmcnealphotography.com
Chip Phillips - www.chipphillipsphotography.com
Jesse Estes - www.jesse-estes.com
Ron Warfield - www.agpix.com/warfield
Jack Graham - www.jackgrahamphoto.com
Isabel & Steffen Synnatschke - www.synnatschke.com
Tom Kirkendall & Vicky Spring - www.kirkendall-spring.com
Terry Donnelly & Mary Liz Austin - www.donnelly-austin.com

Chapter 1 - INTRODUCTION **11**

Chapter 2 - OLYMPIC PENINSULA **21**
Lake Quinault 23
Ruby Beach 26
Hoh Rainforest 27
Second Beach & Rialto Beach 28
Cape Alava 30
Shi Shi Beach & Point of Arches 30
Sol Duc Falls 32
High Divide Trail 34
Lake Crescent & Marymere Falls 35
Elwha River & Madison Falls 36
Hurricane Ridge 36
Deer Park 38
Tongue Point & Dungeness Wildlife Refuge 39
Port Townsend 40

Chapter 3 - SOUTHWEST WASHINGTON **41**
Cape Disappointment State Park 44
Lower Columbia River 45
Ridgefield National Wildlife Refuge 46
Fort Vancouver National Historic Site 47
I-5 Corridor - Southern Lowlands 48
Battle Ground Lake State Park 49
Cedar Creek Grist Mill 49
East Fork Lewis River Waterfalls 51
Silver Star Mountain 52
Lewis & Clark State Park 54
Rainbow Falls State Park 55
Mima Mounds 55

Chapter 4 - PUGET SOUND **57**
Downtown Seattle 59
Kerry Park Cityscape View 61
West Seattle - Alki 62
Rizal Bridge City View 63
Discovery Park & West Point Lighthouse 64
Woodland Park Zoo 65
Washington Park Arboretum & Japanese Garden 66
Kubota Japanese Garden 68
Bellevue Botanical Garden 69
Cougar Mountain Regional Wildland Park 70
Weyerhaeuser Bonsai & Rhododendron Gardens 71
Saltwater and Dash Point State Parks 72
Tacoma 73
Nisqually National Wildlife Refuge 75
Olympia - State Capitol 76
Tumwater Falls 77
Gig Harbor 78
Vashon Island 79
Bainbridge Island 80
Kitsap Peninsula Parks 82
Poulsbo 82
Port Gamble 83
Point No Point Lighthouse 84

Chapter 5 - SAN JUAN ISLANDS — 85

Planning your Trip — 87
Introduction to San Juan Island — 88
Friday Harbor — 88
Roche Harbor - Westcott Bay — 89
English Camp — 90
San Juan County Park — 91
Lime Kiln Point State Park — 92
Pelindaba Lavender Farm — 93
American Camp — 94
Cattle Point — 95
Introduction to Orcas Island — 96
Eastsound — 97
Moran State Park — 97
Eastern Orcas — 99
Western Orcas — 101
Turtleback Mountain Preserve — 102
Shaw Island — 103
Introduction to Lopez Island — 104
Odlin County Park — 105
Spencer Spit State Park — 105
Fisherman Bay Preserve — 106
Shark Reef Sanctuary — 106
Mackaye Harbor & Agate Beach — 107
Iceberg Point — 108
Watmough Bay Preserve — 109

Chapter 6 - NORTHWEST WASHINGTON — 111

Mukilteo Lighthouse — 113
Camano Island State Park — 114
Whidbey Island — 115
Deception Pass State Park — 116
Fidalgo Island — 118
Skagit Wildlife Area — 120
Skagit Valley Tulip Farms — 122
Chuckanut Drive & Larrabee State Park — 124
Bellingham — 125

Chapter 7 - NORTHERN CASCADES — 127

Mount Baker Highway — 128
Mount Shuksan & Artist Point — 129
Yellow Aster Butte — 131
Nooksack Falls — 133
Skyline Divide Trail — 134
North Cascades Highway — 135
Baker Lake — 136
Park Butte Trail — 137
Sauk Mountain — 138
Mountain Loop Highway & Sauk River Valley — 139
Skagit River Bald Eagles — 140
North Cascades National Park — 141
Cascade Pass — 142
Ross Lake National Recreation Area — 144

Maple Pass - Heather Pass Loop Trail 146
Blue Lake 148
Washington Pass 148
Methow Valley 150
Patterson Mountain - Thompson Ridge 152
Lake Chelan - Stehekin 153

Chapter 8 - CENTRAL CASCADES 157
Stevens Pass - U.S. Highway 2 158
Wallace Falls 159
Lake Serene - Bridal Veil Falls 160
Deception Falls 162
Lake Wenatchee & Hidden Lake 163
Tumwater Canyon 164
Leavenworth 165
Alpine Lakes Wilderness - The Enchantments 167
Blewett Pass 171
Alpine Lakes Wilderness – South 172
Snoqualmie Pass 174
Franklin Falls 175
Twin Falls - Olallie State Park 176
Snoqualmie Falls 177

Chapter 9 - MOUNT RAINIER 179
Planning your Visit 181
Nisqually Entrance - Longmire 186
Comet Falls & Van Tump Park 188
Christine Falls & Roadside Viewpoints 190
Narada Falls 191
Paradise 192
Inspiration Point & Pinnacle Peak 198
Reflection Lakes 199
Stevens Canyon 200
Grove of the Patriarchs & Ohanapecosh 201
Tipsoo Lake & Naches Peak Loop Trail 203
Sunrise 204
Carbon River 207
Spray Park & Mowich Lake 208
Wonderland Trail 210
Westside Viewpoints: Gobblers Knob & Glacier View Lookout 211

Chapter 10 - MOUNT SAINT HELENS 213
Spirit Lake Highway 215
Coldwater Ridge 216
Johnston Ridge 217
Northeast Side of Mount St. Helens 218
Norway Pass 220
Pumice Plain & Loowit Falls 222
South Side of Mount St. Helens 223

Chapter 11 - SOUTHERN CASCADES 225
 Goat Rocks Wilderness 227
 Packwood Lake 228
 Walupt Lake and Nannie Ridge 228
 Mount Adams 230
 Adams Creek Meadows 230
 Takhlakh Lake 231
 Council Bluff 233
 Bird Creek Meadows 234
 Lewis River Waterfalls 236
 Indian Heaven Wilderness 239
 Indian Heaven Loop Trail 240
 Trout Lake 241
 Wind River Waterfalls 243

Chapter 12 - COLUMBIA RIVER GORGE 245
 Cape Horn 247
 Beacon Rock State Park 248
 Dog Mountain 250
 Coyote Wall Trail 251
 Catherine Creek 252
 Klickitat Trail 254
 Conboy Lake National Wildlife Refuge 255
 Dalles Mountain Road 256
 Horsethief Lake Petroglyphs 258
 Maryhill 259
 Oregon Waterfalls & Wildflowers 260

Chapter 13 - SOUTHEAST WASHINGTON 261
 Yakima Valley 263
 Oak Creek Wildlife Area 264
 Yakima River Canyon 265
 Wenas Wildlife Area - Umtanum Ridge 266
 Gingko Petrified Forest 268
 Crab Creek Wildlife Area 269
 Ancient Lakes 270
 Beezley Hills & Moses Coulee 271
 Potholes - Columbia National Wildlife Refuge 273
 Hanford Reach National Monument 275
 MacNary National Wildlife Refuge 277
 Wallula Gap 278
 Palouse Falls State Park 278
 Walla Walla to Clarkston 280
 Fields Spring State Park - Blue Mountains 280
 Hells Canyon 282
 The Palouse 283

Chapter 14 - NORTHEAST WASHINGTON **289**
 Spokane 291
 Manito Park Gardens 292
 Riverside State Park 293
 Mount Spokane 294
 Turnbull National Wildlife Refuge 295
 Twin Lakes & Coffeepot Lake 296
 Dry Falls 298
 Steamboat Rock State Park 299
 Okanogan Highlands 301
 Kettle River Range 302
 Selkirk Mountains 303

APPENDIX **305**
 Bibliography - Guidebooks 306
 Bibliography - Photo Books 307
 Helpful Websites 308
 Government Agencies & Visitor Organizations 308

INDEX **309**

RATINGS **313**

ABOUT THE AUTHOR **319**

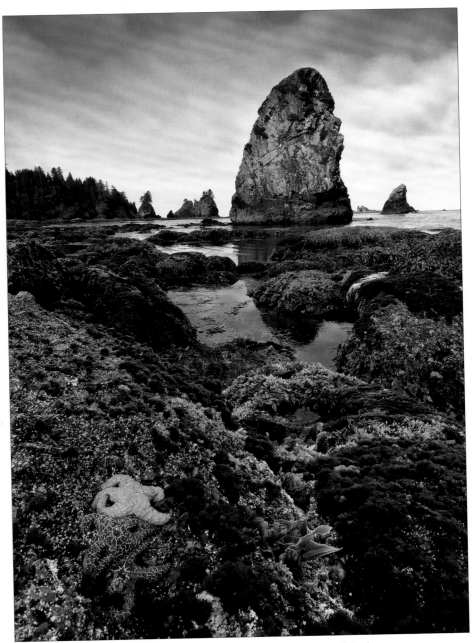

Tidepool at Point of Arches, Olympic National Park

Chapter 1

INTRODUCTION

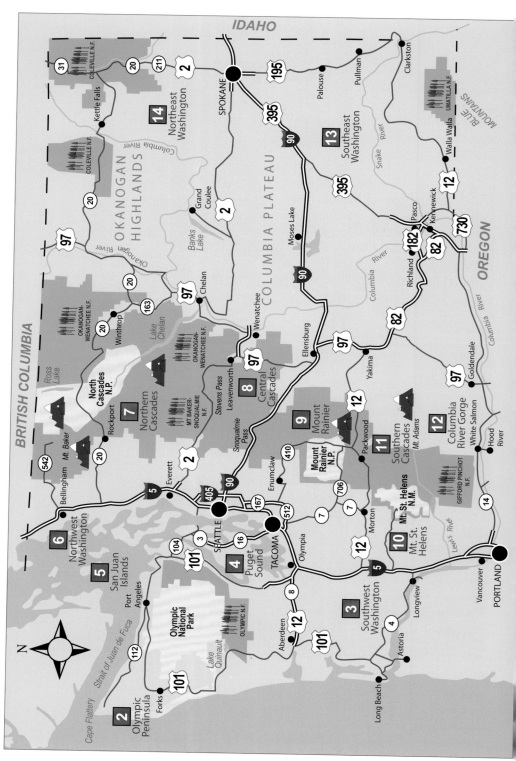

Note: Continue your travels south with **Photographing Oregon** ISBN 978-0916189181

One of Washington's best known locations for nature photography is a place called Paradise in Mount Rainier National Park. Truth be told, the whole state is a paradise for photographers. Within its boundaries are temperate rainforest, Columbia Plateau desert, iconic glacier-streaked volcanic peaks, rolling hills of wheat and a magnificent coastline of beaches, sea stacks, and rocky headlands. The Olympic Mountains, the Cascades, and mountain ranges to the east are covered with beautiful coniferous forest and agricultural areas across the state offer landscape photographers great subject matter for fields of colorful flowers, endless rows of vineyard grapes and classic wooden barns. Channeled Scablands in the east, remnants of the cataclysmic Missoula Floods, show us the power of geologic processes over eons of time. The mighty Columbia River, starting deep in neighboring British Columbia winds through the state and becomes the border with Oregon on it way to the Pacific Ocean.

We'll take a look at every part of the state in this book, with the goal of giving you the kind of information you need to capture great images. Before we begin our tour however, this chapter has some general information you'll need to make the most of your journeys throughout the Evergreen State.

Maps

You may find it surprising that the only map in this book is the simple one on the previous page. The reason for this is that *Photographing Washington* has a different purpose than other guidebooks: think of this book as an illustrated location resource, providing ideas for discovering Washington or expanding on your existing knowledge of the state, and helping you to get the best possible photos on your journeys. This guide is designed to be used with a variety of more detailed maps from other sources.

Good maps are extremely important for any outdoor photographer. A large scale map will give you an overall view of an area and help in making a general plan for your trip; you'll want detailed road maps to follow the instructions in the *"Getting there"* sections of this book. Two map atlases that I find essential for exploring Washington are the Benchmark Maps *Washington Road & Recreation Atlas* and the DeLorme *Washington Atlas & Gazetteer*. The DeLorme atlases show just about every road, track, and old jeep trail in the state, but many of the minor roads are on private land or are otherwise no longer accessible, so there's sometimes too much information on them. On the other hand, the DeLorme atlas does show elevation contours, a very useful feature. The Benchmark atlas does a very good job of marking locations for geologic features, landmarks, and historic sites that are likely to be sites of interest to photographers as well as travelers in general, and I find it a little easier to read. I've worn out a copy of each of these atlases while working on this guide, and I highly recommend that you buy one, if not both, of them if you plan to spend any time at all in the state.

The U.S. Forest Service (USFS) and Bureau of Land Management (BLM) publish maps for each of their respective management units within the state. These detailed maps can be purchased at agency offices, at their online sites, and through retailers like REI.

US Geological Survey topographic maps have long been the standard for hiking, but even better are the Trails Illustrated series from National Geographic and the made-in-the-Pacific-Northwest Green Trails series of maps, which are printed on very durable and waterproof paper. These extremely detailed maps are highly recommended for hiking as well as researching locations. Topo maps are now available on the internet from several sources, some of which let you add your own markers and annotations, and then print only the portion of map corresponding to your route. Tablet computers such as the iPad are great for having all kinds of maps and other data with you as you travel in search of photos. Smartphone apps like Google Maps are extremely valuable for planning trips, but in many areas can't be relied on once you're in the field because you may not be able to get cell phone reception.

GPS considerations

Those of you who are avid GPS users may be disappointed to find that I have not included waypoints in this guidebook. I personally tend to favor paper maps, and coordinates can easily be found on the internet for just about any location. Vehichle GPS units are wonderful, but may not be reliable in remote areas and have been known to mislead people, with dire consequences. If you do choose to use a handheld GPS unit when hiking, make sure that you really know how to use it; don't follow it blindly with your eyes riveted to the GPS instead of the trail and scenery around you, and be sure to always carry extra batteries. If you don't own a handheld GPS unit, you might want to install the BackpackerGPS app on your phone. It's not a replacement for a "real" GPS unit when hiking in remote areas, but it can be a very handy tool for tracking your treks.

Driving around

The vast majority of the locations covered in this guidebook are accessible by good roads. Secondary state, county, USFS and BLM roads are usually well-graded, hard-packed gravel and are only a problem during extreme weather conditions. There are, however, many miles of dirt and gravel backcountry roads in the National Forests, wildlife refuges, and on BLM land. For these places it's usually ground clearance that matters most, but with wet or muddy conditions, a 4WD vehicle may be necessary.

Where road conditions and vehicle type are a factor, I've made note within the text for each location and in the Ratings section at the end of the book. But keep in mind that my recommendation is based on normal (i.e., dry) conditions.

Furthermore, the driveability of gravel and dirt roads can vary greatly depending on season and how long it's been since they've been graded. At elevations from 5,000 feet and up you may run into snow as late as mid-June and as early as mid-October. It's always a good idea to check with visitor centers and ranger stations for current conditions on your planned route.

Whenever venturing off the beaten path, be prepared in case of emergency or getting stuck on a back road. I recommend carrying a small folding shovel, a tow strap, a basic first aid kit, one of those emergency "space blankets", a jug of drinking water and a few energy bars. From October through May, carry a set of tire chains if your plans involve any mountain driving, even if you have 4WD. That degree of preparedness might not be practical if you're flying into Washington for a few days and renting a car, but do at least make sure your rental has a spare tire and complete jack set, and grab some water and emergency rations as you head out. Cell phone reception is good in most of the state, but there are large areas of forest, mountain and desert where you won't pick up a signal.

The following abbreviations are used for the various highway and road designations in this book:

US = US Highway	WA = State Highway
CR = County Road	FR = Forest Road (USFS or BLM)

Washington Discover Pass

A great many of the sites in this guidebook require the purchase of a daily or annual Washington State Discover Pass. The pass must be displayed on your vehicle when visiting state recreation lands managed by the Washington State Parks and Recreation Commission, the Washington State Department of Natural Resources, and the Washington Department of Fish and Wildlife. With the exception of some State Parks, the passes are not available on site. The passes can be purchased at many retailers throughout the state, sometimes even at small mom & pop mercantiles in out of the way places, but don't count on that. Both daily and annual passes can be purchased online at www.discoverpass.wa.gov.

Hiking

When I first started working on this guidebook, Washington photographer Don Geyer advised me that I was going to have to do a lot more hiking than I did for *Photographing Oregon*. And he was right: you need to put in some trail time for a great many of the best photo ops in in Washington. The vast majority of locations in this book can be reached by a short walk or an easy hike (less than 5 miles round-trip, with no more than moderate elevation gain). Unless you're a total couch potato, you should have no problem getting to good photographic

locations in any region of the state. A few places, however, including what is arguably some of the best scenery in the northwest, require longer, more strenuous day hikes or overnight backpack trips. Trail length and difficulty is detailed in the text, and the Ratings section in the appendix serves as a quick reference to how difficult the various hikes are. The ratings are based on the ability of the casual average hiker—you don't have to be a marathon runner or gym junkie, but you should be in reasonably good physical shape.

For longer hikes, or if you'll be doing a lot of hiking in Washington, I recommend supplementing this book with trail guides from other sources, including USFS and BLM handouts, internet sites, and especially the several excellent hiking guidebooks published by The Mountaineers. It's also a good idea to check current trail conditions at visitor centers and ranger stations. I've almost always found the staff at outlying USFS, BLM and wildlife refuge offices to be very friendly, helpful and knowledgeable; I think it is important that these people are aware that photographers are a significant group of public lands visitors.

The right kind of clothing is very important and may vary greatly depending on season and location. I personally prefer the feel of cotton in the dry heat of central and eastern Washington summers, but the modern high-tech, breathable, wicking, and sun protecting fabrics make the most sense just about everywhere and in all seasons. Fleece and outerwear with Gore-tex or similar waterproofing should be considered required equipment in the Pacific Northwest. By wearing several lightweight layers you can be comfortable when first starting out on a trail on chilly mornings, and then maintain comfort level by shedding layers as the day progresses and body heat rises with increased physical activity. A packable, lightweight, waterproof windbreaker is, next to a good pair of hiking boots, probably one of the best investments you can make in hiking clothing.

Some people can hike in river sandals or cheap jogging shoes, but for me a good pair of hiking shoes or boots with soles designed for traction is essential for anything but the easiest, smoothest pathways. I also highly recommend a set of hiking poles. These aid greatly in navigating creek crossings, and can really save your knees from the punishment of steep descents.

If you are hiking during hunting season, or even just venturing off road a bit, it's a really good idea to wear very bright colors, or at least something like a blaze orange hat. Depending on the location, hunting season ranges from August through December.

From spring to late summer, most anywhere you hike in Washington you're going to want mosquito repellent, especially near meadows, lakes and wetland areas. Even if mosquitoes aren't a problem, it's a good idea to use repellent around your ankles and cuffs in order to keep off deer ticks, the carriers of Lyme Disease. Supplement wide-brimmed hats and long-sleeved, high UPF shirts with a good, sweatproof sunscreen.

Anytime you're heading out on a trail, make sure your pack also contains the essential safety items, even if you're just planning a very short dayhike. Among the things you always should have with you are:

❐ First aid kit
❐ Waterproof matches, a small lighter or other fire starter
❐ Pocket knife or multi-tool
❐ Mini LED lamp or flashlight
❐ Loud whistle
❐ High-energy food such as trail mix or energy bars
❐ "Space Blanket"
❐ Large plastic trash bag, for rain protection or to collect drinking water
❐ map of the area (preferably a topo map)
❐ Compass and/or GPS unit with extra batteries

Also in your backpack should be a few feet of toilet paper in a ziploc bag, and another plastic bag to pack out any trash. Orange peels and TP may eventually biodegrade but in the meantime they are an unsightly mess.

Pay attention to warning signs and trailheads and use caution in any wildlife encounters. Elk, moose, mountain goats and even deer can be very aggressive. The local black bears are not generally a threat, unless you get between mama and her cubs. Washington has a healthy population of cougars, too, but in all my years of wandering the northwest I've only seen one, for a fleeting moment.

A digital camera or smartphone can also be useful when hiking to keep track of your route. At the trailhead and whenever you come to a strategic location, turning point or fork in the trail, take a snapshot or a few seconds of video and audio, placing your return direction in the center of the frame.

Outdoors Etiquette & Conservation

Whenever you're hiking or camping (and regardless of whether you're in a state park campground or pitching a tent in a remote wilderness), please use Leave No Trace practices. You know the drill: Take only pictures, leave only footprints. Pack it in, pack it out. I know I'm preaching to the choir here, because most nature photographers have a strong conservation ethic and firmly believe that littering is a mortal sin, but it bears repeating anyway.

Just as the grass is always greener on the other side of the fence, the angle of view always seems to be just a little bit better if we step off the trail or go just beyond the railing at the official viewpoint. Do everything you can to avoid damaging vegetation and contributing to trailside erosion. Biologists tell us that it can take seven years for wildflowers to recover after being stepped on. Beyond environmental considerations, how do you like it when you come to a meadow of beautiful blossoms only to find some idiot trampled through it, thinking only of getting *his* shot? Good wildlife shooters know that no photograph is worth endangering the well-being of an animal; landscape photographers should practice a similar ethic.

Simply put, do your best to ensure that the next photographer, and the next generation of photographers, will find as much or even more of nature's beauty and grandeur as you will certainly find in this truly wonderful state.

Similarly, let's be considerate when meeting other photographers, too. Be nice, and share information. You never know when you might run into Art Wolfe or Jack Dykinga or maybe a lesser known but very accomplished photographer who can help you get better photos. There is absolutely no excuse for being rude to fellow photogs. Several of the contributors to this book are people I met on the trail and who I now count as good friends.

When to visit

In a word: anytime! Washington is a wonderful place to visit and photograph at all times of the year. The diversity of terrain and climate means there's almost always somewhere in the state you can go for good photo opportunities. Washington has a reputation for always being wet and rainy in the winter, and that's largely true west of the Cascades; but those conditions are great for some photo subjects. If you want to escape the gray, a trip up to the mountains or over to the east side of the state will often take you to clear skies and sunshine.

Summer time is absolutely delightful in the Pacific Northwest, with plenty of sun and balmy temperatures. On the coast you may occasionally run into heavy fog when inland temperatures are high, and in the eastern part of the state it can get downright hot, with the thermometer readings well over 90 degrees Fahrenheit, but overall it's a wonderful time to travel in Washington. Higher up in the mountains, roads and trails are finally clear of snow, and wildflowers put on their show in July and August. The only real problem with summer is that the days are so long. You'll often need to be up at 4:00 AM or even earlier to catch the dawn light and dusk won't be over until after 9:30 PM in mid-summer.

Spring and autumn are, to my mind, the optimum times to be photographing in the Pacific Northwest. Slightly chilly mornings followed by comfortably warm days, and an ever-changing mix of weather can mean glorious skies for sunrise and sunset landscapes, or a solid overcast, which is perfect for shooting waterfalls, wildflower close-ups, and fall color. Late spring and early summer are the best times to photograph waterfalls as stream flow is good and foliage is verdant. This is also the best time, of course, for wildflowers at low to mid-elevations. Fall color starts in early September in the mountains and sometimes runs into November in low elevation areas like the Columbia River Gorge. Early in spring and late in autumn the sun remains at a relatively low angle all day, and the period of beautiful golden light at sunrise and sunset lasts longer than in summer.

Wintertime offers choices, too. Snow-covered landscapes in the mountains can be stunning. The major pass highways are well-maintained (with the exception of WA-20, which is closed in winter near Washington Pass) and Sno-Parks offer easy access for cross-country skiing and snowshoeing. Short days mean you can sleep in and still catch sunrise, or be out for sunset at 4:30 PM and back in time for a leisurely dinner.

Month by month, here's a nature photographer's calendar for Washington:

❖ **January** - Winter landscapes in the Cascades, bald eagles on the Skagit River, and huge flocks of geese in the Skagit Valley are all good bets. Elk and bighorn sheep are at Oak Creek Wildlife Area feeding stations near Yakima.

❖ **February** - The first flower blossoms appear in the Columbia River Gorge around Catherine Creek and Columbia Hills State Park.

❖ **March** - Wildflowers start to get good in eastern desert areas and in the Columbia River Gorge. Spring migration on the Pacific Flyway brings thousands of waterfowl to the Columbia and Turnbull National Wildlife Refuges.

❖ **April** - Spring is in full bloom in the western part of the state. Visit the Skagit Valley for a riot of color in the tulip and daffodil fields. The cherry trees at University of Washington usually peak early in the month. It's also a great time to visit the eastern part of the state—the sun is shining, temperatures are mild and wildflowers are popping up all over the desert areas. Columbia Gorge wildflower hotspots are approaching prime late in the month.

❖ **May** - Best time of year for shooting coastal areas on the Olympic Peninsula. In low elevation forests, the waterfalls are cranking. Orca whales return to the San Juan Islands, and the islands themselves are at their scenic best.

❖ **June** - The Palouse! Wheat and pea fields are emerald green and skies are often glorious. Forest foliage is in its prime and the magnificent old-growth forests look their best. Waterfalls are wonderful throughout the state. Cascade trails begin to open up.

❖ **July** - Head to the high mountain trails for the beginning of alpine wildflowers in meadows and on rocky slopes of the Cascades and Olympics. Mosquitoes are thick around meadows and lakes but the volcanic peaks still have plenty of snow on them, making them much more photogenic than later in summer when they're mostly bare.

❖ **August** - High Cascades trails are (usually) clear of snow. Wildflowers peak at higher elevations in the North Cascades and at Mount Rainier.

❖ **September** - Fall color starts in the mountains with vine maple changing to brilliant reds and oranges. Mosquitoes are gone from the high mountain lakes. Aspen and larch turn golden. Some years we have a long-lasting Indian Summer but some years the rains return with a vengeance this month.

❖ **October** - Bigleaf maple and vine maple light up Cascades forests and the Columbia River Gorge, while introduced maples color cities, towns, parks, and gardens. East of the Cascade crest, cottonwood and aspen are bright yellow. As in April, the weather is almost constantly changing, alternating brilliantly crisp and clear days with thunderstorms.

❖ **November** - Storms bring big surf to the Olympic coast and beaches take on their winter form.

❖ **December** - Head to Hurricane Ridge, Mt. Spokane or just about anywhere in the Cascades for pristine winter scenes and forests blanketed with fresh snow.

Best Places for Fall Color

- Alpine Lakes Wilderness - The Enchantments
- Pend Oreille River Valley and Lake Sullivan Loop near Ione
- Washington Park Arboretum and Japanese Garden in Seattle
- Hoh Rainforest, Olympic National Park
- Methow River Valley
- Indian Heaven Wilderness and Trout Lake Area
- Conboy Lake NWR, Glenwood area and nearby Klickitat Canyon
- Naches Peak Loop Trail, Mount Rainier National Park
- Stevens Pass - Tumwater Canyon
- Lake Ann - Maple Pass - Heather Pass Loop Trail
- Columbia River Gorge National Scenic Area - Oregon side

Best Places for Wildflowers

- Dallas Mountain Road - Columbia Hills State Park
- Dog Mountain, Columbia River Gorge
- Paradise Meadows, Mount Rainier National Park
- Spray Park, Mount Rainier
- Hurricane Ridge, Olympic National Park
- Bird Creek Meadows, Mount Adams
- Steamboat Rock State Park
- Kamiak Butte in the Palouse region
- Sauk Mountain, North Cascades
- Patterson Mountain area west of Methow Valley

Other Resources

A number of useful websites, guides, and photo books are listed in Appendix. For links to these as well as additional photography and trip planning resources, please see: www.GregVaughn.com/photographingwashington/resources

Keeping Current

We live in a rapidly-changing world: trails become paved, road numbers change, sites become off-limit while new ones open up, and new rules supersede old ones. The rapid pace of these changes is beyond our ability to keep the information in this book current, but the web is our savior. Corrections and updates can be found online at: www.phototripusa.com/updates/

Should you notice an error or change in this book, kindly let us know about it via eMail to Greg@GregVaughn.com. The entire community will benefit.

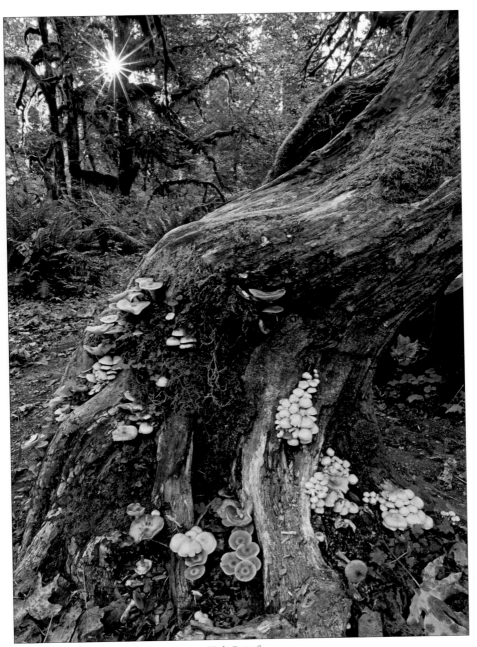

Hoh Rainforest

Chapter 2

OLYMPIC PENINSULA

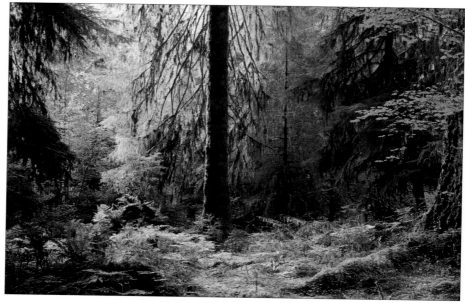

Hoh Rainforest, Hall of Mosses Trail

OLYMPIC PENINSULA

Washington's Olympic Peninsula offers an incredible wealth of opportunity for photographers. Majestic snow-capped mountains, a huge expanse of temperate rainforest, and dramatic sea stacks along a rugged coast are among the splendors for landscape photographers, while elk, deer, mountain goats, bear, raccoons, marmots, and plentiful birds provide additional subject matter for those interested in wildlife photography.

The main attraction on the peninsula is, of course, Olympic National Park. In the very heart of the park, 7,980-foot Mount Olympus gets more than 200 inches of precipitation annually, most of it snow, and the mountain encompasses the third largest glacial system in the contiguous United States. While the park can largely be circumnavigated by highway and a few roads lead a relatively short distance into the interior, the majority of the park—95% of its 922,000 acres—is federally-designated wilderness. The 60-mile stretch from Shi Shi Beach to the mouth of the Hoh River is continental USA's longest wilderness coast. A network of backcountry trails, through valleys, over mountains, and along remote beaches, make it a backpackers' paradise, with some trips requiring as much as a ten-day jaunt. Plenty of great photo locations are also easily accessible via roads and short hikes.

Most travel guides will tell you that the best time to visit Olympic National Park is July, and while that's a great time to go to Hurricane Ridge—the snow is gone and the wildflowers are out—spring and autumn are better for photography

along the coast and in the temperate rainforest on the western side of the peninsula. The forest will be lush and green in spring, while in autumn the bigleaf maple trees brighten the landscape with brilliant yellow leaves. Yes, you might get rained on, but after all, it's a rainforest, right?

There's a lot of territory to cover on the Olympic Peninsula, and while it may look deceptively close to Seattle on a map, you'll need a fair amount of time getting to the best photo locations, and once there you don't want to be in a hurry. If your time is limited, you can get a good sampling of the best of Olympic National Park with visits to Hurricane Ridge, Rialto Beach, and the Hoh Rainforest.

We'll start in the southwest region and work our way clockwise around the peninsula. From Olympia, head west to the seaport of Aberdeen, then pick up US-101 heading north. You'll travel through some beautiful forest areas along the way, and there are some places of historical interest in Aberdeen, but for those primarily interested in landscape and nature photography, my recommendation is to head straight to Lake Quinault.

Lake Quinault

Bordered by the Quinault Indian Reservation on the west, Olympic National Forest on the south, and Olympic National Park on the north, Lake Quinault is surrounded by densely forested mountains. Roads parallel the lake shore on the north and south, and there are several trails in the area giving you the opportunity to experience a rich old-growth temperate rainforest ecosystem.

The best place to start is the Quinault Rainforest Trail, an easy 0.6-mile loop through temperate rainforest in Olympic National Forest land on the south side of the lake. Here you will find a dense forest of huge Douglas-fir, Sitka spruce, western hemlock, and western red-cedar, with ferns and mosses in the lush green understory. There are interpretive signs along the trail to acquaint visitors with the ecology of the forest. You can extend this to a 4-mile hike through forest and along the lake shore by taking the Quinault Loop National Recreation Trail. The trailhead for both hikes is 1.4 miles east of US-101 on South Shore Road, just opposite Willaby Campground.

It's worth a visit to the historic Lake Quinault Lodge just to check out the rain gauge on the back deck, where precipitation is measured

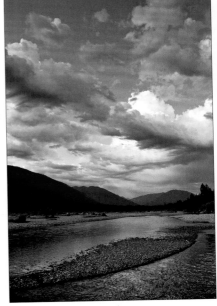

Quinault River & clearing storm

in feet, not inches. You are definitely in rainforest here—the average rainfall is upwards of twelve feet per year! In Quinault Village there is a good little general store and a Forest Service information station.

Continuing east on South Shore Road, about 4.5 miles past the lodge you'll come to Merriman Falls. There's a good-sized turnout next to a bridge and the falls are easy to spot from the road. Several other small waterfalls can be found on the numerous creeks that flow through the area.

You can further explore the area by following the Quinault River via South Shore Road up to Graves Creek Campground and trailheads into the backcountry. Look for the resident herd of Roosevelt Elk as you explore this area. At the campground, you'll find the easy 1-mile loop Graves Creek Nature Trail.

Starting at the end of Graves Creek Road, a popular trail with backpackers leads to Enchanted Valley, also known as the Valley of 10,000 Waterfalls. Following the East Fork of the Quinault River, the trail leads through old growth rainforest to a long, deep valley and can be done as an out-and-back or a through hike to the eastern side of the Olympic Peninsula at Dosewallips. Although this is a fun hike to a beautiful area, the opportunities for great landscape photography are limited and the waterfalls are mostly wispy streams of water falling from distance cliffs. Wildlife shooters, however, find it an excellent location for photographing the plentiful black bear and Roosevelt elk.

On the north side of the lake, where the jurisdiction is National Park Service, the Irely Lake Trail is an easy 1.1-mile hike through the forest to a swampy lake, where tree trunks sticking out of the water can make some interesting photographic studies. Maple Glade Trail, accessed from the Quinault River Ranger Station, is a level 0.5-mile loop through a grove of moss-covered bigleaf maple trees. The leaves of the maples turn beautiful golden yellow in autumn, making this one of the better places in Olympic National Park for fall color. Graves Creek Road and North Shore Road are rather narrow and not really suitable for trailers and large RVs.

Photo advice: Essential gear just about everywhere on the Olympic Peninsula includes rain protection for both you and your camera equipment. Overcast days are ideal for rainforest photography, and you'll find that a polarizing filter will cut some of the reflection on shiny leaves and give more saturated greens to the foliage; be careful not to over-polarize, or the scene will look rich in color but lifeless. Peak time for autumn color in the bigleaf maple trees is usually the last week in October.

Getting there: Lake Quinault is 40 miles north of Aberdeen or 66 miles south of Forks via US-101. Turn east at MP 125 on South Shore Road for campgrounds, lodging, and visitor services.

Time required: At the very least, spend an hour on the Quinault Rainforest Trail and check the lake view from the Lodge; spend a day or more in the area if at all possible.

Right: Throne of Emerald, Quinault rainforest (photo by Laurent Martrès)

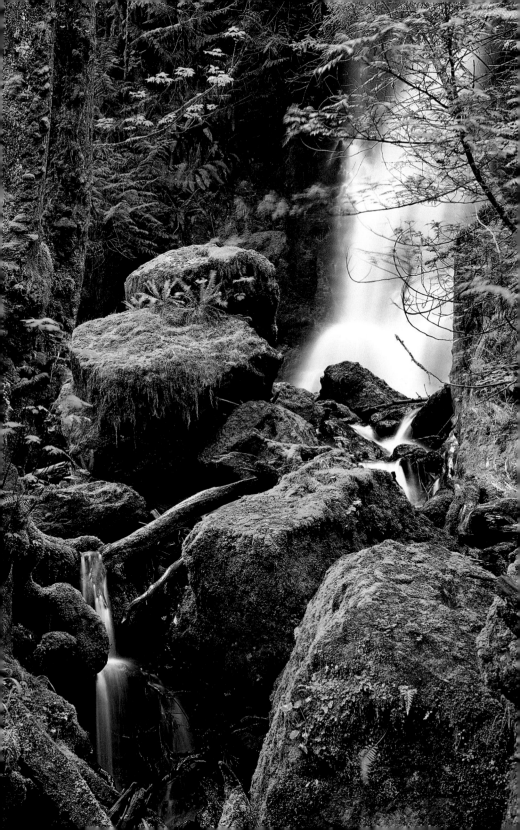

Ruby Beach

Between Lake Quinault and the Hoh Rainforest, US Highway 101 heads out to the coast and parallels the shoreline for a dozen miles. There is beach access at several points, including at Kalaloch Lodge, and a series of numbered beaches.

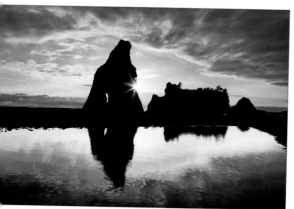

Ruby Beach (photo by Isabel Synnatschke)

It's tempting to stop and check each beach along this wild coast, but if your time is limited aim for Ruby Beach, just where the highway turns inland to follow the Hoh River. A slightly steep 0.25-mile trail descends through coastal forest to a sand and cobblestone beach littered with driftwood logs. Monolithic rock formations known as sea stacks rise dramatically from the beach just off shore. One of the sea stacks has two holes in it, and in spring and fall it's possible to line up the setting sun in one of the holes. Ruby Beach is an awesome place for sunset photos of course, but it can produce great, moody images on days of dense fog, too.

Photo advice: This is a great place to play with really wide angle lenses, using beach cobbles and driftwood as foreground elements leading into the dramatic beachscape scenery. This whole coastline can be fantastic at any time of year, but late spring and early to mid-autumn are best bets for getting late afternoon sun to work its magic on the landscape. On a day with strong light but no clouds as sunset approaches, try shooting along the coast instead of out to sea, capturing the warm late afternoon light on the beach and forested headland.

Getting there: The parking area and trailhead is just off US-101 about 8 miles north of the Kalaloch Ranger Station or 20 miles south of the town of Forks.

Time required: Half an hour to an hour may be enough for a mid-day stop, but be there at sunset if you can and the weather is promising.

Nearby location: To the south of Ruby Beach most of the coastline is a long stretch of flat, sandy beach backed by steep cliffs and thick rainforest. Beach 4 is a pebble beach with some tide pools and is known for strong surf. If you have plenty of time to visit, short trails lead from parking areas along the highway to beaches and coves. Worth the short side trip is a visit to Big Cedar, a gigantic old western red-cedar tree just off US-101 about five miles north of Kalaloch. Looking like something out of Lord of the Rings, the gnarly trunk and roots can be fascinating photo studies.

Hoh Rainforest

Much of the Olympic Peninsula is coniferous temperate rainforest, where giant Douglas-fir, Sitka spruce, and western hemlock trees are part of an ecosystem that contains one of the highest levels of biomass on earth, and there's no place better to see its splendor than the Hoh Rainforest district of Olympic National Park.

It is a truly spectacular forest and great photos of it can be made just a short distance from the visitor center on the Hall of Mosses Trail, an easy 0.8 mile loop. While the forest is primarily coniferous, there are many bigleaf maple trees throughout; in one section of the trail in particular, there is a grove of giant maples festooned with epiphytic mosses and ferns, in a setting that is remarkably beautiful. Most of the year it is a landscape of rich greens, but in autumn the maples turn golden, making it a great location for fall color photography (peak time for fall color is usually the last week in October).

Spruce Nature Trail—also accessed from the visitor center—is another delight for photographers, and an easy 1.2-mile loop that takes you through the rainforest to the Hoh River. For a longer hike, the Hoh River Trail, also starting at the visitor center, will take you deep into the backcountry, reaching Glacier Meadows on the flanks of Mount Olympus in 17 miles. The Hoh River starts high on snow-capped Mount Olympus, and as is typical of glacier-fed rivers, the water has a milky appearance from finely ground rock as it carves its way through forest and valley to the ocean.

Look for the resident herd of Roosevelt Elk that can sometimes be seen wandering through the campground or down by the river. Roosevelt Elk are the

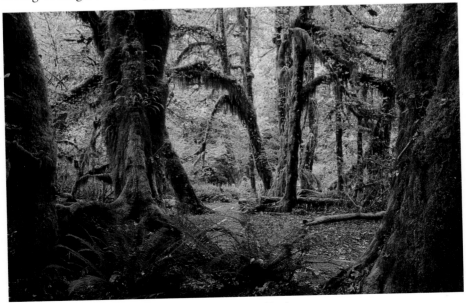

Hall of Mosses Trail

largest of the four subspecies of elk in North America, and are found only in the Pacific Northwest. They are magnificent creatures and portraits of bulls with their huge antlers are a favorite of wildlife photographers. During the fall rut, the high-pitched squeals of the bulls bugling can be heard throughout the valleys as they challenge each other, establishing dominance and protecting their harems. Olympic National Park was actually established to protect these elk, which are named after President Theodore Roosevelt, and the original proposal in 1904 was to name it Elk National Park.

Both the Hoh Rain Forest Visitor Center and the nearby campground are open year round. The average tourist will want to visit in late summer when the weather is generally drier and warmer, but this is a rainforest after all, and looks best when everything is lush green and damp. You're going to get wet if you go in spring, but new growth on the foliage will be beautiful and ferns at their prime. Autumn, as mentioned, is a wonderful time to visit this area, too.

Photo advice: As in most forest situations, you'll want to be shooting when it's overcast and the light is soft, and of course you'll hope for a calm day with little or no breeze. Using a polarizer will bring out the vibrant greens of the moss and, in Autumn, the yellow and gold of the bigleaf maples. You'll mostly want semi-wide to very wide lenses for the forest scenes and a macro lens for close-ups of mosses and mushrooms. A moderate telephoto or mid-range zoom can be used to isolate details or pull in scenes of the distant view of the surrounding forest from the occasional openings along the trails.

Getting there: From US-101, head east on Upper Hoh Road to the Olympic National Park entrance station in 12 miles. Continue for another 6 miles along the Hoh River and through forest to the visitor center and trailheads. The junction of US-101 and Upper Hoh Road is 14 miles south of the town of Forks.

Time required: Count on a half day at least, to include the drive from US-101 and enough time on Hall of Mosses Trail for photography. This is one of the highlights of Olympic National Park, so give yourself as much time as you can.

Second Beach & Rialto Beach

The beaches along the Olympic coast are a landscape photographer's paradise, and it's hard to name any one of them as the best, but Second Beach and Rialto Beach are certainly the favorites of many. At Second Beach, an easy 0.7-mile trail winds through dense forest and ends at a sandy beach with a rocky headland to the north and a large, tree-topped sea stack just offshore. Watch your footing as you cross the piled up drift logs, as they can be loose and slippery. There's awesome sunset potential at all the beaches along this coast, but Second Beach is the favorite of many photographers. At the north end of the beach, one of the sea stacks has a natural arch opening. With low tides, follow the beach south for more sea stacks and good tide pools.

Great photos are just steps from your vehicle at Rialto Beach. The gravel and cobblestone shore is littered with drift logs, and the ones that are smoothed by wind, weather, and water make excellent foreground elements for broad landscapes, as well as graphic subjects in themselves. Down the beach, sea stacks lend themselves to dramatic compositions in just about any weather. Walk north along the beach for 1.5 miles to reach Hole-In-The-Wall, a natural arch in a rock outcropping right on the beach. The tide pools south of Hole-In-The-Wall are barren, scoured clean by the surf, but to the north the pools are teaming with life. Low tide is best for the tide pools of course, and it's easier to walk on the hard-packed sand then, but Hole-In-The-Wall photographs best at medium tide with water swirling around the base of the sea stack. Be careful, however, that you don't get trapped here at high tide.

Photo advice: Before your trip, consult online tide tables or pick up a tide chart from stores along the way. There can be a huge difference in coastal areas between high and low tides. At sunset and dusk, use a neutral density filter to get down to multi-second exposure times, letting the water blur into soft patterns as the surf curls around the rocks and reaches the beach. In summer, you can position yourself on the beach at both Second Beach and Rialto to catch the sun setting through the arches in the sea stacks.

Getting there: From US-101 a couple of miles north of Forks, turn west on La Push Road, taking the left fork on WA-110. At the junction with Mora Road, take the left fork again to get to Second Beach; the trailhead is right where the road comes to the coast on the Quileute Indian Reservation at the town of La Push. To get to Rialto Beach, turn right on Mora Road and go past the National

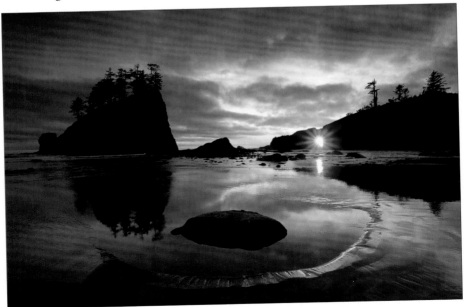

Second Beach sunset (photo by Isabel Synnatschke)

Park Ranger Station and campground to the parking lot for the beach at the end of the road. From US-101, it's about 14 miles to Second Beach, a little less to Rialto. Driving time from Forks to Rialto Beach is about 20 minutes; from Port Angeles it's about an hour.

Cape Alava

North of Rialto Beach, the coast becomes even more wild and rugged, with no direct road access until the very tip of the peninsula. There is, however, a popular trail at Ozette Lake that travels 3.3 miles, most of it on boardwalk (which can be very slippery when wet), to the coast at Cape Alava, the western-most point in the contiguous United States. You can make this a loop hike by walking south along the coast for 3 miles to Sand Point and then returning from there to the Ozette Lake trailhead in another 3 miles. The full loop is referred to as the Ozette Triangle; it's a relatively easy hike, but walking on the sand and cobble beach section can be slow going. For the loop hike, plan to do the Cape Alava to Sand Point leg at low tide, otherwise you'll have to scramble over some bluffs. There's a rocky, large cobblestone beach at Cape Alava, with views to Ozette Island and the Flattery Rocks. As far as grand landscape photography goes, this location doesn't offer near as much as the beaches to the south or Point of Arches to the north, but Sand Point has some good tide pools and there are some very interesting petroglyphs at Wedding Rock about halfway between Cape Alava and Sand Point. There are backpacker camping sites above the beach in several places for those who want to make it an overnight trip.

Photo advice: Most any time of day is okay here, but either good weather or dramatic stormy skies are a necessity—an overcast day won't give you much in the way of photo possibilities along the broad, flat shoreline.

Getting there: From US-101, turn north on WA-113 at the Sappho junction. Travel for 10 miles, turn west on WA-112 and in 11 more miles, just past Sekiu, turn south on Hoko-Ozette Road and drive 21 miles to the end of the road at the Ozette Ranger Station and campground.

Time required: Considering the drive time plus the hike, plan on no less than half a day to visit Cape Alava.

Shi Shi Beach & Point of Arches

Shi Shi Beach and Point of Arches provide truly memorable views of a whole group of sea stacks and an incredibly beautiful coastline, particularly if you're lucky enough to be there when there's a good sunset. Point of Arches, at the south end of the two mile long crescent of Shi Shi Beach may just be the most stunning group of sea stacks on the entire west coast. Fantastic tide pools and

eroded sandstone add further possibilities for great photos, and you're almost assured of seeing bald eagles soaring above the beach or perched in the trees.

Unless you're up for a rugged, 13-mile hike along the coast from Ozette, to get to Shi Shi you'll have to go to the Makah Indian Reservation on the very tip of the Olympic Peninsula and hike south from the tribal lands. Stop at Washburn's store in Neah Bay to pick up a tribal Recreation Permit and a map that will show you the route through town to Hobuck Bay and the road to Shi Shi. There is some day-use parking at the trailhead, but your vehicle will be more secure if you pay to park at one of the residences that have a sign out front (some offer shuttle service to the trailhead, otherwise add about a mile to your hike). The trail (which can be very muddy in winter and spring) passes through thick Sitka spruce forest before dropping down a steep bluff and breaking out on the sand at the north end of Shi Shi Beach in about 2 miles. Continue south on the broad,

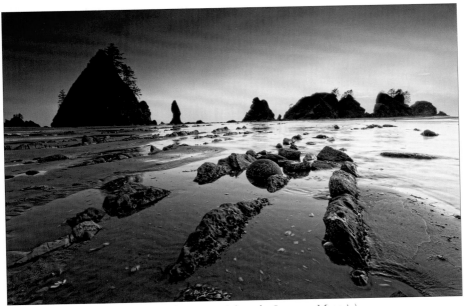

Point of Arches sunset (photo by Laurent Martrès)

sandy beach for another couple of miles to reach the main attraction, Point of Arches. Plan on getting there in plenty of time to line up your sunset shot with the sea stacks. At very low tides, the tide pools here are some of the best in the Pacific Northwest, and contain plenty of bright orange and deep purple sea stars. The jagged sea stacks are wonderful silhouetted against a sunset sky, and they are nicely lit at sunrise.

It's a relatively easy hike and, combined with the spectacular scenery, the beach can get crowded with campers in summer, especially on weekends. If you're planning to camp at Shi Shi, or anywhere along the Olympic Coast, the National Park Service requires that you have hard-sided food containers such as

bear canisters for food and garbage—the raccoons in these parts are notorious camp scavengers, and black bears could be a problem as well if precautions aren't taken. The bear boxes aren't available on the reservation, but you can rent one for a small charge at the Olympic National Park Wilderness Information Center in Port Angeles.

Photo advice: Try to time your visit so that the tide is receding and about halfway out at sunset for the best compositions at Point of Arches. Spring and autumn are best for both beach conditions and dramatic skies. This trip is best done as an overnighter to maximize your chances of capturing great photographs.

Getting there: From US-101, turn north on WA-113 at the Sappho junction and follow the signs north and west to Clallam Bay and to Neah Bay via WA-112 in a total of 38 miles. This is a slow and winding road that takes a bit over an hour to drive. Get your tribal Recreation Permit and a map with directions to Shi Shi at Washburn's store. Note: at the time of this writing, Google Maps shows Shi Shi Beach Rd, which is no longer a public road. The trailhead is on Fish Hatchery Road, just before the hatchery.

Time required: Taking into consideration the time needed for the drive to Neah Bay, getting the reservation permit, finding parking and getting to the trailhead, before even starting the hike to Shi Shi, it's really necessary to plan for at least a full day to visit Point of Arches. If you want to stay for sunset but not carry a pack of camping gear, be prepared to walk out through a very dark forest on a slippery trail. For overnight stays on the Makah Reservation, camping and cabins are available at Hobuck Beach, and there is a basic motel in Neah Bay. Other lodging options are located along WA-112 between Clallam Bay and Neah Bay.

Nearby location: There are a couple of places on the Makah reservation that are good photo locations. Hobuck Beach is a long curve of sand where sunsets off Waatch Point can be beautiful. At Cape Flattery a 0.75-mile, moderately strenuous hike on good trail leads to excellent views of the dramatic Olympic Coast and Tatoosh Island. The coastline at the cape is particularly beautiful in late afternoon sunlight. The Makah Tribal Museum in Neah Bay is another worthwhile stop.

Sol Duc Falls

This beautiful waterfall is one of the 'don't miss it' scenes in Olympic National Park. The Sol Duc River starts deep in the Olympic Mountains, running many miles across the peninsula before joining the Quillayute River and emptying into the Pacific Ocean at La Push. The name Sol Duc, and variations on the spelling found throughout the area, comes from a Native American legend of two dragons who lived and did battle nearby.

An easy, mostly level 0.8-mile trail takes you through a beautiful forest of towering conifers and mossy maples to a footbridge where the river cascades over

sculpted bedrock and suddenly drops 50 feet into a narrow chasm. The bridge over the river right at the falls is a very good vantage point, as are the fenced viewpoint and rocks just upstream. In the past, photographers have worked their way downstream a bit to shoot back towards the bridge, but the view has become overgrown and a log wedged across the gorge below the bridge has somewhat spoiled the view.

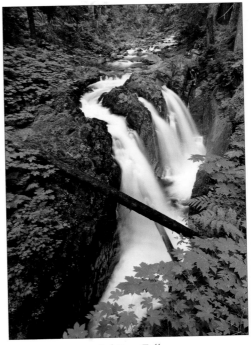

Along the trail to the falls, look for a small creek cascading over rocks covered in bright green moss. This photographer's favorite is a fun place to shoot both overall landscapes—perhaps getting low and close with a wide angle—as well as detail shots that single out just one section of creek flowing between the rocks covered with velvety green moss.

Photo advice: The main falls are in a narrow, dark basalt gorge surrounded by dense forest, so mid-morning to mid-afternoon on an overcast or cloudy day works well. No need to pack a long telephoto lens on this hike - you'll probably want your widest wide at the falls and semi-wide to short tele for other scenes along the trail.

Sol Duc Falls

Getting there: From US-101, turn south on Sol Duc Hot Springs Road; the turn is about 27 miles west of Port Angeles. Drive to the end of the road, past the hot springs resort, in about 14 miles. The resort features a large swimming pool fed by natural hot springs and has cabins for rent; there is also a campground next to the resort. The campground and resort are both very popular places in the summer, and you probably won't find a place to stay at either if you arrive late in the day without reservations. If you're staying at the resort, you can follow Lovers Lane Trail along the river for 2.8 miles to the falls.

Time required: Allow one to two hours for the hike and photography, plus maybe another hour for the round-trip drive from US-101.

Nearby location: Along Sol Duc Hot Springs Road are a couple of worthwhile stops. At Salmon Cascades a 0.1-mile path leads to a platform overlooking the Sol Duc River with a view of the series of cascades that migrating salmon must negotiate as they travel up river in late summer and fall. The Ancient Groves Nature Trail is an easy 0.6-mile loop passing through some of the best old-growth lowland and temperate rain forest in Olympic National Park.

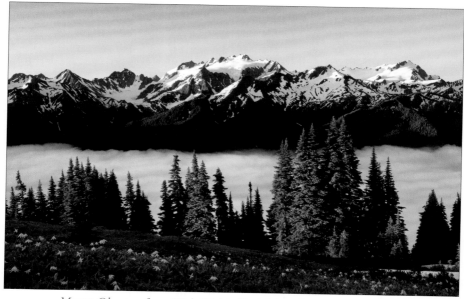

Mount Olympus from High Divide Trail (photo by Kirkendall-Spring)

High Divide Trail

For a hike that takes you through some of the best lowland forest and then up into the high country of the Olympic Mountains for superb views of the Bailey Range, the High Divide Trail can't be beat. The 18-mile, somewhat strenuous backpack loop takes off from Sol Duc Falls. Hiking it clockwise means a somewhat steeper ascent to get to the Divide, but a more gradual descent on the return. This is a popular hike through a wilderness area, and requires a backcountry permit from the Park Service. You'll have to go to the Wilderness Information Center in Port Townsend to get the permit, and an assignment for one of the designated camp sites on the trail. Bear canisters are also required, and if you don't have your own, the Park Service will loan you one for a small donation. Call the WIC for more information or to get a permit in advance *(see Appendix)*.

The High Divide Loop is not an easy trail—quite a bit of elevation gain on rocky, uneven ground—but the scenery is truly fantastic. Starting in old-growth forest along the Sol Duc River, the trail ascends to subalpine meadows, traverses a ridgeline separating the Seven Lakes Basin from the Bailey Range mountains, then returns to Sol Duc Falls via Deer Lake. Up on the divide, you can look south across the Hoh River Valley to glacier-clad Mount Olympus, and to the north are the alpine tarns of the Seven Lakes Basin—jewel-like remnants of glacial activity surrounded by rocky peaks and coniferous forest. Carpets of avalanche lilies and large patches of lupine adorn the high meadows in July; huckleberries abound along the trail near Deer Lake, attracting bears as well as human berry pickers in late August.

There are some idyllic campsites at the meadows of Sol Duc Park and around Heart Lake, but camping at one of the sites up on the divide will put you in the right place for photos of the snow-capped Olympic Mountains across the Hoh River Valley when the golden light hits at the end of the day. There are more great campsites at some of the tarns in Seven Lakes Basin. Bears aren't really a problem here, as along as you keep all food in a bear canister, but the mountain goats can be pesky, chewing socks and bandanas left to dry at camp sites. The goats here show little fear of humans, so it's relatively easy to get good close-ups of the shaggy white critters. Don't forget to bring plenty of bug spray as the mosquitoes are voracious around the lakes and meadows.

Photo advice: For some of the best views of Mount Olympus and the Bailey Range, take the trail east along the ridge towards Cat Basin from the junction of Sol Duc River Trail and the High Divide Trail, just above Heart Lake.

Getting there: From US-101, turn south on Sol Duc Hot Springs Road, reaching the hot springs resort in 12 miles. Continue 1.5 miles beyond the resort to the trailhead for Sol Duc Falls.

Time required: It's possible to hike up to the Divide and the Seven Lakes Basin as a out-and-back dayhike, but doing so doesn't leave much time for photography and won't put you there in the right light. A one-nighter will work, two nights is much better and three will allow for a more leisurely pace with plenty of time to enjoy the fantastic scenery.

Lake Crescent & Marymere Falls

On one of the most scenic sections of US-101 on the Olympic Peninsula, the winding road hugs the south shore of Lake Crescent just a few feet above water level. There are several turnouts with good views of the 12-mile long, narrow lake, carved eons ago by glacial forces. Depending on the weather, the lake can be a perfect mirror for the surrounding steep, forested hillsides, or it can be stormy, choppy, and windblown. Sometimes, a dense fog lays on the surface, temporarily obscuring much of the overall scenic beauty, but also providing other photographic opportunities.

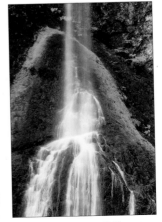

From the Storm King Ranger Station on Crescent Lake, it's a pleasant 1.5-mile round-trip hike to Marymere Falls, one of the most popular destinations on the north side of Olympic National Park. Narrow Falls Creek forms a thin waterfall as it plummets over a cliff then fans out as it hits a shelf, falling for a total 90 feet or so into a pool jammed with logs. In spring and with the fall rains there's a nice

Marymere Falls

flow, while in late summer the waterfall becomes rather wispy. There are at least a couple of vantage points from which to photograph the falls; try the lower one first, then climb the steps for a higher viewpoint.

Photo advice: A fairly wide lens is needed to get the whole waterfall, but you might find a more pleasing composition by using a short telephoto to frame just a portion of the falls. The waterfall faces north and is shaded by a ridge to the west in the late afternoon.

Getting there: The Storm King Visitor Center is about 22 miles west of Port Angeles on US-101.

Time required: An hour is about right for the hike and time for photos.

Elwha River & Madison Falls

Madison Creek Falls is a very short walk from the park entrance station for Elwha Valley, 2 miles south of US-101 on Olympic Hot Springs Road. The 40-foot waterfall and pool is worth checking, but you may find, as I did, a great many logs and blown down trees, making good photos problematic.

The Elwha River Drainage is the largest in Olympic National Park, and is quite scenic but to my mind doesn't offer any definitive landscape photo opportunities. The Elwha River is, however, extremely important ecologically. It is the only river in the Pacific Northwest where all five species of salmon are found, and it is also home to four other anadromous trout species. In 2012 the National Park Service began removal of the two dams on the river as part of a 25+ year project to restore the Elwha River ecosystem and once again allow the salmon to reach spawning grounds 70 miles into the interior of the Olympic Peninsula.

Hurricane Ridge

Hurricane Ridge is one of the most popular destinations in Olympic National Park, and for good reason: The views are truly magnificent. You'll want to spend a good amount of time here, especially in early summer when wildflowers abound. Even the drive to get there from Port Angeles is spectacular, climbing steadily from sea level to 5,300 feet with great scenery the whole way. The road takes you through old-growth forest in the lowlands to open meadows and scattered stands of subalpine fir at timberline.

Mid-summer is a great time to visit this area, but keep in mind that sunset is around 9:30 PM at the summer solstice and you've got some driving to do to get back to the campground or Port Angeles. Mid- to late-June is the time to be there for maximum wildflowers. Hillsides are carpeted with avalanche lilies in early summer, giving way to a profusion of purple lupine as the season progresses.

The visitor center at the top of the ridge is a great place to shoot panoramic images of the Olympic Mountains, with the rugged and glaciated Bailey Range directly before you. Paved trails from the visitor center allow for an easy stroll through Big Meadow, a great place for summer wildflowers and more sweep-

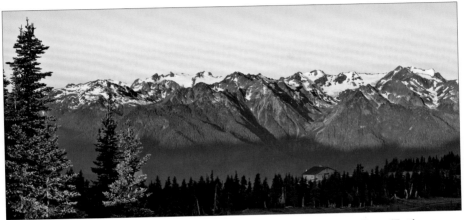

Bailey Range & Hurricane Ridge Visitor Center from Sunrise Point Trail

ing views of the surrounding mountains. Black-tailed deer are common in the meadow and around the visitor center, and you're likely to see cute little spotted fawns in early summer. The rangers must get awfully tired of telling people not to feed the deer; apparently four out of five tourists are unable to read the signs posted everywhere saying that the feeding of wildlife is prohibited.

You'll almost certainly want to do the Hurricane Hill hike, which starts at the end of the road, a mile past the visitor center. It's a moderately strenuous 1.5-mile hike, mostly level at the start and then climbing to the summit where you'll have views of the Olympic mountains and north over the Strait of Juan de Fuca. Great potential here for both sunsets and sunrises. Olympic marmots can be easily photographed along the trail and in several other spots on Hurricane Ridge; look for the furry critters scurrying among rocky outcrops and munching on lupine flowers in July. An endemic species, these marmots are found only in the Olympic Mountains. You might also spot black bears foraging on the alpine meadows, especially in late summer.

Fields of avalanche lilies, lupines, and other wildflowers can be found on the slopes below Obstruction Point Road to the east of the Visitor Center. As always, use care not trample the area while trying to get to a good spot and just the right angle. Here as well, opportunities for panoramic views of the distant peaks are plentiful. This rough gravel road usually opens by early July and it can be a bit of a challenge for passenger vehicles. The road follows the ridgeline and continues for almost 8 miles from the visitor center; be sure to park in the occasional pull-outs so as not to block traffic on the narrow road. A number of trails take off from the road and from Obstruction Point, leading into the interior mountains

for day hikes or multi-day treks; serious hikers spend a week to ten days or more hiking all the way to Lake Quinault or Queets.

Weather is extremely variable at Hurricane Ridge and can change rapidly, so be prepared for anything. As you might guess from its name, it can be very windy here. It's not unheard of to experience dense fog, clear sunny skies, and snow all in one day—in July no less.

In winter, the visitor center makes a good base for snowshoe walks and cross-country skiing on unmarked routes across the meadows and through the forests. Before you go, call the parks Road & Weather Hotline *(see Appendix)* to

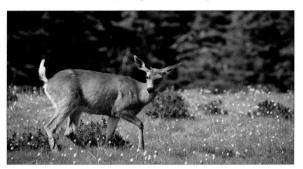
Blacktail deer at Hurricane Ridge

get the latest information on road conditions and closures. Between November and May, the road to Hurricane Ridge is only open Friday-Sunday from 9:00 a.m. until dusk, except for the winter holiday period around Christmas and New Year, when it opens every day except December 24 and 25.

Photo advice: Unless you're planning on lots of hiking, you'll want to bring your full arsenal of photo gear. There are opportunities here for everything from ultra-wide to long telephoto lenses. It's also an any time of day place. During wildflower season get there early, before the breeze picks up. Light will be good on the Bailey Range mountains early in the day from the visitor center area, and even better from Sunrise Point right at sunrise.

Getting there: From US-101 in Port Angeles, head south on Race Street and stop at the Olympic National Park Visitor Center for current information and a weather check. If you are camping, stake your claim at Heart o' the Hills Campground and then continue to the summit of Hurricane Ridge. It's 17 miles from town to the Hurricane Ridge visitor center. The road is good but long and steep enough that RVers probably shouldn't attempt to pull large trailers to the top. Driving time from Port Angeles to the visitor center is about 45 minutes. On your way down, remember to use lower gears and don't burn out your brakes.

Time required: Pack a picnic and plan on spending at the very least half a day here. There's a ton of great stuff to see and photograph.

Deer Park

The high elevation views from Blue Mountain—like those from Hurricane Ridge—are spectacular, but you won't find crowds up here due to the long, rough road. This route and the road to Hurricane Ridge are the only access by vehicle

to the interior, alpine areas of Olympic National Park. From the top, take in the Strait of Juan de Fuca to the north and a wonderful view of the Olympic Range to the west. Spend the night at the campground so you can go for both sunset and sunrise.

Getting there: From Port Angeles, drive east on US-101 for 5 miles and look for the signed road leading south to Deer Park. It's an 18-mile long narrow and winding road; the pavement ends after about five miles and the road gets pretty rough, definitely not suitable for RVs or trailers. This road isn't plowed in winter, so it's closed by snow from late autumn to melt-out in late spring.

Tongue Point & Dungeness Wildlife Refuge

About 20 minutes west of Port Angeles is Salt Creek County Park and a wonderful marine sanctuary where Tongue Point juts in the Strait of Juan de Fuca. When the tide is low it's an excellent place to photograph tidal creatures like starfish, mussels, and gooseneck barnacles.

The 636-acre Dungeness National Wildlife Refuge includes one of the world's longest natural sand spits, tidelands, and a small forested area. It's very important habitat for marine creatures and birds, but, to my mind at least, it doesn't offer much for the landscape photographer. Hardy lighthouse lovers will want to make the 10-mile round-trip hike to the New Dungeness Lightstation towards the tip of the spit.

Photo advice: Check tide tables and plan your visit for a day when there are minus tides. Both locations are also good for sunrise and sunset over the Strait of Juan de Fuca.

Getting there: To get to Salt Creek County Park, head west on US-101 from downtown Port Angeles for about 6 miles. Turn right on WA-112 and continue west for 7 miles. Turn north onto Camp Hayden Road (near milepost 54) and go 3.5 miles to the park entrance. For Dungeness NWR, head east from Port Angeles on US-101 for about 12 miles and turn north on Kitchen Dick Road. Follow this road as it dog-legs east and turns into Lotzgesell Road. Turn left into the Dungeness Recreation Area.

Time required: If you're a tide pool fan, allow at least a couple of hours at Tongue Point. The hike to the lighthouse at Dungeness Spit is a 4-6 hour trek round-trip.

Nearby location: The busy town of Sequim, a popular retirement community that sits in the rain shadow of the Olympic Mountains, has become well known for its lavender farms. From mid-June until the harvest is complete in August, fields of the fragrant flowers can be found in a number of locations surrounding the town. Many are just small plots, but Jardin de Soleil on Sequim-Dungeness Way has a field with row after row of mature plants that are a solid mass of color in mid-summer.

Port Townsend

Situated at the very northeast tip of the Olympic Peninsula, Port Townsend is not exactly a nature photography location but several features make it attractive to photographers. There are a number of historic buildings in the old downtown waterfront area and some beautifully restored Victorian houses throughout the town. Fort Worden State Park has many historic buildings, including vintage row houses that were used as a set for the movie "An Officer and a Gentleman"; the houses are now available as vacation rentals. Point Wilson Lighthouse is an excellent photo subject, particularly on a clear day when snow-capped Mount Baker can be included in the scene. You can walk to the lighthouse in a little over a mile along the sandy beach at Fort Worden, or use a telephoto for a more distant view.

Photo advice: Point Wilson Lighthouse works very well at both sunrise and sunset; position yourself to the southeast of the lighthouse to get Mount Baker in the background.

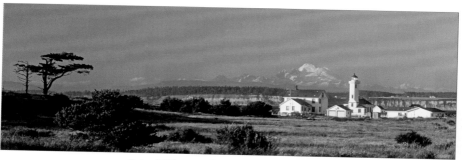

Point Wilson Lighthouse & Mount Baker

Getting there: When making the loop around the Olympic Peninsula on US-101, look for the signs at the junction with WA-20 at Discovery Bay and travel 13 miles to the historic downtown area. The Washington State Ferry runs between Port Townsend and Whidbey Island; reservations are recommended on this ferry route.

Nearby locations: US-101 follows the shoreline of Hood Canal along the eastern side of the Olympic Peninsula, with the thick forest of the mountains reaching almost to the coast. It's a scenic drive through some pretty territory, but it's hard to find photo subjects as grand as what is available elsewhere on the peninsula. Towns, resorts, and campgrounds along the way are all about oysters and clams on the tidal flats, and fish in the waters of Hood Canal or inland lakes and rivers.

❖ ❖ ❖

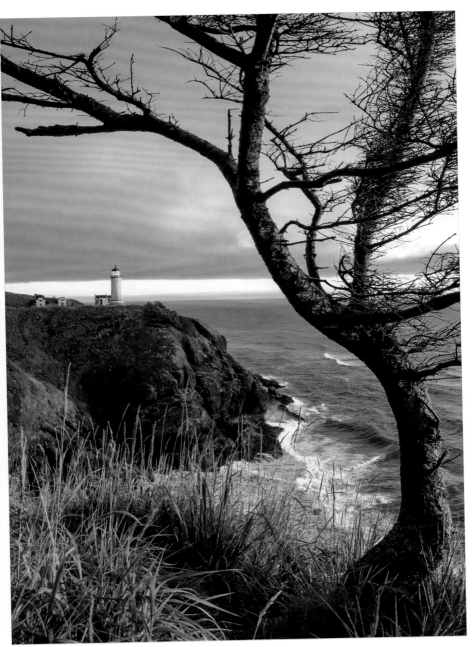

North Head Lighthouse

Chapter 3

SOUTHWEST WASHINGTON

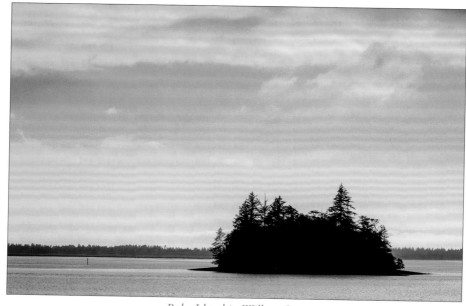

Baby Island in Willapa Bay

SOUTHWEST WASHINGTON COAST

Miles and miles of flat, sandy beach backed by low, grass-covered, or forested sand dunes stretch south from the entrance to Grays Harbor, and the communities of Westport, Grayland, North Cove, and Tokeland are collectively referred to as South Beach. If you like to photograph old fishing boats at dock, with their piles of nets and stacks for crab pots, head for the marina at Westport; it's the biggest town on the southern coast of Washington, and long a major fishing port.

Westport Light State Park is the location for Grays Harbor Lighthouse, first lit in 1898. At 107 feet high, it is the tallest lighthouse in Washington and the third tallest on the West Coast. The lighthouse's designer, C. W. Leick, considered it his masterpiece. Unfortunately, its warning beacon no longer shines through the large Fresnel lens, but the lighthouse is still quite photogenic. Due to its location—set back from the coast and almost surrounded by trees—about the only option for good photos here is with early morning sun hitting the tower and either a blue sky or dark stormy clouds behind.

This area is also known as the Cranberry Coast, and if you're visiting in autumn, check out the bogs near Grayland that turn into masses of bright red color at harvest time in October.

Across the entrance to Willapa Bay, it's only five miles as the crow flies from Tokeland to the tip of Long Beach Peninsula on the south side, but it's quite a few more miles traveling by vehicle. Willapa National Wildlife Refuge, with

headquarters near the south end of Willapa Bay, includes one of the largest undisturbed estuaries on the West Coast. It's a great place to see shorebirds and waterfowl, and you can also canoe or kayak to Long Island for hiking and camping in an old-growth forest of western red-cedar. Tiny Baby Island sits by itself in the bay and can be an interesting focal point for sunset photos from roadside pullouts a couple of miles west of refuge headquarters.

Between Willapa Bay and the coast lies the Long Beach Peninsula with its 28-mile long sandy beach. Beaches like this, and the Tokeland to Westport stretch to the north, can be a bit more challenging to photograph than the dramatic rocky coasts of the Olympic Peninsula and much of the Oregon coast to the south. Try using dune grass and drift logs as foreground elements to add interest to the flat sandy beach. In the town of Long Beach, a half-mile long boardwalk traverses the grass-covered dunes, and intersects with the Discovery Trail, linking Ilwaco with the coast on the route followed by Capt. William Clark during the Lewis & Clark Expedition in 1805. On the east side of the peninsula, check out the historic towns of Oysterville and Nahcotta for old buildings and giant piles of oyster shells. At Leadbetter Point, the northern tip of the peninsula, there are trails through forest to the coast and bay beaches on state park and wildlife refuge lands. On foggy days, the harbor at Ilwaco is another great place to photograph crusty old fishing boats.

Photo advice: Summer is the most popular time for the majority of visitors to the coast, but it's also the time you're mostly likely to have a heavy fog bank sitting on the horizon, precluding really good sunsets. Spring and autumn are generally considered much better times for photography on the coast. On the other hand, winter weather can bring dramatic skies, ferocious wind, and pounding surf.

Getting there: From the Puget Sound area, take US-101 north from I-5 at Exit 104 in Olympia, then west on WA-8 and continue west on US-12 to Aberdeen. Turn south on WA-105 for Westport-Grayland or south on US-101 to Willapa Bay and Long Beach. From the Portland-Vancouver area, travel north on I-5 to Kelso, then west on WA-4 to the junction with US-101 at Willapa Bay; head south for Cape Disappointment and the Long Beach Peninsula, or north for Westport and Grayland. Alternatively,

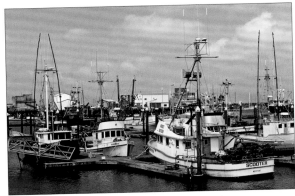

Fishing boats at Westport Harbor

you can travel from Portland to Astoria on the Oregon side of the Columbia River and cross the Astoria-Megler Bridge to the Washington side a few miles south of Ilwaco.

Cape Disappointment State Park

For landscape photographers, and history buffs as well, Cape Disappointment State Park holds more interest than any other location on the state's southern coast. Located at the very southwest tip of Washington and formerly known as Fort Canby, this state park includes two very photo-worthy lighthouses, views of the Columbia River, driftwood-strewn beaches, and old-growth forest. Sturdy concrete structures of Fort Canby, originally built during the Civil War and in use until the end of World War II, are embedded in the hillside of the cape. The Lewis & Clark Interpretive Center sits atop the promontory, with a commanding view of the mouth of the Columbia River and the Pacific Ocean beyond.

Cape Disappointment Lighthouse, marking the entrance to the Columbia River, can be viewed from the Lewis and Clark Interpretive Center, or by hiking a 1.2-mile round-trip trail through temperate rainforest to the lighthouse itself. I personally think it's best photographed from Waikiki Beach—yes, that is indeed the name of the beach at the little cove below the lighthouse. The tower sits high on a hill overlooking the coast, and you'll want to be there for the late afternoon to sunset light on it, or stay past sunset for the soft light of dusk. Time your exposures carefully to catch the rotating beam of light from the lighthouse. Driftwood

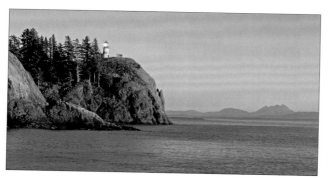

Cape Disappointment Lighthouse

piles on the beach might interest you as a foreground element, and on clear days you can see across the Columbia to Oregon's Coast Range mountains.

Nearby North Head Lighthouse, perched 200 feet above the sea on a rocky headland, is now automated with one of those tiny beacons that serve the purpose for mariners but sure don't do much for photographers. Nonetheless, it's possible to get really nice images of this lighthouse, and it can be photographed from a variety of angles: from the southeast, from directly behind the lighthouse, from the base of the lighthouse itself, and from a promontory to the north. Late in the day, you have the option of silhouetting the lighthouse against the sunset, or working from the viewpoint to the north to catch the sun rays sidelighting the tower and its rocky perch. To get to the north view, take the marked trail to Bells Viewpoint; when you get to the old concrete gun emplacements, follow the overgrown trail west until the trees no longer block the view. It's a 10-15 minute walk from the parking area. If you're working the sunset, don't tally too long because this part of the park closes at dusk.

The park's Lewis and Clark Interpretive Center commemorates the great

expedition and their visit to the area in 1805. Some of the trails in the park follow routes used by the Corps of Discovery in their local explorations. Also commemorating Lewis & Clark's journey is one of artist Maya Lin's seven installations for the Confluence Project, the Boardwalk, which is the pathway to Waikiki Beach.

Photo advice: Northead Lighthouse can be photographed at just about any time of day due to the variety of vantage points, but Cape Disappointment Lighthouse doesn't work in morning light (except perhaps silhouetted with a winter sunrise sky). Both are best with the golden light just before sunset. Getting good shots in this area takes planning with weather in mind—Cape Disappointment is one of the foggiest places in the world, and winter storms commonly bring gale-force gusts of wind.

Getting there: From US-101 heading either north or south on the Long Beach Peninsula, head for the town of Ilwaco and follow signs to the park two miles to the south via WA-100.

Time required: You'll want at least one afternoon through sunset for the best photos of the lighthouses.

Nearby location: Like Fort Canby, nearby Fort Columbia State Park is now part of the Lewis and Clark National and State Historical Parks complex. Chinook Point was the site of

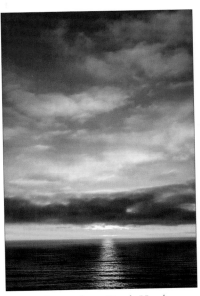

Sunset from North Head

an Indian village until the 1850's, and, with its commanding view of the Columbia River, became a U.S. defense outpost from 1896 to 1947. Historic buildings and gun batteries remain today. There are additional Lewis and Clark sites nearby, including the place from which the Corps got their first glimpse of the Pacific Ocean.

Lower Columbia River

Lacking the dramatic scenery of the Gorge to the east, the lower Columbia River isn't known as a photo destination, but there are some interesting places to visit and photograph as you travel the route of Lewis and Clark on State Highway 4 from the coast to I-5, and then south towards Vancouver and Portland.

Julia Butler Hansen National Wildlife Refuge was established in 1972 to protect the endangered Columbian white-tailed deer, one of the many native species first described by Lewis & Clark. Located between Highway 4 and the Columbia River about a mile west of the town of Cathlamet, the 5,600 acres of pasture,

tidal swamps, and sloughs also provide habitat for elk and a good variety of birds, including nesting bald eagles and osprey. Wildlife viewing and photography are encouraged at the viewing site just off the Highway 4, from Center Road running through the refuge, and by canoe or kayak in the sloughs.

The little towns of Cathlamet and Skamokawa have a few historical buildings and rustic canneries along the riverfront, if you're into photographing that sort of thing. Grays River Covered Bridge is reported to be one of the best of the old wooden covered bridges remaining in Washington. It's rather plain looking and not easy to photograph, but worth the slight detour if you're a bridge fan.

Ridgefield National Wildlife Refuge

Bordering the Columbia River north of Vancouver, Ridgefield National Wildlife Refuge is comprised of 5,150 acres of marshes, grasslands, and woodlands. Originally established to provide wintering habitat for the dusky Canada goose and other migratory waterfowl, it's also a great place to see shorebirds, songbirds, great blue herons, sandhill cranes, and red-tailed hawks. Black-tail deer, coyotes, and a variety of smaller mammals also live here. The refuge is actually a complex of several units, some of which are managed primarily as waterfowl and wetland wildlife habitat, while the main objective at other units is to preserve the natural Columbia River floodplain. The River 'S' Unit has a 4.2-mile driving tour route that is not only excellent for spotting wildlife but also leads to some nice landscape photo scenes. There is a good wildlife observation blind at about

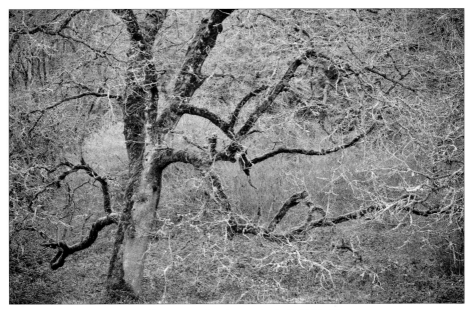

Lichen-covered Oak tree, Ridgefield NWR

the halfway point in the driving tour. May though September you can walk the auto tour route or the 1.2-mile Kiwa Trail, a wheelchair-friendly loop through Oregon ash trees between open wetlands.

The refuge encompasses lands with historical and archeological importance as well. The native Cathlapotle people lived in established villages in this area and the journals of Lewis and Clark detail their stay here in 1805. A Chinookan-style cedar plankhouse has been constructed at the Carty Unit of Ridgefield NWR, in a natural setting overlooking wetlands and woodlands. The plankhouse is open on weekends, from April to October, and volunteers give talks and demonstrations on the life and traditions of the Chinookan people. The 2-mile Oaks to Wetlands loop trail is open year-round and is good for landscape and close-up nature photography, as well as wildlife spotting.

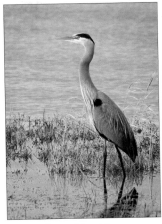

Great Blue Heron

Photo advice: As is typical at most refuges, early morning and late afternoon are the best times for seeing wildlife. Sunshine at these hours lights up the wetlands beautifully, but this can be a good place to visit even on dreary days in the dead of winter. The lichen and moss-covered oak trees on the nature trails make interesting studies on foggy days. Autumn brings some nice fall color to the cottonwood and oak trees bordering Lake River at the start of the auto tour route. The plankhouse at the Carty Unit is best photographed early in the morning.

Getting there: From I-5, take Exit 14 and go west on WA-501 (NW 269th Street) for 2.7 miles to the town of Ridgefield. Turn left on South 9th Avenue for the River 'S' Unit or right on North Main Street for the Carty Unit; in both cases, follow signs for a short distance to the refuge entrance.

Time required: An hour or two just before sunset or right after sunrise should yield some good photos.

Fort Vancouver National Historic Site

This book is mostly about nature and landscape photography locations, but Fort Vancouver merits inclusion due to its importance in the history of the Pacific Northwest; it also offers good photo possibilities as a general travel subject and to readers with an interest in historical places. Overlooking the Columbia River, the fort was built to serve as headquarters for the vast Hudson's Bay Company fur-trading empire in western North America. Subsequently, it became a U.S. Army post and remained an active installation until shortly after World War II.

There are several components to this historic site, the best known being the

reconstructed log-wall fort containing several buildings with authentic period furnishings. Depending on time of year and staffing, guided tours and cultural

demonstrations are given, often by costumed volunteers who are quite happy to pose for photos. The annual weekend-long Brigade Encampment in June is a fun event when modern-day mountain men recreate a fur trappers rendezvous on the grounds just outside the fort.

Photo advice: In most of the buildings, access and camera angle are restricted by ropes and other barriers, but a wide-to-short tele-zoom will let you compose some good shots. On my visits, the staff has had no problem with the use of tripod and flash, but you'd probably want to avoid busy summer weekends to make sure that policy remains.

Blacksmith shop

Getting there: To get to the fort, take I-5 Exit 1-C (Mill Plain Blvd.) and go east to Fort Vancouver Way. Turn south and, at the traffic circle, go east on Evergreen Boulevard then follow the signs to the visitor center. You can park there or at a lot closer to the fort, just to the south of the visitor center.

Time required: Allow at least an hour for a quick visit to the exhibits in the various buildings; several hours if you like historical subjects.

Nearby location: History buffs will also want to visit the nearby Officers Row, a collection of period houses from the mid- to late-1800's, and Pearson Air Museum, with aviation exhibits in a former Army Air Service facility dating back to World War I. Also, as part of Maya Lin's Confluence Project commemorating the Lewis & Clark Expedition, a new pedestrian bridge connects the fort with the Columbia River.

I-5 Corridor – Southern Lowlands

Between Vancouver on the Columbia River and Olympia on the Puget Sound, I-5 travels through broad valleys and deeply forested hills. Most of the interest for nature photographers in this area lies to the east in the Cascade Mountains, but there are a few places not far off the freeway worth mentioning.

Hulda Klager Lilac Gardens includes not just acres of lilacs but many other garden flowers, as well as a Victorian farmhouse, at this National Historic Site in Woodland. The gardens are open year round, but the best time to visit is during the annual Lilac Festival, which begins in April and ends on Mother's Day.

Wolf Haven International, near the town of Tenino, is a sanctuary for rescued captive-born wolves and is also a breeding facility for a multi-agency effort to restore Mexican gray wolves to the Southwest. This is not a zoo or one of those

game farms where trained animals pose for photographers; in fact, photography is strictly limited to handheld cameras with short lenses. The sanctuary does have occasional half-day photo tours, and these are the only times tripods and long lenses are allowed. The tours are held in fall, winter, and early spring when the wolves have their winter coats and are generally more active. Reservations are required, so call or check the Wolf Haven web site for dates.

Northwest Trek is a wildlife park geared toward visitors and features over 200 North-American animals, many in free-roaming areas. A tram ride and several miles of trails give visitors a chance to see bears, wolves, deer, elk, bison, big cats, and more in the 725-acre park, which is open year-round. Special tram tours for photographers are held about once a month; reservations are necessary for these popular tours and can be made online *(see Appendix)*. Northwest Trek is located on State Highway 161 near the town of Eatonville, about 55 miles south of Seattle and 30 miles east of Olympia.

Battle Ground Lake State Park

Prior to my first visit to this state park, I'd looked at maps and figured that it must be something of a suburban park situated on the edge of the city of Battle Ground. I was pleasantly surprised to find a wonderful little lake surrounded by beautiful west Cascades forest. The lake sits in a crater formed by an ancient volcanic explosion. At one time it was called Crater Lake, but the name was changed in deference to the more famous Crater Lake in Oregon.

Battle Ground Lake is very popular and busy in summer as it is a favorite camping, swimming, and trout fishing recreation spot for those in the Vancouver metro area. In autumn, however, crowds disappear and the park becomes a very pleasant and peaceful place to visit. The forest of large second-growth Douglas-fir and western red-cedar includes plenty of bigleaf maple and vine maple for some great fall color. It's also a good place to look for mushrooms, which pop up all over after the first rains in early autumn. Ten miles of mostly easy-walking trails throughout the park give access to good forest and lake views.

Autumn reflections

Note that the gate at the park entrance is closed from dusk to 6:30 AM. As at many Washington State Parks, campers are allowed to enter until about 9 PM and can also leave early.

Photo advice: Fall color starts in September and is usually at peak around mid-October. Early in the morning and late in the afternoon when the lake surface is glassy calm, look for abstract compositions of fall foliage reflected on the water.

These tend to work best when the sun is hitting the foliage but not the water itself. A polarizer helps saturate colors.

Getting there: From either northbound or southbound I-5 in Vancouver, take Exit 11 and drive east on WA-502 (E. 219th St.) to the city of Battle Ground. On the east side of downtown, turn left on N.E. Grace Ave. and follow the signs to the park in approximately three miles.

Time required: Battle Ground Lake works well as a brief stop along the way to the East Fork Lewis River waterfalls, or it can be a destination itself for a half-day or longer trip.

Cedar Creek Grist Mill

This historic old wooden grain mill reminds me of jigsaw puzzle scenes of classic New England mills that we used to work on at grandma's house. Nicely restored and maintained, Cedar Creek Grist Mill is a photographer's favorite and frequently appears in Washington calendars and photo books. The view is particularly attractive in autumn when the Bigleaf maple trees add splotches of bright yellow to the scene.

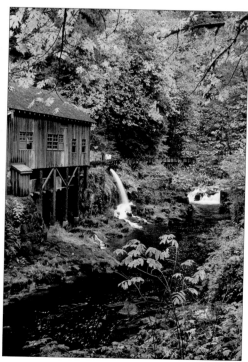

Cedar Creek Grist Mill

Photo advice: Due to the forested setting, overcast days works best here. A polarizing filter helps to bring out the greens and yellows of the foliage, but be careful not to over-polarize so that the water in the creek goes black.

Getting there: From either the Puget Sound area or Portland-Vancouver, take I-5 to Exit 21 at Woodland. Head east on the first road immediately after the exit, cross the bridge over the North Fork Lewis River then take a left on NW Hayes Road. Continue east on this road, which becomes Cedar Creek Road, for about 8 miles. Turn left at Grist Mill Road and go 0.7 miles to the mill. The route is well signed all the way.

Time required: Possible photo angles are limited here, so once on location a half hour is probably sufficient.

East Fork Lewis River Waterfalls

Just East of Battle Ground a series of waterfalls on the East Fork of the Lewis River make good subject matter for photographers. I don't consider any of them spectacular photo subjects, but they can be fun to work and are conveniently close to the Vancouver-Portland metro area. There are some larger falls further north on the Lewis River, which are covered in the Southern Cascades chapter of this book; the ones mentioned here are on the East Fork of the Lewis River.

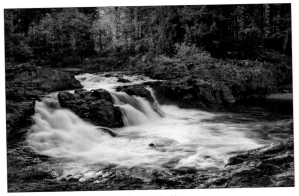

Lucia Falls

First in the line-up, heading west to east, is Lucia Falls. This waterfall is within Clark County Park, and is a very short walk on an easy trail. Depending on the level of flow, broad fingers of water or the full width of the river drop 15-20 feet over dark basalt lava bedrock.

Continue east on Lucia Falls Road for 3 miles to reach Moulton Falls (note that the Benchmark Atlas has the location marker a bit too far to the east). Once again the viewpoint is just a few steps from the picnic and parking area. Here the river tumbles over and down a series of dark gray lava ledges for a total drop of about 15 feet. More waterfalls, including Big Tree Creek Falls, can be seen by hiking a 1-mile loop trail.

Leaving Moulton Falls, keep going east for 0.25 mile then turn right on Sunset Falls Road (CR-12) and go another 7.5 miles to reach Sunset Falls. A sign will direct you to the right for the campground, but go straight just a bit and turn into the second day-use parking area for the shortest route to the falls. Make your way

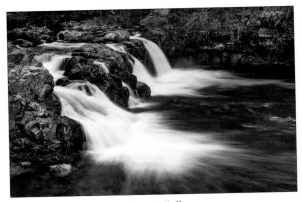

Sunset Falls

upstream about 150 yards on a paved, wheelchair accessible trail to a constructed viewpoint for this pretty little waterfall. The view from the official lookout is quite good, but you can also scramble down to the pool and shoot looking upstream to the 20-foot high falls.

All of these falls are at their best in spring when there is good flow in the river and the forest is vibrant green, or even better in early to mid-October when leaves turn and there is good color in the surrounding vegetation.

Photo advice: As always, cloudy or overcast days work best for waterfalls. On sunny summer days, the contrast between the white water of the falls and the underlying dark lava is just too great for pleasing photos. These falls are also good for trying close-ups and abstracts of just the water, eliminating the dark rock from the photograph. Play with shutter speeds from 1/2 to 1/15 second with a telephoto lens for different effects and interpretations of the falling water.

Getting there: From Battle Ground Lake State Park (see directions above), head north on NE 182nd Ave., make a left at 27th Ave, go past the Heisson Store and turn right on NE 172nd Ave. At the junction with NE Lucia Falls Road, turn right and look for the signs for Lucia Falls Park in 2.4 miles. If coming from the city of Battle Ground, the Cedar Creek Grist Mill, or the main fork of the Lewis River, take WA-503 to NE Lucia Falls Road and head east to Lucia Falls Park. Moulton Falls is 3 miles further on the same road.

Time required: Due to the short walks to get to these falls, you can photograph each of them in just a few minutes, but it's also possible to spend quite a bit of time with various compositions and photo techniques; the combination of these falls can make a nice day or half-day trip.

Silver Star Mountain

Hiking guides, trip reports, and photo friends all said that there are great views on Silver Star Mountain, as well as meadows full of wildflowers and a natural rock arch, so I knew I had to do this hike. Did all the prep, checked the weather forecast and headed out for this peak in the lower Cascades northeast of

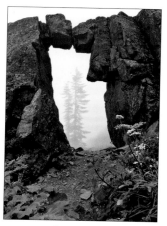

Silver Star arch

Vancouver. I arrived at the trailhead at dusk, planning to start hiking at 0-dark-thirty in order to catch sunrise from the summit. The view from the parking area at the trailhead was promising—a panorama from the shimmering lights of Vancouver to the south to the snow-capped summit of Mount Saint Helens looking north. The Big Dipper was hanging just over the last orange glow from sunset on the horizon to the west. When the alarm went off at 4 AM, I looked out to find that a marine layer had moved in, totally blanketing the mountain in fog. My headlamp couldn't penetrate the mist to find the trailhead sign fifty yards away.

The fog finally lifted enough so that I could see the trail, but the sun never did come out so I'll have to go

back to Silver Star another time for the promised views. Still, it was a very nice hike. In mid-summer, most of the wildflowers were past their peak but there was still plenty to enjoy on the rocky slopes. The largest forest fire in Washington history, the Yacolt Burn, devastated this entire area in 1902, and as is often the case with such fires, the burned forest has turned into meadows of prime wildflower habitat. Thimbleberry and huckleberry were ripening, and judging from the piles of fresh bear poop on the trail, this is a very popular place for their end of summer feasting. I didn't see any bear on this trip, but several times during the hike I could sure smell them. After my hike, a Forest Service worker told me that the bears here are timid and usually hide at the sound of boots and trekking poles hitting the rocky trail.

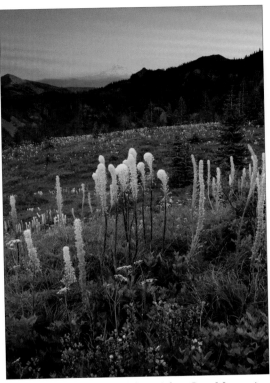

Bear grass & Mt. Hood from Silver Star Mountain (photo by Jesse Estes)

Depending on your route and how much you want to see, the hike is 6-9 miles round-trip, with an elevation gain of around 2,100 feet from trailhead to the 4,390-foot summit of Silver Star Mountain. Overall, it's not too strenuous, but there are a couple of places with steep climbs. I recommend making a clockwise loop that includes Ed's Trail, which takes you through the rock arch and then rejoins the main trail for the hike to the summit. At the trailhead, you can opt for a narrow path that starts out heading south, or a wider old road route that immediately climbs to the east and is a little more direct. After about a mile, the road and trail meet; shortly after that, at a wide turn, look for the sign for Ed's Trail above the old road. Follow this rocky route through sloping wildflower meadows on the east side of a ridge, staying to the left at all junctions with other trails. In about 1 mile you'll arrive at the rock arch, which is just big enough to easily walk through. Soon after the arch, the trail does a couple of steep (but short) climbs, including a rocky scramble, bends around the ridge, and enters a pine and fir forest. At a signed junction, take Trail 180D to Silver Star Summit in another 0.6 miles. At the top, the views include a stretch of the Columbia River and the snowy peaks of surrounding Cascade mountains. You can also extend your hike by continuing past the summit trail for another mile to the Indian Pits,

an area of rock walls and pits thought to be the site of vision quests for the Native Americans that once inhabited the area. The return trip on the official Silver Star Trail is a relatively easy walk on an old road, again passing through acres of sloping rocky wildflower meadows.

Photo advice: Late May through June is the best time to visit, when a number of wildflowers appear in succession; these include paintbrush, lupine, iris, and beargrass. In Autumn, the huckleberry and heather add nice touches of color to the hillside meadows. The rock arch gets morning to mid-afternoon light and becomes shaded by the ridge in late afternoon.

Getting there: From either the Puget Sound area or Portland-Vancouver, take I-5 to Exit 9 and head east of WA-502 towards Battle Ground. Go north on WA-503 for about 5 miles and turn right at Rock Creek Road, which becomes Lucia Falls Road. Travel this road for 6 miles, past Lucia Falls and Moulton Falls, then turn right on Sunset Falls Road (CR-12) and go 7.4 miles to Sunset Campground. Turn right on FR-41, passing the camping area entrance and crossing the bridge to a T junction. Continue on FR 41 by turning left and go 3.3 miles to the junction with FR-4109—a hairpin turn to the right. The gravel road becomes narrower and rougher, but with care all but the lowest slung passenger cars should be able to navigate this road. At 1.4 miles, take the left fork and continue for another 2.7 miles to the trailhead at the end of the road.

Time required: Between the drive to the trailhead (over an hour from Battle Ground) and the hike, this is a minimum half-day excursion.

Lewis & Clark State Park

Lewis and Clark never got this far north in western Washington on their epic journey, but some of the trees in this beautiful little park were around at that time. The park is situated in one of the last remaining stands of old-growth

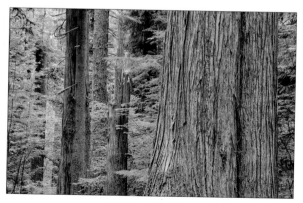

Old-growth forest

forest in the Puget Sound lowlands and is open for camping and day use from April through September. Also of historical interest, the buildings here were constructed in the classic log and rock design by the Civilian Conservation Corps (CCC) during the Great Depression.

There are more than 10 miles of trails in the park, including the Old Growth

Forest Trail, a 0.5-mile loop on an easy walking path that winds through giant Douglas-fir, western red-cedar, and western hemlock trees. Some of the huge Doug firs are more than 8 feet in diameter and hundreds of years old. The lush understory includes vine maple, large ferns, and Oregon grape, very typical of western Cascades lowland forests. Add the adjacent Trail of the Deer for an extended hike through this lovely forest.

Photo advice: As in any deep forest, cloudy or overcast days are necessary; the mottled light of sunny days just doesn't work. Old-growth forests are at the best in late spring when the understory foliage is lush and vibrant green, and the air is usually calm early in the morning.

Getting there: From I-5, take Exit 68 for US-12, heading east towards Morton and Mount Rainier National Park. In 2.5 miles, following the signs, turn south on Jackson Highway to the park entrance in another 2 miles.

Time required: If you're on your way to the Nisqually entrance of Mt. Rainier National Park, or going east on WA-12, this is a nice stop to break up the drive. A half hour is enough time for the loop trail and a few photos in the forest.

Rainbow Falls State Park

How many waterfalls do you suppose there are in this country that are named Rainbow Falls? There are at least six in Washington alone. This one isn't going to get a spectacular rating on anyone's list, but there is a nice view from a footbridge where the Chehalis River drops 5-10 feet at a popular summer swimming hole. The falls aren't the only attraction here for photographers, however—there are six miles of trails in a Douglas-fir, hemlock, and cedar forest, much of it virgin old-growth. For flower lovers, a small garden features forty varieties of fuschias.

Photo advice: Unless you're a real waterfall collector, this one is probably not worth a special trip.

Getting there: From I-5, take Exit 77 at Chehalis and drive 17 miles west on WA-6. Coming from the coast, it's 35 miles from Raymond via WA-6.

Nearby Locations: As with Rainbow Falls, Paradise Point and Millersylvannia State Parks don't have any features that make them great photo destinations, but they are good places to stay if you're traveling and prefer camping over motels.

Mima Mounds

A National Natural Landmark, Mima Mounds Natural Area Preserve is a 625-acre area of mounded prairie grassland. No one really knows the origin of the 6 to 8-foot tall mounds, which are also found in various other places around the world and are sometimes referred to as hogwallows. Possibly the result of glacial

activity, here they are part of the South Puget Sound prairie and woodland eco-system and a wonderful place to photograph spring wildflowers. Purple camas and blue violets emerge from the prairie grasses, accented with buttercups and shooting stars. Mima Mounds is also known as a great place to photograph butterflies, and 18 different species have been seen here. Mid-May to early June is the best time for the flowers and butterflies, but if you can't make it then some species linger into the summer, and good light can make the mounds interesting at any time of year.

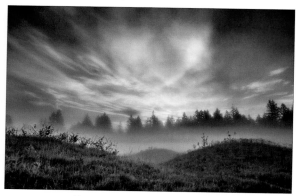
Foggy sunrise at Mima Mounds

Native Americans who lived in the area periodically lit fires, as they did in Oregon's Willamette Valley, to keep forests from encroaching on the plains where they harvested camas bulbs—a dietary staple in those days—and other vegetation. A wheelchair-friendly interpretive trail meanders through the mounds, and additional trails let you get close to the flowers and butterflies without trampling the unique habitat.

Photo advice: A wide-angle lens is useful to capture the mysterious mounded landscape. A short tele-zoom with close-focusing capabilities, or macro lens in the 100-200mm range, should work well for the butterflies. The same set of lenses works well for wildflowers too. Early mornings are the best time to be there—breezes haven't picked up yet so the flowers aren't waving and butterflies usually get more active as the day warms up. If it turns out to be a breezy day, try playing with longish exposures and let the grasses and flower blur somewhat to graphically illustrate the wind.

Getting there: From I-5 south of Olympia, take Exit 95 and head west on WA-121 for about 3.5 miles to Littlerock. Continue through the town on 128th Avenue SW until it ends at Waddell Creek Road. Turn right, go 0.8 mile and look for the entrance to the preserve on the left.

Time required: An hour is sufficient to walk the main trail and get a few representative photos, but I recommend an entire morning, starting at sunrise, if you're visiting during butterfly and wildflower season.

❖ ❖ ❖

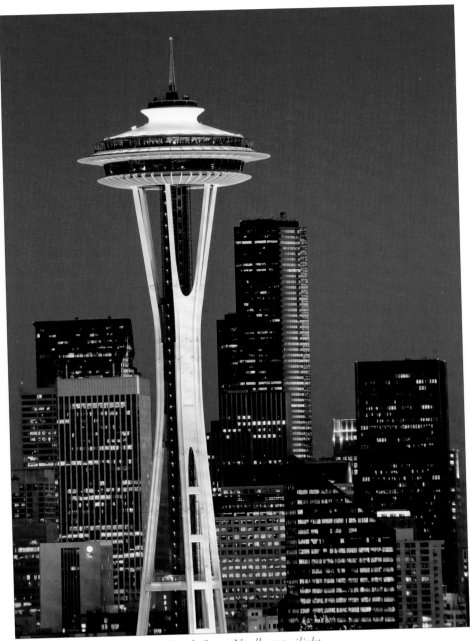

Seattle Space Needle at twilight

Chapter 4

PUGET SOUND

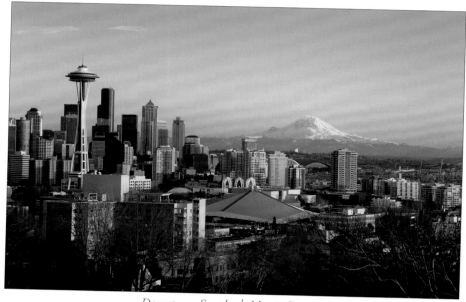

Downtown Seattle & Mount Rainier

PUGET SOUND

One of the unique features of Pacific Northwest geology and geography, Puget Sound is a complex of bays, islands, peninsulas, and estuaries which are fed by rivers and streams coming out of the Olympic and Cascade Mountains. Within the sound are 500 square miles of water, 1,400 miles of shoreline and around 300 islands. Puget Sound also includes, by a huge margin, the majority of Washington's human population.

There are several ideas as to the extent and boundaries of Puget Sound, and some confusion about how far north it extends. One commonly accepted definition has Deception Pass, between Whidbey and Fidalgo Islands, as the northern boundary. So where does that leave Whidbey and the other islands and coastal areas to the north? In recent years, the name Salish Sea has been established to refer to the collective waters of Puget Sound, the Strait of Juan de Fuca, and the Straight of Georgia (which includes the San Juan and Gulf Islands and extends north between Vancouver Island and the British Columbia mainland).

For this book, we're going to consider that the Puget Sound territory encompasses the Olympia-Tumwater region in the south, the Kitsap Peninsula with its associated islands, and the metropolitan area on the east side of the sound from Tacoma to Edmonds, slightly north of Seattle. Puget Sound may not have the mountainous peaks and dramatic coast of the Olympic Peninsula and Cascade Mountains that make for glorious landscape photography, but there are certainly plenty of great subjects to see and photograph in this territory.

Downtown Seattle

The Pacific Northwest's largest city is not only a great base for photographing the natural wonders of Washington, but in itself has a lot to offer as a photo subject. Hilly neighborhoods provide great views over the city to the waters of Puget Sound, the distant Olympic Mountains, and iconic Mount Rainier. The city's culture reflects its history as logging town, Klondike gold rush gateway, home of Boeing aircraft, major shipping port, and more recently high tech and "green" industries. Some might argue that coffee and micro brews are both important industries in Seattle, as well as cultures unto themselves.

The Seattle area had been inhabited by native peoples for thousands of years before the arrival of white settlers, and when the town was founded in 1853 it was given the name Seattle, a derivative of Sealth, the name of the chief of the Suquamish tribe at the time.

Soon after its founding, Seattle was dubbed "Queen City", but in 1981 some community leaders felt that a new nickname was needed, and as a result of a public contest, "Emerald City" is now the official tag. Thanks to plentiful moisture, there certainly is plenty of emerald green in the surrounding landscape. Seattle has a reputation as being very rainy, but in fact, it receives less annual precipitation than New York, Boston, Miami, and Houston. It is, however, cloudy 200+ days per year, and towards the end of winter the drizzle can seem interminable. Rainy weather doesn't stop Seattleites from enjoying the outdoors, however, and its population is probably one of the most active in the country.

While this book is primarily concerned with the best places for nature and landscape photography, visitors and residents alike will certainly want to also aim their cameras at some of Seattle's well-known attractions. If you're new to Seattle, pick up one of the free maps at visitor centers and attractions all over town to get yourself oriented.

One of the first places visitors want to go to is Seattle Center, location of the Space Needle. Take some time walking around the site of the former World's Fair looking for angles on the iconic tower, and maybe for a ride up to the observation deck for panoramic views of the city and Elliott Bay. The shiny, multi-hued and undulating surface of the Frank Gehry-designed EMP Museum can be a fun photo subject, especially where the monorail emerges from a tunnel in the building.

Totem pole in Pioneer Square

Pike Place Market is one of Seattle's most famous attractions, known for the fishmongers that toss giant salmon over the counter, and the colorful displays of fruits, vegetables, and fresh cut flowers. It's not an easy place to do photography with the crowds, narrow aisles, and problematic lighting, but it's not to be missed. Using a tripod inside the market is difficult, but bring one for a twilight shot of the famous neon "Public Market" sign at the main entrance.

Pioneer Square is the site of the first development in Seattle, with a number of old and historical buildings that are great for architectural studies and detail shots. Many of the buildings have been beautifully restored and are great examples of several 19th and early 20th century styles. Look for the bronze bust of Chief Seattle, for whom the city was named, and the ornate ironwork pergola in Pioneer Square Park. The district now boasts a lively arts scene, with a good number of galleries exhibiting a diversity of work.

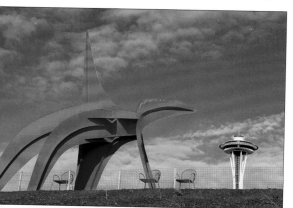

Alexander Calder sculpture & Space Needle

There's more great art at the Olympic Sculpture Garden, located in a park just above the waterfront on a plot of land that was formerly an industrial site. Large sculptures and installations by the likes of Alexander Calder and Richard Serra are placed in an eco-friendly landscape that features native plants. It's a wonderful place to spend a sunny afternoon, with views out over Elliott Bay to the Olympic Mountains.

For even more creative inspiration, there are several excellent museums in Seattle, including Chihuly Garden & Glass and the EMP at Seattle Center, the nearby Seattle Art Museum, and the Asian Art Museum in Volunteer Park. On rainy and overcast days, the Volunteer Park Conservatory is a good place to photograph exotic flora, including orchids, bromeliads, and other tropical plants.

On the north side of Lake Union, Gas Works Park has brightly painted old machinery from the old gasification plant that formerly powered much of Seattle. The colorful pipes and tanks can be a fun photo subject, especially for images that can be given artsy treatments in processing. The park is also a good place for cityscape views looking across the lake to downtown Seattle.

Need photo gear, or just want to ogle the latest toys? Glazer's Cameras at 430 8th Avenue North has long been the pro's source, with the best and most complete selection of photo supplies and equipment in the Pacific Northwest. For general outdoor gear, head to the REI flagship store at 222 Yale Avenue North (just off I-5 and one block north of Denny Way).

A must-do for anyone interested in nature and travel photography is a visit to the gallery of Seattleite and world-renown photographer Art Wolfe at

520 First Avenue South on the west side of Pioneer Square. Other Seattle galleries that feature photography include G. Gibson at 300 S. Washington Street, and Photo Center Northwest at 900 12th Avenue.

Kerry Park Cityscape View

Shortly after moving to the Pacific Northwest, I ventured up to Seattle intending to build my stock photo file with iconic images of the city. In particular, I wanted the classic view of the Space Needle and the downtown skyscrapers with Mount Rainier looming in the background. This was before Google Earth, Flickr and widespread sharing of information on internet forums, so I studied paper maps trying to find a likely viewpoint. It quickly became obvious that the view was from Queen Anne Hill, so I started driving up and down streets in that neighborhood. It was a beautiful late afternoon day and I was getting anxious that I might miss the golden light. I kept getting tantalizing glimpses between houses, but no place to really get the view. Turning onto Highland Drive, I found the street lined with cars and thought, whoa, must be a big party. Turns out the big party was a whole bunch of photographers, lined up shoulder to shoulder and tripod to tripod along a low wall at Kerry Park, talking gear and waiting for the sweet light that was soon to happen. Eureka!

Photo advice: When the weather is good and the skies promising, this is a very popular spot so get there plenty early if you're planning a sunset-twilight shoot. You'll want time to find just the precise place along the wall for the best line-up of buildings and mountain. Obviously a day with little or no haze is best for seeing Rainier. A polarizing filter will help separate the mountain and sky and cut at least some haze. Sunrises can also be very good here.

Getting there: From Seattle Center, head north for a couple of blocks and then turn left on 1st Avenue North. In one block, turn right on Queen Anne Avenue, continue north for five blocks and turn left on Highland Drive. Kerry Park will be on the left in two more blocks.

Time required: For a daytime standard postcard view, fifteen minutes is probably enough. For the glory shot, get there at least an hour before sunset and stay for half an hour afterwards to get the right balance between city lights and evening sky.

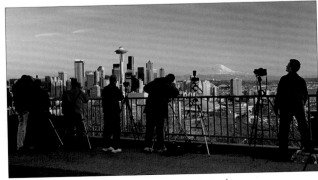

Room for one more tripod.

West Seattle – Alki

In 1851, a group of white settlers landed on what is now called Alki Point and platted a settlement that was intended to become the city of Seattle. A few months later, they abandoned that site in favor of some land on the east side of Elliott Bay, at present day Pioneer Square. Alki is now part of the thriving West Seattle neighborhood, with something of the flavor of a 1960's southern California beach town. A waterfront pathway, Alki Trail, extends for several miles, and is a popular place to stroll, bike, skate, and jog.

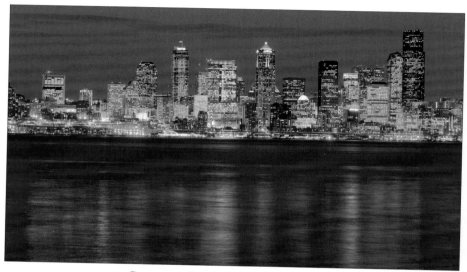

Downtown Seattle skyline from Alki Point

The shoreline path is also a great place to photograph the downtown Seattle skyline across Elliott Bay, particularly at sunset and at twilight when the lights of the city buildings come on. For a slightly elevated view, take the road up to Hamilton Viewpoint Park, which also looks across Elliott Bay.

Alki Beach Park is a fun spot to hang out while waiting to photograph the sun setting over Bainbridge Island and the distant Olympic Mountains. At the western most point of the peninsula, you can walk along the shore to photograph Alki Point Lighthouse. The grounds are closed to public access and a chain-link fence around the lighthouse detracts from the scene, but it's still possible to get some pretty decent shots of the attractive red-and-white lighthouse.

Photo advice: The Seattle cityscape view is perfect for making a series of photos and then digitally stitching them together to a make a panoramic image that captures the city from the Space Needle to the core of downtown and even south to the industrial port area. I prefer the waterfront view to the higher elevation lookout, using a long exposure to let the water in the bay blur and reflect the city lights.

Getting there: From downtown Seattle, take Highway 99 south, or take I-5 to Exit 163 for West Seattle. After crossing over the Duwanish River on the West Seattle Bridge, take the Harbor Avenue SW exit and turn right on Harbor Avenue. For Hamilton Viewpoint Park, veer left onto California Way SW in 1.4 miles and continue for half a mile as the road curves around the north point of Alki and up to the park. For waterfront views of Seattle and for Alki Beach Park, continue on Harbor Avenue rather than turning on California Way. The road becomes Alki Avenue SW as it bends around the north point of the peninsula and follows the shore to the beach park and lighthouse. Another option is to take the passenger-only water taxi from Pier 50 on the downtown Seattle waterfront to West Seattle and walk north on the Alki Trail pathway for waterfront views.

Time required: Allow at least an hour to get to Alki and back with time for photos. Travel time will be greatly increased during the afternoon commute time.

Rizal Bridge City View

Not quite as popular as the Kerry Park view, but a vantage point for an excellent cityscape is the view from the Jose P. Rizal Bridge in the Beacon Hill neighborhood on the south side of downtown Seattle. A variety of lens focal lengths will work from this point, but one classic view uses a wide-angle lens to capture the S-curve of the Interstate I-5 freeway leading to downtown skyscrapers. An exposure of several seconds will let the lights of vehicles on the freeway form streaks of red and white light. Telephoto shots of the buildings with sunrise light on them work very well, too.

Another option here is capturing a series of images to make a panorama encompassing the downtown buildings, Safeco and CenturyLink sports fields, Elliott Bay, and the distant Olympic Mountains beyond Puget Sound.

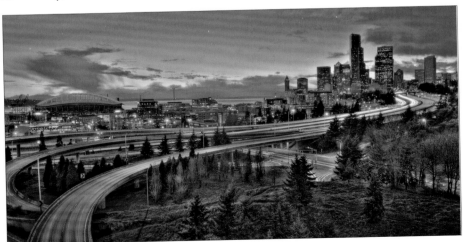

Lousy sunset? Have fun cranking the sliders in HDR processing

Photo advice: About 15-20 minutes after sunset, or before sunrise, the city lights, sky, and streaks of light from freeway traffic will balance nicely. Vehicles driving across the bridge cause it to vibrate enough to mess up long exposures, so time your shooting carefully.

Getting there: From downtown Seattle, take I-5 south to Exit 164, the exit for I-90 East, and take the off-ramp for Dearborn Street. Turn right on Dearborn, go one block, make another right onto 8th Avenue, and head north for three blocks. Turn right on King Street, pass under the freeway, and in two blocks turn right on 12th Avenue. Cross over the Rizal Bridge in two blocks, turn right on Charles Street and look for a place to park. If you can't find on-street parking, continue a short distance to parking lot for Doctor Jose Rizal Park.

Time required: A couple of hours will let you find your precise composition and get into position for both sunset and twilight photography.

Nearby location: Somewhat similar views can be had from the pathway in Doctor Jose Rizal Park.

Discovery Park & West Point Lighthouse

Just 15 minutes from downtown, Seattle's largest city park encompasses 534 acres of forest, meadow, and tidal beaches. A network of trails on Magnolia Bluff leads to Puget Sound overlooks with views of both the Olympic and the Cascade Mountain ranges.

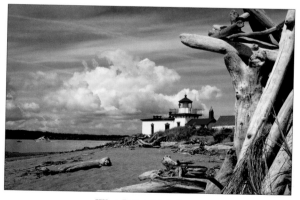

West Point Lighthouse

A 3.4-mile round-trip hike from the south parking lot will take you down to the beach at West Point Lighthouse. The attractive building houses an active light maintained by the Coast Guard. The trail is hard-packed gravel for year-round use, and is easy walking most of the way. The upper part of the trail traverses an open, grassy prairie, then drops down through forest to the beach. The sign for South Beach Trail says that it is rated Moderate to Difficult; it does get a bit steep and walking on soft sand at the beach is slow going, but overall it's not that bad.

Wolf Tree Nature Trail is a ¼-mile loop at the north parking lot featuring a large collection of northwest native plants. The popular 2.8-mile Loop Trail circles around Magnolia Bluff, taking in forest, meadow, and sand dunes along the way. In June, fields of tall native large-leaved lupine are brilliant deep blue

along Hidden Valley Trail, accessed from the Loop Trail or South Beach Trail on the west side of the park.

Photo advice: The lighthouse faces due west and has some potential for sunrise and sunset views from North Beach around the summer solstice. From South Beach, the light is best from late afternoon through dusk in fall, winter, and spring. Look for interesting drift logs on sandy South Beach for foreground elements in your composition.

Getting there: From downtown Seattle, head west on Denny Way to where it joins Western Avenue, which then merges with Elliott Avenue, heading northwest and paralleling the shore at Elliott Bay Park. Turn left on West Garfield Street, and follow this street until it ends at West Emerson Place and the entrance to the south parking lot for Discovery Park.

Time required: A quick hike to the lighthouse and back can be done in a couple of hours.

Nearby location: Daybreak Star Cultural Center on the north side of the park is run by the United Indians of All Tribes Foundation, and is the site of a huge pow-wow in summer during Seattle's annual Seafair festival.

Woodland Park Zoo

What started as a small private menagerie in Seattle's Phinney Ridge neighborhood has grown and developed to be one of the very best municipal zoos in the country. Woodland Park Zoo has long been an innovator in exhibit design, having originated the natural environment concept, and has won more Best National Exhibit awards from the Association of Zoos and Aquariums than any other zoo with the exception of New York's Bronx Zoo.

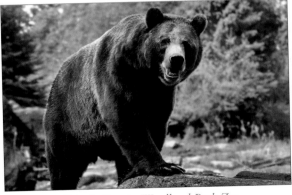

Grizzly Bear in Woodland Park Zoo

Several of the exhibits in the zoo are quite good for capturing natural looking animal portraits. Appropriately for the location, the Northern Trail section that features Pacific Northwest species can be quite rewarding for getting good photos of grizzly bear, Roosevelt elk, and mountain goats.

Photo advice: As at all zoos, best chances for viewing and photography are early in the morning and at feeding times, when the animals are most active. With the large mammals, try for portraits using a long telephoto and large apertures to get

shallow depth of field and a more natural looking background. For most of the exhibits, the softer light of an overcast day works best.

Getting there: From downtown Seattle, travel Dexter Avenue north, cross the Fremont Bridge and continue north on Fremont Avenue to 50th Avenue and the entrance to the Zoo.

Time required: More than likely you'll want to spend several hours enjoying the different habitats in the zoo.

Nearby location: If you're visiting in early to mid-summer, work the Woodland Park Rose Garden next door while you're waiting for the zoo to open (the garden is open from 7:00am until dusk). The topiary trees are also quite interesting.

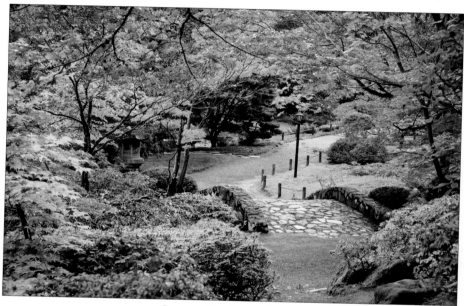

Japanese Garden in autumn

Washington Park Arboretum & Japanese Garden

Much beloved by Seattle residents and a highlight of the city for visitors, the 230 acres of gardens, wetlands, and woods in Washington Park make it a wonderful place for nature photography. Jointly managed by the City of Seattle and the University of Washington Botanic Gardens, the Arboretum features more than 10,000 plants, shrubs, and trees from all over the world.

In spring, head for the Rhododendron Glen and walk Azalea Way, which is lined with pink flowering cherry trees. The folks at the visitor center can steer you to what's blooming where in the rest of the arboretum. In autumn, the collections of Japanese and Asiatic maples provide plenty of opportunity for fall color studies.

The Arboretum gardens and pathways are open year round from dawn to dusk, with no admission fee and no restrictions on tripod use.

Adjacent to the Arboretum and a must-do for photographers is the Seattle Japanese Garden. Construction of this truly beautiful garden began in 1960, with a design team led by Japanese garden expert Juki Iida. The features of the Garden represent mountains, forests, lakes, and rivers, with each rock, tree, and shrub carefully placed. Fascinating fact: Mr. Iida personally selected more than 500 granite boulders from the Cascade Mountains, and had them wrapped in bamboo mats so they wouldn't get scratched during transport to the Garden.

The Japanese Garden is open daily except Mondays, and admission is charged. Unfortunately, the Garden doesn't open until 10:00 am, and the closing time, which varies with the season, is well before sunset, so there's no opportunity for golden light here. Another hitch for photographers is that tripods are forbidden (monopods, however, are okay). Special photo sessions, where tripods are allowed, are held on Tuesday and Saturday mornings in October. These sessions are very popular, are limited to 10 participants, and are by advance registration only. Check the Garden's website (see Appendix) for more details.

North of the Arboretum, on the other side of Highway 520, the Union Bay Natural Area gives access to one of the largest wetlands on Lake Washington, and one of the best sites for bird watching in Seattle. You can also explore demonstration gardens at the University of Washington's Center for Urban Horticulture.

Photo advice: The cherry trees along Azalea Way start the spring bloom show in early April, followed by the azaleas and rhododendrons, which are generally best from mid-April to mid-May. The Japanese maples are at their fall color peak around mid-October. The inability to use a tripod in the Japanese Garden is unfortunate, but you'll still get excellent results hand holding by using a higher ISO with one of today's digital SLRs; better still if coupled with a vibration reduction lens.

Getting there: From I-5, head east on WA-520 and take the first exit, Montclair Blvd. Follow the signs for University of Washington Arboretum, taking Lake Washington Boulevard East. At the stop sign, turn left for the Visitor Center and the main part of the

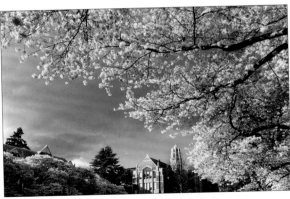

Cherry trees at University of Washington

Arboretum, or go right for the Japanese Garden. For the Union Bay Natural Area, head north on Montlake Boulevard to 45th Street, turn right, then right again on Mary Gates Memorial Drive and follow that road to the Visitor Center on NE 41st Street.

Time required: Allow a minimum of one hour, and a lot more if it is the peak of spring blossom season or fall color.

Nearby location: In spring, huge old cherry trees on the University of Washington campus are covered with delicate pink blossoms, creating a truly glorious sight. The peak of the bloom is typically early April, although it can vary greatly depending on late winter weather. When the trees do bloom, don't procrastinate about going to see them – the flowering only lasts for a little over a week. To get there, take I-5 to Exit 169 and travel east on NE 45th Street, make a right on 15th Avenue SE start looking for a parking place or go into the campus parking garage at 41st Street. Walk towards the center of the campus where the trees line the Quad.

Kubota Japanese Garden

Twenty years after immigrating to the United States, Fujitaro Kubota bought five acres of logged wetland in south Seattle and began to turn it into a showplace for displaying northwest flora in the style of a traditional Japanese garden, complete with ponds, waterfalls, and arching bridges. Self-taught as a gardener, Kubota went on to design other Japanese gardens in the Puget Sound area, including those at Seattle University and Bloedel Reserve on Bainbridge Island. The Kubota family continued to work on the garden, expanding it to the present twenty acres, although they

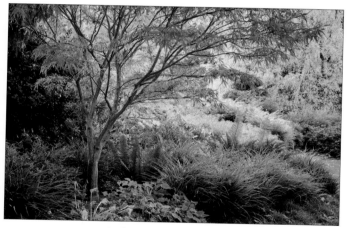

Kubota Garden in autumn

had to abandon their efforts for four years when they were sent to an internment camp during World War II. The City of Seattle purchased the garden in 1987, and has added adjacent property to protect the natural area of Mapes Creek.

Surrounded by busy south Seattle suburbs, this garden is a delight to visit and a great place for nature photography. The pathways, ponds, and bridges enhance the landscapes and there are plenty of opportunities for close-up photos of the many varieties of plants, shrubs, and trees. Photographers are welcome to use tripods, although commercial use and using the gardens for portrait and wedding sessions requires a permit.

Photo advice: Visit during the latter half of October for the best fall color, or in April and May when the azaleas and rhododendrons blossom. A polarizing filter will bring out the color and make foliage a more verdant green.

Getting there: From the downtown Seattle area, travel I-5 south to Exit 158 and turn left at Boeing Access Rd. Cross over the freeway and keep going east, past Martin Luther King Jr. Way as the street changes to S. Ryan Way. Continue for 0.5 mile to 51st Ave. S, make a left and drive another 0.5 to Renton Ave. S. Turn right and go 0.3 mile to 55th Ave and the entrance to the garden on the right. If coming from SeaTac or points south, take I-5 Exit 157, turn right on Boeing Access Road to MLK Way and follow the directions above. The route is signed most of the way.

Time required: This is not a large garden, but surely you will want to spend at least an hour wandering the paths.

Nearby location: The Boeing Museum of Flight is very interesting, with many historical aircraft on display and exhibits on the history of aviation. There are no restrictions on photography and tripods are okay. To get there, take the same I-5 exits as above for Kubota Garden, but turn west on Boeing Access Road, then north on E. Marginal Way for 0.25 mile.

Bellevue Botanical Garden

In the midst of busy Bellevue lies a tranquil refuge of cultivated gardens and urban forest. A partnership between the city parks department and the Bellevue Botanical Society, together with a lot of community support, has created a beautiful 53-acre park that includes several themed gardens. Of special interest to nature photographers are the Alpine Rock Garden, the Fuchsia Garden, Rhododendron Glen, and the Native Discovery Garden that features Pacific Northwest native species in a restored forest setting. The Yao Japanese garden is a favorite, with vibrant azaleas and rhododendrons blooming in spring and delicate maple trees turning beautiful colors in autumn.

Bellevue Botanical Garden is open daily from dawn to dusk, year round. There is no admission fee, and

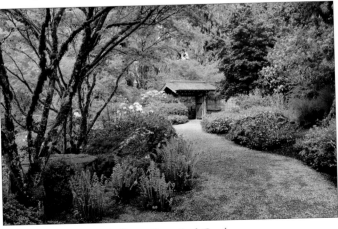

Bellevue Botanical Garden

no restriction on tripod use. If you're a busy Seattleite, or perhaps a visitor here for just a few days and can't get away to the mountains, this garden is a great spot for doing some serious nature photography.

Photo advice: Azalea blossoms are profuse in early May, followed by Rhododendrons towards the end of the month; this is also a good time for native forest species in the Native Discovery Garden. As with other Puget Sound locations, the second half of October is typically the best time for fall color. Photographing in early morning usually means calm winds and fewer visitors so you don't have to worry so much about people tripping on your tripod.

Getting there: Travel I-405 to Exit 13 and head east of NE 8th Street. Take the first right onto 116th Ave NE and go 0.6 mile and make a left onto SE 1st Street. In 0.2 mile, turn right onto Main Street and continue for about a quarter mile to the entrance to the gardens.

Time required: An hour is enough time for a leisurely stroll through the garden, but you'll probably want two or three times that at times of peak fall color and spring flowers.

Cougar Mountain Regional Wildland Park

A testament to community effort, Cougar Mountain is not only the largest park in King County, it is one of the largest urban wildland parks in the country. The 3,000 acres of land that once housed Army missile silos and former landfills is now home to plenty of wildlife, including cougars (although the likelihood of spotting a cougar is extremely slim). A network of trails, over 36 miles in total, makes this a popular recreation site for Seattle area walkers, hikers, and mountain bikers. Clearings near the top of the mountain afford views of the Snoqualmie Pass to the east and the Seattle area to the west.

Photo advice: Autumn brings some nice, if a little limited, fall color, thanks to bigleaf maple trees. Look for wildflowers along the trails and in the clearings in April and May.

Getting there: There are several access points to Cougar Mountain. For the Sky Country Trailhead, travel from the metro Seattle area travel I-90 to Exit 13 and turn south on Lakemont Blvd SE. Go 2.3 miles and make a left on SE Cougar Mountain Way. In 0.6 mile turn right on 166th Way SE and continue for 0.8 mile, past the housing development and park gate, to a good-sized paved parking area.

Time required: An hour or a day, depending on the season and how much hiking you want to do.

Nearby location: Squak Mountain State Park, immediately southeast of Cougar Mountain, is a 1,545-acre day-use park with several miles of multi-use trails. The heavily forested terrain includes deep ravines and bubbling creeks.

Weyerhaeuser Bonsai & Rhododendron Gardens

The corporate headquarters for Weyerhaeuser, one of the biggest and oldest timber companies in the Pacific Northwest, sits on 500 acres of forested and landscaped property in Federal Way. A good portion of the property is open to the public and includes a number of features attractive to nature photographers: open meadows, a 10-acre lake, and two marvelous gardens devoted to bonsai and rhododendrons.

The Pacific Rim Bonsai Collection is open daily except Mondays from 10:00am to 4:00pm. There is no restriction on personal photography, but Weyerhaeuser claims ownership and copyright on each of the bonsai displays and requires permission for commercial use of images.

The Rhododendron Species Botanical Garden is owned by a non-profit foundation, and since 1975 has been located on 24 acres of the Weyerhaeuser corporate campus on a non-cost lease. It also is open 10:00am to 4:00pm daily except Mondays; admission is charged. This beautiful garden contains not only 450 species of colorful and showy rhododendrons, but also azaleas, ornamen-tal trees, ponds, a fern collection, and spring flowers. There are no restrictions on tripod use in the garden, but it's a good idea to visit on weekdays during the peak seasons so you don't have to worry about blocking pathways when setting up your shot.

Rhododendron Species Garden

Photo advice: Bloom time in the Rhododendron Species Garden is from mid-March through May. Peak bloom for the rhodies is usually late April to mid-May. In autumn there is a nice variety of fall color provided by the aza-leas, maples, and other ornamen-tal trees and shrubs. The gardens are heavily forested, so days with bright overcast light are best for photography.

Getting there: From Interstate 5, take exit 143 and head east on South 320th Street. Turn right on Weyerhaeuser Way South and drive until the road becomes a roundabout. Take the second right out of the roundabout, which is a continu-ation of Weyerhaeuser Way South. Drive 1/4 mile to the east entrance of the

Weyerhaeuser Corporate Headquarters. Follow the signs marked "Rhododendron and Bonsai Gardens".

Time required: Allow several hours for a leisurely stroll around the gardens and plenty of time for careful photo compositions.

Nearby location: In late May and early June, a large meadow on the north side of Weyerhaeuser headquarters is full of very colorful blooming lupine. These are not the low, deep blue-purple native species of the Cascades and Olympics, but a variety of taller ornamentals ranging from almost white to bright magenta. Ducks and Canada geese frequent the little lake that fronts the headquarters building. In flower season, this is a great place to shoot early in the morning while waiting for the gardens to open. To get there, follow the initial directions for the gardens, but take the first exit from the roundabout and head west on South 336th Street; the meadows will be seen almost immediately along the road.

Saltwater & Dash Point State Parks

These two parks, on the southeastern shore of Puget Sound, are popular with summer beachgoers and have several miles of pleasant hiking trails. Neither has any outstanding geological features like sea stacks or sandstone formations that make for great photo subjects, but they are good places for catching sunsets over the Sound. At Saltwater State Park, located halfway between Tacoma and Seattle, the two cities literally buried a hatchet to symbolize an end to their longstanding rivalry.

If you're like me and prefer campgrounds to hotel rooms, these two parks are the closest places to camp near Seattle. Like most Washington State Parks, the entry gate is closed overnight, but in my experience the gates aren't locked so you can still get in if you've been out late for the sunset light, or slip out early to catch sunrise light. Saltwater is the closest to the city, but it is also under the flight path for SeaTac Airport.

Photo advice: Trails on the bluffs leading down the to the shore provide viewpoints that can give better photo compositions than the flat, straight horizon view from the beach.

Getting there: For Saltwater State Park, take I-5 Exit 149 and head west on S. Kent-Des Moines Road (WA-516). In 2 miles, turn south on Marine View Drive and go another 1.6 miles to the park entrance on 252nd Street. For Dash Point State Park, take I-5 Exit 143 and head west on 320th Street for 4.5 miles. When 320th St. ends at a T-intersection, turn right onto 47th Street and then left on Dash Point Road (WA-509). The entrance to the park will be on the left in about one mile.

Time required: For a sunset shoot, arrive about an hour before the sun actually sets so you have time to find just the right angle and get set up.

Nearby location: Browns Point Lighthouse is just a short distance south of Dash Point State Park. From the grounds, you can watch big ships in Tacoma's Commencement Bay, kite boarders taking advantage of strong gusty winter winds or kayakers on smooth summer waters. On clear days, Mount Rainier will line up over the shipping docks in Tacoma. The lighthouse itself isn't much to see—chain-link and barbwire surround a small plain looking tower with automated light—but the lighthouse keepers quarters is a beautifully preserved historical house and is available for vacation rentals.

Tacoma

Washington's third largest city isn't usually thought of as a photo destination, but there are actually a number of very camera-worthy attractions in Tacoma. Nature photographers can spend many hours with the flowers in several beautiful gardens. At Point Defiance Park, individual gardens feature roses, dahlias, rhododendrons, herbs, and northwest native species, plus there is a traditional Japanese Garden. In the downtown area, Puget Gardens comes alive in spring with three acres of azaleas, rhododendrons, and primroses, just a short walk from the Ruston Way waterfront. You can even work on exotic flora during rainy winter days at the W. W. Seymour Botanical Conservatory. Seasonal displays are changed monthly in the classic, domed, Victorian-style glass-and-steel building originally constructed in 1908.

In addition to the gardens at Point Defiance, the 700-acre park includes several other attractions of interest to photographers and visitors in general. Most popular is the Point Defiance Zoo & Aquarium, which features many animals in natural habitats and exhibits on northwest marine life. For history buffs, Fort Nisqually includes a restored Hudson Bay Company trading post. Buildings, interior furnishings, and displays reflect life in the Pacific Northwest during the fur trading days around 1855. Park staff and volunteers dress in period clothes while demonstrating 19th century crafts and are usually quite willing to pose for photographs.

Five Mile Drive in Point Defiance Park is a scenic one-way road that loops around the point, passing through native old-growth forest on the way to beaches and waterfront viewpoints. Owen Beach is a good place to photograph the ferry boats going to and from Vashon Island and the large ships in Commencement Bay with Mount Rainier in the background. The road, like the park, is open from half an hour before sunrise to half an hour after sunset.

Not to be missed in downtown Tacoma is the Museum of Glass. Photography is restricted inside the museum, but the tilted cone architecture of the building is quite striking, as is the Chihuly Bridge of Glass. The bridge, which crosses over Interstate 705, links the Museum of Glass with the Washington State History Museum and was created by Tacoma native and world-renowned glass artist Dale Chihuly. The nearby Union Station building is a wonderfully preserved piece of

historic architecture. It's now an office building instead of train depot, but you can go inside to see and photograph Chihuly's "Monarch Window", a beautiful glass and steel sculpture. The downtown museum district also includes the Tacoma Art Museum and, over by the Tacoma Dome, the LeMay Museum, a large collection of automobiles and displays dedicated to America's love of cars.

Tacoma Museum of Glass

Photo advice: At the Chihuly Bridge of Glass, try shooting at dusk, positioning your camera at a 45 degree angle to the glass wall and use a polarizing filter to cut reflection in order to better see the art glass.

Getting there: To get to Point Defiance Park from I-5, take the WA-16 Exit toward Bremerton, then Exit 3 for 6th Avenue in Tacoma. Cross 6th and continue on Bantz Boulevard, then make a right onto Pearl Street, WA-163. Travel north on Pearl for 3 miles to the park entrance and Five Mile Drive. This is the same route as for the Vashon Island ferry terminal. For the downtown museum district, take Exit 133 for City Center and I-705, exiting I-705 at Shuster Parkway. At the first signal, turn right onto South 4th Street, which curves around to join Dock Street. The Museum of Glass will be on the left in about one mile.

Nearby location: If it's spring, head for Van Lierop Bulb Farm in Puyallup. The open-to-the-public garden features tulips, daffodils, and blossoming fruit trees, and the owners are photographer-friendly. The glory shot here is a view of Mount Rainier rising above acres and acres of brilliant yellow daffodils. Flowering season runs from late March through mid-May, with early April the best for the daffodils-and-mountain photo. Gray days are great for flower close-ups, but you'll want good skies for the scenic. Late afternoon light is best for the scenic view, but early morning can work, too. To get to Van Lierop Bulb Farm from Tacoma, take I-5 to Exit 135 and travel east on WA-167 toward Puyallup for 6 miles. Turn right on Meridan Street, go south for 0.5 mile and turn left onto Pioneer Ave. In 2 miles, turn left onto 134th Avenue. Make an immediate right onto 80th Street to enter the gardens. The best view of the fields and Mount Rainier is from 134th Avenue.

Nisqually National Wildlife Refuge

High on Mount Rainier, the melted ice of Nisqually Glacier starts its journey to the sea, coursing down a deep canyon before reaching the lowlands and emptying into the southern end of Puget Sound. At the Nisqually River Delta, freshwater from the river combines with the saltwater of the Sound in an estuary that is important habitat for a variety of fish and wildlife.

Nisqually National Wildlife Refuge was established in 1974 to protect this valuable environment and its inhabitants. While most major estuaries in Washington have been dredged or filled, the Nisqually was relatively undisturbed, and since the establishment of the Refuge, work has been ongoing to restore to a more natural state the portions of the delta that had been modified for farming. Today the refuge encompasses 3,000 acres of marsh, grassland, riparian, and mixed forest habitat.

There are several walking trails in the refuge with viewpoints of the Nisqually River, McAllister Creek, marshland, and tidal flats. A 4-mile round-trip walk on the Nisqually Estuary Trail includes a mile-long boardwalk with viewing platforms and a blind for good looks at the wildlife. A regular local birder figures there are around 150 species that can be spotted here, both year-round residents and migratory songbirds, shorebirds, and waterbirds. The forests above the delta provide roosting and nesting habitat for bald eagles, osprey, and great blue herons.

Boardwalk trail at Nisqually NWR

Photo advice: For bird photography, best times are the spring migration period from mid-March through mid-May and the fall migration from September through December. Landscape photographers will probably want to concentrate on details or work with a telephoto lens to avoid large areas of blank sky in the largely flat terrain.

Getting there: From I-5, take Exit 114 and turn north on Brown Farm Road, pass under the freeway and turn right, following the signs to the refuge, which is reached in lesss than a mile.

Time required: Birders and those mostly out for a pleasant hike will probably want to spend several hours here. Alternatively, an hour will let you explore the trails through forest and wetlands closest to the visitor center.

Olympia – State Capitol

The Washington State Capitol grounds are very attractive, particularly in spring when the cherry trees are covered with their delicate pink blossoms and the manicured landscape is filled with flowers. The Legislative Building is the largest of the buildings on the Capitol Campus and the main attraction for photographers. The architecture combines elements of both Roman and Greek styles, with many ornate details, and is topped with the tallest masonry dome in North America. Inside the building, the view of the dome and its supporting marble-covered arches rising up from the Rotunda floor is quite beautiful. Tripod use is allowed in the Rotunda but there are sometimes tours and school groups that need to be taken into consideration.

There are a number of statues, fountains, memorials, and garden areas on the Capitol Campus that also make interesting photo subjects.

Photo advice: The main entrance of the Legislative Building faces north, so only gets direct light early in the morning and late in the afternoon in summer months. The south face of the building is also very good for architectural studies and has more options for pleasing photo compositions.

Getting there: From I-5, take the State Capitol/City Center Exit 105, merge onto 14th Avenue SE, and continue for about a mile to the Capitol Campus.

Time required: Half an hour to an hour is good here, depending on your interest in historical and architectural subjects.

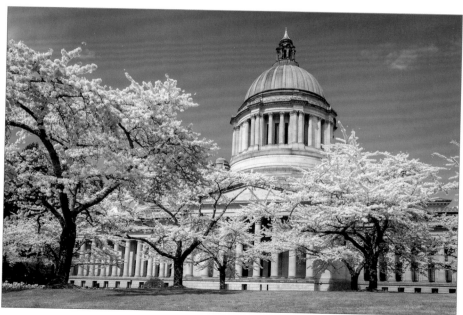

Cherry trees in spring at the Legislative Building

Nearby location: Head north on Capitol Way to 5th Avenue SW and take a left to reach Capitol Lake Park. With good weather and calm water, the capital buildings are reflected in the lake.

Tumwater Falls

When I was a kid, my dad's favorite beer was Olympia. The brand's slogan was "It's the water" and it was made in a large facility overlooking Tumwater Falls. Naturally, we had to visit there on a family vacation to Washington, and I still remember the pungent odor of the brewing hops, malt, and barley. The brewery building still stands, but the beer, not very highly regarded by northwest beer aficionados in these days of specialty micro-brews, is no longer made here.

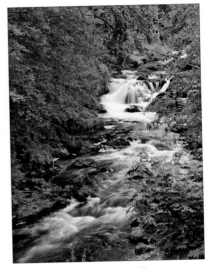

The Deschutes River does still flow in the little canyon next to the former brewery, and trails along both banks are part of a 15-acre city park. Native trees and shrubs line the river as it makes a series of drops in a short course, and while none of the views are particularly spectacular, dedicated waterfall lovers will certainly want to pay a visit. If you're visiting in the fall, you can see salmon jumping at the fish ladder at Middle Tumwater Falls.

Photo advice: From the parking area, walk down the path on the left or west side of the river, past the foot bridge and under two street bridges to view what I consider the best of the

Tumwater Falls

cascades. The trail continues down to Lower Tumwater Falls, where the river makes a final drop into Capitol Lake, but it will take some effort to make this view a good photographic composition due to concrete channels and spillways.

Getting there: Heading south from Seattle or Olympia on I-5, take Exit 103 and continue south as the road merges with 2nd Avenue SW. In 0.2 mile, turn left onto Custer Way SW, proceed for 0.3 mile and take a right on Capitol Blvd S. Go 0.4 mile and make a right onto E Street, then another right on Deschutes Way. In 0.1 mile turn right on C Street for the park entrance. If coming from the south on I-5, take Exit 103 for Deschutes Way and proceed 0.2 mile to C Street, then turn right to the park entrance.

Time required: An hour should be enough for the trails and some photos.

Nearby location: Head north on Deschutes Way to Tumwater Historical Park and then continue along the west side of Capitol Lake on Deschutes Parkway to find views of the state capitol building reflected in the lake.

Gig Harbor

Here's another one of those Puget Sound towns that visitors delight in discovering and residents claim is the best place on earth to live. Gig Harbor is a wonderful mix of history, fishing port, boating marina, tourist amenities, and scenic beauty.

What really works for photographers (and the visitors bureau) is the view of Mount Rainier rising above boats in the harbor. For a good take on this iconic

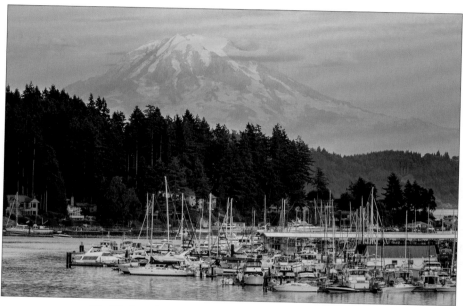

Gig Harbor & Mount Rainier (photo by Terry Donnelly)

image, follow Harborview Drive to where it bends right on the north side of Gig Harbor and look for the vacant lot opposite the house at 8802 North Harborview Drive. Hopefully, when you get there some developer hasn't snapped up this piece of property for a McMansion or commercial enterprise. A block further, on the east side of Finholm Market, there are signs to a stairway and the Bogue Viewing Platform (also accessible via Franklin Ave.), The view here is impressive, but in my opinion not quite as good as the Harborview Drive view for photography. If you're traveling with a non-photographer spouse/partner/friend, there are also some good waterfront dining options on North Harborview where you can sneak a couple of shots between courses.

Photo advice: Plan for a day with exceptionally clear skies to really show off Mount Rainier over the harbor. If you're there on a day that is somewhat hazy but with a decent view of the mountain, a polarizer may help and you can also try boosting the local contrast when processing to bring out more detail.

etting there: From Seattle, Tacoma or Olympia, travel I-5 to Exit 132B. Follow
/A-16 north for about 10 miles, crossing the Tacoma Narrows Bridge, and exit
the signs for Gig Harbor City Center. Follow Pioneer Way for one mile and
irn left on Harborview Drive.

ime required: With the harbor and Mount Rainier view as a goal, allow for at
ast an hour to find just the right location for a good composition and wait for
e sweet light.

Vashon Island

Prior to my first visit to Vashon Island, I asked my friends Mary Liz Austin
d Terry Donnelly, both long-time pro landscape photographers, if there was
yything good to shoot on the island where they make their home. Mary replied,
think Quartermaster Harbor is one of the prettiest harbors in the northwest,
d the Point Robinson Lighthouse is nice, too." Now that I've been there, I can
y I definitely agree, and I sure see why they love living there. It's a beautiful little
id back island and it's hard to find a more idyllic harbor scene than that of the
)ats and rowing crews on the well-protected inlet of Quartermaster Harbor.
The very cute little lighthouse at Point Robinson is plenty photogenic itself,
it catch a clear day with The Mountain—always majestic Rainier—in the back-
'ound and you've got a real winner. The historic Lighthouse Keepers Quarters,
ith that same great view of Mount Rainier, are available to rent for vacation
ays from the Vashon Park District. Point Robinson is actually on Maury Island,
it a road now connects the two islands where there used to be a narrow water-
ay between them.

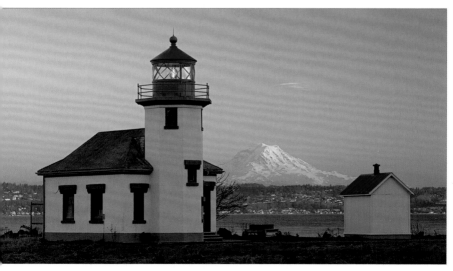

Point Robinson Lighthouse (photo by Terry Donnelly)

Photo advice: The light is good on the lighthouse from mid-afternoon on. At sunset the lighthouse will be in the shade from the hill to the west while Rainier —if you're lucky—will be bathed in golden light. You'll need to position yourself carefully to put Rainier between the lighthouse and the nearby Oil House, a shed that was used to store fuel for the original light.

Getting there: The only way to get to Vashon is via ferry, either from the Fauntleroy Terminal in West Seattle, the Point Defiance Terminal in Tacoma, or the Southworth Terminal from Port Orchard on the Kitsap Peninsula. Check the state ferry website (see Appendix) for schedules and wait times. Once on the island, follow north-south running Vashon Highway to Quartermaster Road and turn east to reach the lighthouse at Point Robinson.

Time required: Add an art gallery or two and a meal in one of the island cafés to your Vashon visit plans for a really nice day trip and an escape from the busy side of Puget Sound. Even if you just want to photograph the lighthouse, you'll have to budget plenty of time for the ferry and the slow-going island roads.

Bainbridge Island

Just a short ferry ride from the Seattle waterfront, Bainbridge Island is a world apart from the hustle and bustle of the big city. The 36-square mile island of rolling hills and dense forest is home to a large artistic community. Late spring through summer the historic ferry terminal town of Winslow hosts open-air concerts in scenic Waterfront Park and a busy Saturday Farmers Market.

The island is also home to a world class botanical garden, the Bloedel Reserve. The privately owned 150-acre gardens are well worth a visit at any time of year, but are perhaps at their finest photographically in autumn. Ornamental maple trees in the Japanese Garden are fiery red, vibrant orange, and brilliant yellow. Almost as a counterpoint to the eye-grabbing bright color, the reflecting ponds, classic teahouse and very Zen rock garden invite quiet contemplation and studied photographic compositions.

There is a lot more to Bloedel than the Japanese Garden. A self-guided 2-mile path winds across meadow and through a forest of native northwest species. Hemlock, cedar, and alder trees shade an understory of salal, Oregon grape and several species of ferns. Rhododendrons brighten the lush growth in spring, and mushrooms pop up from the forest floor after the first fall rains. Traditional landscaped gardens and a formal English garden also grace the property.

The Reserve was originally the estate of timber heir Prentice Bloedel, and the family's stately manor house overlooking Puget Sound now serves as visitor center for the gardens. Bloedel devoted much of his life to developing the garden, enlisting the aid of notable landscape architects in bringing his vision to fruition. Bloedel Reserve is open daily except Mondays, and admission is charged. There are no restrictions on tripods; let's use them wisely so that policy remains.

Right: Laceleaf Maple tree in autumn at Bloedel Reserve

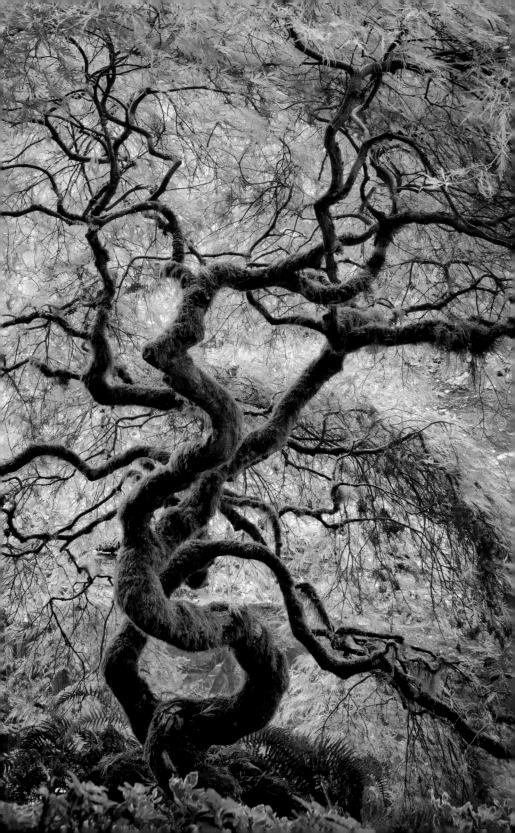

Photo advice: At Bloedel Reserve, the Rhododendron Glen is best in May, and peak of fall color is generally around mid-October. There can be quite a bit of seasonal variation, so if you're visiting Bainbridge just for the gardens, call in advance to inquire about conditions.

Getting there: To get to the Bloedel Reserve from the ferry terminal at Winslow, head north on SR-305 for 6 miles and turn right onto Agatewood Road. Go 0.3 mile and turn right on Dolphin Drive and look for the gate at a bend in the road at 0.5 mile. If coming from the Kitsap Peninsula, head south on SR-305 from Poulsbo, cross the Agate Pass Bridge to Bainbridge and turn left on Agatewood Road in 0.6 mile, then follow the directions above.

Time required: At Bloedel, once there you'll want to spend at least a couple of hours. If the fall color is good, I recommend getting there as soon as they open at 10am, because you may want to stay all day.

Nearby location: Fay Bainbridge Park offers camping and picnicking on 17 acres of Puget Sound shoreline. On clear days, there are distant views of Mount Rainier and Mount Baker from the sandy beach.

Kitsap Peninsula Parks

Purist nature photographers are likely to merely traverse Kitsap Peninsula on their way to Olympic National Park from Seattle or Tacoma, but there are some quite photo-worthy locations to visit on the peninsula, whether en route or as destinations themselves.

On the west coast of the island, Scenic Beach State Park and Kitsap Memorial State Park are both camping and beach recreation parks with good views across Hood Canal to the Olympic Mountains. The peaks are somewhat distant, but there can be great sunsets along this coast when weather conditions are right.

Poulsbo

A number of Pacific Northwest communities retain strong ties with the culture of the early Scandinavian settlers who came to log, fish, and farm the fertile territory. The Norwegians that came to this part of Kitsap Peninsula found Liberty Bay to be remarkably fjord-like. Poulsbo honors the culture and traditions of those settlers with the colorful Viking Fest, held annually in mid-May.

Tourism is a big part of the local economy today, and many of the shops and restaurants on Front Street have a Scandinavian design and décor theme. There is a very nice park along the downtown waterfront, and the large and attractive marina in Liberty Bay can make a pretty picture. The key shot, however, is from across the bay, where you can capture Mount Rainier rising above the yachts in the marina. The view is especially nice in the low-angled light of late afternoon.

Photo advice: A telephoto lens will compress the perspective and make Mount Rainier more dominant in the scene. Using a polarizing filter will help lessen the effect of any haze in the air and also usually makes the mountain stand out a bit more from the sky.

Getting there: For the Mount Rainier view, head north from downtown Poulsbo on Front Street for about a mile. At the head of Liberty Bay the road bends left and becomes Lindvig Way. Turn left on Viking Avenue and travel south for 0.6 mile to Liberty Shores Assisted Living, on the left immediately past Bovela Lane. Pull into the parking lot on the left, and then follow the public access path next to the Liberty Shores building down to the beach. Walk north along the beach for the best view.

Time required: A visit to Poulsbo makes a nice day trip from the Seattle area. If you're on the way to Olympic National Park or touring Kitsap Peninsula, allow an hour or two to explore the downtown and waterfront area.

Nearby location: The town of Suquamish, located on the Port Madison Indian Reservation, is headquarters for the Suquamish tribe. Those with an interest in Native American culture will want to visit the Suquamish Museum, Old Man House Park, and the gravesite of Chief Sealth, for whom Seattle is named, and who is famously quoted as saying "The earth does not belong to us. We belong to the earth."

Port Gamble

This former mill town is classic Americana. The General Store and stately St. Paul's Church are the social centers of a small town of well-preserved New England Victorian-style homes. The 120-acre village has been declared a National Historic Site. Founded as a company town, and remaining so even though the mill has shut down, it was modeled after the Maine hometown of lumbermen Andrew Pope and William Talbot.

Photo advice: Maple trees line the town streets, making the town especially attractive in autumn. The church faces due east, so early to mid-morning light works best.

Getting there: Port Gamble is at the north end of Kitsap Peninsula, on WA-104 about a mile east of the Hood Canal Bridge and 8 miles from the Kingston ferry terminal. If coming from downtown Seattle, the most direct route is via the Bainbridge Island ferry.

Time required: Port Gamble is one of those places where you can jump out of your car and get a couple of decent photos in a few minutes, or you can spend all day wandering around town, finding great subjects in the architecture, historic artifacts and overall small town setting.

Point No Point Lighthouse

The light station at Point No Point is the oldest lighthouse on Puget Sound, having been in operation since 1879. The light now shines from a small, automated beacon rather than the old Fresnel lens, but the lighthouse itself is the original—and, interestingly, is the twin of West Point Lighthouse in Seattle's Discovery Park. The historic lightkeepers house is a duplex, with half available as a vacation rental and the other half serving as headquarters for the U. S. Lighthouse Society. Tours of the lighthouse are given on weekends from April through September, or at other times by special arrangement.

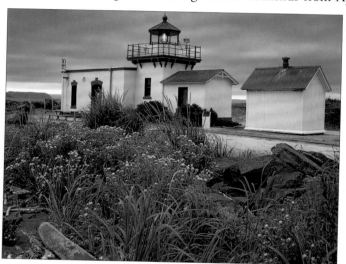

Point No Point Lighthouse (photo by Mary Liz Austin)

Located on a spit at the northeast end of Kitsap Peninsula, the lighthouse looks across Puget Sound to Whidbey Island, and is now part of a county park, so access is easy, both along the beach and via park pathway.

Photo advice: One side of the lighthouse gets great sunrise light and the other catches the late day sun, so you're good at either end of the day here. Shooting from down low on the beach, using vegetation and driftwood as foreground works well, especially in spring when wildflowers bloom and the beachgrass is nice and green.

Getting there: From either Port Gamble or the Kingston ferry terminal, travel WA-104 to Hansville Road and go north for 7.4 miles. At Point No Point Road, turn right and drive another mile to the lighthouse.

Time required: Not including drive time, an hour should be good for a sunset or sunrise shoot; less is needed for a mid-day visit unless you also take the tour.

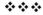

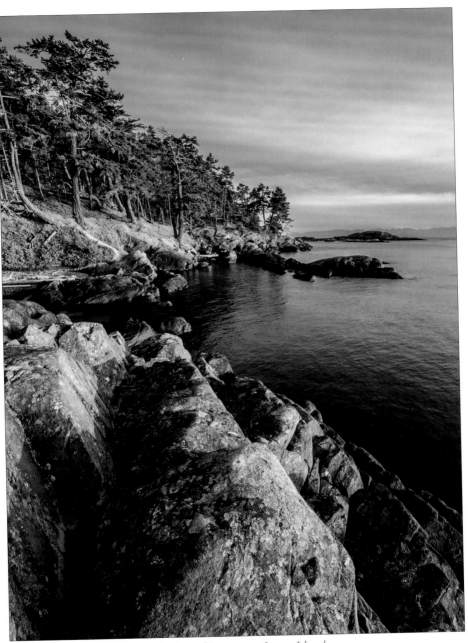

Shark Reef Sanctuary, Lopez Island

Chapter 5

SAN JUAN ISLANDS

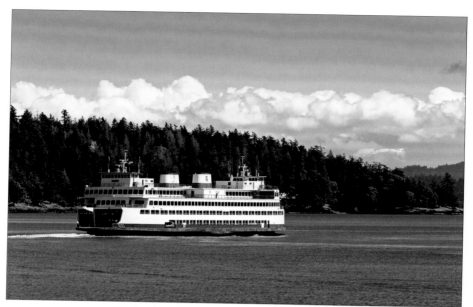

Washington State Ferry en route to the San Juans

SAN JUAN ISLANDS

Together with Canada's Gulf Islands to the north, the San Juan Islands are an archipelago that many millions of years ago was a mountain range. Mount Constitution on Orcas Island is the only remaining peak with any real elevation, but evidence of glaciation is found throughout the islands. The archipelago sits directly between the southern end of Vancouver Island and Washington's northern coast. In recent times the various channels and straits that surround the islands have come to collectively be referred to as the Salish Sea, a term that includes the Strait of Juan de Fuca, Puget Sound, and the Strait of Georgia.

Due to the surrounding ocean and mountain ranges, the San Juan's are blessed with some of the best weather in the Pacific Northwest. Temperatures tend to be moderate year round, and thanks to the rain shadow effect from the Olympic Mountains, rainfall is much less than on mainland Washington and nearby Vancouver Island. Arctic blasts occasionally come through in winter, but the inclement weather doesn't stick around for very long. Autumn and spring are usually delightful, and wildflowers abound in the second half of May.

The pastoral farmland, forested woodlands, secluded coves, and miles of scenic shoreline make the San Juan Islands a wonderful place for nature and landscape photography. Those same traits, plus friendly locals, a vibrant arts community, and a range of lodging from primitive camping to upscale resort, make the islands a favorite vacation destination.

Wildlife lovers flock to the San Juan Islands for whale watching. From May to September, migrating orcas join three resident pods, providing a thrilling show when they breach. Minke whales and Dall's porpoises can be spotted as well.

Planning your Trip

Of the many hundreds of islands in the Salish Sea, only 172 of the U.S.-owned San Juan Islands are named, and of those only the four largest are accessible to the public by scheduled transportation. Washington State ferries depart from Anacortes on Fidalgo Island for Lopez, Shaw, Orcas, and San Juan Island. If you're going to visit multiple islands, it's easiest to start with the furthest west (like San Juan Island) and work your way back; this is because the fare structure is such that all tickets are round-trip, so your eastbound fare is taken care of once you purchase your ticket.

The islands are very popular destinations on holidays, all summer and most weekends. Ferry traffic is especially heavy leaving Anacortes on Friday afternoons and Saturday mornings, and from the island terminals on Sunday afternoon and evening. No reservations are available on the San Juan Island routes. Plan to be at the Anacortes terminal 90 minutes prior to sailing during those busy times; an hour early should be sufficient on weekdays. On your return trip, allow for similar waiting times at San Juan Island and Orcas, perhaps a little less at Lopez and 30-45 minutes for Shaw Island.

Walk on passengers and those traveling by bicycle (or kayak!) bypass the long queue of vehicles at the ferry terminals, and they are first on and first off the boats. Public ground transportation is available on Orcas and San Juan Island. Private boat charters and kayak tours provide great opportunities for photography with a unique perspective and to gain access to the smaller islands.

In summer months it is necessary to make reservations for lodging in advance, as island accommodations are often fully booked. Even in the off-season, reservations are advised. Some campgrounds are first-come, first serve, but don't count on getting a site if you arrive at noon on a summer Saturday. None of the public campgrounds have hookups for RVs. The sites at the campground on Shaw Island aren't big enough for a large RV, nor are they level. RVer's can find full service sites at private campgrounds on Lopez, Orcas, and San Juan Island.

Folks in the San Juan Islands (all of Washington for that matter) are protective of their property and privacy, and unlike in neighboring Oregon, the beaches are not public. "Private Property" and "No Trespassing" signs are ubiquitous and coastal access is very limited in some areas. Most likely those signs are there because past visitors have been a problem, so please respect them and take advantage of the many parks and preserves and all that they have to offer.

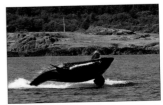

Orca off Lime Kiln State Park

Introduction to San Juan Island

Second largest by size in the Salish Sea archipelago and with the biggest population, San Juan Island is a busy summer holiday destination but also a place prized by residents for its laid-back lifestyle and healthy environment. It is one of the very best places in the world for shore side viewing of whales and has a number of locations that are excellent for nature and landscape photography.

Another attraction is its great weather. San Juan Island is in a rain shadow, receiving less than half of Seattle's annual precipitation and many more days per year of sunshine. On the other hand, while most visitors and residents like all that sun, from late summer through early October weeks can go by without a cloud in the sky—which is definitely not the optimal situation when trying to make beautiful landscape photographs.

For photographers, the ideal time to visit San Juan Island has to be in May. It's the beginning of the annual orca whale migration, the summer crowds haven't arrived yet, farmland and prairie are lush green, and flowers bloom in gardens and wildlands.

As with the rest of the San Juan Islands, it's really a good idea to make advance reservations for lodging or campsites during summer months, especially weekends, and for any holidays. You'll also want to arrive at ferry terminals plenty early during those times to ensure there's room for you on the boat. How long of a trip to plan? You could see all the major sites on this island in one day, but to have time for some real photography and not just quick tourist snapshots, three days is a much better idea.

Getting around San Juan Island by car is quite easy, the roads are good and it takes as little as 15 minutes to get across the island from east to west or 30 minutes from north to south. There's no need to hurry, and it's important to remember that bicycle touring is very popular in the San Juans and there is seldom a bike lane or paved shoulder for bicyclists to use.

Friday Harbor

The town of Friday Harbor, which is the county seat for all the San Juan Islands, is a historic seaport built on a hill overlooking a busy and very scenic harbor. It's an easy walking town, with a good number of shops, galleries, and dining options.

If you haven't visited Friday Harbor before, I suggest that the first thing you do after getting off the ferry is wander around the downtown area a bit and pick up a map at the Visitor Center on Spring Street (the main street, which you get onto as soon as you leave the ferry terminal). The Whale Museum on First Street has some very interesting displays on the resident Orcas and other whales found in the Pacific Northwest. Further up the hill on Price Street, the San Juan Historical Museum is located in the picturesque James King Farmhouse, built in 1894.

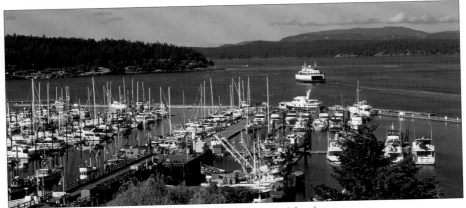

Friday Harbor, San Juan Island

A log cabin and other historic buildings are also on the museum property.

The harbor itself, with its large boat-filled marina is a great subject for travel photos. It's okay to wander on the docks looking for angles, or walk up the hill in town for a higher perspective. A small park on West Street next to the Friday Harbor House inn has a very good view overlooking the marina.

Photo advice: If you're staying overnight in or near Friday Harbor, sunrise light is especially nice for the harbor view.

Getting there: Exiting the ferry, follow the traffic onto Front Street and then an almost immediate left onto Spring Street; start looking for a parking spot.

Time required: An hour or two will give you time to get some marina views and look for other travel photo opportunities around town.

Nearby location: As you're driving across and around the island to other destinations, keep an eye out for the occasional classic old wooden barns.

Roche Harbor – Westcott Bay

In the late 1800's, what started as a quiet little Hudson Bay Company camp grew to be a bustling lime works and company town with a population larger than Friday Harbor. Structures from the lime processing plant can still be found at Roche Harbor, but the town has now become a full-scale resort with a large marina. The complex is quite attractive and the harbor, gardens full of flowers, and the historic Hotel de Haro provide some nice photo opportunities.

The San Juan Islands Museum of Art Sculpture Park at Westcott Bay is quite unique and worth

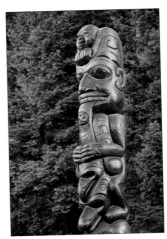

Raven & Wolf by Mike Olsen

stopping at to enjoy some wonderful works of art in a natural setting. More than 100 sculptures, large and small and of various media, are scattered throughout a preserve with trails through woods and meadows. A large pond in the center of the park is designated as a bird sanctuary.

Photo advice: Late afternoon to sunset light is best for the Hotel de Haro and the surrounding gardens. Due to the varied placement of sculptures at the Westcott Bay park, just about any time of day will be okay.

Getting there: From the center of town in Friday Harbor, head northwest on 2nd Street, continuing west as it changes to Guard Street, and make a right on Tucker Avenue. In 0.4 mile, go left onto Roche Harbor Road at the Y junction. Follow this road around the north end of the island for 8.5 miles and the entrance to Westcott Bay Sculpture Park. Continue on Roche Harbor Road for about another half mile to reach the harbor and resort area.

Time required: An hour will give you time for some photos around the resort and a quick stop at the sculpture park.

Nearby location: Along the road from Friday Harbor to Roche Harbor you'll pass a classic barn or two and a picturesque little white church at San Juan Vineyards. The winery tasting room is located in a historic schoolhouse. If you have time, check out Ruben Tarte County Park, the only public access beach area on the north end of the island.

English Camp

The Treaty of Oregon, signed in 1846, established the boundary between the United States and Canada from the Rocky Mountains to the sea channel separating the continent from Vancouver Island, but oddly enough it didn't specify whether that channel was the Haro Strait or Rosario Strait. Subsequently, both the British and Americans laid claim to the San Juan Islands, which lay between the two straits. Tensions between settlers on both sides had been building for several years when, in June 1859, an American shot a British pig that was rooting in his garden. In the ensuing brouhaha, both sides rallied their troops and rattled their sabers in what came to be known as the Pig War. The British established a military base on the northwest coast of the island at what is now known as the English Camp unit of San Juan Island National Historical Park, while the Americans encamped at the south end of the island, now the American Camp unit of the national park. Fortunately, the two sides chose to negotiate rather than have the United States and Great Britain go to war, and without any actual fighting an agreement was reached that established the international boundary in the middle of Haro Strait, making the San Juan Islands part of United States.

The British had a pretty nice setup at English Camp, where today a blockhouse and barracks remain on the parade grounds, a wide expanse of lawn overlooking Garrison Bay. An attractive formal garden surrounded by a white picket

fence sits at the south side of the field. Back of the bay, the terrain rises in a forest of pine, fir, and madrone.

English Camp is open for visitors year round from dawn to 11 PM. From June through September a visitor center is open in the old barracks building.

From the visitor center and parking area a trail climbs to an elevation of 650 feet at the top of Young Hill. A short spur trail leads to English Camp Cemetery. The summit view is a panorama that looks over Garrison Bay and the Haro Strait to Henry Island and Vancouver Island. The trail is somewhat steep in parts, but it's only 1.5 miles round-trip, and the summit view-point is great for sunsets.

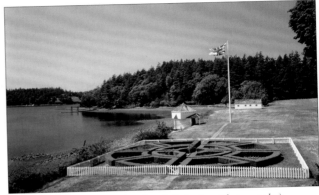

English Camp (Kirkendall-Spring Photography)

The parade grounds are also an excellent choice for a sunset location, offering both the view of the sunset itself over Garrison Bay and the chance for golden light on the historic buildings and garden.

Photo advice: Mid- to late afternoon light is best for the view from the formal garden to the blockhouse; in the morning the garden may be partially shaded by the adjacent forest. This view is at its best in spring and early summer with the garden in bloom and the lawn a rich green. Late summer through winter the lawn is dead and will only look good with late afternoon golden light raking across it.

Getting there: From the center of town in Friday Harbor, head northwest on 2nd Street, continuing west as it changes to Guard Street. The road jogs right and then left, in 0.7 mile becoming Beaverton Valley Road. Follow this cross-island road, continuing as it becomes West Valley, reaching the entrance to English Camp in 7.5 miles.

Time required: You could be in and out of here in half an hour if you just want a typical view of the garden and blockhouse, but 2-3 hours is better for hiking to Young Hill and plenty of time for exploring and fine-tuning compositions around the Parade Grounds.

San Juan County Park

This small camping park is a favorite with kayakers and bicyclists. It has a nice little sandy beach for launching kayaks, and a large, grassy open area for pitching tents. It's also a good place for sunset photography, with a view due west over

Haro Strait to Vancouver Island. Frequent passing boats and a tiny islet provide some additional visual interest. During whale migration season orcas can be spotted just offshore.

Photo advice: There's not much here to photograph other than the sunset, and you'll get far better images shooting around the lighthouse at Lime Kiln State Park just down the coast.

Getting there: From the center of town in Friday Harbor, head northwest on 2nd Street, continuing west as it changes to Guard Street. The road jogs right and then left, in 0.7 mile becoming Beaverton Valley Road. Follow this cross island road, continuing as it becomes West Valley Road, for 5.8 miles. At Mitchell Bay Road, turn left and in 1.3 miles make another left onto West Side Road. The park entrance will be on the right in 1.8 miles.

Time required: Check it out in about 10 minutes and see if you want to spend more time there.

Lime Kiln Point State Park

By far the best and most popular location on San Juan Island for landscape and nature photographers, Lime Kiln State Park boasts a beautiful, rugged, rocky coastline, a distinctive lighthouse, and May through September the opportunity to see false killer whales (Orcas) swimming, diving, and breaching in close proximity. It is also probably the prime location on the island for sunset photos.

The lighthouse is best photographed from the south side, and there are a number of choices for placing your tripod so take some time to find your best composition. Check the angle from the rocks right down next to the water, or step back a bit and try framing the lighthouse with the madrone trees.

During their annual migration, the whales sometimes come relatively close to the shoreline, although you'll still need a rather long telephoto lens, 300mm or more, to get a decent photograph. If really want good photos of the orcas breaching, book one of the whale watching tours that operate out of Friday Harbor and Roche Harbor. These can usually get you in range for good photos with a 70-200mm zoom lens. The action happens quickly and usually unexpectedly, so you'll need to crank up the ISO a bit, use a high shutter speed, and be ready to react instantly. A few orcas are year-round residents here, but the best time to viewing the whales is during the annual migration between May and September when several pods move through the Salish Sea channels. On whale watching tours, participants are also likely to spot Dall's Porpoises and Minke whales.

Photo advice: At sunset, use a slow shutter speed (1 second or more) and time your exposures to catch the rotating beam of the lighthouse while the shutter is open. Stick around for at least 20 minutes after the sun sets – the color in the sky is often best at that twilight time. When photographing whales from the shore, the best light is early to mid-morning.

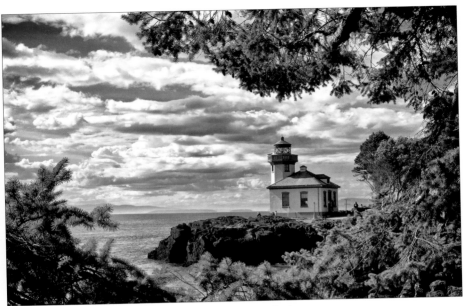

Lighthouse at Lime Kiln Point

Getting there: Continue south on West Side Road if coming from San Juan Park and points north. If coming from Friday Harbor, head southwest on Spring Street from the center of town, continuing as it becomes San Juan Valley Road. In a little over a mile, turn left onto Douglas Road and drive south for 1.7 miles. At Bailer Hill Road, turn right and go 4.0 miles across the island to the coast where it becomes West Side Road. Continue northwest for 1.6 miles to Lighthouse Road.

Time required: Allow at least an hour or two here. You may need lots of patience and many tries in photographing the whales and at sunset you'll want to stick around for the afterglow.

Nearby location: Westside Preserve Viewpoint, 0.8 mile south from the lighthouse area, is another very good location for whale watching and photographing the rugged coastline.

Pelindaba Lavender Farm

Quite a few lavender farms have sprung up in the Pacific Northwest in recent years. Pelindaba is one of the oldest, largest, and best for photography. Acres and acres of plants are covered with masses of blooms in multiple purple hues. Better still, Pelindaba walks the walk when it comes to environmental standards and their fields are certified organic.

Of course, the bloom is seasonal so there's not much to photograph between fall and spring, but in mid- to late summer Pelindaba is certainly worth a visit.

The folks here are photographer friendly and their Demonstration Garden features more than fifty varieties of lavender. During the annual San Juan Island Lavender Festival in mid July the farm offers tours of the fields and production facilities.

Lovely lavender

Photo advice: Peak blossom season is during the month of July. Try working early or late in the day and use a polarizing to achieve richer greens and purples.

Getting there: From the center of town in Friday Harbor, head southwest on Spring Street, continuing as it becomes San Juan Valley Road. In a little over a mile, turn left onto Douglas Road and drive south for 1.7 miles. At Bailer Hill Road, turn right and go 2.5 miles to Wold Road. Turn right and go north for 0.6 mile to the farm.

Time required: Half an hour to an hour is probably sufficient, but you might want even a little more with good light at the height of the bloom.

American Camp

While the British troops were ensconced on the north end of the island during the infamous Pig War, the Americans set up an encampment on the southern tip. I imagine it wasn't too tough of an assignment for any of the troops on either side, given the moderate climate, inviting scenery, and lack of actual fighting.

At first glance, there's not a whole lot here for the nature photographer, but the San Juan Island National Historical Park visitor center has some very interesting exhibits about the history and archeology of the area. Coast Salish Indian artifacts have been found on the island dating back 8,000 years. Keep an eye out for bald eagles here, too—a pair have been nesting in the trees above the visitor center since 1995.

From the visitor center, a trail leads across an open prairie to the American Camp's Officers' Quarters, a white clapboard house surrounded by picket fence that was built in 1859-1860. The oldest structure on San Juan Island, it may have been the home of Capt. George Pickett, the U.S. Army captain who later gained fame as a Confederate general in the Civil War.

Additional trails from the Visitor Center and from trailheads further east on Cattle Point Road lead across the prairie to beaches and viewpoints on the north and south sides of the peninsula. A one-mile hike will take you to South Beach, the longest public beach on the island. A 3-mile loop trail to Mount Finlayson affords wonderful panoramic views to the east, south and west that include Mount Baker, the Strait of Juan de Fuca, the Olympics, and Vancouver Island;

on exceptionally clear days, you can see all the way to Mount Rainier. One of the most popular hikes on the island is the 1.5-mile out and back through forest to Jakle's Lagoon on the north side of the peninsula. Watch your step while hiking, as rabbits have dug warrens all over the prairie.

This part of the national park is open from dawn to 11pm daily; the Visitor Center is open year round, with hours varying by season. During the annual Encampment festival in July, costumed staff and volunteers recreate island life of the mid-1850's.

Photo advice: The bright white paint on the Officers Quarters and surrounding picket fence may throw off your camera's meter. Check the LCD and the histogram to make sure the exposure is correct.

Getting there: From downtown Friday Harbor, head southwest on Spring Street for about half a mile, then turn left onto Mullis Street. Proceed south, passing the airport, and continuing as the road becomes Cattle Point Road, reaching the entrance to San Juan Historical Park in 5 miles.

Time required: Depending on your interest in history, half an hour or so may be enough to visit the Officers Quarters and visitor center displays.

Cattle Point

There are quite a few very interesting and attractive lighthouses in Washington; unfortunately the lighthouse at Cattle Point is not one of them. Too bad, because it's a great setting. In this case, rather than get up close to the lighthouse, the best photos are going to be from some distance away, using the lighthouse as a point of interest in a landscape photo.

Driving towards the lighthouse, look for the small parking area and San Juan Island National Historic Park interpretive signs on the right. The view from here is across a broad, sloping, open landscape of grass, with the lighthouse some distance away to the southeast. The area beyond the National Park boundary is now part of the recently created San Juan Islands National Monument, the combination giving protection to one of the last native prairie ecosystems in the Puget Sound/Salish Sea region. In summer, California poppies and a variety of other wildflowers pop up among the grasses. The prairie is also home to the island marble butterfly, thought to be extinct until it was discovered here in 1998.

Sunrise and sunset light on the prairie is beautiful and will make a really nice photo with the lighthouse on the horizon, whereas any other time of day it's likely to be a rather bland scene. Follow one of the established paths a short distance west for a view that includes South Beach.

Photo advice: Split rail fences in the grassy fields near the lighthouse can be very effective compositional elements in the landscape, and they can also be the main subject of a photo. In late summer through winter when the grass is dead, try photographing with black & white or alternative processes in mind.

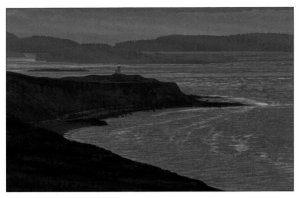

Cattle Point lighthouse pre-dawn

Getting there: From American Camp, continue on Cattle Point Road for about 3 miles to the southeast tip of the island.

Time required: Half an hour to an hour is probably sufficient here, although you could spend a lot more time playing with compositions built on the graphics of the fences.

Nearby location: Continue driving past the lighthouse to a historical area on the east side of this peninsula, with interpretive signs and a trail on a bluff overlooking the narrow channel between San Juan Island and Lopez Island. On the way to Cattle Point, look for the trailhead to Mount Finlayson, at 290 feet elevation the highest point on the peninsula, with a view to the Cascades and the Olympics.

Introduction to Orcas Island

Perhaps the most popular of the San Juan Islands with nature photographers, Orcas Island is a beautiful mix of pastoral farmland, dense coniferous forest, rocky shorelines, and protected bays. For the visitor, the island also offers a nice selection of inns, restaurants, shops, and art galleries. Outdoor activities include kayaking, mountain biking, camping, and hiking on many miles of trails.

As elsewhere along Washington coasts, waterfront access on Orcas is rather restricted. Having lived most of my life in Oregon and Hawaii where all beaches are public according to state law and access is mandated, I've sometimes found it frustrating when traveling in Washington and can't get to what I know is a great photo location. Fortunately, there are a number of public access points around Orcas Island with outstanding views and the potential for some great landscape photography.

A note when planning your photo outings on Orcas: low tides often reveal unattractive mudflats and algae-covered cobblestone beaches, so consult tide charts and try for mid- to high tides for the best coast photography. Also keep in mind that all of the San Juan Islands are extremely popular destinations on holidays and all summer. Advance reservations for lodging are almost mandatory and you may have long waits at the ferry terminals.

There is certainly good reason for the popularity of the San Juan's, and Orcas in particular. The beautiful topography, laid-back lifestyle of the residents, and opportunity for either active adventures or total relaxation make the islands a favorite destination for visitors from all over the Pacific Northwest.

Eastsound

The only real town on Orcas Island is Eastsound, which serves as hub for the community, local businesses, and visitors. Here you'll find restaurants, shops,, and art galleries. A natural foods store and a well-stocked supermarket supply groceries. Wi-fi is available at several cafes and there is Orcas Online pay service throughout the village.

Park on Main Street or North Beach Road (the main streets through town), and wander the village for some nice detail photos of art and architecture. Key town photos include the historic museum, and a large sculpture out front and the community church, both of which look best in morning light.

Follow North Beach Road to the top of Orcas for one of the few coastal access points on the island. At low tide you can walk far enough out on the sand and cobble beach for a view of Mount Baker to the east. Resist the urge to walk up or down the beach for a better view—it's all private property except for the narrow strip at the end of North Beach Road.

Photo advice: The view of Mount Baker from North Beach is a very good sunrise location. Depending on the dawn clouds, you might want a long telephoto to bring in the mountain, or a wide lens if there is a great and expansive sky.

Getting there: Exiting the ferry, make an immediate left onto Orcas Road and head north across the island, reaching Main Street in Eastsound in about 8 miles. North Beach Road is the main street through Eastsound. Follow it north from the village center for a little over a mile to reach the beach.

Nearby location: Judd Cove Preserve is a quiet little nature preserve on the east side of Fishing Bay. Look for the signed access road near the junction of Orcas Road and Crow Valley Road. Just south of the junction, along Orcas Road, is Fowler Pond, another nature preserve set aside through the efforts of the San Juan County Land Bank.

Moran State Park

The most popular destination on Orcas Island, and the one with the most opportunity for nature photographers, is Moran State Park. This outstanding park includes lakes, waterfalls, old-growth forest, campgrounds, and nearly 40 miles of hiking trails. The park dates from 1921, when shipbuilder and former Seattle mayor Robert Moran donated more than 2,700 acres to the state; since then the park has almost doubled in size.

The biggest draw for most visitors is the view from the top of 2,409-foot Mount Constitution. A stone observation tower, built by the Civilian Conservation Corps in 1936, stands at the top of this highest peak in the San Juan Islands. The view from the top includes neighboring islands and a panoramic sweep from British Columbia to Mount Rainier to the Olympics. Directly to the east, the classic volcanic peak of Mount Baker rises majestically above neighboring

Cascade Mountains. The view of Mount Baker is especially enchanting on days when a clear horizon to the west lets the golden tones of the setting sun light up the glaciated peak. The view of the sunset itself is blocked by tall trees on the west side of the summit of Mount Constitution.

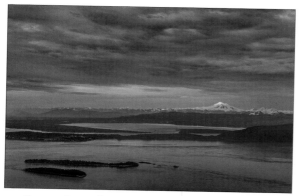

Rosario Strait & Mt. Baker from Mt. Constitution

The view from the top can also be outstanding at sunrise, but unfortunately the road to the summit is locked at night and does not open early enough for sunrise viewing with the exception of a few weeks in spring and fall when the gate opening time is slightly before sunrise.

For a slight different view to the east and south, hike the trail from the top of Mount Constitution south towards Summit Lake and Cold Springs. About half a mile from the trailhead there is a very nice view from an open ridge of Mountain Lake, just below, with Fidalgo Island and the Cascade Mountains in the distance.

Mountain Lake can also be photographed from a number of places on its forested shore. The boat launch and campground are the takeoff points for a trail that circles the lake. The lake is big enough that it often gets windy and choppy in mid-day, but can be beautifully glassy at dawn and late in the day.

Close to the park entrance on the west side, Cascade Lake is a popular summer recreation area with a day-use swimming area on the north side and camping on the south end. At South End Campground, a 0.7-mile trail leads to Sunrise Rock. The quad stretching trail gains 300 feet of elevation to a viewpoint over-looking the lake. As the name suggests, it's a great place for sunrise, but it can also work at the other end of the day when the lake is calm and the sky above is filled with colorful clouds. This could also be an excellent location for some time-lapse photography.

Cascade Creek tumbles down the south flank of Mount Constitution, creating a series of waterfalls that are easily accessible in a 10-minute walk. From the trailhead on Mount Constitution Road, the trail descends for 0.25 mile to Cascade Falls. This 75-foot tall waterfall is the tallest and most spectacular of the creeks plunges, but at last visit was choked with fallen logs and blowdown; perhaps time and a good storm flow will wash some of the debris away prior to your visit. A short walk upstream leads to Rustic Falls—not nearly as tall but in a pretty setting surrounded by ferns and big firs. Keep going up the trail a bit for Cavern Falls, where the creek drops in two tiers to tumble into a small pool. The setting here isn't the most photogenic and requires some work and scram-

bling to find a worthwhile composition. Cascade Creek dwindles significantly in summer, so these falls are best viewed in spring when the runoff is still strong. Waterfalls are best photographed with the soft light of overcast skies, but it's possible to work with these falls on sunny days both early and late and in the day when the creek is in shade.

Photo advice: Many days in summer the haze is thick enough at mid-day to make views from Mount Constitution flat and uninteresting, and can even block the view of Mount Baker and Mount Rainier. With any luck, that haze will light up with a nice warm glow right at sunset, giving a nice look to telephoto landscapes of the neighboring islands in the Salish Sea. There are also times when the view is entirely obliterated by fog. Make lemonade from the lemons and find some really great foggy forest compositions along the road or trail just below the summit.

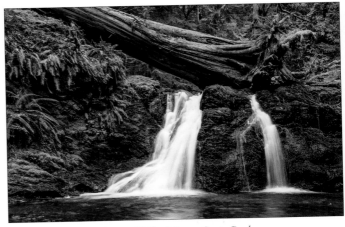

Rustic Falls, Moran State Park

Getting there: Exiting the ferry, make an immediate left onto Orcas Road and head north across the island, reaching Main Street in Eastsound in about 8 miles. Go east on Main Street through town and continue past Crescent Beach for about a mile, then turn right on Olga Road. Travel three miles to the entrance to the park. The road follows the northeast shore of Cascade Lake for a mile before reaching the junction with Mount Constitution Road.

Time required: Count on half a day for the view from the top of Mount Constitution, photographing the waterfalls and time to check out the lakes.

Nearby location: On the winding five mile drive up to the summit of Mount Constitution look for a couple of small pullouts that have nice views of the islands and waterways to the south.

Eastern Orcas

In 1906, shipbuilder, businessman, and former Seattle mayor Robert Moran began construction of his dream home at Rosario Estate on a bluff overlooking Cascade Bay and East Sound. The estate is now the Rosario Resort & Spa, and the original mansion houses a museum. Moran was an avid photographer, and

the museum contains original photos from the late 1800's and early 1900's, as well as a 1913 Aeolian pipe organ. The resort grounds are beautiful, and the great views over the sound make it a popular venue for weddings.

For another view of East Sound, head down to the little community of Olga. The long weathered wood pier jutting out into the sound offers possibilities for artsy photo compositions, as does the old gas pump in front of the Olga Store.

At Obstruction Pass State Park, an easy walk on a 2.3-mile round-trip trail passes through fir and fern forest to a nice little cove and beach. There are a half-

Olga Pier

dozen or so primitive campsites in the trees just above the beach. Carry your camping gear in from the trailhead, or bring it ashore from kayak or boat.

A boat ramp on the bay next to Lieber Haven Resort provides one of the few public access points to the coast. The 180° view from the beach includes Deer Point, Obstruction Island, and the distant Olympic Mountains. When the sun's azimuth is furthest south in winter, there is good potential here for sunrises and sunsets over Obstruction Pass and off the points of land to the east and west.

There isn't much of a beach at Doe Bay, but the coastal scenery is lovely, and the Doe Bay Resort folks don't mind if you wander on the bluff overlooking the tranquil bay. The resort facilities include a general store, open-air clothing optional hot tubs, rustic cabins and camping in yurts or forested tent sites overlooking the bay and Rosario Strait. The restaurant, also with a view of the bay, serves gourmet food prepared with ingredients grown in their own garden and on neighboring farms.

One of the most enjoyable ways to see and photograph Orcas Island is from a kayak. Rentals and tours are available at Crescent Beach, Rosario Resort, Doe Bay Resort, and Deer Harbor on the west side of the island.

Photo advice: The views at each of these locations are best early in the morning or very late in the afternoon on fair weather days. On cloudy and overcast days, work more on details and (in spring and summer) flower close-ups rather than overall landscapes.

Getting there: From the center of Eastsound, head east on Main Street, which becomes Crescent Beach Drive. In about a mile, turn south on Olga Road (aka Horseshoe Highway). After three miles, look for the sign to Rosario Resort on the right, or continue on Olga Road passing under the arch at the entrance to Moran State Park. Passing Cascade Lake, veer right at the "Y" to continue south to Olga. From Olga, turn east on Point Lawrence Road, turning right on

Obstruction Pass Road for the state park and Lieber Haven Resort, or continue east to Doe Bay.

Time required: Plan on all of a morning or afternoon for a leisurely drive on the east side of Orcas with time for photography.

Nearby location: Road maps of Orcas will lead you to believe there might be good views on the northeastern coast of the island. There are indeed some great views, but there is no public access so you can only get to them if you're staying in a waterfront vacation rental.

Western Orcas

Deer Harbor marina has a nice mix of sailboats and motorboats, and there are good vantage points for photos from a couple of viewpoints. Deer Harbor Preserve, just north of the resort and dock entrance has parking and a path down to the water. On the south side of Deer Harbor Resort, look for the "Public Path" signs for a trail that runs along the waterfront with some nice views of the marina and the entrance to the bay.

West Sound Marina at White Beach Bay is also attractive, especially when seen from the east side where a row of large madrone trees can be used to frame the view. There's room to pull off the side of the road on the right just south of the beautiful trees.

The only public-accessible location for a waterfront sunset shoot on the island is at West Beach Resort. You can check the view at the end of the road just past the entrance to the resort, although a sign indicates the beach is private property. With a mix of cabins (some right

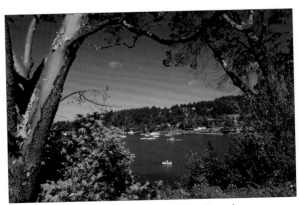

Madrone trees frame West Sound

on the bay) and camping spaces for both RVs and tents, the resort is a great place for a family vacation or as a base for a photo trip, and its amenities include wi-fi service near the office and store. A wooden pier jutting out into President Channel can make a nice graphic element for sunset scenes.

Photo advice: Early morning light is best for both Deer Harbor and the White Beach Bay marina. As elsewhere on Orcas, mid- to high-tide is best for the waterfront areas, because low tides expose large, flat areas of mudflats or rocky beaches that can be a challenge for scenic photography.

Getting there: Exiting the ferry, turn left on Orcas Road, then go 2.6 miles and turn left again on Deer Harbor Road. Follow this road past White Beach Bay and West Sound to Deer Harbor.

Time required: Allow an hour just for a leisurely look-see and exploration of West Sound, Deer Harbor, and West Beach.

Nearby location: This side of the island features some really beautiful farmland and some classic wooden barns. Just cruising the roads in search of landscapes is rewarding, although places to pull off and park can be hard to find.

Turtleback Mountain Preserve

In 2007, a cooperative effort between the San Juan County Land Bank, the San Juan Preservation Trust, the Trust for Public Land and over 1,500 private donors acquired 1,576 acres surrounding Turtleback Mountain, forming one of the largest protected natural areas in the San Juan Islands. The preserve habitats include coniferous forest, grasslands, rare Garry oak woodlands and wetlands.

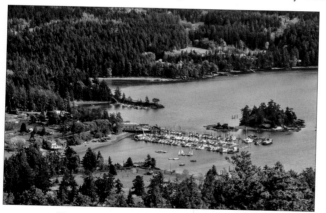

West Sound Marina from Ship Peak Trail

Trailheads at the northeast and southwest corners of the preserve provide access to the heart of the preserve, and more than seven miles of trails lead to two summits and several overlooks with great views of Orcas and neighboring islands.

From the North Trailhead, the trail wraps around the north end side of the preserve, reaching a point near the 1,519-foot summit of Turtleback Mountain in about 2.5 miles. That's a good amount of elevation gain in that distance, with steep sections that can make it a slightly strenuous hike. Two short spur trails along the way lead to overlooks with some pretty nice views. At North Valley Overlook, the view looks down into Crow Valley and across to Mount Constitution. The view from Waldron Overlook takes in Waldron Island and British Columbia's Gulf Islands, with Vancouver Island in the distance. The Raven Ridge Trail skirts the summit of Turtleback, but the path is mostly forested, with no openings for views.

Much better views are to be found in the southern part of Turtleback Mountain Preserve, and you'll get there sooner by hiking from the South Trailhead. In my opinion, the views from rocky outcroppings at 931-foot Ship Peak are some of the finest in the San Juan Islands, perhaps even rivaling those from Mount

Constitution on the east side of Orcas. The path from the trailhead to Ship Peak is about 1.5 miles, almost all uphill and some of it rather steep. The views are definitely worth the effort. One mile up from the trailhead is West Overlook. The view over West Sound is enticing, but my advice is to push on to Ship Peak, because the vistas just keep getting better. On one of my hikes I was treated to the sight of a bald eagle riding the thermals just above me, and shortly thereafter seeing the magnificent bird perched on a treetop just off the trail.

Log benches on moss-covered rocky outcroppings near the summit of Ship Peak face south and west, looking over West Sound to several other islands. Walk a little to the north for the summit of Ship Peak, and more views looking from northeast to southeast. The panorama includes British Columbia to the north, Eastsound, Crow Valley, Mount Constitution, West Beach Marina, and beyond to the distant Cascade Mountains.

Photo advice: With the range of views from Ship Peak, just about any time of day from sunrise to sunset can work, but mid- to late-afternoon sun will give you the most options. Lug that tripod, as you're sure to want it for extractive landscapes with a telephoto, or for multiple-frame panoramas.

Getting there: To get to the South trailhead from the ferry terminal or Eastsound, take Deer Harbor Road almost to the top of West Sound and turn right on Wildrose Lane. The trailhead parking area is about 100 yards up the lane. The north trailhead is located on Crow Valley Road just south of the turn for West Beach Resort.

Time required: For the hike up to Ship Peak and back, allow 2-3 hours.

Shaw Island

Smallest and least visited of the San Juan Islands that are accessible by the state ferry system, Shaw Island is a great place to go if you want to do a little sightseeing and then camp on a beautiful beach, kick back and relax. A small, first come, first served campground is the only option for overnight accommodations. The 200 or so residents of the island, a good number of them nuns, like the peace and quiet of living on a tiny island of forest and farms.

First thing to do after getting off the ferry is pull over at the little park and run back to the terminal to photograph the ferry as it heads to Orcas or Anacortes. After that, check out the general store—one of those old fashioned mercantiles that carries just about everything anyone living in a small, isolated community needs.

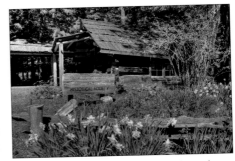

Shaw Island Historical Society log cabin

From the store, head south and follow the road for about a mile as it curves around Blind Bay. If the weather and light is good, look for a spot on the road shoulder wide enough to pull over to photograph boats moored in the bay or dinghies pulled up on the beach. At the southwest corner of the bay, turn down Smugglers Cove Road for another look at Blind Bay.

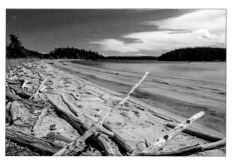

Indian Cove beach

Continuing west on Blind Bay Road for about another mile, you'll come to the Shaw Island Library and Historical Society. The log cabin and split rail fence make a good photo subject, especially in spring with blooming flowers in the garden.

Backtrack on Blind Bay Road for one mile and then turn south onto Squaw Bay Road. In half a mile, look for the entrance to Squaw Island County Park on the left. The camping is a bit rustic here and there isn't any accommodation for large RVs (or even flat places to park for small ones), but the long, sandy beach is the biggest and perhaps the best in all of the San Juan Islands. Sunrise light on Indian Cove and the bleached driftwood lining the beach is quite nice.

Photo advice: On sunny days, the contrast in light at the Historical Society log cabin is extreme and will likely require some type of extended dynamic range (HDR) processing of a bracketed set of digital captures.

Time required: If you didn't come at least in part for the camping, it's possible take in the above sights in just a few hours.

Introduction to Lopez Island

Rolling farmlands, small woodlands, protected bays, and rocky coasts characterize Lopez Island, third largest of the San Juan Islands. It's a laid back kind of place, with some referring to the island as "Slopez". Many of the locals make their livelihood through farming or fishing and there are also a good number of artists that make the island their home. Summer time brings an influx of tourists, especially bicyclists who come to enjoy the relatively flat and low traffic roads, and boaters who take advantage of the scenic bays and coves.

Tourism promotion organizations like to tag Lopez as "The Friendly Isle", and the locals certainly seem friendly when you see that drivers almost invariably wave at you on the road. Smile and return the wave, but don't expect that the friendliness extends to beach access. As elsewhere in the islands, public rights of way to coastal areas are very limited. Some of the places that visitors *can* easily get to on the coast have quite spectacular scenery, and on Lopez Island you may just find that you're the only one watching, and photographing, a great sunrise or sunset from a very special viewpoint.

Odlin County Park

This little park is probably packed with campers and picnickers all summer long, but visit on a spring or autumn weekday and you might have it all to yourself, with the peaceful sound of little waves lapping the shore broken only by the rumble of a passing ferry. In any season, you can enjoy one of the few places in the entire Pacific Northwest with true beachfront camping, a nice stretch of sand for strolling, and sunsets over Upright Channel beyond your campfire.

Photo advice: With low, relatively flat Shaw Island on the horizon, you'll want to find an interesting foreground element to add to your composition if shooting the sunset view.

Getting there: The well-signed entrance to the park is just a short distance south of the ferry terminal on Ferry Road.

Time required: If the sky looks promising for sunset, aim to be there an hour before the sun goes down and stay for half an hour after.

Nearby location: At low tide, walk 1.2 miles south along the sandy beach and then up a set of stairs to wooded Upright Channel Picnic Area, or drive there via Military Road.

Spencer Spit State Park

With a combination of a very nice woodsy campground, a long stretch of accessible beach, and a bird-filled lagoon, Spencer Spit is one of the most popular places on Lopez Island. The tip of sandy spit that encloses the lagoon varies seasonally due to changes in wind and tides. The spit also provides some protection for boaters and is a popular mooring spot along the Marine Trail in the waters of Lopez Sound. This is a good location for getting photos of the ferries going to and from Anacortes. During the fall and spring migrations, the lagoon can be a great place for photographing shorebirds.

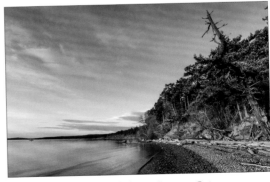

Morning light at Spencer Spit

Spencer Spit offers the most possibilities on the island for sunrise nature photography. At dawn, the waters of the lagoon and just offshore are most likely to be calm and glassy for sky reflections. The warm, early light also really enhances the view south along the coast of cliffs and forest.

Photo advice: The smooth, weathered driftwood all along the beach can be good foreground subjects for landscapes, or come in tight with a close-focusing lens

for details and abstracts of the wood grain patterns. At twilight time, crank up the ISO to capture the ferryboats with lights glowing.

Getting there: From the ferry terminal, head south on Ferry Road, then make a left onto Center Road. After Center Road curves south, turn left on Cross Road, make a right on Port Stanley Road and shortly after that a left onto Baker View Road, which leads directly into the park.

Time required: Allow at least an hour for the short walk down from the parking area and then some time on the spit.

Nearby location: In the community of Port Stanley, just north of Spencer Spit, the beach along Swifts Bay is all private but there is some interesting driftwood "art" along the bayfront and a row of decorated mailboxes make a nice detail travel photo.

Fisherman Bay Preserve

The tip of the peninsula that protects Fisherman Bay has recently been acquired and dedicated as a 29-acre nature preserve with woodland, meadows, and a sandy spit with a mile of shoreline. In spring, the meadows are lush green, with spots of color from daffodils and wildflowers. When it's full of boats in summer, this is a good vantage point for travel photos of the bay and Lopez Village.

Photo advice: Late afternoon to sunset light is best for the village and bay views. The bay vista makes a good panorama composition.

Getting there: From Lopez Village, head south on Fisherman Bay Road and turn right onto Bayshore Road at the south end of Fisherman Bay. Follow the road across the narrow spit, and then make a left onto Peninsula Road in the residential area. The road ends at the preserve in less than a mile.

Time required: Half an hour is sufficient for a look-see from the meadow knoll. Taking the trail down to the beach and a walk along the shore will require an hour or two.

Nearby location: Otis Perkins Day Park has a nice sand and pebble beach but horizon is just low, flat islands, so it's not particularly great for photos. Across the street the south end of Fisherman Bay becomes an expanse of mud flats at low tide and attracts shorebirds and waterbirds like the great blue heron.

Shark Reef Sanctuary

This place gets my vote for best sunset location on Lopez Island. An easy 0.3-mile walk through a pretty forest leads to a rocky bluff with views over the Inner Passage to Cattle Point on San Juan Island. Heading south, the trail ends in 0.7 mile at a Public Lands Boundary sign. Some really nice, gnarly trees along the

rail lend themselves nicely to sunset silhouettes or framing views of Skull Island and on clear days the distant Olympic Mountains. You're likely to hear the call of seabirds and the bark of sea lions while working here.

Photo advice: While waiting for the sunset, look for the warm, just-before-sunset light hitting the rocky bluff and trees looking south. Even if the sunset isn't spectacular, stick around for twenty minutes or so and see if the sky lights up and provides a colorful background for tree silhouettes.

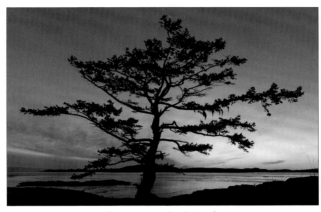

Sunset silhouette at Shark Reef Sanctuary

Getting there: Starting in Lopez Village, head south on Fisherman Bay Road for about 3 miles, turn right on Airport Road and then in half a mile make a left onto Shark Reef Road. Continue south for 1.7 miles to the signed parking area and trailhead just before the end of the road.

Time required: The very short trail will let you check out the possibilities and the light in just a few minutes. If conditions are good, an hour or two at sunset will be well spent.

Nearby location: Leaving Shark Reef Sanctuary, head east on Burt Road, continuing east as it becomes Davis Bay Road, then turn south on Richardson Road. Just after the road turns east and becomes Vista Road, make a right and drive a block or two until the road ends at an old fuel terminal. The dilapidated gas pump and pier can be worked if you like weathered and rusty old stuff, and the view over the bay is good for fall through spring sunsets.

Mackaye Harbor & Agate Beach

Looking at a map at the southwest corner of Lopez Island, you might guess that Mackaye Harbor and Agate Beach should be good sunset locations. With sandy beaches, sailboats moored in the bay, and a west-facing view over the Inner Passage and Haro Straight, they do have great potential for sunset photography. Shooting here can be a challenge, however. With the exception of a small, rocky stretch at the south end of Agate Beach, this coast is all private property, with signs every few feet saying keep out and no trespassing. There are one or two places where the road shoulder is wide enough to pull over and park so there is some option in shooting from the roadside, but it is frustrating when you can see a nice piece of driftwood that you know would make a great foreground element

if you could just get close enough to it for that classic landscape composition. The public road ends at Agate Beach County Park, where there are stairs leading down to a pebble beach. A large rock in the bay, accessible at low tide, adds interest to the landscape.

Photo advice: Mackaye Harbor is a popular mooring site for pleasure boats in summer, as well as a great place to kayak, and these human elements can make it quite picturesque.

Getting there: From Lopez Village, head south on Fisherman Bay Road, turning right on Center Road in 4.6 miles. In another half mile, turn left on Mud Bay Road and go 2.8 miles to Mackaye Harbor Road, where you'll want to make a right turn. Follow this road along the east side of Mackaye Harbor and south to Agate Beach.

Time required: Half an hour will probably be plenty of time here, although a good sunset will need more time.

Nearby location: Don't miss the toilet in the woods just behind the parking area at Agate Beach County Park. It is without doubt the nicest and cleanest outhouse I've ever seen—painted, decorated, and kept spic'n span clean by a local gent who even adds fresh flowers. It's worth a photo, for sure.

Iceberg Point

On the trail out to Iceberg Point, a local couple returning from their outing greeted me and said, "Going to stay for the sunset? You're in for a treat." Indeed, it turned out to be a glorious sunset watching viewpoint. Even without a sunset, the view on a clear day is excellent. A sweeping 180° panoramic vista takes in the Cascade Mountains to the east, Mount Rainier to the southeast, the Strait of Juan de Fuca and the Olympic Mountains to the south, and Vancouver Island to the west.

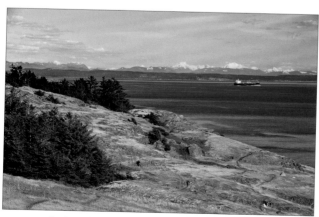

Iceberg Point, as well as Watmough Bay and Point Colville (see next section) are part of the recently established San Juan Islands Nat'l Monument—a collection of ecologically significant properties on Lopez and other islands that are now protected for future generations.

Iceberg Point, Rosario Strait, & the Cascades

Treat yourself to the view with an easy and enjoyable hike of about 3 miles, round-trip. From the parking area at Agate Beach County Park, walk south on Flint Road (marked private but not "no trespassing"). Go about 0.1 mile and look for a gate on the right, and a post with a sign that is an old saw saying "Iceberg Point". Walk down this dirt road for about 100 yards to another gate, and when the trail forks stay to the left.

The trail passes through a forest of fir, cedar, fern, and salal, and then, in about a mile, emerges on a rocky headland. Veer left at a trail junction and head for the white obelisk marker for Iceberg Point with a plaque noting the Treaty of 1908 that established the US-Canada border.

A network of trails spreads across the headland. If possible, stick to the established tracks so as not to trample the vegetation, some of which is rare and endangered. Follow a path towards a navigation station on the westernmost edge of the point for another view that wraps around to take in San Juan Island and Outer Bay. Retrace your steps or pick one of the obvious alternative paths that will take you back to the main trail.

Note: check your cell phone for network status while you're on this hike. I almost missed the warning from Verizon that I was on International Roaming and subject to high charges with my data plan. Apparently the signal I was picking up came from Vancouver Island.

Photo advice: In late spring and early summer the grasses on the rocky headland will be lush and green, with wildflowers providing some spots of color. Late summer through early spring the landscape is dominated by dry grass and dark gray rock, so great light and interesting skies are required for good photos.

Getting there: Follow the directions above for Mackaye Harbor and park at Agate Beach County Park.

Time required: A walk out to the point and back with a little time for photos needs 1.5 hours. If conditions are good, it's worth spending a lot more time.

Watmough Bay Preserve

The Lopez Bicycle Alliance's Beachcomber's Guide that I found at the bike riders rest stop at the corner of Ferry Road and Military Road describes Watmough Bay as "Beautiful short pebble beach featuring a rock cliff and view of Mt. Baker." The person who wrote that must not be a photographer, because this has to be one of the best places on the island for a sunrise shoot. It's also a wonderful place to just sit, relax, and enjoy the beauty of nature.

From the parking area trailhead, an easy, flat, 0.3-mile forested path leads to a beautiful little cove with a sandy/pebbly beach, with Mount Baker rising above Fidalgo Island. To the left, a dramatic rocky cliff rises straight from the bay, while a more heavily wooded headland borders the driftwood-lined beach on the south side. From early spring through late fall, sunrise will be happening over the bay somewhere in the gap between the two headlands.

Try to time your visit for a mid- to low-tide as the beach is mostly submerged at high tide. At the south end of the beach a trail enters the forest then turns east to follow the contour of the headland. Take the left fork at 0.3 mile to reach a very nice viewpoint overlooking the bay in about half a mile (the right fork leads to a road and private property, with no additional views).

Photo advice: If you can't make it there for sunrise, try mid-morning until noon for the best light on the cliffs to the north and on distant Mount Baker. A polarizing filter may help at those times to cut haze and darken the sky.

Getting there: From Lopez Village, head south on Fisherman Bay Road for 3.6 miles, then turn right onto Center Road. After 0.5 mile, turn left on Mud Bay Road and follow the curves and turns for 4.7 miles to Aleck Bay Road. When Aleck Bay Road makes a sharp right, keep straight for 0.5 mile and turn left onto Watmough Head Road. Follow this gravel road for 0.9 mile to a sign for the preserve on the left, and then go another 0.1 mile to the parking area and trailhead.

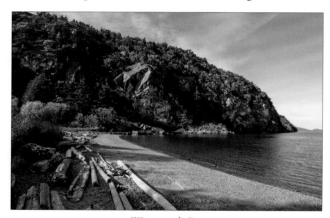

Watmough Bay

Time required: An hour is probably enough for a visit to the beach and walking the forest trail out to the viewpoint. If you're there for the sunrise you might want to add a little to that in order to get the pre-dawn glow.

Nearby location: After sunrise at Watmough Bay, hike out to Point Colville for some excellent views of dramatic coastline and a panoramic vista from Mount Baker to Mount Rainier to the Olympics across the Strait of Juan de Fuca. The rocky headland, like Watmough Bay, has been designated by the Bureau of Land Management as an Area of Critical Environmental Concern for a number of years and is part of the recently established San Juan Islands National Monument. Wildflowers bloom on the open, south-facing slopes in late April and May. The trail is an easy loop of about 2 miles; going either right or left at the junction soon after the trailhead will soon get you through the forest and out to the headlands. To find the trailhead, follow the directions above for Watmough Bay, but instead of making the left down to the bay, continue on the main road for a bit until you see trees leaning over the road and forming an "X". A trailhead sign is on the right, with parking on the left.

❖ ❖ ❖

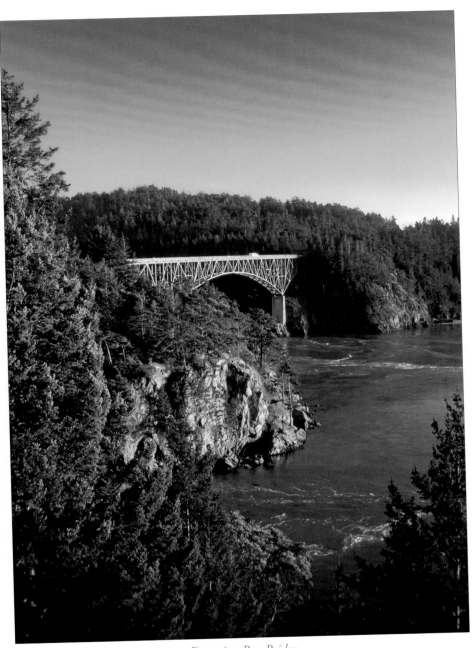

Deception Pass Bridge

Chapter 6

NORTHWEST WASHINGTON

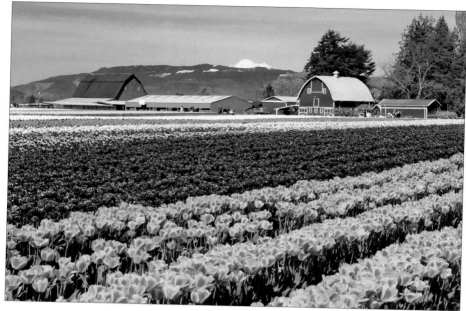

Tulip field in Skagit Valley

NORTHWEST WASHINGTON

The geology and geography of Washington sometimes make it difficult to divide the state into convenient quadrants and logical divisions for a travel guide. For the purposes of this book, I've chosen to include Whidbey and Fidalgo Islands as part of Northwest Washington, even though they could be grouped with the San Juan's as islands in the Salish Sea, and even though some Washingtonians consider them to be within Puget Sound. Traveling north on I-5, it's hard to tell where metro Seattle ends, but for this book I'm saying it's around Lynnwood, so this chapter includes everything north of there up to the Canadian border, within the I-5 corridor and out to the coast. Some folks include the Mount Baker area and much of the Skagit River valley when they're talking about Northwest Washington, but I've chosen to put those areas in the North Cascades chapter because it makes more sense to me when planning a photographic journey.

With the exception of the Skagit Valley in tulip season and a couple of destinations on Whidbey and Fidalgo Islands, most visitors to Washington might consider most of the locations in this chapter just places to pass by on the way to the San Juan Islands or the Cascades. Washington photographers, however, know that there are a number of great locations in the northwest part of the state that are very worthy of a planned trip.

A couple of mentions about places you might see on the map and wonder about, but I don't go into detail here: Lummi Island is a pleasant little island,

reachable by ferry and with some limited visitor accommodations but it doesn't have a lot to offer the avid nature photographer in the way of grand vistas. Wenberg County Park is a boating recreation campground on a lake surrounded by houses and private property. Pleasant enough place to stay if you're a camper passing through the area, but not much of a photo destination. Nearby Kayak Point County Park is a very popular coastal campground and day use area, but other than sunset watching from the beach it really doesn't offer a whole lot of photo possibilities.

Now let's move on to some places with excellent photo potential.

Mukilteo Lighthouse

The carefully tended grounds and interesting architecture of this historical site will delight lighthouse fans, and even if lighthouses are not one of your favorite subjects, this one makes a good diversion while waiting for the ferry to Whidbey Island.

Originally built in 1906, the light and Fresnel lens are housed in a 38-foot tall wooden tower. The US Coast Guard wanted to replace the original Fresnel lens with a smaller automated modern optic, but local residents organized to save the light. The lighthouse is now owned by the City of Mukilteo, with much of the day-to-day operations and upkeep handled by the Mukilteo Historical Society.

The lighthouse grounds are open to the public year round, and tours of the lighthouse itself are available on weekends and holidays from April to September between noon and 5pm.

Photo advice: The attractive entrance side of lighthouse faces south-southwest and gets good light from early morning to mid-afternoon most of the year. In summer, sunset light will hit the north face of the building. Shooting into the sunset with the lighthouse semi-silhouetted also works very well. Angles are somewhat limited by the keepers houses and fence, making a wide-angle lens necessary. On the other hand, a slight telephoto will capture nice architectural studies and graphic details of the light at the top of the tower.

Getting there: From the metro Seattle area, head north on I-5 and

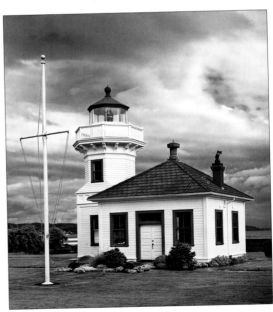

Mukilteo Lighthouse

take Exit 182 to WA-525. Continue north for 9 miles and turn left onto Front Street at the ferry terminal entrance. Lighthouse Park will be on the right in a few hundred feet.

Time required: You can be in and out of here in fifteen minutes for a decent photo, or spend an hour or more really working the scene when the conditions are really good.

Nearby location: The lighthouse grounds and the shoreline immediately to the west are good locations for getting photos of the Whidbey Island ferry as it arrives and departs the Mukilteo Terminal. With careful timing and precise framing, it's possible to get both the lighthouse and ferry in one shot.

Camano Island State Park

Kikalos and Snohomish Indians spent summers on Camano Island, gathering berries and harvesting the bounty of northern Puget Sound waters. Camano is now a favorite summer destination for urban Washingtonians, with many visitors coming to fish, relax on the beach, and just generally enjoy the slow pace of life on the island.

On the west side of the island, Camano Island State Park features a combination forest, rocky cliffs, and gravel-sand beach. From the beach and a trail to the campground at the top of the bluff, there are panoramic views looking across the Saratoga Passage to low-lying Whidbey Island and the distant Olympic Mountains. In addition to the beachside picnic facilities and very pleasant campground, there are three miles of hiking trails in the park. Interesting factoid: in an amazing display of community involvement, after designation of the land as a state park in 1949, the initial development was accomplished in a single day by a group of almost 900 volunteers from Camano and nearby Stanwood.

Photo advice: The beachfront and bluff-top views aren't especially dramatic and the horizon is rather flat, so you'll really need some colorful sunrise or sunset clouds in the sky to make a good photo here.

Getting there: For Camano Island State Park, travel I-5 to Exit 212 and head west on WA-532 toward Stanwood. After 10 miles, follow the road as it curves left as it becomes NE Camano Drive. Continue for 5.7 miles to Monticello Drive, make a right and cross the island, traveling 2 miles until you hit SW Camano Drive. Turn left, go 1.3 miles and make a right onto Lowell Point Road and continue for another mile to the park entrance.

Time required: Camano Island is best suited for a leisurely explore or a relaxing overnight trip.

Nearby location: Cama Beach State Park is rather unique in that it was formerly a Puget Sound fishing resort harking back to the 1930's. A favorite family summer vacation spot for many years, the resort was acquired by the state in 1994. The waterfront cedar cabins and bungalows have been refurbished,

modern conveniences have been added and they are available for rent year round. The beach offers a panoramic vista of Puget Sound, Whidbey Island, and the Olympic Mountains. A mile-long trail connects Cama Beach with Camano Island State Park to the south.

Whidbey Island

On the short ferry ride from Mukilteo to Whidbey Island there is barely enough time to get out of your vehicle and run up to the viewing deck before the captain announces the arrival at Clinton. It's an abrupt change from the busy city atmosphere of Seattle and Everett to the green and forest of an island that obviously moves at a slower pace. Before heading off to see the rest of the island, take some time to walk the cliff-side promenade and enjoy the view looking back across Puget Sound to the Cascade Mountains.

If nature photography isn't your only goal in visiting Whidbey Island, head north to Langley, one of those little towns that it's hard to avoid using the cliché "quaint" in a description. Antique shoppers in particular will want to make the detour.

Heading north towards Coupeville, another town with plenty of claim to quaintness as well as a picturesque water-front, you'll first want to visit Fort Casey State Park. If you're coming to Whidbey from Port Townsend on the Olympic Peninsula, make a left as you

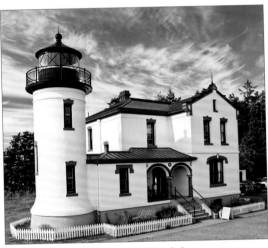

Admiralty Head Lighthouse

leave the ferry terminal and you'll almost immediately be at the state park entrance.

There are some historically interesting structures at Fort Casey State Park from the days when it was an army post, but the primary interest point for most photographers is Admiralty Head Lighthouse. The lighthouse building and tower are quite interesting visually, but making a good photograph is a little challenging. Shooting from the southeast in the morning will give you the best light on the front of the building but there are usually cars parked on the right side of it. Moving around for a view from the southwest in the afternoon solves the car park problem, but doesn't show the architecture of the lighthouse to its best advantage. It's one of those situations where you wish the park planners were

also photographers and would take into consideration the placement of parking facilities and visual approaches. The expanse of grass in front of the lighthouse looks best in spring when it's green or with late afternoon light turning it golden at other times of the year. Forest to the east side of the lighthouse blocks sunrise light from the lighthouse except perhaps in the dead of winter.

North of Fort Casey, the Ebey's Landing National Historical Reserve doesn't look like much as you drive across the farm fields and through forested woodlands, but if you have the time during your Whidbey traverse, or if you're a Washington resident looking for a great outing, you're sure to enjoy the 5.6 mile round-trip trail from Prairie Overlook to the beach at Ebey's Landing. The trail leads you to the highest coastal bluffs in Washington, 270 feet above the Salish Sea, with gnarly fir trees to frame the view. Spring wildflowers certainly add to the enjoyment and photo potential.

Photo advice: The obvious shot of Admiralty Head Lighthouse is from the southeast as you approach it from the parking area, but in afternoon light, or on gray days, try moving to the west and using the grove of trees to frame the lighthouse.

Getting there: From the Seattle area, take I-5 to Exit 182 and head north on WA-525 to the Mukilteo ferry terminal. See the section earlier in this chapter about Mukilteo Lighthouse, which is about a block away from the ferry landing. If coming from the Olympic Peninsula, take the ferry from Port Townsend to Keystone (next to Fort Casey State Park). Advance reservations are available, and highly recommended, on the Port Townsend-Keystone ferry route.

Time required: It's possible to drive the length of Whidbey Island, from Clinton to Deception Pass, in a little over an hour. Add an hour (or more) for each stop along the way.

Nearby location: South Whidbey State Park on the south end of the island is a camping park with old-growth forest and a beach with very nice views across Puget Sound to the Olympic Mountains. On the north end of island, day-use only Joseph Whidbey State Park also has Puget Sound views from its beach, looking northwest to Lopez and San Juan Island. Both can be good places for sunset viewing, but for photo possibilities you're much better off spending your time at Deception Pass State Park.

Deception Pass State Park

With spectacular coast views, old-growth forest, lakes, sand dunes, wetlands, and a very photogenic bridge, it's no wonder that Deception Pass State Park is one of Washington's favorite visitor destinations. Wildlife abounds, too, with 174 species of birds recorded.

When British sea caption George Vancouver was exploring this part of Puget Sound, he originally thought that he was cruising by a peninsula, but then saw

Deception Island from Rosario Head

a narrow passage and realized that land mass was an island. He promptly named the island Whidbey, in honor of his assistant, and dubbed the passage Deception Pass because of his initial error. Prior to Vancouver's discoveries, and up until the early 1900s, native Samish and Swinomish people inhabited the areas on Fidalgo and Whidbey islands around Deception Pass.

In 1923, Congress dedicated this area to public recreation, and in the 1930s the Civilian Conservation Corps (CCC) built roads, trails, buildings, and portions of the historic bridge that spans Deception Pass. The bridge is actually two spans, one from Whidbey Island and one from Fidalgo meeting on Pass Island in the channel between the two larger islands. This bridge, which was added to the National Register of Historic Places in 1982, is one of the iconic views of Washington State. There are several places from which to photograph the bridge, with convenient highway pullouts and either end, and coast trails to views from below.

Several beach areas within the park offer multiple opportunities for sunset photography. West Beach and Bowman Bay work well in winter months when the sun sets in the southwest; North Beach is good mid-summer.

To the north of Deception Pass, the Rosario Beach section of the park is especially good for photography. The view from Rosario Head is fantastic at any time of year, with a panorama vista across Puget Sound that takes in nearby Lopez Island and the distant Olympic Mountains. Tiny Deception Island sits just offshore, providing a nice focal point for many compositions. Walking out to the beach or Rosario Head from the parking area, look for the large wooden carving Maiden of Deception Pass, a double-sided story pole depicting one of the important stories of the native Samish people. This area is also great for tide-pools,

Rosario Beach sunset

particularly at the extreme low solstice tides.

Beaches and coast views aren't the only photo-worthy subjects at Deception Pass. Several trails wind through old-growth forest on the northern tip of Whidbey Island, and according to northwest wildflower expert Mark Turner, Pass Island is one of the premier locations in this part of the state for early season blooms. Look for the blossoms to start popping out as early as mid-March.

Even if you're not that interested in wildflowers, spring is an excellent time to visit, especially if you want to camp at Deception Pass. The state park is extremely popular in summer and the campgrounds are often full. Major caveat about camping here, however: at any time of day or night jets from the nearby Naval Air Station may come screaming over the park. I didn't know this the first time I stayed there and had the bejesus scared out of me in the middle of the night when the flyboys started practicing their war games.

Photo advice: Late afternoon light on Deception Pass Bridge is gorgeous, particularly from pullout on the northwest side of the bridge. The trick is to get that shot just as the light gets golden and then quickly get into position for the sunset from the bridge, Rosario Head or one of the beaches.

Getting there: Drive I-5 to Exit 230, then west on WA-20, crossing Fidalgo Island to reach the State Park in about 16 miles. Alternatively, take the Mukilteo-Clinton ferry (see Whidbey Island section, above), and drive north on WA-20 for about 50 miles to Deception Pass.

Time required: If the weather is at all conducive to good photography you'll want at the very minimum a couple of hours for photos of the historic bridge and some coast views.

Fidalgo Island

The majority of visitors to Fidalgo Island probably just drive through the town of Anacortes on the way to the San Juan Islands ferry terminal, or else head south to Deception Pass State Park at the southern tip of the island. There are, however, several places on the island, in addition to the north side of Deception Pass, that are worth visiting for their photo potential.

Just north of Deception Pass, pretty little Pass Lake has some good photo potential, as does Whistle Lake in the Community Forest Lands in the central part of the Island.

On a peninsula at the northwest tip of Fidalgo Island, just a mile or so beyond the ferry landing, Washington Park is a prime sunset photography location. Owned by the city of Anacortes, the 220-acre park is a combination of forest, meadow, and beach, and offers year-round camping. Thanks to the Olympic Mountains rain shadow effect, the weather is drier here than on the mainland and it is one of the earliest and best locations in the northwest to see spring wildflowers. The south side of Washington Park overlooks Burrows Bay and Burrows Island. Consider an evening trip with Anacortes Kayak Tours to take in the scenic shores and an abandoned lighthouse on Burrows Island.

The city of Anacortes, popularly promoted as "Gateway to the San Juan's" is a former mill town that has transitioned nicely to a recreational boating center with both a strong arts culture and large retirement community. There are a number of historic and otherwise photogenic buildings in the downtown and waterfront areas. The marinas and shipyards provide additional photo opportunities right in town.

Anacortes can boast that half its land is city park or forest preserve and Washington Park is just one small part of that. On the east side of Anacortes, drive to a lookout at Cap Sante Park, a forested promontory with a panoramic view that includes the city, marina, Fidalgo Bay, the Cascade Mountains to the east and the San Juan Islands to the west.

More great panoramic views can be had south of town atop 1,273-foot Mount Erie. The view sweeps from southeast to northwest, with Lake Campbell directly below; on really clear days, Mount Rainier can be seen over 100 miles away. You can drive to the summit on a narrow, winding road, which has additional viewpoints looking northwest over Rosario Strait to the San Juan Islands and northeast to Mount Baker. Hiking trails at the summit lead to still more vistas. Since the views are omnidirectional, just about any time of day is workable for photos, but in general the light is best from late afternoon through sunset.

Photo advice: The viewpoints mentioned above need exceptionally clear skies to work for daytime photos. On the other hand, these locations can produce unique and much better photos with stormy skies, fog or hazy summer sunsets.

Getting there: To reach Anacortes from the I-5 corridor, head west on WA-20, crossing over the Swinomish Channel that separates Fidalgo Island from the Skagit Valley. Entering Anacortes, take the first right at the traffic roundabout to get on Commercial Street, the main drag through town. Follow the signs for WA-20 Spur and turn left on 12th Street to get to the ferry terminal and Washington Park. To get to Mount Erie from Commercial Street in downtown Anacortes, head west on 29th Street, continuing as it turns south to become H Avenue. Leaving the city behind, this route becomes Heart Lake Road. After driving through woodland for about a mile, look for the turn to Erie Mountain Drive that will take you to the summit.

Time required: Allow 1-2 hours for either the Washington Park or Mount Erie views if going for sunset. Traffic may be heavy due to the ferry schedule heading out to Washington Park, and the road to the top of Mount Erie is slow going.

Nearby locations: Guemes Island, located across a narrow channel on the north side of Anacortes, is accessible by a small ferry that accomodates only pedestrians and bicycle passengers. A short walk up the hill from the ferry landing to Anderson's General Store affords views of the Anacortes waterfront and the ships and boats passing through the channel.

Bay View State Park is a small beachfront camping park on Padilla Bay just north of WA-20 at the edge of Skagit Valley. Much of the bay is designated National Estuarine Sanctuary, and it is a very good place to see shorebirds. The beach has a nice view to the San Juan Islands, and also directly across the bay to a huge oil terminal and refinery.

Skagit Wildlife Area

One of the great natural phenomena of the Pacific Northwest is the arrival in late fall each year of tens of thousands of snow geese and hundreds of tundra swans. The huge flocks of birds come from their mating grounds in Alaska and Siberia to spend the winter feeding in the fields and wetlands here and in other parts of the Pacific Northwest. The big birds and bald eagles that come to prey on the weak among the waterbirds, generally arrive in late November and have mostly left by the end of March.

The best area to spot the birds is in the fields along Fir Island Road, a little west of Interstate 5. Unfortunately, there is no shoulder on this road and it is lined with "No Parking" signs. Tempting as it is to pull over on the edge of the road, you'll find safe and legal parking at the Washington Department of Fish & Wildlife Skagit Valley Wildlife Area just south of the road. A neighboring farmer is contracted with DFW to grow winter wheat as forage for waterfowl, making this a reliable place to find plenty of birds. With luck, you'll be able to line up a shot with snow-capped Mount Baker in the background. Note that you'll need a Washington Discovery Pass to park here. If you're visiting spring through fall when the geese and swans are absent, walk the short trail to a dike with a view across Puget Sound to the Olympic Mountains. At low tide, the mudflats are a good place to find great blue herons and a variety of shorebirds.

Continue on Fir Island Road as it turns north and you'll soon come to Snow Goose Produce. There is a small parking area off road opposite the produce stand with a good view of fields and distant Mount Baker. When the produce stand is open, this is a great place to pick up some farm fresh fruits and veggies.

A little further north, you can turn left onto Best Road, go over the bridge and head for La Conner or Mount Vernon, or continue on Moore Road, where there are a couple more places to pull off the road with good vantage points to

spot birds in the fields looking south. Another option is to cruise Polson Road, which cuts across the center of Fir Island; it's a much less trafficked road and does have a few places to pull over for photography. If you're visiting at the right time of year and don't see many birds, check the fields further north in the tulip growing area of Skagit Valley.

The geese and swans usually spend the night on the water and fly into farmed fields early in the morning. In my experience, it works best to scout the area in mid-day to locate the biggest concentration of geese and swans, and hopefully find a location where they are close to the road. From late afternoon until sunset the birds will be actively feeding in the fields before returning to open water for the night.

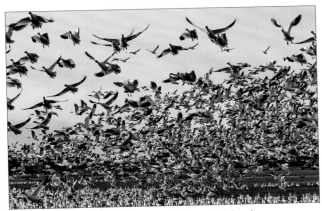

Snow geese taking flight, Fir Island

Photo advice: The image that most photographers want to capture here is a blizzard of birds taking off from a field, filling the sky with white wings. That usually happens when something disturbs the birds while they're feeding or resting. Resist the temptation to walk out into the field or make sudden loud noises to get them to fly; it's bad for the birds and bad for you when the wildlife officer tags you with a citation. Be patient, and be ready with your camera set to fire at its fastest frame rate when the birds suddenly lift off. Choose a high shutter speed to freeze the action, or try panning the action with a slow shutter speed in the range of 1/4 – 1/15 second. Nail down your exposure in advance, while the birds are still on the ground, taking a few frames and checking the histogram to make sure the white feathers don't get blown out. Stay and shoot as long as you can - it's likely to require a lot of captures to get just one really good one of the mass of birds.

Getting there: From I-5 take Exit 221 for Lake McMurray and Conway and head west. In 0.1 mile turn right onto Fir Island Road. Drive west for 3.2 miles to the WDFW sign, turn left and go 0.5 mile to the parking area.

Time required: Allow an hour at the very minimum to scout the locations and have time for photos.

Nearby location: Immediately west of the bridge over the Skagit River on Fir Island Road, turn south and follow Mann Road to the intersection with Wylie Road. Turn left and drive a short distance to the WDFW boat ramp. While on Mann Road you'll have fields on one side and Wylie Slough on the other, both excellent bird spotting habitat.

Skagit Valley Tulip Farms

One of the biggest draws in western Washington for both photographers and flower lovers is the annual Tulip Festival that takes place during the month of April in the Skagit Valley. A riot of color carpets cultivated fields with millions of blooms. While not as many acres of the fertile valley farmland are devoted to tulips now as in past years, there are still extensive fields of eye-popping color.

The peak of the bloom varies each year (mid-April is usually the best), as does the location of fields that have been planted to tulips and daffodils. Check the official website for the Tulip Festival, www.tulipfestival.org, for more information about the event, prime blossom time and to get a downloadable map that shows which fields are in bloom.

The two main bulb farms that open their fields for the festival each year are Roozengaarde and Tulip Town. Both places are open from 9:00 am to 6:00 PM daily during the Tulip Festival, and there is a nominal admission charge at each location. The festival is a very popular multi-generational family outing, and both places also have food booths, gift shops and miniature windmills.

Roozengaarde (part of Washington Bulb Company) has not just acres and acres of tulips, but a very nicely landscaped flower garden that includes daffodils, hyacinth, iris, and other spring blooms. The fields that are cultivated may vary from year to year, and they sometimes open other nearby fields that can be photographed earlier in the morning than the main visitor area and display garden.

Tulip Town is a photographer's favorite, thanks to a classic red barn on a neighboring property that makes a great background. The barn is on the east side of the fields and is nicely lit from mid-morning through noon (after that, the light tends to be very flat on the barn and on the tulips if shooting in that direction).

If you are planning to spend a whole day photographing the tulip festival, I recommend starting early in the morning to see if any roadside fields are accessible, then move to Tulip Town with an eye to the best light on the neighbor's barn, saving Roozengaarde for later in the day.

Photo advice: The tulip fields offer the opportunity to use every lens in your bag, and just about any post-processing technique you want to try. The flat landscape is also well suited for panoramic images. It's quite likely the fields will be somewhat muddy, so consider wearing something like lightweight waterproof rain pants and bring a plastic trash bag to set your bag or backpack on while working. Try for a nice, sunny day for the overall landscapes, and bring a reflector/diffuser for making close-up photos without the harsh, contrasty light of direct sun.

Getting there: Take I-5 to Mount Vernon at Exit 226. Turn left on Kincaid Street and follows the signs through town for WA-536. After crossing the bridge over the Skagit River, continue on WA-536 (now Division Street) for four blocks and make a left onto Wall Street. In one block, turn right on McLean and travel

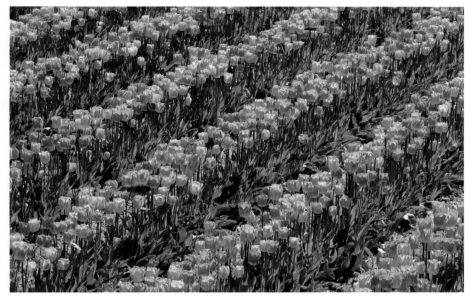

Tulip time

2.5 miles to Beaver Marsh Road. Turn left for Roozengaarde or continue for another mile and turn right on Bradshaw Road for Tulip Town. During the Tulip Festival, the route is well signed all over the valley.

Time required: In a crunch for time, you could easily great some very nice photos in about an hour. With plenty of time, you could easily spend a whole day working with every lens in your bag..

Nearby location: Travel to Pleasant Ridge, on the west side of Skagit Valley, for a slightly elevated view of the pattern of rectangular fields spread across the valley. To get there, travel west on McLean Road to Best Road, turn south and go about two miles to the rise in road. From this vantage point you'll be able to pick out fields of blooming tulips and daffodils. The daffodils are usually at their peak in mid-March and by April are starting to fade, but they still provide a bright splash of yellow in an overall landscape.

Chuckanut Drive & Larrabee State Park

Bigleaf maple trees hang over the winding two-lane Chuckanut Drive and frame views of Puget Sound, the San Juan Islands, and the Olympic Mountains as State Highway 11 hugs the coast along Samish Bay between the Skagit Valley and Bellingham. This is perhaps one of the most beautiful drives in the state at any time of year, but is especially grand when the maple leaves turn golden in autumn. Chuckanut Drive was the first road to connect Whatcom County to points south, and from 1913-1931 it was part of Pacific Highway, which stretches from British Columbia to San Diego.

Approaching from the south, the highway crosses several miles of flat farmland, and then winds along the coast at Chuckanut Mountain. Between mileposts 10 and 13 are several convenient pullouts. I particularly like the slightly elevated view at the pullout about half way between MP 11 and MP 12, where the vista includes Anacortes and Padilla Bay to the south and Lummi and Orcas Island to the west. There is potential here for some really nice sunset (and sunrise) photos, especially from fall to spring when the suns arc stays to the south.

Larrabee State Park provides easy access to the coast at Samish Bay and some very nice waterfront sandstone formations. There is a pleasant campground and a well-developed picnic area a little ways above the beach. A sign in the campground notes that there may be some noise from the active railroad line that bisects the park.

To get to the shore, look for the trail that starts next to the amphitheater in the Day Use area. The pathway passes under the railroad tracks and soon comes to a T-junction. A short jaunt to the right leads to Wildcat Cove, a boat ramp and, at low tide at least, a little beach. Turn left at the T and follow the trail for a few hundred yards to its end to find the best sandstone formations. The hike from the amphitheater to the end of the trail is only about 0.1 mile. The sandstone here is a unique form, named chuckanut sandstone, and while it is prevalent along the coast at Larrabee, the small area at the end of the trail has rock that is smoothly eroded into visually pleasing shapes. There is additional coast access at Clayton Beach, about half a mile south of the campground, with more rock formations. Keep an eye out for sea lions just offshore and bald eagles roosting in the trees along the coast.

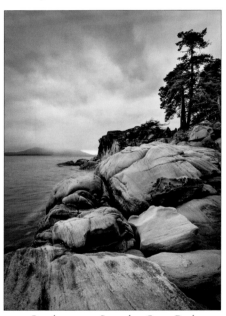

Sandstsone at Larrabee State Park

In addition to the coastal access, Larrabee, which is Washington's very first state park, includes two freshwater lakes and several miles of hiking and mountain biking trails on the forested slopes of Chuckanut Mountain. Chuckanut is technically part of the Cascade Range, and this is the only place where the Cascades reach to the sea.

Photo advice: Autumn is definitely the best time to visit Chuckanut. The peak of fall color can vary quite a bit, but mid-October is usually a good bet. Wildcat Cove, the sandstone area, and Clayton Beach are good sunset locations; aim to be there at low tide. When the sun rises furthest south in winter the view from

the end of the trail at the sandstone can also be good.

Getting there: If you're coming from the south, leave I-5 at Exit 231 in Burlington and head north on WA-11, which is Chuckanut Drive. If coming from the Fairhaven District in Bellingham, head south on 12th Street, which becomes WA-11 and Chuckanut Drive.

Time required: Chuckanut Drive runs about 20 miles from Burlington to Bellingham, so you'll probably want a minimum of two hours to drive the route. A combination of Larrabee State Park, Chuckanut Drive, and some of the attractions in Bellingham makes a very nice day or weekend trip from Seattle.

Bellingham

Bellingham is one of those quintessential Pacific Northwest cities with a history as seaport and logging town, and which has in recent years seen a revitalized historic district and the growth of a strong progressive community among its population. Present day Bellingham can also brag that it ranks second nationwide for *per capita* arts businesses, as it is home to a good number of galleries, theater and performance groups, and museums. In and around town are several places of interest to visiting photographers.

On the east side of town, Whatcom Falls Park is a 241-acre oasis of forest where Whatcom Creek drops twenty feet, forming a very photogenic waterfall. This one is almost too easy—it's only 50 feet from the parking lot and the view is quite good from the historic Works Progress Administration bridge, made of chuckanut sandstone, which spans the creek. There are a couple of smaller falls upstream and downstream. Bigleaf maple trees in the thick forest make the falls especially photogenic in autumn.

Stimpson Family Nature Preserve is a wonderful place to experience and photograph low-elevation old-growth forest. Loop trails, a little less than five miles in total, provide easy walks through forest and to ponds, wetlands, and small waterfalls. In early spring, look for the bright yellow, and odiferous, skunk cabbage in the wetlands and the distinctive three-pointed white blossoms of trillium. After the first fall rains, a variety of mushrooms pop up from the forest floor.

Sehome Hill Arboretum is 165 acres of woodland at the top of Sehome Hill and adjacent to the Western Washington University campus. Unlike some arboretums that are heavily landscaped, Sehome is largely wild in nature, with many indigenous plants, shrubs and trees, and a healthy population of deer and other critters. Nearly six miles of trails wind up, down and around the park, and a tower at the top offers views of the city, Bellingham Bay and across Rosario Strait to the San Juan Islands.

The historic Fairhaven District is known for its Victorian-era red-brick architecture, unique shops, and variety of restaurants. Village Books and the Colophon Cafe (check the cow paraphernalia!), both on 11th Street at Harris Avenue, are popular spots and might be good for a couple of travel snaps.

Photo advice: Overcast days are needed when photographing the waterfalls and in the forest; fortunately, there is no shortage of such weather most of the year in this part of the northwest.

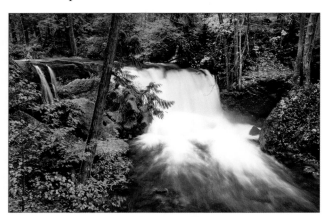
Whatcom Falls

Getting there: If coming from Chuckanut Drive, continue north from Larrabee State Park, following the road right into the Fairhaven district at 12th Street. If traveling I-5, take Exit 250 and follow Old Fairhaven Parkway for 1.5 miles to the historic district. For Whatcom Falls Park, take I-5 Exit 253, make an immediate right on King Street then left on Lakeway Drive. Head east on Lakeway for about a mile to the entrance to the park at Silver Beach Road. To get to the Stimpson Family Nature Preserve, continue past Whatcom Falls Park on Lakeway Drive and continue east for 1.8 miles as it curves and becomes Cable Street, then turn right onto Austin Street. Turn left onto Lake Louise Road in 0.4 mile, and continue for another mile to the preserve. To get to Sehome Hill Arboretum, take I-5 Exit 252 for Samish Way, cross over the freeway and turn left onto Bill MacDonald Parkway. Go past Sehome High School and turn right on 25th Street, then up Arboretum Drive to a parking area at the end of the road.

Time required: Half an hour to an hour is plenty at Whatcom Falls. Time spent at Sehome Hill Arboretum and Stimpson Nature Preserve depends on how much hiking you want to do and how seriously to work the flora and habitat.

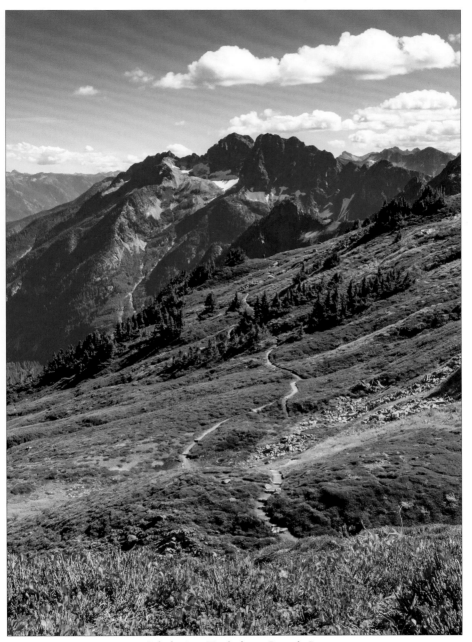

Sahale Arm Trail above Cascade Pass

Chapter 7

NORTHERN CASCADES

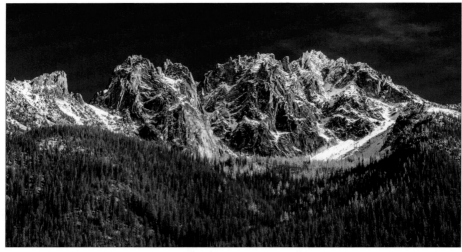

Kangaroo Ridge from Washington Pass

NORTHERN CASCADE MOUNTAINS

The Cascade Range of mountains extends from southern British Columbia to Northern California, dividing the rain-soaked lowlands on the western side of the Pacific Northwest from the higher and drier east. Not only is this mountainous terrain spectacularly beautiful, it is an incredibly diverse ecosystem. Deer, black bear, and a variety of small mammals are common throughout the range, but in the remote wilderness areas of the northern Washington Cascades, elusive and rare critters such as the wolf and wolverine continue to make their home. Canadian grizzly bears pay no attention to the border line on the map and forage in North Cascades valleys and meadows.

An interpretive panel at one of the many trailheads states "The North Cascades are the wildest and steepest mountains in the lower 48 states." A hike on one of these high country trails will leave you awestruck with views of ridge after ridge and peak after snow-capped peak in this majestic mountain range. Photographers and all lovers of nature revel in the views of jagged peaks, gleaming glaciers, alpine lakes, summer meadows of wildflowers and glowing larch trees in autumn. Be prepared for a lot of vistas where you'll look in amazement and say "Wow!"

Mount Baker Highway

Soon after leaving the I-5 corridor at Bellingham, Washington Highway 542, the Mount Baker Highway, enters the Cascade foothills. The highway follows the Nooksack River east, less than 10 miles, as the raven flies, from the Canadian border.

There are several locations with excellent opportunities for nature and landscape photographers that are accessed from the scenic highway. By far and away the most well known and most popular is the classic view of Mount Shuksan from Picture Lake near the end of the road, so we'll start from that area and work back towards the Puget Sound. On the way, you might want to make a quick stop at the Glacier Public Service Visitor Center on the east side of the community of Glacier, for up-to-date info on road and trail conditions.

Mount Shuksan & Artist Point

One of the most iconic images of Washington State is that of the dramatic peak of Mount Shuksan rising above Picture Lake. The tripod holes are obvious and the angle of view for compositions is somewhat limited, but the light is ever changing and the scene never fails to inspire, even when the weather makes getting a good photo extremely difficult. The classic view of Mount Shuksan is on just about every landscape and nature photographers 'must have' list.

The Picture Lake view isn't the only attraction here by any means. The vistas of Shuksan and Mount Baker from aptly named Artist Point are spectacular. Myriad trails lead to further great views, whether you're a casual day hiker or technical mountain climber. It's a winter wonderland, too, with the road up to Picture Lake kept open thanks to nearby Mount Baker Ski Area (the road to Artist Point is blocked by a snow gate in winter, but you can snowshoe up the steep hill for the view).

The iconic view of Mount Shuksan is easy to find. Highway 542 forms a one-way circle around Picture Lake, with parking on the (in most places) wide shoulder. A short walk on the loop trail will put you in position to capture the dramatic peak above, and hopefully reflected in, the beautiful little lake. At first glance the view from Picture Lake is a piece of cake, but really good images here require careful framing: crop out the ill-placed road sign across the lake, make sure no vehicles or people intrude in the view, and try to incorporate an interesting foreground. Fall color here is usually prime in late

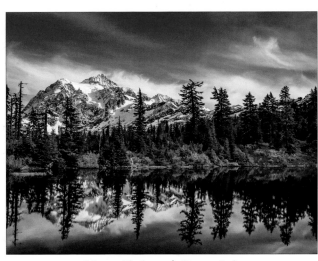

Mount Shuksan & Picture Lake

September, and at that time of year 2:00-4:30pm is a very good time to be work-ing the scene. Later in the day the blueberry bushes and mountain ash around the lake will be shadow, requiring the use of a graduated neutral density filter or digital processing with HDR or layer blending techniques.

There are more great views of Mount Shuksan up at Artist Point. The Mount Baker Highway ends here in what must be one of the most scenic parking lots in the world. Look back down to Heather Meadows and Bagley Lakes as you approach, then go to the south end of the lot for the views of Mount Baker. To the east, a short trail follows Kuhlsan Ridge, passing a couple of tiny tarns on the way to Huntoon Point, with breathtaking views of Shuksan the whole way. The tarns are great for capturing Mount Shuksan reflected in the still waters on calm days, especially at sunset. Looking in the other direction, Mount Baker vies for your attention, with nice tree-framed compositions from a couple of spots along the ridge. These viewpoints beg for a dawn shoot, capturing the first rays of light hitting the summit of Baker's glaciated peak.

A trailhead at the southwest corner of the Artist Point parking lot is the start-ing point for hikes to Table Mountain, Ptarmigan Ridge, and Chain Lakes. Every avid outdoors photographer I know that is familiar with the area tells me the views of Mount Baker from Ptarmigan Ridge are outstanding. They've got the photos to prove it, but I've been stymied so far my in attempts to do the hike myself due to unusually heavy snowpack.

The trail to Chain Lakes starts on the Ptarmigan Ridge Trail, then turns and heads north at the 1.2-mile point. Just before dropping down to the first lake there is a nice view of Mount Baker rising above Ptarmigan Ridge. The trail loses quite a bit elevation in reaching a series of small, very pretty lakes. Forest surrounds the lakes, except on the east side, where Table Mountain and Mazama Dome rise steeply from the waters edge. There are no good views of Mount Baker or Shuksan from the lakes, but there is a quite nice view of Shuksan where the trail reaches the saddle between Table Mountain and Mount Herman on the way to Bagley Lakes and Heather Meadows. This trail makes a very scenic loop for a long dayhike or overnight backpack.

Another popular hike starts just below Artist Point, and heads southeast to Lake Ann for an up close look at Mount Shuksan from the base of Curtis Glacier. From the trailhead at Austin Pass, 1.5 miles up WA-542 from Picture Lake, the trail descends 800 feet in a little over two miles to Swift Creek, then regains the elevation in another two miles as it reaches the rocky shore of Lake Ann.

If you've got young kids with you, or just want an easy stroll, wander the Bagley Lakes Trail in the Heather Meadows area. The 2.0-mile trail passes two small lakes and crosses a burbling creek on an arched stonework bridge. There are plentiful wildflowers in early summer and good fall color in autumn. To get there, look for the large parking area a little beyond the Mount Baker Ski Area, just above Picture Lake.

Photo advice: Late September is the best time for the Picture Lake/Mount Shuksan view; winter and spring the lake is covered by snow and in summer the

afternoon light is very flat. If there is too much breeze for a glassy reflection on Picture Lake but the light is good on Mount Shuksan, try adding a heavy neutral density filter to your lens to get a long (5-10" or more) exposure. The water will turn silky and streak-ing clouds may give some dynamics to the image. Sunrises can also work very well here when weather conditions provide great skies and the clouds light up at dawn.

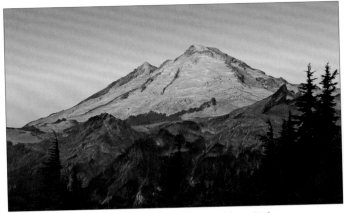

Mt. Baker at sunrise from Kuhlsan Ridge

Getting there: From I-5 in the Bellingham area, travel east on WA-542 for 55 miles to Picture Lake; the road ends 3 miles further up at Artist Point. The drive from I-5 to Picture Lake takes about 75 minutes if traffic is light and road conditions good.

Time required: If all you're going for is the Picture Lake view, plan for about an hour on location. When fall color is prime and the weather forecast is good, you may have to jockey for position with other photographers. You could easily spend a full day (or three) here, with a dayhike in the morning, the Picture Lake scene in the afternoon and Artist Point views around sunset.

Yellow Aster Butte

You won't find any yellow asters on the Yellow Aster Butte Trail, but you will find stellar vistas, a profusion of flowers in summer, and plenty of mouth-watering berries* in early autumn. Slopes covered in berry bushes, heather, and mountain ash make this an excellent choice for fall color landscapes.

* Are they blueberries or huckleberries? Both, actually. Many northwesterners use the terms interchangeably. In some places, there is a difference, but the spe-cies of bushes here are Cascades blueberry, also known as blue-leaf huckleberry. *Vaccinium deliciosum* is the scientific name, and they most certainly are delicious. Bears love them as much as people do, gorging themselves on the berries in preparation for winter hibernation.

There are asters here, but they're purple; whoever named this butte probably had in mind the alpine golden daisies (okay, well they are members of the Aster family). Among the more colorful of the other wildflowers found here are pensте-mon, paintbrush, monkeyflower, fireweed, and lupine. Possible wildlife sightings include ptarmigan, marmot, mountain goat, and black bear.

With a couple of steep climbs and an elevation gain of 2,550 feet, this 7.5-mile round-trip hike can be considered strenuous, but the rewards are well worth the effort. Trekking poles will help, especially on the downhill return jaunt.

The trail begins with a steady, sometimes steep, climb, first through forest and then switchbacking across open avalanche slopes covered with thimbleberry. At

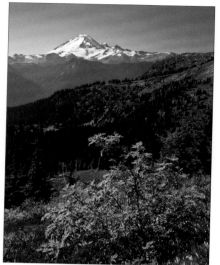

Mt. Baker from Yellow Aster Butte

1.4 miles take a left at the trail junction. The path contours around the southeast side of Yellow Aster Butte with some ups and downs before reaching a rocky bench and heather meadow. The views of Mount Baker and Mount Shuksan are grand.

Another climb leads to a saddle, at 3.5 miles, with a view of alpine tarns just below. Turn right to scramble up to the summit in another half mile, or go left and down, following the tracks to tarns and meadows of flowers or berries. The subalpine meadow environment is fragile, so please stay on established trails to minimize your impact, and if camping do so on bare rock or at designated sites around the tarns.

Something to consider: start the day with an early morning hike up Yellow Aster Butte, coming down in time to make it to Picture Lake in the afternoon for the classic view of Mount Shuksan. Finish the day at Artist Point for the sunset light on Shuksan or Mount Baker.

Photo advice: Both Mount Baker and Shuksan are backlit from mid-morning until late afternoon. Sunrise light is great on Baker, and both mountains will get nice sunset light in the summer when the sun is farthest north. Prime time for wildflowers is usually late July to early August. The berry bushes and mountain ash are colorful mid-September to early October.

Getting there: Drive WA-542, the Mount Baker Highway, to MP 46 and turn north on Twin Lakes Road (FR-3065), which is immediately to the east of a state Transportation Department facility. Follow the road, going left at a junction that may or may not be signed, for 4.5 miles to the trailhead. You may have to park on the side of the road some distance from the trailhead on busy summer weekends.

Time required: Making this a full day hike will give you plenty of time to enjoy and photograph both wildflowers and landscapes, with a leisurely stop for lunch or snacking on fresh berries.

Nearby location: From the Yellow Aster Butte parking area, walk 2.5 miles further on Twin Lakes Road (really rough, serious 4WD only) until its end,

then hike the 2-mile trail up to Winchester Mountain Lookout. Here you'll find close-up views of Goat Mountain to the south and Mount Larrabee, almost on the Canadian border, to the north. More great mountain vistas and wildflower meadows await on the Hannegan Pass trail. Dayhike or overnight 8.5 miles round-trip to the pass or 10.6 miles to Hannegan Peak. Get to the trailhead by taking WA-542 to where it crosses the Nooksack River just before starting up to Heather Meadows and Artist Point. Head east on FR-32 for 1.3 miles and fork left on Ruth Creek Road, then continue for 5.4 miles to Hannegan Campground at the end of the road.

Nooksack Falls

The North Fork Nooksack River, which begins high on the glaciated slopes of Mount Shuksan, finds its way through forest and rock, plunging 88 feet at this popular waterfall. Several sources give the height of the waterfall as 170 feet, but it can be seen that this is obviously wrong when visiting the falls. A short walk leads to a fenced viewpoint of the falls. It may be tempting to go beyond the fence for a better view, but as warning signs indicate, more than a few people have slipped and fallen to their deaths by doing so. Northwest waterfall expert Bryan Swan states categorically that there is no way to get a view from the bottom of the falls; I'm sure if there was, he'd have found it and come back with the photos.

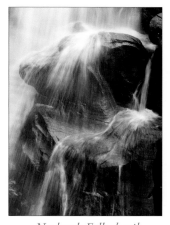

Nooksack Falls detail

Most of the year, the waterfall is split by a column of basalt but in times of high water the river flows across the entire gap in the gorge.

Photo advice: Direct sun hits the falls from mid-morning until late in the day. The viewpoint is close enough to the falls that a very wide angle lens is needed to capture the whole scene. Since it's impossible to photograph the whole falls from the viewpoint, and scrambling beyond is out of the question, you may want to work on compositions framing just a portion of the falls with a longer lens.

Getting there: At MP 40 on WA-542, turn south on Wells Creek Road, FR-33, signed for the falls. Drive 0.7-mile to the parking area.

Time required: This can be a quick 15-minute stop on the way to Picture Lake, Artist Point or Mount Baker Wilderness trails unless you're really intent on making something of the falls.

Nearby location: About two miles west of Nooksack Falls, there is a little cascading waterfall on Fossil Creek, on the north side of WA-542 that is especially nice with fallen maple leaves in autumn.

Skyline Divide Trail

Like many other hikes in the North Cascades, this one starts out with an uphill climb that seems to go on and on and on. The effort is well worth it, however, with the reward of very impressive views of Mount Baker, Mount Shuksan, and countless other peaks and ridges in the North Cascades. Large and small meadows are full of wildflowers in summer. The moderately strenuous hike gains 2,100 feet in elevation and is 6-10 miles round-trip (depending on how far up the Divide you hike). The trail is generally snow free from the very end of July until October.

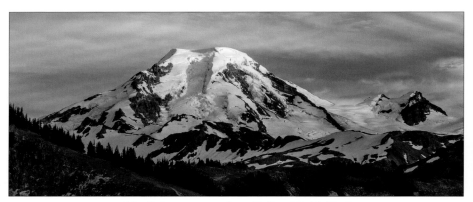

Mt. Baker at sunset from Skyline Divide Trail

After switchbacking up through a dense forest of hemlock and silver fir, the trail crosses several pocket meadows, full of corn lily, sitka valerian, arnica, lupine, and other wildflowers in summer. Soon after entering the Mount Baker Wilderness, at about 2 miles, the trail breaks out of the forest onto a wide, open meadow. A final few yards of climbing and a left turn on the path takes you to the top of a small grassy knoll—named Lunch Box Hill by Washington hiking guru Ira Spring—and a glorious panoramic view: the glaciated north face of Mount Baker to the south, Shuksan to the east and peak after peak to the north looking into Canada. On a clear day you can see to the islands in the Strait of Georgia off the coast. It's no wonder this is considered one of the best hikes in the northern Cascades; on late summer weekends it can be a busy trail.

For an even more close-up view of Mount Baker, follow the ridge trail south for about 0.75 mile to another knoll. The trail continues on Skyline Divide, climbing to a tundra-crested high point of 6,563 feet.

The long downgrade on the return trip goes pretty quickly, but you'll want a flashlight or headlamp for hiking out if you stay for the best light at the end of the day. Bring plenty of bug repellent for the mosquitoes and flies, too.

Photo advice: Late afternoon to sunset in early- to mid-August is the best time to do this hike—the wildflowers are blooming in the meadows and the sun is far enough north for great light on Mount Baker.

Getting there: Travel the Mount Baker Highway, WA-242, to Glacier Creek Road, one mile east of the town of Glacier. Just 100 yards down the road, turn onto Dead Horse Road (FR-37). Follow this road, along the Nooksack River for the first 4 miles, to the parking lot and trailhead in 12 miles. Look for waterfalls along the way at the 7.5-mile point.

Time required: If the light is good, you'll want 4 hours or more for the hike, plus time to get to the trailhead.

North Cascades Highway

One of the most spectacularly scenic roads in the United States has to be Washington State Highway 20. From its western terminus on the Olympic Peninsula, the highway hops a ferry from Port Townsend to Whidbey Island, crosses to Fidalgo Island with a must-see stop at the Deception Pass Bridge, traverses the fertile farmland of Skagit Valley, and then follows the Skagit River into the northern Cascade Mountains. From the crest of the Cascades at Washington Pass, the highway descends to the Methow and Okanogan River valleys, then climbs again, winding its way over and through the Kettle Range and the Selkirk Mountains to reach the Idaho border.

From Sedro-Woolley, just east of I-5, to Winthrop in the Methow Valley, Washington 20 is known as the North Cascades Highway. This is, without question, the most scenic of the cross-Cascades routes in Washington. The road gains elevation slowly at first, urban landscape giving way to rural farmland and then to dense, west-side forest. Climbing into the mountains, the views open up to the jagged and glaciated peaks of "America's Alps" in North Cascades National Park.

The highway route follows old Native American trails used for trading between the coast and interior, but the modern road did not completely traverse the mountains until 1972. Heavy snows and the danger of avalanches close the road between Ross Lake and Mazama every winter from around late November through the end of April. Exact dates vary according to snow pack, so check conditions online or by phone call if you're traveling in autumn or spring.

If you're doing a cross-Cascades trip, make sure you have plenty of gas and have at least basic emergency

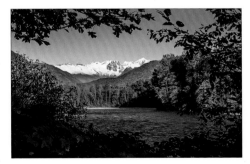

Skagit River at Rockport

supplies in your vehicle. Other than a small convenience store in Newhalem (no gas), there are no services between Marblemount and Mazama. Cell phone reception between the two towns is also virtually nonexistent.

Baker Lake

Situated on the southeast side of Mount Baker and easily accessed from the North Cascades Highway, Baker Lake is a popular recreation area for boaters and fishermen, with several campgrounds on its shores. Formerly a small natural lake, the construction of a dam expanded the water area to the extent that it is now one of Washington's biggest lakes.

Driving north on Baker Lake Road from Highway 20, the serrated peak of Mount Shuksan appears over the trees at about Milepost 8, and Mount Baker comes into view at about 13 miles. For really grand views of both mountains over the lake, turn right at the sign for Baker Dam and Kulshan Campground near MP 14. Drive 1.5 miles, passing the entrance to the campground, and turn left at the sign for the boat ramp. From the boat launch area there is a clear view of Mount Shuksan to the north and Mount Baker to the northwest.

Further up Baker Lake Road, there's another nice view of Mount Baker from the bridge at Boulder Creek. Nearby Panorama Point Campground offers views of the surrounding Cascade mountains, including a peek at Mount Shuksan. Hike the East Bank Baker Lake Trail for more views of Shuksan and a good look across the lake to Mount Baker. The elevation here is low enough that the lake and trail are accessible year round, although all the campgrounds except Kulshan at the south end of the lake are closed in winter.

Photo advice: Try for the first rays of the sun hitting Mount Baker. From fall through spring, there's a good chance of alpenglow on Mount Shuksan at both sunrise and sunset.

Getting there: Traveling on WA-20, turn north between MP 82-83 onto Baker Lake Road, FR-11. It's 14 miles to the turn for Kulshan Campground, 19 miles to Panorama Point Campground and 26 miles to the end of the road for the north trailhead for East Bank Trail. All but the last 3 miles of the road are two-lane pavement.

Time required: A minimum of two hours just to make the drive up to the lake and make some photographs at one or more of the campground viewpoints.

Nearby location: The DeLorme and Benchmark atlases, as well as some older trail guides, mark the site of Rainbow Falls at the end of FR-1130 north of Baker Lake. Unfortunately, a slide wiped out the viewpoint for this waterfall and the Forest Service has no plans to rebuild it. Trees below the site of the viewpoint have grown to obscure the view of the falls and the very steep and unstable slope make it so that bushwhacking for a closer view is not a good idea.

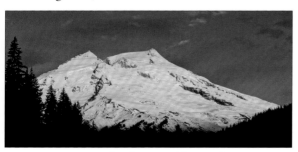
Mt. Baker from Boulder Creek

Park Butte Trail

Of the many great hiking trails in the Washington Cascades, Park Butte Trail ranks near the very top for superb views. Located in the Mount Baker National Recreation Area, this is a 7-mile round-trip, moderately strenuous trail with 2,000 feet of elevation gain. The trail first crosses flat, grassy Schreibers Meadow, then climbs through forest before emerging onto open, rocky meadows. The first views of Mount Baker are quite nice, but they just keep getting better and better the further you go up the trail.

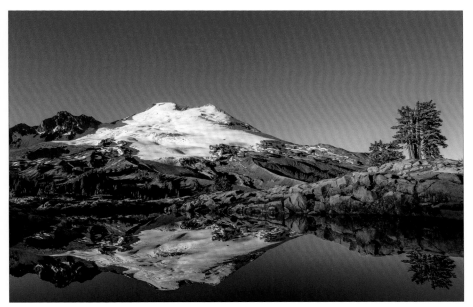

Mount Baker & alpine tarn

At 2.4 miles, keep left at the trail junction to continue to Park Butte (the right fork is for Railroad Grade trail). The climb continues, reaching an old lookout on top of the butte in another 2.1 miles. You'll find a variety of sub-alpine wildflowers in the meadows, plus huckleberries for eating in late summer and some nice fall color in early autumn.

About half a mile below and to the east of the lookout are a couple of tarns that are ideal for capturing views of the mountain with a mirror reflection. Use care in getting to these jewel-like ponds, stepping on rocks instead of the delicate plants and soil surface. If we're not extra careful in areas like this, they will be declared off-limits. Overnight camping is possible at the lookout on a first come, first serve basis. This is a very popular hike, so try to go midweek if possible.

Photo advice: Plan to do this hike in autumn when the sun's azimuth is more to the south than in summer, giving better light on the mountain at sunrise and

sunset. The view is great in mid-summer, but the angle of the sun means that Mount Baker only gets edge light at sunrise and sunset. If you're going for wildflowers, peak bloom is late July to mid-August.

Getting there: Traveling on WA-20, turn north between MP 82-83 onto Baker Lake Road (FR-11). Keep on this road for 12.5 miles, turn left onto FR-12, go another 3.5 miles and then turn right on Sulphur Creek Road (FR-13). The road ends in 6 miles at the trailhead parking area.

Time required: Time Required: Minimum five hours for the hike and time for photography, and I highly recommend making it an overnight backpacking trip to take advantage of early and late light on Mount Baker.

Nearby location: If this hike doesn't have enough trail miles for you, include the route up Railroad Grade for close-ups of Easton and Deming Glaciers. As in the lower meadows, lupine, arnica, and paintbrush abound. From the junction with the Park Butte Trail, it's a little over a mile up to the top of Railroad Grade.

Sauk Mountain

A long and wonderful wildflower season, great views, and relatively quick access from the I-5 corridor make Sauk Mountain Trail a favorite for those living in or visiting northwest Washington. Flowering starts at the lower elevations in June, when there is still plenty of snow on top, and continues into September. You'll see plenty of wildflowers along the road on the way to the trail, albeit covered with gravel dust, and the great views of the Skagit River Valley right from the parking area give you an idea of what's to come.

Skagit River Valley from Sauk Mountain

The 4-mile round-trip hike is moderately strenuous, but do-able even for youngsters. From the trailhead the path switchbacks on a continuous climb for an elevation gain of about 1,200 feet to the summit of Sauk Mountain. The sloping meadows along the whole trail are among the best places in the North Cascades for wildflower displays. Depending on whether it's early or late in the season, among the more colorful flowers are mountain arnica, broadleaf lupine, red columbine, tiger lily, and several species of aster and penstemon. When the snow first melts in early summer, avalanche and glacier lilies adorn the slopes with their delicate white and yellow blossoms.

At 1.5 miles, a trail leads to Sauk Lake. Including this side trip in your hike will add 3 miles of mostly forested trail, with a drop of 1,100 feet in elevation to reach the emerald green lake.

From the top of 5,540-foot Sauk Mountain, the marvelous 360-degree panoramic view includes Mount Baker and Mount Shuksan to the north and distinctive Glacier Peak to the south. The horizon to the east is filled with the jagged peaks of North Cascades National Park.

This trail is almost all exposed, so sunscreen and plenty of water are advised; bug repellent also, at least in early and mid-summer. Hiking poles are highly recommended.

Photo advice: Just about all of July is great for the wildflower bloom. Be there at sunrise to catch the flowers while the air is calm, or aim to be at the summit for sunset light on the surrounding peaks (don't forget your headlamp for the return trip).

Getting there: Travel WA-20 to Sauk Mountain Road (FR-1030), two miles west of Rockport. At unmarked junctions, stick to the obviously more traveled route for 7.4 miles, turning right on FR-1036. The road ends at the trailhead in 0.4 mile. The gravel road is steep and narrow but okay for passenger cars.

Time required: The hike can be done in less than 3 hours, but you'll surely want to take more time than that for photographing the blooms and the vistas.

Nearby location: At Rockport State Park (WA-20, MP 96.5) you can stroll through a lush forest of old-growth conifers. The campground is closed out of fear that even a branch falling from one of the humongous trees could crush an RV or tent full of campers.

Mountain Loop Highway & Sauk River Valley

For a very scenic drive through lush west side forest and mountain valleys, try the Mountain Loop Highway. Heading east into the Cascades from Granite Falls, the road enters Mount Baker-Snoqualmie National Forest, following the winding course of the Stillaguamish River.

Mount Pilchuck State Park is a popular summer destination with 1,893 acres of mountainous terrain. A rather strenuous three-mile hike gains 2,200 feet in elevation to reach an old fire lookout on the mountain's 5,324-foot summit. The panoramic view from the top includes nearby Cascade peaks and a look across Puget Sound to the Olympics. The trail can remain snow-covered until mid-summer, and from then until late fall it can be rather busy on weekends.

Further east, Mountain Loop Highway passes several forest service campgrounds and trailheads. The road crests Barlow Pass at 2,361 feet and then turns north to follow the Sauk River. This section of the highway turns to gravel for several miles, but it's relatively well graded and no problem for passenger cars most of the year.

Waterfall lovers might want to make a short detour at Bedal Campground to North Fork Falls. Head east on FR-49 for 1.2 miles to the trailhead sign, then walk about 0.3 mile to a view of the North Fork Sauk River as it plunges 60 feet into a narrow canyon.

Sauk River Valley gradually broadens, with small farms and ranches along the highway as it runs north to Darrington. Turn west here on WA-530 to loop back to the I-5 corridor, or continue north through the Sauk Valley on WA-530 to reach the North Cascades Highway at Rockport.

Photo advice: Best time to visit this area is late spring when the forest is at its lushest, or in early October when the many bigleaf maple trees turn golden.

Getting there: From the I-5 corridor, head east at Everett on US-2, north on WA-204 and WA-9 to Lake Stevens, then east on WA-92 to Granite Falls to the start of Mountain Loop Highway.

Time required: From Granite Falls to Rockport is about 75 miles. Allow three hours for the drive and a few short stops for photos.

Skagit River Bald Eagles

The Skagit River flows for 150 miles from British Columbia to the Puget Sound, and the ten-mile stretch between Rockport and Marblemount vies with Lower Klamath National Wildlife Refuge on the Oregon-California border for highest concentration bald eagles in the lower 48 states. A few eagles inhabit the area year round, but each winter, hundreds of these magnificent birds come to the Skagit River to feed on the salmon that swim upstream to spawn. The eagles arrive in late November and stay through January, with peak numbers from Christmas until mid-January. The best places to spot the eagles:

• Skagit River Bald Eagle Natural Area (WA-20 to Rockport, south on WA-530, turn right on Martin Road just after the bridge over the Skagit). A

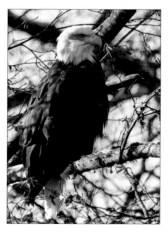

cooperative effort between Washington Dept. of Fish & Wildlife and The Nature Conservancy. A short trail leads from the parking area to the river.

• Howard Miller Steelhead Park in Rockport (look for signs on WA-20 near junction with WA-530). Eagles are often in trees just upstream from the bridge.

• Milepost 100 Highway 20 Rest Area at Sutter Creek. Gravel bars on the south side of the river are a feeding area and the eagles roost at night in the trees on the mountain above.

• Milepost 101 on Highway 20. Great viewing right from the road. The river makes a big bend here with the angle just right for winter sunrise photos.

• Marblemount Fish Hatchery (cross the Skagit River on Cascade River Drive, turn right on Rockport-Cascade Road). Also check the area around the Marblemount Boat Launch, just over the bridge.

Photo advice: The eagles feed primarily from sunrise to mid-morning. One challenge for good photography is that in most cases you're looking south into the sun at this time, so the birds may be backlit or silhouetted against the sky.

Getting there: Rockport is 38 miles east of I-5 at Burlington via WA-20.

Time required: If you a serious birder with long lenses you'll probably want to devote at least one whole morning to photographing the eagles.

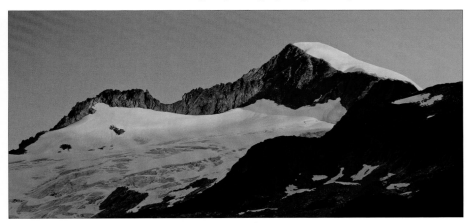

Eldorado Peak & Glacier

North Cascades National Park

This incredibly scenic National Park is the very heart of Washington's North Cascades. Included in the alpine wonderland are plunging waterfalls, sculpted valleys, and peak after jagged peak of mountains formed by ancient volcanoes and eons of erosion. The mountains are adorned with more than 300 glaciers (more than any other park in the lower 48 states), and more than 127 jewel-like alpine lakes. There are hundreds of miles of hiking trails, including the northernmost stretch of the Pacific Crest Trail, and 93% of the park is designated as the Stephen Mather Wilderness.

North Cascades National Park is a 684,000-acre complex administered by the National Park Service that includes the North and South Units of North Cascades National Park, plus the Ross Lake and Lake Chelan National Recreation Areas. If you're visiting in the summer, a stop at the North Cascades Visitor Center in Newhalem is a good introduction to the park complex. Note that the visitor center is only open May-October, and that the North Cascades Highway is closed between Ross Lake and Mazama in winter. Also worth noting: dogs are not allowed on any of the trails within the National Park.

Cascade Pass

If you do just one serious hike in the North Cascades, make it this one. Between the drive to the trailhead and the hike up to Cascade Pass and then on to Sahale Arm, you'll see the gamut of climate zones and experience the full range of environmental and geologic features that make the North Cascades so special. Starting from Marblemount, Forest Road 15 follows the Cascade River deep into the mountains as it cuts through wonderful, lush, old-growth west-side forest of Douglas-fir, cedar, and alder. Lots of bigleaf maple make this a great autumn drive as well. After 23 miles and a climb to 3,600 feet, the road emerges from the forest at the trailhead, with a wonderful close-up view of 8,200-foot Johannesburg Mountain and its hanging glaciers right from the parking area. Watch and listen for the frequent glacier avalanches and rockfalls. Ice-capped Eldorado Peak is prominent in the view to the northwest. Go ahead and exercise your shutter finger at the parking area, but there are even better views just up the trail at bit where you can use the tall firs to frame Johannesburg and the nearby dramatic pinnacles of The Triplets.

You won't want to linger too long with these early views however, because the vistas to come are much more spectacular. The hike to Cascade Pass is a moderately strenuous a 7.4-mile round-trip hike with 1,800 feet of elevation gain. The trek up Sahale Arm to the base of Sahale Glacier is more strenuous and adds about 4.5 miles and another 1,800 feet of elevation gain to the hike.

The well-maintained trail climbs gradually through thick forest. Occasional openings on talus slopes and rock-strewn sloping meadows will tempt you to stop for more photos of surrounding peaks and valleys, and of the lupine, columbine, aster, heather, and corn lily. Look for marmots stuffing themselves on wildflowers. Pikas call out in high-pitched squeaks, as if saying, "betcha can't see me".

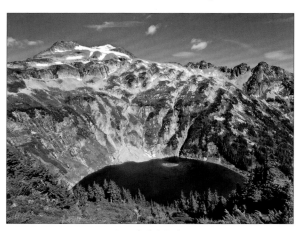

Doubtful Lake

After 3.7 miles and 37 switchbacks, the trail reaches Cascade Pass, elevation 5,392 feet according to the USGS benchmark. Great spot for a bit of a rest and a snack as you take in the view to the southeast of the Stehekin River drainage between rugged snow-capped peaks. A trail leads down to Pelton Camp and then follows the Stehekin to Lake Chelan. The native Upper Skagit people used this route to get to eastern Washington, as did later traders and miners.

The trail to Sahale Arm begins with a drop, then climbs steeply across open slopes up into subalpine meadows. In mid-September, some wildflowers are still blossoming and the huckleberry is starting to take on its bright fall hues. If you're hiking in autumn, scan the open slopes of huckleberry for black bears gorging themselves on the delicious fruit. It's a real treat to see these critters and they're not generally aggressive, but you don't want to inadvertently get between a mama and her cub.

A mile up the trail from Cascade Pass, a side trail leads to Doubtful Lake. Continue up the Sahale Arm trail for another 0.1 mile for the best view of this

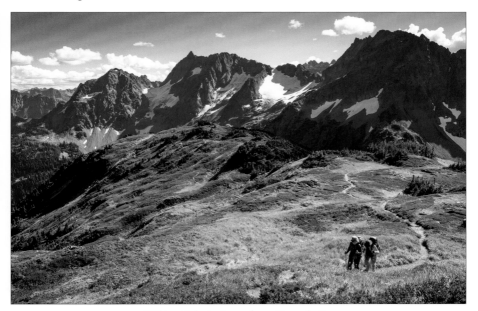

Hiking Sahale Arm above Cascade Pass

jewel of a lake set in a granite bowl below the peak of Sahale Mountain.

Another 0.6 mile up the trail, a slight rise next to a tiny tarn affords a spectacular 360° view of the surrounding ridges, peaks, and valleys. The trail continues to climb a ridge of subalpine meadows and barren talus to a couple of rock-walled camp sites for backpackers and climbers at the base of Sahale Glacier on the west flank of Boston Peak. It's often windy and subject to extreme weather up here, but some claim it has one of the very best campsite views in North Cascades National Park.

Because of the grand scenery and the relatively short, easy access to an alpine environment, the Cascade Pass Trail is the most popular day hike in the National Park, and can be rather busy on summer weekends. Dogs are not allowed on the trail, and overnight campers need to get a backcountry permit from the Ranger Station & Wilderness Info Center in Marblemount. Hiking season is July through September.

Photo advice: Accomplished photographers as well as those who come here just for the enjoyment of the hike agree that autumn is the best season for Cascade Pass. In mid-September the huckleberry provide broad areas of orange to deep red color in the landscape. The view from Cascade Pass to the Stehekin River valley has great potential at sunrise, but is totally backlit from mid-morning until noon in early autumn. It's not uncommon however, to find smoky skies here coming up from wildfires in the east. Sunsets from Sahale Arm can be great, but be prepared for wind and storms at any time at the glacier camps.

Getting there: From WA-20, head east from Marblemount and turn south at MP 106 onto Cascade River Road, FR-15. Follow this road for 23 miles, about an hour's drive, to its end at the trailhead. The last section is steep and rough, but okay for passenger cars. The road is usually open all the way to the trailhead by late June, but may be gated a few miles short of the parking area until early July in heavy snow years. Allow three hours for the drive from Seattle.

Time required: If just going as far as Cascade Pass, allow at least five hours. Continuing to Sahale Arm makes it a full-day hike with stops for photos and food. Even better is an overnight backpack to catch the best light at both sunrise and sunset from Sahale Arm.

Nearby location: Cascade River Road is quite scenic, particularly in autumn, and there are a couple of nice views of the river from pullouts along the way. Although it's extremely unlikely you'll be so lucky, in the fall of 2010 a hiker in the Cascade River drainage spotted and photographed a grizzly bear, the first photographically confirmed sighting in the North Cascades in half a century.

Ross Lake National Recreation Area

Bisecting the north and south units of North Cascades National Park, the Ross Lake National Recreation Area stretches from the western foothills of the Cascades to the Canadian border, following the course of the Skagit River. Dams built on the river to generate electricity for Seattle created Gorge, Diablo and Ross Lakes, popular summer destinations for camping, fishing, and hiking.

The North Cascades Visitor Center just west of the community of Newhalem is open daily from spring through fall, and on weekends in winter. Most of the recreation area is not accessible by car in winter, as snow closes Highway 20 between Ross Lake and Mazama from about mid-November through mid-April. Newhalem is a company town, owned by Seattle City Light, and is your last chance for food and supplies before heading up into the mountains. On the eastern side of town, a short trail leads to multi-tiered Ladder Creek Falls. The possible angles of view are very limited as the creek tumbles through a narrow gorge, but this can be an interesting waterfall to work with on overcast days. Park across the river from the Gorge Powerhouse building and walk over the suspension bridge to start the trail.

Three miles east of Newhalem, Gorge Creek Falls plunges 242 feet in several tiers within a very narrow chasm. Look for the signed parking area at the top of Gorge Dam, then walk the pedestrian bridge over the gorge for views of the falls. The narrow gorge faces south and only gets direct sun for a few hours in mid day, so plan for an early morning or later afternoon visit to take advantage of shaded light and reduced contrast.

The Diablo Lake Overlook, at MP 132 on Highway 20, is a great place to stop on a cross-Cascades tour. A series of interpretive panels give details about the history, geology, and geography of the panoramic landscape of peaks rising above the lake. The lake is a milky turquoise blue due to glacial runoff of Thunder Creek. Above the southern arm of the lake, dense forest covers the slopes almost to the summits of Colonial Peak and Pyramid Peak. I find that the views of Diablo Lake, Davis Peak, and the tiny islands in the lake are best towards the north end of the path at the overlook.

Washington Highway 20 continues to climb into the Cascades, reaching the parking area for Ross Lake Resort just a couple of miles east of the Diablo Lake Overlook. The resort consists of some cabins built on log floats anchored just north of Ross Lake Dam. A one-mile trail leads from the highway parking area to the dam and resort area. Cabin guests can opt for a boat ride across Diablo Lake and then a truck transfer to the resort; the truck will also transport guest kayaks and canoes. Other than a dirt road coming from Canada, there is no vehicle access to 24-mile long Ross Lake.

A mile east of the turn-off for Ross Lake Resort, a highway pullout at MP 135 has the best roadside view of the fjord-like lake. Look north towards Canada and

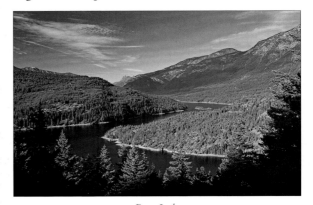

Ross Lake

pick out Desolation Peak, where writer Jack Kerouac spent the summer of 1956 working as a fire lookout on the 6,102-foot peak while writing *Dharma Bums* and *Desolation Angels*. The fire lookout is still staffed in summer, and can be reached by a somewhat strenuous hike (13.6 miles round-trip with 4,400 feet of elevation gain).

Photo advice: At Diablo Lake Overlook, the view to Colonial Peak and Pyramid Peak, with the milky blue-green lake below, is looking almost due south, and is strongly backlit at mid day; early to mid-morning light is much better; later in the afternoon works, too, but the view west over the lake to Mount Davis may be backlit then. On cloudy and overcast days, concentrate your photographic efforts on the waterfalls near Newhalem and along the highway above Diablo Lake.

Getting there: From I-5, travel to Burlington at Exit 230 and take WA-20 east for 60 miles to Newhalem and the North Cascades Visitor Center. From eastern and central Washington, travel west on WA-20; it's 58 miles from Winthrop to Ross Lake.

Time required: Including driving time, this is a minimum half-day trip. If you're stopping at Diablo Lake as part of a Cascades loop drive, allow half hour at the viewpoint to explore the photo possibilities and read the interpretive signs.

Nearby location: Thunder Knob Trail is an easy 3.6-mile round-trip hike through old-growth forest, switchbacking up to views of Diablo Lake and surrounding peaks. The trailhead is located on the north side of WA-20 at Colonial Creek Campground (MP 130).

Maple Pass – Heather Pass Loop Trail

Just about every trail guide and online review of the Heather Pass - Maple Pass loop trail around Lake Ann agrees that this is one of the supremely scenic hikes in the North Cascades. The 7.2-mile trail takes in mature forest, open talus slopes, rocky ridges, and subalpine meadows. There are stunning views of surrounding steep granite peaks and beautiful blue lakes nestled in glacial cirques. Wildflowers adorn forest and meadow in summer and golden alpine larch trees stand out on the forested slopes in autumn.

Almost all the guides have it all wrong, however, about which direction to do the loop. Every hiking guide and trail report I read about this trail said it was best done counterclockwise. They all also noted such a route entailed a steep descent at the end. Personally, I want the less steep option coming down because it's easier on my knees, but also because I prefer to do the hard work, the steep climbs, early in the hike when I'm still fresh and energetic.

Furthermore, looking at topo maps and the sunrise and sunset angles projected by The Photographer's Ephemeris (www.photoephemeris.com), it was obvious that a clockwise circuit would be the best for photography as well.

Most of the trail isn't difficult, but that one rather long section with significant elevation gain/loss merits the overall hike a moderately strenuous rating. Trekking poles are highly recommended.

Starting from the Rainy Pass Picnic Area, the trail heads south on the paved Rainy Lake Trail for 0.5 miles, then turns west and begins to climb through forest and up steep switchbacks to the ridge between Rainy Lake and Lake Ann. Stopping for photos of Rainy Lake, 1,700 feet below, is a good way to break up the uphill grind. The trail climbs to 6,850 feet then descends slightly to reach Maple Pass at 3.7 miles.

The trail then contours along a ridge for about a mile to Heather Pass, with breathtaking vistas to the south and west of Corteo, Black, Frisco, and Glacier peaks. Look east over the near-perfect oval of Lake Ann with its tiny island, and across Rainy Pass to Whistler Mountain and Cutthroat Peak. Delicate glacier

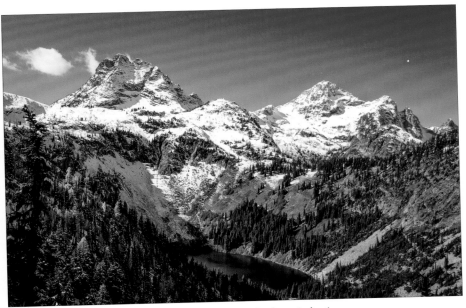

Corteo Peak & Black Peak above Lake Ann

lilies fill the meadows in early summer, followed by colorful arnica, aster, penstemon, paintbrush, monkeyflower, and lupine. Marmots and pikas squeak and whistle in the rocky areas.

From Heather Pass, the trail descends gradually, crossing open talus slopes before reaching an old-growth forest of hemlock and fir. Huckleberry bushes provide a feast in late summer and wonderful color in fall. A mile from Heather Pass, a side trail leads to Lake Ann. Marshy areas, pools, and moist meadows along the trail as it approaches the lake make this a worthwhile side trip (or a nice, easy short hike by itself). From this junction, it's another 1.5 miles to the trailhead.

Part of this trail was originally intended to be a section of the Pacific Crest Trail, but the impact of so many hikers, and equestrian travel, would have had a severe negative impact on the fragile meadows, so the PCT was routed slightly to the west. The fragility of the environment is also the reason that backcountry camping is not permitted within ¼ mile of Heather Pass, Maple Pass or Lake Ann. If you're visiting here in wildflower season, remember that meadows mean masses of mosquitoes.

Photo advice: Do this hike in late September or early October to get the larch trees at their most colorful stage, or mid-July to mid-August for the best wildflower bloom. Start hiking in the morning so that the vistas of prominent peaks from the passes won't be heavily backlit.

Getting there: Travel WA-20 to Rainy Pass at MP 158. The trailhead and picnic area is 50 miles from Marblemount or 35 miles from Winthrop.

Time required: Give this one a full day to really enjoy and take advantage of all it has to offer.

Nearby location: Rainy Lake is reached via a paved, wheelchair accessible, 1-mile path. It's a pretty lake with a distant view of a tall waterfall, although I don't find it quite as photogenic as Blue Lake. The trail to Lake Ann is relatively easy and about 4 miles round-trip.

Blue Lake

The term "jewel of a lake" is perhaps a bit overused, but the colors of this beautiful little lake certainly are gem-like. The crystal-clear water ranges from emerald green in the shallows to a deep turquoise blue. Larch trees around the lake make this a prime location for shooting in the fall. Subalpine wildflowers can be found in open areas along the trail in summer. Mountain goats are sometimes spotted on the steep granite slopes surrounding the lake.

Getting to Blue Lake entails a relatively easy, 4.4-mile round-trip hike with an elevation gain of 1,050 feet. Snow may linger in some places until mid July, and come again in October. The trail parallels Highway 20 for the first 0.5 mile, then climbs gradually through subalpine forest and meadows. A couple of clearings along the way have a nice look at prominent Cutthroat Peak to the north. Follow the trail around the west side of the lake to its end at a rough talus slope for views of the Early Winters spires. The views are even better if you scramble across the talus another 50 yards or so, or up the slope on the east side of the lake.

Photo advice: In early morning, the Early Winters spires are strongly backlit and the east side of the lake in deep shadow. Mid-morning will get you the standard postcard view, while late light hits the spires nicely. The larch trees are at their best late September to mid-October.

Getting there: The trailhead parking area is on the south side of WA-20 near MP 161, about a mile west of Washington Pass.

Time required: Three hours should be sufficient for the hike and time for some studied photography.

Washington Pass

Washington Highway 20 crests the Cascades at 5,477-foot Washington Pass, the dividing point between western and eastern Washington. A short hop off the highway to a parking area and a short walk on a paved path leads to a developed overlook with striking views of jagged Kangaroo Ridge, Vasiliki Ridge, and Silver Star Mountain rising abruptly above Early Winters Valley.

Even more photogenic, however, are the dramatic peaks of Liberty Bell and the Early Winters Spires. You'll catch glimpses of them through the trees looking

to the south as you walk the path from parking area to overlook. This massif is among the most photographed of all the North Cascades geological riches.

Immediately north of the highway at the turn for the overlook is a large, open meadow. Green, marshy, and full of mosquitoes in early summer, it turns a beautiful golden brown in autumn and becomes a brilliant white snowfield with the onset of winter.

Leaving the overlook area, look up right from the highway junction for a clean view of the north face of Liberty Bell. Spring through fall, this north face is beautifully side lit at both sunrise and sunset.

Soon after dropping down from the pass and through Early Winters Valley, heading east on Highway 20, you'll notice a significant change in topography, geography, and flora and fauna. The dense Douglas-fir, hemlock, and cedar forests of the wetter west side give way to drier, more open forests of lodgepole and ponderosa pine. Cottonwood and aspen replace bigleaf

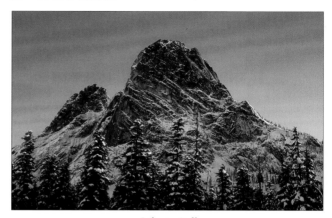

Liberty Bell

maple and vine maple as the colorful autumn trees. The jagged, glaciated peaks of the Cascades become distant views from ranchlands and the more rounded mountains of the Okanogan Highlands appear to the east.

Photo advice: The main view from the overlook is of the ridges to the east, and they're going to be backlit in early morning, but if you're there at dawn, you can catch the first rays of the sun striking Liberty Bell and the Early Winters Spires. In October, larch trees will add some color to the dark green forest and granite gray mountain scenes.

Getting there: Travel WA-20 to MP 162 and turn north onto the 0.5-mile road to the overlook parking area. Soon after the first significant snowfall of the season the gate at the highway is closed, but it's an easy walk or snowshoe to the viewpoint.

Time required: Half an hour or so will be enough for some nice photos, although you'll need to spend a bit more time if trying for the sunrise light on the Early Winters Spires.

Nearby location: Cutthroat Lake is another of the jewel-like high Cascades lakes that is especially scenic in autumn when the larch turn golden. The lake is reached via an easy 3-mile round-trip hike, with just 400 feet of elevation gain via a very gradual grade. Half a mile up the trail is a great view of Cutthroat

Peak, which in summer should get great light right at sunrise. The lake itself is set in a bowl with a panorama of peaks rising above it to the southeast. To get to the trailhead, head east from Washington Pass on WA-20, which immediately makes a big looping turn to the north as it descends into Early Winters Valley. In 4.5 miles, turn west at Cutthroat Creek Road and drive 1.5 miles to the end of the road. For a longer, more challenging hike with even better views, start at Rainey Pass on WA-20 and take the Pacific Crest Trail to Cutthroat Pass, then drop down into the bowl of Cutthroat Lake.

Methow Valley

High in the Cascades above Washington Pass, rivulets of snowmelt join to form the Methow River. Numerous tributaries add to the flow as the river works it way through the Methow Valley to meet the Columbia River. As the river flows from mountains to eastside desert, the landscape of the very scenic Methow (met'-how) Valley changes from ponderosa pine forest to flat-bottomed ranchland to sage and rabbitbrush. Groves of aspen and stands of cottonwood trees turn brilliant yellow in autumn. Miles of cross-country ski trails provide access to snowy winter landscapes.

The western-themed town of Winthrop is definitely touristy, but also a fun place to visit. The old-west wooden buildings are good travel photo subjects. Stop at the Rocking Horse Bakery for wi-fi with tasty pastry and excellent coffee served by friendly folks. The nearby Trails End Bookstore has a great selection for reading and reference.

When it's fall color time, early- to mid-October, head to the south end of the main part of town for a wonderful view of bright yellow cottonwoods lining the river with snow-capped Mount Gardner in the distance.

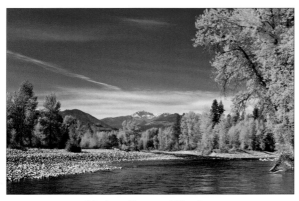

Methow River in Winthrop

On the north side of Winthrop, West Chewuch Road will take you along the Chewuch River, with a few nice aspens among the ponderosa pine (the spelling Chewack is sometimes used, but Chewuch is preferred as it is closer to the original Native American name). At 11 miles, a short, paved trail leads to pretty Falls Creek Falls. The waterfall can be a bit of a challenge to photograph due to surrounding trees and the inability to see both of its two tiers at once. Spring and early summer, heavy

Right: Balsamroot on Gobblers Knob, Thompson Ridge

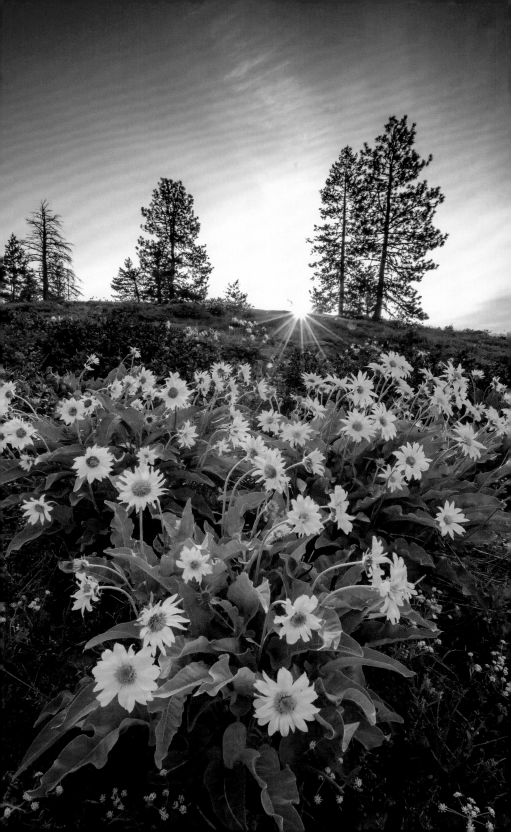

spray is a problem at the best vantage point. Another issue is that there are some pieces of rebar sticking up from a rock at the base of the falls. The road continues north to reach Pasayten Wilderness trailheads.

A very nice grove of aspen stands near the entrance to Pearrygin Lake State Park just east of Winthrop. The park lands and adjacent state Wildlife Area are excellent places to photograph mule deer. It is, however, a rather busy place during hunting season.

Methow Valley is home to Washington's largest herd of mule deer, and extra caution is needed driving Highway 20 early and late in the day. Billboards totaling the yearly damage from vehicle-deer collisions show some remarkable figures.

Photo advice: If you have an infrared-converted digital camera or shoot black & white infrared film, the autumn scenes of cottonwood and aspen trees are outstanding subjects.

Getting there: From Washington Pass in the North Cascades head east on WA-20 and down into the valley. From central Washington, take US-97 along the Columbia River north to Pateros, turning onto WA-153 and continue to WA-20 at Twisp.

Time required: Washington residents and visitors alike enjoy driving the Cascade Loop (crossing the Cascades on WA-20 and US-2) as a daytrip or weekender, with a lunch or overnight stop in Winthrop.

Nearby location: Twisp River Road leads deep into the Cascades, providing trail access to the Lake Chelan-Sawtooth Wilderness. In autumn, head east from Twisp on WA-20 to capture western larch trees showing their fall color around mid-October at Loup Loup Pass.

Patterson Mountain – Thompson Ridge

In spring, the hills and forests just west of Winthrop are excellent for wildflowers. Eye-catching clumps of bright yellow arrowleaf balsamroot are mixed with blue lupine and orange paintbrush. On closer look you'll find larkspur, desert shooting star, grass widows, and more.

The 5-mile Patterson Mountain loop trail is the best place to find these from late April to early May. The moderately strenuous trail gains 1100 feet of elevation as it circles the rounded summit of the mountain. The hike is mainly across open meadow, with some forested areas of aspen, ponderosa pine, and Douglas-fir. Nearing the top, there are views to the north of Methow Valley and distant Cascade peaks.

At the end of May, flowers on the open slopes of Patterson Mountain will be cooked, but those higher up and in the open understory of the ponderosa pine forest on Thompson Ridge are just about in their prime. The Methow Valley Sport Trails Association maintains an extensive network of trails here, primarily for mountain

biking in summer and cross-country skiing in winter but also wonderful for wandering on foot. The combination of Overland and Criss-Cross trails makes an easy loop through open forest with the same profusion of wildflowers as on Patterson Mountain. Photographer and wildflower expert Charlie Gurche recommends an easy 4.6-mile loop that includes Inside Passage, Meadowlark, and Blue Jay trails.

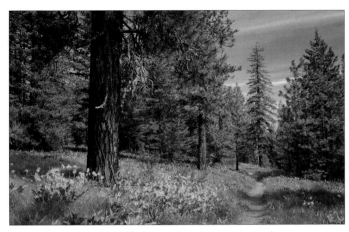

Overland Trail near Sun Mountain Lodge

Photo advice: Bright, sunny days, of which there are many on this side of the Cascades, make photographing flowers in the forest challenging because of the extreme contrast. Working right at sunrise and in the very late afternoon works well in these situations.

Getting there: From Winthrop, head south on WA-20. Immediately after the bridge, look for the sign for Sun Mountain Lodge and turn right onto Twin Lakes Road. In 3.5 miles turn right onto Patterson Lake Road and travel 4 miles to Patterson Lake and the trailhead for Patterson Mountain. Shortly beyond that is the junction for Sun Mountain (an excellent and very attractive resort lodge). Continue on the main road as it becomes Thompson Ridge Road (FR-4410) for the well-signed trailheads in the forest.

Time required: Allow 3-4 hours for either of the hikes, depending on how much time you want to spend with the flowers.

Lake Chelan – Stehekin

Fifty-five-mile long Lake Chelan, nestled in the second deepest gorge in North America (only Great Gorge in Denali National Park is deeper), connects the dry east side of the Cascades with the core of the Cascades mountain range, and provides access to some of the best of North Cascades National Park backcountry. Chelan is North America's third-deepest lake—at its deepest point, the lake is a remarkable 400 feet below sea level.

The town of Chelan (shah-lăn') has developed into a good-sized resort destination, with the requisite motels, restaurants, shopping, and outdoor recreation facilities. The surrounding area of low hills at the edge of the Columbia Basin

desert has been a big apple producer since the construction of the Columbia River dams and irrigation projects, and in recent times has seen the establishment of several vineyards and wineries.

For nature photographers (and lovers of nature in general), the big attraction is at the far end of Lake Chelan, from Stehekin Landing and up the Stehekin River Valley into the remote Cascades. The name Stehekin (steh-hee'-kin) is a Native American word meaning "the way through", and refers to the ancient travel and trade route that went from eastern Washington, up over Cascade Pass and all the way to the Pacific Ocean. Nowadays, the territory from the top end of the lake and up into the Stehekin River Valley is designated as the Lake Chelan National Recreation Area and is administered as part of the North Cascades National Park Complex.

There are no roads to Stehekin, so the options for getting there are private boat, Chelan Airways float plane or one of two passenger ferries. The larger, more well-known Lady of the Lake II offers a leisurely four hour cruise, while the smaller, faster Lady Express reaches Stehekin Landing in about 2½ hours. Ship pilots do a good job of narrating the voyage, pointing out historical sites and natural highlights on the very scenic trip. There is a very nice view of glaciated Buckner Mountain at the head of Stehekin Valley as the boat approaches the end of the lake.

Stehekin Landing includes several lodging options, an excellent restaurant and snack bar, gift shop, and bike & kayak rentals. You can also book a rafting trip or a horseback ride. Wi-fi is available for guests of Stehekin Landing Resort. Pacific Crest Trail through hikers often make Stehekin a stop, even though it's well off the trail, to take advantage of the store, post office, laundry, and showers.

A short walk up the hill is the National Park Service's Golden West Visitor Center. If you're planning to camp at one of the campgrounds in the valley, or venture up into the backcountry, you'll need to pick up a permit at the visitor center. While you're there, check out the work of local photographers Mike and Nancy Barnhart. Pick up one of the interpretive guides for the 0.8-mile Imus Creek Loop nature trail, an easy walk through the forest above the landing. Next door to the Visitor Center is The House That Jack Built, a gallery for locally made arts and crafts in a historic log cabin.

During summer months, shuttle buses leave the landing several times each day, taking visitors up the Stehekin River Valley to Rainbow Falls and campgrounds along the river as far as High Bridge, departure point for trails to Cascade Pass and Bridge Creek. On the return trip, the bus stops at the Stehekin Pastry Company bakery and restaurant for 10 minutes, giving everyone a chance to load up on the delicious pastries and sandwiches. PCT hikers go nuts here after days of trail food chosen mainly for minimal weight and maximum nutrition.

Rainbow Falls

Rainbow Falls is one of the highlights of a trip to Stehekin. One of the most impressive waterfalls in the state of Washington, Rainbow Creek plunges 312 feet, cascades through boulders then fans out over a basalt cliff into a pool for a total drop of 470 feet. Interpretive signs point out that Rainbow Creek is a raging torrent in spring, and the falls can be one giant icicle in winter. In late summer the flow has dwindled such that the main falls may only be a wispy ribbon. The upper falls faces southwest and gets nice light in the late afternoon. An overcast day will give nice, even light on the entire falls from the lower viewpoint. If you want to walk to Rainbow Falls instead of taking the shuttle or tour, it's an easy, almost level 3.5 miles on paved road from Stehekin Landing.

Nearby stands an old schoolhouse, still furnished and a worthy photo subject. More photo opportunities await at the historic Buckner Orchard. Old farm

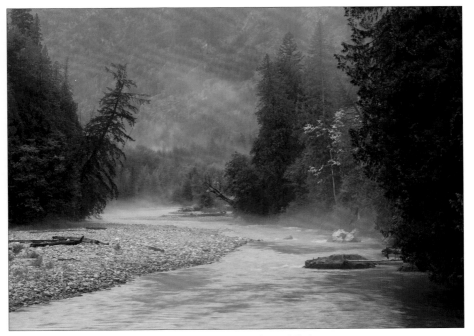

Stehekin River on a foggy fall day

implements are found amongst the still-producing apple trees. While you're there, check out the two-seater outhouse.

If you're camping, you'll find nice river views around Harlequin Campground, 4.4 miles up the road from Stehekin Village. There's a good chance you'll spot black bears along the milky blue Stehekin River. Moose are more common further north, but are regularly sighted from nearby Stehekin River Trail. The trail starts at the south end of Stehekin Airstrip and follows the river for 4.0 miles to Weaver Point boat-in campground on the lake. There are nice (distant) views of Rainbow Falls along the way.

There are many miles of hiking and equestrian trails in Stehekin Valley. Particularly recommended is the Agnes Gorge Trail near High Bridge (last stop for the shuttle). The easy 2.5-mile trail gains 400 feet of elevation while passing excellent views of Agnes Mountain on the way to a deep gorge and waterfall; golden aspen in autumn make the trail even more scenic. The 6.8-mile Rainbow Loop Trail is a popular hike with good views of the valley and surrounding mountains; wildflowers abound in late spring and early summer. Backpackers can opt for the Pacific Crest Trail along Bridge Creek, or follow the Stehekin River all the way up to Cascade Pass.

Photo advice: Around the first week in October, pockets of aspen, vine maple, and bigleaf maple show their autumn colors. Alpine larches are golden then at higher elevations, while cottonwoods down in the valley and by the lake turn a little later. Pacific dogwood trees bloom in early May. If you overnight near Stehekin Landing, try for a sunrise photo looking down the lake from the boat dock or the trail leading south from the Visitor Center.

Getting there: Lake Chelan is reached via US-97/97Alt as it follows the Columbia River in north central Washington. The Lady of the Lake ferry dock is on the south side of the lake on US-97Alt. See the Appendix for phone and website info to check schedules and fares.

Time required: While it's possible to visit Stehekin Valley on a day trip, most of your time would be spent on the boat, with only about 3 hours at the landing and in the valley. A minimum two full days/one night is recommended. A week's vacation at Stehekin would be sublime.

Nearby location: There are some good photo possibilities from the top of Chelan Butte looking down on the Columbia River. Panoramics across the river gorge at sunrise may work well. The butte is a favorite launching site for hang gliders and much of it is designated state Wildlife Area. Get there by driving US-97ALT to about MP 232 in the Lakeside area, then turn southwest onto Chelan Butte Road. The road changes from paved to gravel, reaching the summit in 4.3 miles.

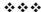

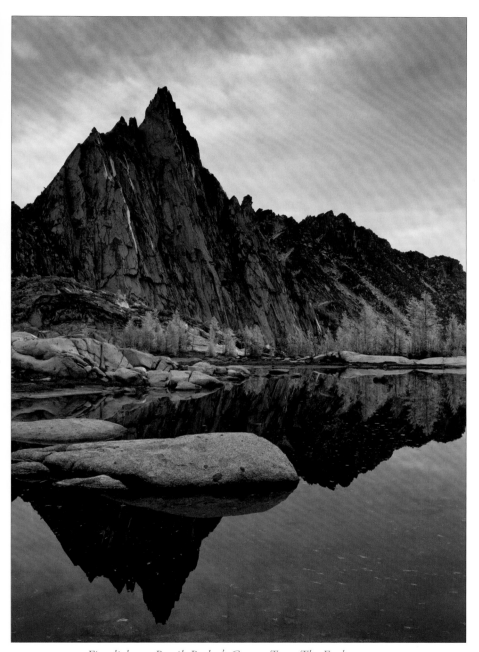

First light on Prusik Peak & Gnome Tarn, The Enchantments

Chapter 8

CENTRAL CASCADES

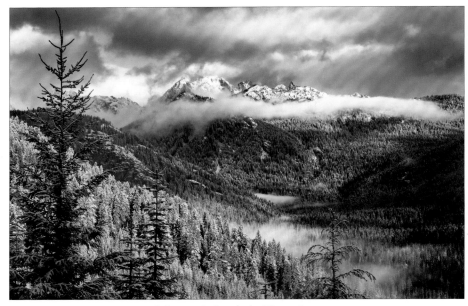

Chikamin Ridge & the Three Queens

CENTRAL CASCADE MOUNTAINS

Many Washingtonians from both sides of the Cascades enjoy making a weekend loop trip that includes US-2 over Stevens Pass, US-97 through Blewett Pass and I-90 over the Snoqualmie Pass. This is a fantastically scenic route with a multitude of opportunities for outdoor photography in all seasons. Spring and summer wildflowers, sparkling lakes nestled below jagged glaciated peaks, hillsides of brilliant fall color, pristine winter scenics of alpine splendor and waterfalls for any season can be found here in the heart of the Cascade Mountains. This chapter will cover the territory in a loop heading clockwise from the Puget Sound metro area over Stevens Pass and returning via Snoqualmie Pass.

Note that for most of the locations mentioned in this chapter, a Northwest Forest Pass or Federal Recreation Lands Pass is required. State-managed lands require a Washington Discover Pass. The passes are not available at all trailheads so it's a good idea to pick them up beforehand at a USFS Ranger Station, State Parks office or licensed retailer. The Discover Pass can also be purchased online.

Stevens Pass – U.S. Highway 2

The terrain at the crest of the Cascades between the Skykomish River and Nason Creek drainages is so rugged that when John Stevens surveyed the area for the Northern Pacific Railway he found no trails or any other evidence that

the Native Americans or early white settlers made use of the 4,056-foot pass. Despite the lack of an existing trail, Stevens determined that this was the best route through the Cascades for a rail line, but to make it work the railroad had to dig a tunnel through the mountains almost 1,200 feet below the pass summit.

With a designation such as US Highway 2, one would think that the Stevens Pass Highway has a lot of history and dates back to origin of the national highway system. In some places that is true of US-2, but the portion of the highway from Everett through Stevens Pass to just west of the Columbia River is relatively recent, having only been completed in 1931.

Today US-2 is a major conduit between western and eastern Washington, and the Stevens Pass Highway sees a lot of traffic from those seeking recreation, outdoor adventure and getaways from the big city. Stevens Pass Ski Area at the pass summit is a world-class alpine ski area with out of this world views from its slopes.

West of the pass, the terrain is typical western Cascades forest with dense stands of Douglas-fir, hemlock, and western redcedar. Bigleaf maple in the lowlands and vine maple higher up turn beautiful shades of yellow, orange and red in autumn. Descending the eastern slope you'll start to see Ponderosa pine and even better fall color from vine maple, aspen, and cottonwood.

Photo advice: Unless you're heading for just one or two specific locations and don't want to leave any gear in your vehicle, pack your whole kit when traveling this route.

Getting there: From Seattle and the metro Puget Sound area, travel I-5 or I-405 to WA-522 at Bothell, then continue north on WA-522 to Monroe, where it meets US-2. If coming from central or eastern Washington, pick up the loop where US-2 meets US-97 in Wenatchee, or just north of the junction of I-90 and I-82 at Ellensburg.

Time required: How much time do you have?

Nearby location: If you're coming from the eastern side of the state and don't want to go to the big city, you can take WA-202 and WA-203 between North Bend and Monroe, traveling through some nice farm country and avoiding most of the urban traffic.

Wallace Falls

A pleasant hike on a very popular trail leads to a series of waterfalls on the Wallace River, including one of the tallest and most impressive plunges in Washington. Going all the way to Upper Falls entails a moderately strenuous 5.5-mile round-trip hike, but Middle Falls, at 265-feet is the big attraction for photographers and is a bit easier to get to with only 4-mile round-trip hike.

From the trailhead, the path heads into a forest of hemlock, alder, and maple, then parallels Wallace River, which can be a raging torrent during spring runoff. The forest here was logged many years ago, as evidenced by the giant stumps

with notches where loggers placed their standing boards. After a little more than a mile you'll come to the junction with Railroad Grade Trail, which you may want to take on return—it adds a mile to the trip but is less steep and easier on the knees. For now stay on Woody Trail with its ups and downs, reaching the Middle Falls viewpoint at 2.1 miles from the trailhead. If you want to check out Upper Falls, continue on the trail for another 0.5 mile and a 500-foot climb. With the popularity of this trail and the limited viewing angle, it's a good idea to visit Wallace Falls on a weekday; if that's not possible, get there early in the morning.

Wallace Falls

Photo advice: The view to Middle Falls looks almost due east. If the falls and tumbling waters of the river are kicking up a lot of misty spray try using a polarizing filter to cut some of the haze (local contrast enhancement in digital processing can also help). As with virtually all waterfalls in the Cascades, stream flow drops considerably in late summer and the falls, while still very nice, are not quite as impressive.

Getting there: Travel US-2 to the town of Gold Bar, about 13 miles east of Monroe. Turn north on 1st Street then in 0.4 mile turn right on May Creek Rd. Follow signs to reach the entrance to Wallace Falls State Park in 1.4 miles. Don't forget your Discover Pass.

Time required: Plan on 3-4 hours to enjoy the hike with plenty of time for photos. Accompanied by a non-photographer? There is a picnic area near the falls.

Nearby location: Wallace Falls State Park has camping cabins and walk-in tent sites, but no drive-in sites and no accommodation for RV campers.

Lake Serene – Bridal Veil Falls

Seattleites seem to think any hike with less than 2,000 elevation gain is just a stroll in the park. Here's another trail that is extremely popular with the Puget Sound crowd, but might be a bit of challenge for those who only occasionally lace up the boots for a day hike.

The popularity of this trail is certainly justified, with views of a couple of waterfalls and a pretty like lake nestled beneath the towering granite cliffs of the Mount Index massif.

To take in both Lake Serene and the side trail to Bridal Veil Falls, plan on a 7.2-mile out and back hike with the requisite 2,000-foot rise in elevation. Starting from the trailhead, the first part of the trail is an easy walk, mostly on

an old logging road, with a steady but gradual grade. At 1.6 miles, a sign points the way for the side trail to Bridal Veil Falls. Continue on the main trail, crossing a footbridge with a view of the falls through the trees, and then start a series of switchbacks. The trail steadily climbs, a rocky path with several sets of well-made stair steps. A couple of waterfalls along the trail are worth working for a variety of photo compositions and effects, but it's best to press on and photograph these falls on the return trip.

In early summer there will be wildflowers in the forest and on the open, vegetated talus slopes, and in autumn there is a bit of fall color from maple trees on the mountainsides. The open slopes also afford fine vistas of the Skykomish River Valley and the distant peaks of the Wild Sky Wilderness.

Continuing up the trail, glimpses of Mount Index give an indication of what's to come. At 3.5 miles the trail reaches a saddle then descends a short distance to the shore of lovely Lake Serene.

In early morning with the glassy surface mirroring the dramatic cliffs and spires of Mount Index rising 3,000 feet directly above, the lake is not only serene but also sublime.

Ouzels, the delightful little bird also known as American Dipper, are most often associated with rivers and creeks, but I enjoyed watching one hop, bob, and dive among the logs on the lakes edge as I worked my way around trying to find a good angle for a lake and mountain composition.

By all means, follow the trail to its end at Lunch Rock, and admire the view even if you didn't pack a picnic. The spur trail to Valley View is also worth the few minutes extra hiking time. The vista from the top of the creek that later forms Bridal Veil Falls is grand, even if there isn't a good photo composition.

On the return trip, take time for some photos of the trailside waterfalls and perhaps the valley and peak views.

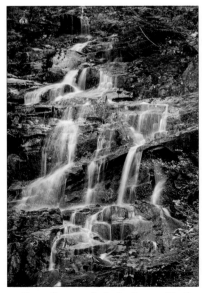

At the junction with the trail to Bridal Veil Falls, take a left and follow the path as it climbs for 0.5 mile to the base of the falls. The billowing spray from the falls precludes getting a photo at trail's end, but a little bit of scrambling achieves a direct side view as the thundering torrent hits bottom. In late summer, the flow diminishes and spray is not a problem.

Back down the stairs and then the easy part of the trail returning to the parking area. Approaching the trailhead, the forest transitions from a variety of conifers to an area that is primarily red alder, trees with greyish white bark reminiscent of aspen.

Some maps and guidebooks show Canyon Falls and Sunset Falls in this same area.

Cascading creek, Lake Serene Trail

Unfortunately, access to them is via private property, with No Trespassing signs posted prominently.

Photo advice: Get to the lake as early in the day as possible. Mount Index gets good light early in the morning but is backlit from late morning on in spring and autumn. It would be ideal to start this hike at 0-dark:30 and arrive at Lake Serene at sunrise to get the first rays of the sun on Mount Index reflected in the calm water of the lake. Hiking with a headlamp would be no problem for the first part of the trail, but the last couple of miles would be tricky in the dark. Backpacking might be an option, but camping is prohibited within ¼ mile of the lake. Bridal Veil Falls faces north, so the problems of extreme contrast from sun hitting the falls are only a concern around the summer solstice when the sun is furthest north in the sky.

Getting there: Travel US-2 to about MP 35, 8 miles east of Gold Bar, and turn onto Mount Index Road (FR-6020). Follow this gravel road for 0.3 mile, turn right at the sign for Lake Serene Trail 1068 and proceed another 500 feet to the parking area at the end of this spur road. As with most USFS trailheads, a Northwest Forest Pass is required here for your vehicle.

Time required: Make this a destination for the day, not just a stop on the way over the pass, so that you have plenty of time for multiple views of the falls, lake, and trailside views of the Skykomish River drainage and distant Cascade peaks.

Nearby location: The South Fork of the Skykomish River makes a series of dramatic drops at Eagle Falls. There's a good view and easy access from a roadside pullout near MP 39 on US-2. At times of high flow from autumn through spring, the falls are a raging torrent of whitewater and it's a challenge to make a pretty picture; when the flow slows and the water clears in summer, it's a nicer scene and the pool below the falls is a popular swimming hole.

Deception Falls

A few miles east of the historic railroad town of Skykomish, look for the signed entrance to Deception Falls Picnic Area. A short path crosses Deception Creek on a footbridge, and then ducks under the highway to a platform view of thundering Upper Falls. It's an impressive waterfall, dropping 60 feet in a series of plunging cascades. Well worth a quick stop on the way over the pass. If you're not in a hurry, stroll the easy 0.5-mile loop trail. Lower Falls is also impressive, although not as photogenic. The trail wanders through beautiful forest along Deception Creek as it joins the Tye River. Giant trees have trunks coated with moss and lichen hanging from branches. Interpretive signs along the way tell the story of forest and river.

Photo advice: The viewing platform for Upper Falls is the only possible angle on this waterfall, but it's actually a quite nice view. Get down low and play with a variety of shutter speeds here; the 1-2 second exposure that works well with

lesser water flows tends to turn this torrent into a washed-out mass of whitewater.

Getting there: The well-signed entrance to the picnic area is found at about Milepost 57 on US-2, about 8 miles east of Skykomish. A gate at the parking area is locked from late autumn to spring, but there is room for a vehicle or two to park on the edge of the highway.

Time required: Half an hour is plenty of time for the photo of Upper Falls. Allow another half hour to include the loop nature trail.

Nearby location: Iron Goat Trail follows the route of the historic Great Northern Railway, with a gentle but continuous climb on the old railroad grade. It is not a particularly great hike for land-

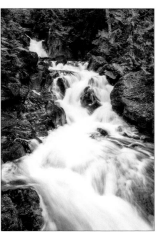

Deception Falls

scape photography, but it's a relatively easy walk suitable for all ages and of interest to history and railroad buffs. An interpretive site and trailhead is located just off US-2 at MP 58.

Lake Wenatchee & Hidden Lake

One of Washington's largest lakes, Wenatchee is a popular recreation area with a large state park campground that is open year round. The north and south shores of the lake are lined with private homes and vacation cabins, affording little opportunity to visitors for access to, or even views of, the lake, with the exception of the state park and at Glacier View Campground at the end of the road on the south side of the lake.

In autumn, good nature photo opportunities do exist at Hidden Lake. From the trailhead near Glacier View Campground an easy-walking trail meanders for 0.6 mile through dense forest to this pretty little lake. In autumn, bright yellow cotton-wood trees and multi-colored vine maple along the lakes shore stand out from the dark green conifers, and alpine larch adorn the steep slopes rising above the lake.

Photo advice: In early morning and just before sunset, the lake is likely to be calm, with the glassy water reflecting the fall color of the trees. The fall color is best in late October.

Getting there: From US-2, go north on WA-207 for 3.5 miles and turn left on Cedar Brae Road at

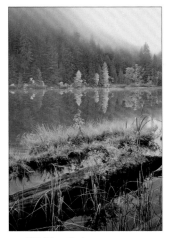

Hidden Lake in autumn

the sign for Nason Creek and Wenatchee State Park. For Hidden Lake, continue on this road for 5 miles to the trailhead. The road ends about half a mile further, at Glacier View Campground.

Time required: An hour is enough for the walk and time for a few photos. If conditions are good you'll likely want to at least double that time.

Nearby location: There are a couple of nice campsites right on the lake at Glacier View Campground, which lives up to its name with a distant view of Glacier Peak to the northwest. With dramatic skies at sunrise or sunset there is potential for good photos looking in that direction; looking east you'll pick up lights from the lakefront houses.

Tumwater Canyon

From Stevens Pass down to Leavenworth, fall color erupts in brilliant shades of yellow, red, and orange along rivers and on the hillsides above US Highway 2. This is a scenic route at any time of year, but during October the maple, dogwood, cottonwood, and groves of aspen trees make this area especially attractive to nature photographers.

Descending from Stevens Pass on the east side, look for fall color starting around Nason Ridge Road at Milepost 81. Near Milepost 86, a mile east of the

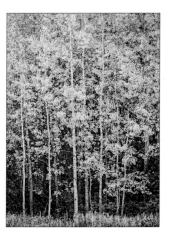

Aspen, Winton Road

junction with State Highway 207 to Lake Wenatchee, look for a classic barn and grove of aspens on the south side of Highway 2. Turn right on the road just east of the barn, then right again at the T-junction onto Winton Road to find more aspen and some red-osier dogwood along this side road.

Tumwater Campground, at Milepost 90.5, closes for the winter after Labor Day, but you can park outside the gate and walk through the campsites and along a trail that follows Wenatchee River. At the end of autumn a nice assortment leaves in varying hues litter the forest floor, lending themselves to close-up studies of texture, pattern, and color.

Across the Wenatchee River at Swiftwater Picnic Area (MP 92.5, about 7 miles west of Leavenworth), bright red and orange vine maple grow among a forest of charred snags and stumps, remnants of a wildfire that burned through this part of the canyon a few years ago.

Closer to Leavenworth the canyon narrows and there are few places to stop along the highway, but there is room to pull off at Tumwater Dam, where a nice grove of cottonwoods line the banks on the opposite side of the river.

Photo advice: The fall color starts around the first of October (or even earlier) at

the higher elevations, working its way down the canyon as the season progresses. Most of the color is gone by the end of October, although there may still be some nice yellow cottonwood close to Leavenworth. If the color is not thick in the forest, try using a telephoto lens to tightly frame one or two trees, or even a small portion of the colorful foliage on one tree.

Getting there: Head east over Stevens Pass on US-2 from the Seattle metro area, or west from Wenatchee and Leavenworth in central Washington.

Time required: Tumwater Canyon makes a good day exploration when fall color is prime, or just take a few minutes to photograph if you see good material on your way through Stevens Pass to another destination.

Nearby location: In early autumn, look for salmon spawning in the Wenatchee River at the above locations.

Leavenworth

Formerly a small, struggling timber and railroad town, Leavenworth transformed itself into a tourist destination when civic leaders convinced businesses and residents to adopt a citywide Bavarian theme. Fortunately, like western-

themed Winthrop, Leavenworth has managed for the most part to maintain a nice, folksy feel and not become a tacky tourist trap.

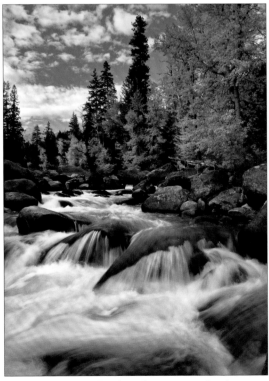

Leavenworth is host to a number of festivals throughout the year, including the Autumn Leaf Festival, the Salmon Festival and Oktoberfest. The town can get rather crowded during these popular festivals and lodging may be scarce without advance reservations. Most of the festivals include an art fair in the downtown plaza and there is usually some very good photography on display from local photographers. The downtown area itself is very photogenic, especially when it is all lit up with holiday lights in winter.

Beyond all the amenities of the town itself, the surrounding area is fantastic for outdoor photographers. Year round, there are great subjects for landscape, nature, and adventure sports images. Stop at the Wenatchee

Icicle Creek (photo by Sean Bagshaw)

River Ranger District office on Highway 2 in the middle of town for maps, trail guides, and current information on conditions and access.

On the west side of town, drive Icicle Road into a canyon for several miles as it follows Icicle Creek deep into the Cascades. A series of easy walking trails, with access points at several trailheads gets you right next to the river for scenes

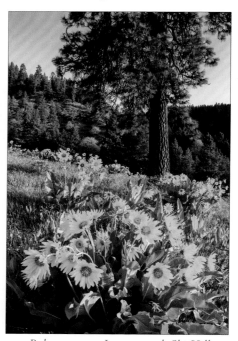

Balsamroot on Leavenworth Ski Hill

that vary from icy water flowing over smooth water-worn bedrock, to torrents of spring runoff cascading over boulders to calm pools during the low water of late summer and early fall. The Icicle Creek area is especially beautiful in autumn with cottonwood and aspen trees lining the river and road and golden larch trees adorning the slopes above. Campers have a choice of several Forest Service campgrounds along the river.

Leavenworth Ski Hill is where the locals go for some winter fun on the slopes. Those same ski runs and cross-country trails are excellent places to find wildflowers in spring. Bright yellow balsamroot are thick on the slopes in late April, with colorful lupine and paintbrush popping up in early May. The Ski Hill is easy to find; from the plaza in the center of town go 0.3 mile west on Highway 2, then turn north on Ski Hill Drive and go 1.4 miles to the parking area.

Photo advice: Icicle Creek is a great place to experiment with longer shutter speeds to blur the flow of water. Depending on lens focal length and desired effect, anything between 1/15 second for close-ups and 2 seconds for broader scenes can produce excellent results. The still pools are excellent for capturing abstract images of color in the reflection of fall color foliage. Look for the best autumn color during the second and third weeks of October.

Getting there: The drive from Seattle to Leavenworth via US-2 through Stevens Pass is about 115 miles and takes a little over 2 hours, assuming good weather and road conditions.

Nearby location: Peshastin Pinnacles State Park, nine miles east of Leavenworth on US-2, features a group of sandstone spires and slabs, some reaching 200 feet into the air. Due to power lines running through the park an overall landscape view can be challenging for photographers, but there are some interesting rock formations to work with. The park is open from March 15 to November 15. Nearby apple and pear orchards along the highway are a visual treat in spring when the trees are covered in blossoms.

Alpine Lakes Wilderness – The Enchantments

On a beautiful early October morning I stood with a 40-pound pack on my back at the bottom of Aasgard Pass and muttered "O-M-G!" Twice. Once for the incredible beauty of milky blue Colchuck Lake and the towering mountains above, and once for the daunting climb ahead of me: a 2,200-foot elevation gain in less than a mile of "trail". Trail is in quotes because the route is basically follow-the-cairns over loose scree and chunks of granite rock after scrambling across a slope of car-sized boulders.

The granite scramble and steep ascent were most definitely worth the effort. For the next several days I wandered through the area known as The Enchantments in Washington state's Alpine Lakes Wilderness. Located on the eastern side of the central Cascade Mountains, the hike to this alpine wonderland is considered by many to be the premier backpack trip in Washington. It didn't take me long to see why, and I'd say it has also got to be one of the absolutely premier locations in the Pacific Northwest for nature and landscape photographers.

The sparking lakes and jagged glaciated peaks of the Alpine Lakes Wilderness are spectacular at any time of year, but become even more incredibly beautiful in autumn when the alpine larch trees turn brilliant with fall color. An anomaly, the larch is a deciduous conifer: the needles change from pine green to lemony yellow to almost orange before dropping.

The trail through The Enchantments winds its way through a terrain of granite boulders and slabs, past a series of stunning alpine lakes, each filled with water of amazing shades of blue. Waterfront backpacker campsites offer million

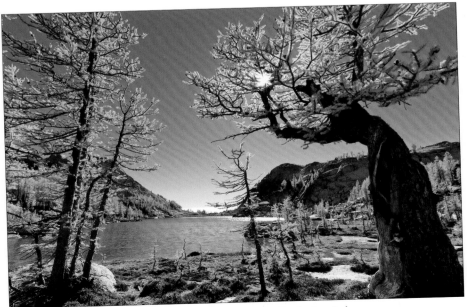

Alpine larch trees in autumn at Perfection Lake

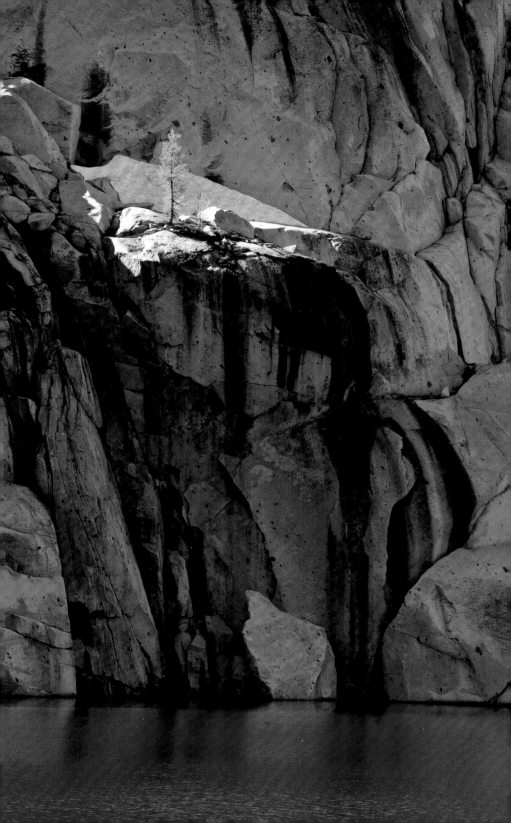

dollar views by day, visits by nonchalant mountain goats, and mind boggling star shows at night.

This is by no means an easy hike—it can be quite a challenge even for experienced backpackers—but is so popular that the number of hikers is limited and permits are required for overnight stays. The permit system is fully explained on the Okanogan-Wenatchee National Forest website.

The most superb scenery in this wonderland is in what's referred to as the Enchantments Basin, and within that the very best locations for photography lie between the area from just above Inspiration Lake down to Lake Viviane.

Hiking west to east in this area, just past the lookout for Crystal Lake and just before the trail starts to drop down to Inspiration Lake, look for side trails leading east up to a broad, rounded granite knob. Some scrambling is required, but from the top of this formation the view is truly superb. Perfection Lake lies directly below, and beyond that Prusik Peak juts skyward, the most distinctive of the jagged spires in the surrounding panorama. This is an awesome spot for sunrise and for night sky photography. A campsite or two can be found at the base of the hill on the west side. Pick a protected site, as it can get windy up here.

After the trail drops and skirts Inspiration Lake, look for the junction with Prusik Pass Trail. Lots of alpine larch here, including one exceptional tree often used as a frame for the view of Prusik Peak. Head up Prusik Pass Trail for a bit and at the top of a large open meadow look for a path on the right leading across the meadow. Follow this path northeast, up and over a ridge to reach Gnome Tarn. Sunrise light hitting Prusik Peak reflected in this little pond is almost guaranteed to be one of your favorite images. Night sky photographers will also love this location; time exposure star trails will form an arc over Prusik Peak looking northeast from Gnome Tarn.

Back on the main trail, the route follows the shoreline of Perfection Lake. Nice views looking southwest from here of Little Annapurna peak rising above the lake. A postcard perfect view with early morning light.

Leprechaun Lake offers fantastic lakeside campsites among the larch and pine trees, with views in all directions. Mountain goats can be seen throughout the Enchantments, but especially seem to like this area and wander at will through campsites. Look for some great views of Prusik Peak from the narrow eastern arm of Leprechaun Lake.

Lake Viviane sits in a granite bowl, with cliffs of smooth rock rising dramatically on the west side. I really enjoyed using a telephoto zoom here to isolate sections of landscape, picking details or aiming for abstracts. The trail down to Lake Viviane is over a slick granite slab and is so steep that iron rebar has been pounded into the rock for steps and hand holds.

Additional information on The Enchantments, and an excellent guide to the trail, is available on the Washington Trails Association website.

Photo advice: The alpine larch get really good at the end of September, with the first week of October reliably the prime time for maximum color. This is the

Left: Granite & larch, Inspiration Lake

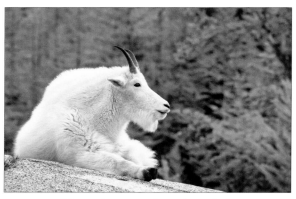

Mountain goat at Leprechaun Lake

same time, however, that the first storms often hit the high Cascades, meaning you may find yourself huddled in a tent under white out conditions or a cold and nasty blow.

Getting there: At the west end of Leavenworth, turn south on Icicle Creek Road and drive about 4 miles to the Snow Creek Trailhead. For the Stuart Lake Trailhead, continue on Icicle Creek Road for another 4 miles, then take a left on FR-7601 (bumpy and rutted but usually passable by passenger cars) and drive to the trailhead parking area at the end of the road.

Time required: There are crazy people who actually run through the Enchantments in one day, and some of them probably even snap a few photos on the way. I found that five days was just barely enough to really see, photograph, and enjoy this magnificent wilderness. Stay longer if you can.

Nearby location: If you didn't get a permit and don't want to hang around Leavenworth hoping to win the daily lottery, or if you want an easier hike requiring fewer days, head for Stuart Lake. A relatively easy trail leads to some pretty awesome views of Mount Stuart and other peaks in the Alpine Lakes Wilderness. This hike is 10 miles round-trip, with about 1,600 feet of elevation gain. Bonus: the water is warm enough to swim in by late summer and the cutthroat trout have been known to swallow some hooks.

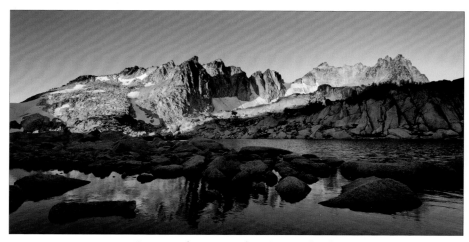

Dragontail at sunrise from Tranquil Lake

Blewett Pass

Winding through the Wenatchee Mountains, the stretch of Highway 97 between US-2 and I-90 is a splendidly scenic route. Most travelers hurry through this route to get to their destination, but photographers may want to make Blewett Pass a destination in itself.

Heading south on US-97 from the junction with US-2 east of Leavenworth, the route passes apple orchards and local produce stands of small family farms, then begins to climb to Blewett Pass. Patches of balsamroot brighten the scenery in spring, and cottonwood trees do the same in autumn. As the route gains elevation, western larch trees stand out from similarly shaped conifers when their needles turn golden in fall. At peak times the fall color in Blewett Pass can be quite spectacular.

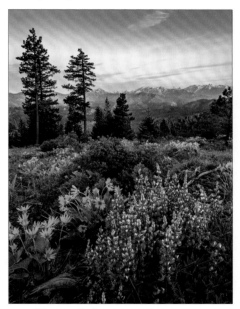

Ingalls Creek Trail is a very enjoyable hike with good opportunities for wildflower photography along a pretty creek and noteworthy views of the surrounding mountains. Find the trail by driving US-97 to MP 178 and turn west on Ingalls Creek Road. Cross the creek, go left at the junction and continue for 1.2 miles to the trailhead.

East of Highway 97 the mountains rise steeply to Tronsen Ridge, an outstanding area for wildflower photography. Always colorful balsamroot, lupine, and paintbrush are profuse on hillsides, meadows and mountain saddles from late May to early June. There are also panoramic vistas to be had, including a great view of the jagged peaks of the Alpine Lakes Wilderness to the west. An easy walking trail runs along ridge

Tronsen Ridge view to Stuart Range

for several miles, or you can wander on the primitive roads and tracks. To get to Tronsen Ridge, drive US-97 to MP 169 and turn east onto FR-7224, marked on a highway sign as Fivemile Road. Proceed up this road for about 3 miles to the signed trailhead for Tronsen Ridge. FR-7224 is a steep, narrow dirt road and may be deeply rutted in spots, so a vehicle with good ground clearance is required.

Blewett Pass is also a historic gold mining area, and there are still a number of active claims along the creeks and primitive roads heading into the mountains. A massive wildfire burned through this whole area in 2012, greatly changing the landscape, but burned areas often quickly become great for wildflowers so it may be worth a visit even if the trees are mostly dead snags. In winter, this area is popular for both motorized and non-motorized snow sports, with designated routes for snowmobiles and snowshoers.

Photo advice: The variation in elevation also means a variation in peak times for spring wildflowers and fall color, but mid-October is generally a good bet for the autumn leaves and mid-May through early June is good for colorful flowers.

Getting there: From Seattle, the most direct route to the Blewett Pass area is via I-90; it's about a 1.5-hour drive.

Time required: Both Ingalls Creek and Tronsen Ridge make great day-long excursions. For overnight trips, backpackers will find campsites along Ingalls Creek Trail and there are roadside primitive camping spots on Tronsen Ridge.

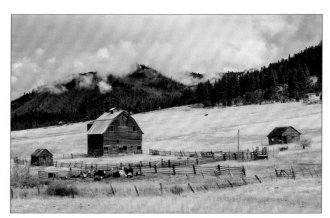
Barn along Highway 97

Nearby location: If you're making a loop trip from Seattle through Stevens Pass and then back over Snoqualmie Pass on I-90, you'll probably want to take the WA-970 cutoff south of Blewett Pass, but if you're a fan of old barns, stay on US-97 for 1.5 miles past the junction with WA-970. A classic weathered wood barn sits next to the highway near Milepost 148, at the edge of very scenic ranch land. This scene is workable in just about any kind of weather and any season; mid-morning to late afternoon light works best on the barn itself.

Alpine Lakes Wilderness – South

The Alpine Lakes Wilderness, perhaps the most scenic of all federally designated wilderness areas in the United States, includes the vast majority of the Cascade Range and Wenatchee Mountains lying between I-90 and US-2. There are several outstanding trails leading into this rugged territory, most requiring overnight or multi-day backpack trips to get to the real scenic gems of the area.

Some of my photographer friends who are also serious backpackers rave about the beauty of Tuck and Robin Lakes, a 14-mile round-trip deep into the Alpine Lakes Wilderness that warrants a 3-4 day trip. Most of those who recommended it also opined that maybe it would be best if I didn't mention Tuck and Robin in this guide—not because they didn't want others to photograph the beautiful granite, glaciers, and azure blue lakes, but because of fears that overuse will spoil the wilderness experience and lead to a permit system such as used for The Enchantments. If you go, tread lightly and use Leave No Trace practices.

A shorter and slightly easier hike in the Rampart Ridge area can be done as a day hike, but really requires an overnight backpack to fully take advantage of the location and visit the several lakes and tiny tarns that dot the landscape. From the trailhead, it's 8 miles round-trip to Rachel Lake, the first and largest lake of the hike. The first couple of miles are a gentle ascent, but then there is a switchbacking climb with an elevation gain of 1,300 feet in a mile of track. The effort is well worth it, particularly in autumn because there are plenty of colorful larch trees on the slopes and around the lakes. The rocky, open terrain also sports a good variety of wildflowers in summer.

An option for those who want to car camp and have great scenery with vehicle access nearby is to head for Cle Elum Lake and beyond, to Salmon la Sac or Cooper Lake. Exploring FR-4600 above Cooper Lake and FR-4330 along the Cle Elum River will likely be very productive.

For some great fall color, drive up the North Fork Teanaway River for photos of the golden yellow Lyall Larch. For yet more outstanding backpacker hikes in the Alpine Lakes Wilderness, continue along the river on FR-9737 until the road ends and trails begin for treks into the Wenatchee Mountains.

Photo advice: In some years, the fall color starts as early as mid-September on the eastern side of Snoqualmie Pass, but in general the best color is between the end of September and mid- October. The alpine scenery is even more spectacular after the first snows in autumn, but be careful not to get caught on mountain roads or backcountry trails if Mother Nature suddenly dumps a load of the white stuff. Wildflowers can linger in the higher elevation areas until late summer.

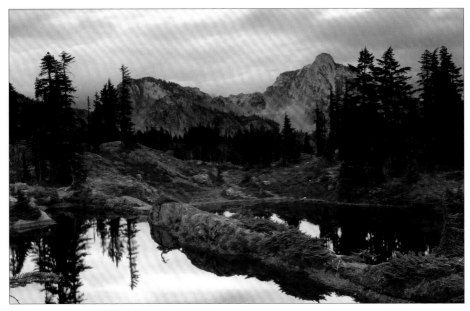

Hi Box Mountain reflected in Ramparts Lakes (photo by Don Geyer)

Getting there: For Teanaway Basin, travel WA-970 between Blewett Pass and I-90 to Teanaway Road, CR-970 and head north, staying right at the junction to continue along the North Fork Teanaway. For the Cle Elum Basin and Cooper Lake, exit I-90 at the town of Cle Elum and head north on WA-903, which becomes Salmon la Sac Road as it follows the eastern shore of Cle Elum Lake. For the Ramparts Ridge hike, travel I-90 to Exit 62 and go north on FR-49 for 5 miles, following signs for Kachess Lake Campground. Turn left onto FR-4930 and drive about 4 miles to the end of the road and trailhead parking.

Time required: As mentioned above, multi-day trips are really the best idea in this beautiful region, but a day trip can work well for the Cle Elum area or perhaps fall color landscapes found close to I-90.

Nearby location: If you were a fan of the TV series "Northern Exposure", be sure to visit Roslyn, a historic mining town that was cast as Cicely, Alaska. The mural on the side of the Roslyn Café will be instantly recognizable. Peek in the window of the set for radio station KBHR, and belly up to the bar at The Brick, the oldest continuously operating saloon in the state of Washington.

Snoqualmie Pass

Like many cross-Cascade routes, the way through Snoqualmie Pass was first a trail used by the early Native American inhabitants on both sides of the mountains, then a wagon road, followed by a railroad line and finally a motor vehicle road. In the late 1960's, Interstate 90 was built, making the historic passage the most heavily trafficked route between Seattle and eastern Washington. With a summit elevation of 3,022 feet, the pass gets plenty of snow, and is the closest developed alpine ski area to the Seattle metro area. Opportunities to get off the freeway for landscape photography are somewhat limited, but there is plenty of pretty nature here.

Snow Lake Trail is one of Washington's most popular paths, with easy access for Seattleites into the always-gorgeous Alpine Lakes Wilderness. There are several steep sections on this 8-mile round-trip hike, but overall the 1,300-foot elevation gain is not difficult to manage and the lake is quite scenic. You might find yourself sharing the views with deer or mountain goats. Keep in mind that on weekends, the trail traffic gets pretty heavy. Find the trailhead across the parking lot from the lodge at Alpental Ski Area, just north of the freeway exits for the main Snoqualmie Pass Ski Area.

The Ira Spring Trail, just a few miles west of Snoqualmie Pass, is named in honor of Washington's most well-known trail pioneer and advocate. Spring was a photographer whose images had a huge influence in the establishment and protection of the state's trails and wild areas. The series of trail guides he co-authored with Harvey Manning are excellent references for hikers and nature photographers. The namesake trail, 6.0 miles round-trip with an elevation gain of 2,550 feet, leads into the Alpine Lakes Wilderness, passing through forest on

its way to the deep pool of Mason Lake. A side trip to Bandera Mountain nets a nice view of Mount Rainier. Hardy hikers can continue up to Mount Defiance for great views of surrounding Cascade Peaks, and in summer a profusion of wildflowers on south facing slopes.

Photo advice: While you're not going to find carpets of color on either of these hikes, both areas a good for wildflowering from June through August with peak blossom time around the latter half of July. Fall color in early to mid October can be quite nice all around Snoqualmie Pass. Both trails are also very good for snowshoeing to winter scenics.

Getting there: For Snow Lake Trail, travel I-90 to the summit of Snoqualmie Pass (Exit 52 if traveling eastbound from Seattle or Exit 53 if westbound from central Washington), then follow signs on the north side of the freeway to the Alpental Ski Area. To reach the trailhead for Ira Spring Trail, take Exit 45, turn north and follow FR-9030 for about a mile. At the fork, turn left onto FR-9031 and continue for 3 miles to the end of the road.

Time required: The hike to Snow Lake and the Ira Spring Trail are both great for a daylong excursion.

Nearby location: For a short, easy hike, maybe just a leg stretcher to break up a long road trip, try the Gold Creek Pond Trail just east of Snoqualmie Pass summit. A paved, 1.25-mile loop circles a small lake in habitat created for wildlife and recreation at the site of a gravel pit that was used during the construction of the I-90 freeway. On calm days, the lake provides nice reflections for the surrounding Cascade peaks. For a longer hike, Gold Creek Trail leads deep into the Alpine Lakes Wilderness. To get to Gold Creek Pond, take I-90 Exit 54, go north on

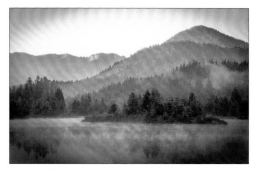

Gold Creek Pond, Snoqualmie Pass

FR-9090 then almost immediately turn right on Lake Mardee Road, FR-4832. Look for the signed turn to Gold Creek Pond on the left just after Keelchelus Lake comes into view on the right.

Franklin Falls

It's rather odd to hike through dense old-growth forest to photograph this beautiful waterfall while at the same time hearing a constant roar of freeway traffic just above. In this narrow canyon just west of Snoqualmie Pass, Interstate 90 splits into east and west bound highways, with the South Fork Snoqualmie River winding its way through a gorge beneath and between the twin roads.

The 70-foot plunge of Franklin Falls is, however, well worth photographing, and the hike to get there passes through some lovely stands of giant redcedar, western hemlock, and Douglas-fir trees. Some of the cedar trees have spreading roots at their base which make very good photo studies.

The 2-mile round-trip hike begins in an area of Forest Service cabins, following Denny Creek through the forest. After one mile the trail drops down to the

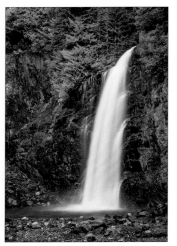

Franklin Falls

plunge pool for Franklin Falls. On hot summer days, this is a popular swimming hole, so you might want to plan to be there early on a weekday. For the return trip, retrace your steps or continue on a loop trail that is partially on the old Snoqualmie Pass Wagon Road. A sign says wagon ruts can still be seen, but these days they're pretty faint. Returning this way is an easier walk on a nice dirt and duff trail, but the forest is not nearly as attractive as the first part of the loop.

Photo advice: As always, overcast days work best for waterfalls, and in times of heavy stream flow there is a lot spray to contend with. This waterfall remains shaded until mid-morning.

Getting there: From the Seattle area, drive I-90 east to Exit 47, cross the freeway and turn right on FR-9034. In 0.3 mile go left on FR-5800 and proceed 2.3 miles to Denny Creek Campground and the trailhead for Franklin Falls. If driving from central Washington on I-90, take Exit 53 at Snoqualmie Pass, cross the freeway and turn right on WA-906, the summit ski area access road. When the road crosses the freeway again, turn left on FR-58 and go 2.5 miles to Denny Creek Campground.

Time required: Two hours is plenty for a leisurely hike and time for exploring multiple photo compositions.

Twin Falls – Olallie State Park

Whenever I feel like complaining about having to lug a backpack full of camera gear up a trail I try to remember the quite elderly lady I met who was coming down this trail with the aid of two canes. She had just done more than two miles with almost a thousand feet of elevation gain. She assured me it was "a lovely walk". I sure hope I share her cheerful outlook, and continue to be on the trail, when I reach that age.

It was indeed a lovely walk, hiking the two-mile round-trip path to visit this pair of waterfalls on the South Fork of the Snoqualmie River. The trail is nice and wide, and well used. Not too strenuous but the elevation gain is enough that couch potatoes will be huffing and puffing.

From the trailhead, it is 0.6 mile to the first view of the falls; continue until reaching a set of stairs at 0.9 mile that lead down to a viewing platform overlooking the lower falls, a 135-foot plunge. Back on the main trail continue upstream for a short distance to a bridge over the river with a view of the upper falls. This segmented drop is the more photogenic of the falls in my opinion.

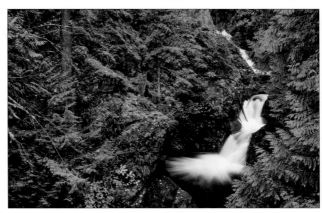

Twin Falls in Olallie State Park

The waterfalls aren't the only attraction here. The trail passes through some wonderful forest, including a few old-growth firs that are ten feet or so in diameter. Other nature photo subjects include the little seasonal side creeks, a variety of ferns, and the mushrooms that pop up in early autumn. Lots of bigleaf maple and vine maple trees in the forest mean this is a good fall color destination as well.

Photo advice: The view of the lower falls from the platform requires a very wide-angle lens to get the whole thing in one frame. Like most Cascade waterfalls, these are raging torrents with solid whitewater and lots of spray during early spring run-off, and they dwindle to reveal lots of bare, black basalt late in summer. Optimum timing is late spring or in autumn after the first rains but before the fall color is gone.

Getting there: Travel I-90 to Exit 34, Edgewick Road, and head south on 468th Ave. for 0.7 mile. Turn left at the sign for Olallie State Park on 159th St., just before a bridge that crosses the river, and drive 0.5 mile to the trailhead at the end of the road.

Time required: Two hours is sufficient to hike the trail and have a little time with the camera, but you could easily spend double that.

Snoqualmie Falls

Thundering Snoqualmie Falls is a impressive sight, so much so that it is considered Washington's most famous waterfall and it gets over 1.5 million visitors each year. The falls are certainly well worth seeing and photographing, but if you try to go there on a sunny summer Sunday afternoon you're likely to find total gridlock in the parking lot and hundreds of people lined up at the viewpoints for the falls. Plan your visit instead for early or late in the day mid-week when you can really enjoy this spectacular 270-foot waterfall.

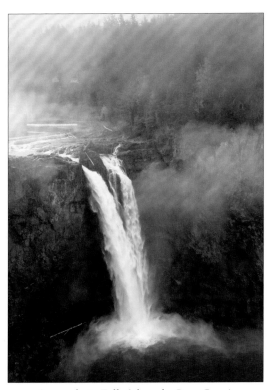
Snoqualmie Falls (photo by Don Geyer)

There are several viewing options for the falls, including the rim top view just off the main parking lot, and a pathway that leads down to the river and the base of the falls. River level is such that with winter rains and spring runoff, you're likely to get spray on your lens from any of the viewpoints.

When photographing the entire falls, it's darn near impossible to avoid getting man-made structures in the picture. The hydroelectric plant sits at river's edge at the top of the falls, and historic Salish Lodge (formerly Snoqualmie Falls Lodge), is perched on a bluff just above the falls on the left side. You can crop very precisely to eliminate those buildings, but keeping them in the frame gives a nice sense of scale on the size and power of this remarkable waterfall.

Photo advice: Peregrine Viewpoint, a short walk along the rim from the parking area, gives a nice angle on the falls from the topside and the amount of spray is usually manageable. After capturing the whole falls, try using a tele-zoom to frame just a section of the plunging water, and play with shutter speeds from a second or more to about 1/30 second for a variety of effects.

Getting there: Traveling I-90, take Exit 25 and head north on Snoqualmie Parkway. In 4 miles, turn left on Railroad Avenue, cross the Snoqualmie River and look for the signs pointing to the falls in half a mile, immediately past Salish Lodge.

Time required: Grab a decent snapshot in 15 minutes or spend a couple of hours hiking to the base of the falls and exploring multiple viewpoints.

❖ ❖ ❖

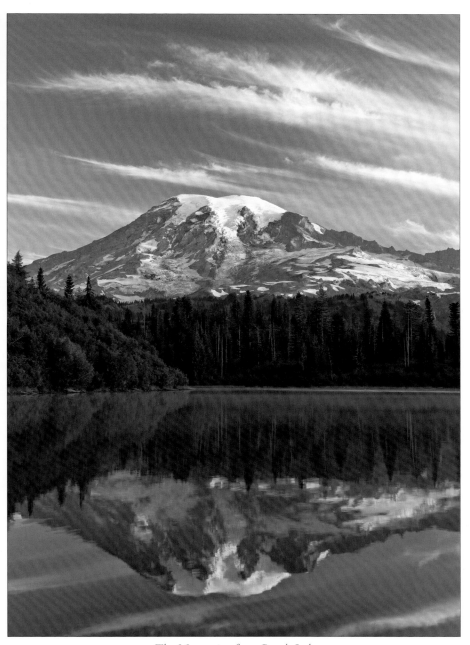

The Mountain, from Bench Lake

Chapter 9

MOUNT RAINIER

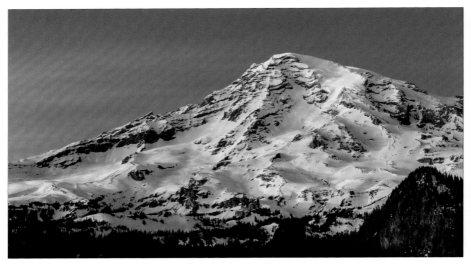

The view from Ricksecker Point at sunset

MOUNT RAINIER NATIONAL PARK

Of all the fire mountains which, like beacons, once blazed along the Pacific Coast, Mount Rainier is the noblest. - John Muir

Superlatives like magnificent and awesome seem inadequate when talking about Mount Rainier. Considered by many the most prominent mountain in the contiguous United States, it is the iconic image of Washington State, perhaps even of the entire Pacific Northwest. The distinctive snow-capped peak is imposing as the dramatic backdrop for classic views of downtown Seattle, and becomes ever more awe-inspiring as you get closer to it.

Called Tahoma by the native Yakama and Klickitat people to the east, and variations of Takhoma by the Puyallups and others in the west, the mountain slopes provided the tribes with an abundance of food and other necessities, and the mountain itself was considered a source of spiritual strength. Certainly today it still lifts the spirits of all who gaze upon it. On his visit to the Puget Sound area in 1792, the British sea captain George Vancouver christened the peak Mount Rainier in honor of his friend, Rear Admiral Peter Rainier. Visible from miles and miles away in all directions, to many Washingtonians today it is often referred to simply as The Mountain.

Technically a stratovolcano, 14,411-foot Mount Rainier was formed by layers and layers of ash and lava flows built up from a succession of volcanic eruptions over eons of time. It is geologically much younger than its neighboring peaks in the Cascade Range, and at one time probably topped out at 16,000 feet. For a million years, steam explosions, sector collapse, glacial carving, and erosion from

flooding sculpted the conical peak into the majestic mountain that we see today. Mount Rainier is, geologically, an active volcano, and has the potential to wreak many times the havoc that Mount Saint Helens did in 1980 if it erupts.

Mount Rainier became our fifth national park on March 2, 1899, when President William McKinley signed the congressional act after a six-year campaign by local citizens, conservationists, business leaders, and national and international dignitaries. Today, upwards of 1.5 million people visit the park each year, taking advantage of year-round recreation opportunities on 140 miles of roads and more than 300 miles of trails on the mountain. Among the attractions is the largest number of projects constructed in the 1930's by the Civilian Conservation Corps that are still in use today in any national park.

The overall Mount Rainier region encompasses 2,800 square miles, and includes not only one of the nation's first national parks, but portions of three national forests and seven designated wilderness areas. There are over one hundred named peaks, vast areas of dense old-growth forest, 300+ jewel-like lakes, more than a hundred waterfalls, acres and acres of colorful wildflower meadows, deep rugged canyons, and the most extensive single-peak glacier system in the country with 25 individual glaciers and fifty permanent snow fields. From the summit to the lowest elevation of 1,610 feet, there are multiple life zones ranging from alpine to lowland temperate rainforest. The abundant wildlife includes black-tailed deer, Rocky Mountain elk, black bear, mountain goat, red fox, hoary marmot, pika, bobcat, mountain lion, pine

Marmot munching on lupine

marten, chipmunk, squirrel, golden eagle, Clark's nutcracker, raven, Steller's jay, gray jay, and a slew of interesting reptiles, amphibians and insects.

For photographers, Mount Rainier National Park offers a myriad of imaging possibilities, from grand panoramic vistas to macro details of wildflowers. As in any place, the more time you take and the more you get out to experience a location in depth, the more you're likely to find and create outstanding photographs, and to appreciate all that the place has to offer. And Mount Rainier has a *lot* to offer.

Planning Your Visit

Mount Rainier National Park encompasses a huge area, and unless you have a lot of time for leisurely wandering and exploring, it's essential to have a good plan covering where you want to go and when to be there. In addition to this guide, I recommend picking up the National Geographic Trails Illustrated Map of Mount Rainier, which is waterproof, tear resistant, and very detailed, with

trails and points of interest well marked. *Day Hiking Mount Rainier* by Dan Nelson and Alan Bauer is a great trail guide, going into more detail and covering many more hikes than I've included here. For outstanding and inspirational photographs, check out books by Ron Warfield, Charles Gurche, and Don Geyer, all titled *Mount Rainier*. Geyer's book in particular is recommended, as it is a season-by-season guide to the park written with photographers in mind. If you can't find these books in advance, they are available at the gift shops in the park.

There are five main areas of Mount Rainier National Park that have the most interest both for photographers and for visitors in general:

• Longmire, near the most often used Nisqually entrance, has the most complete services in the park, including a wilderness information center, museum, lodging, and general store.

• Paradise, with its vast wildlife meadows in summer and extensive winter snow recreation opportunities is the most popular destination in the park.

• Ohanapecosh offers a pleasant place to camp and explore the southeast corner's forests, rivers, and waterfalls.

• Sunrise, the highest point you can drive to in the park, is another favorite for summer wildflowers and scenic hikes.

• Mowich Lake and Carbon River in the northwest corner are somewhat remote and therefore much less visited but with vistas that are among the best.

Within the park, lodging is available year-round at National Park Inn at Longmire, and in summer only at Paradise Inn. Outside of the park, lodging is available in Packwood in the southeast and in Ashford near the southwest Nisqually entrance. Summer season campgrounds are located at Cougar Rock near Longmire, Ohanapecosh in the southeast corner, and White River near Sunrise. These campgrounds have room for RVs, but no hookups. A small campground at Mowich Lake is walk-in only. Camping is allowed only in designated sites, and sleeping in vehicles along the roads or in parking lots is prohibited. Backpacker campsites are scattered throughout the park, and require a backcountry camping permit, available during business hours from the visitor centers and ranger stations. Be advised that without reservations, it can be difficult or impossible to find lodging or a campsite on summer weekends.

Should you be traveling with a non-photographer—or someone who doesn't appreciate the delights of pre-dawn setups and staying at a promising location for half an hour after sunset, hoping the light will get glorious—I highly recommend staying at the National Park Inn in Longmire. Your friend probably won't mind sitting in one of the rocking chairs on the front porch with a latte or glass of wine, gazing up at The Mountain between passages in a good book. Alternatively, a stuffed chair in front of the fireplace in the great hall at Paradise Inn will probably suffice quite nicely.

There are restaurants at Longmire, Paradise, and Sunrise. The general store at Longmire has a pretty good selection of hiking and camping supplies, and the gift shops at Paradise and Sunrise carry a few essential items. Gasoline is not available anywhere within the park, and not for quite a few miles from the

northeast section, so it's a good idea to fill the tank at Morton, Eatonville, Elbe, Ashford, Packwood, or Enumclaw.

Cell phone service is spotty around Mount Rainier. I've been able to get marginal reception at Sunrise and from Panorama Point on Skyline Trail (but not down lower at Paradise), and surprisingly, at a pullout on the big hairpin turn heading down into Stevens Canyon from Reflection Lakes. On the southwest side, it's necessary to drive a few miles west of Ashford on WA-706 to pick up a signal. At last check there was no wi-fi service at any of the lodges or visitor centers in the park. The café at Whittakers Bunkhouse and a couple of other places in Ashford have wi-fi, as does The Bean Tree coffee shop in Morton and Butter Butte Coffee in Packwood. The situation may have improved by the time you read this.

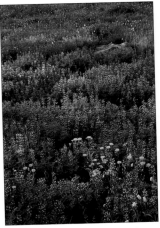

In winter, the only road that is open is the route from the Nisqually Entrance to Longmire and up to Paradise. Between Longmire and Paradise, the road is closed each night at dusk and opening time in the morning depends on how much clearing the snow plows have to do (the sign on the gate says 8 AM, but it's often earlier than that). Stevens Canyon Road, Sunrise Road, and the road to Mowich Lake are open from late June or early July until closed by snow in October. WA-123 and WA-410 on the east side are open May through November.

Lupine & aster at Paradise

You can get a report on current road conditions by calling the Park Service or checking online *(see Appendix)*. This is especially important in autumn and early summer, but it's also a good idea at any time of year because road washouts and landslides occur with some frequency.

When hiking, always carry the Ten Essentials *(see Introduction chapter)*. Word of advice: mountain meadows mean mosquitoes, and on some summer days the little black flies can be extremely annoying, so don't forget to pack bug repellent. Because of the number of people who visit Mount Rainier, it's really important to stay on the trails so as not to destroy what we all come to experience and photograph. Off-trail travel is strictly prohibited at Paradise and Sunrise. Note too that pets and bicycles are not allowed on any of the trails in the park.

Rising 7,000 feet above the surrounding mountains, Tahoma creates it own weather as moist winds coming off the Pacific Ocean hit the massive mountain. The Longmire area receives an average of 80 inches of precipitation each year and Paradise gets around 112 inches, burying the meadows under tens of feet of snow each winter. Conditions can change rapidly so it is important to be prepared for possible snow and freezing temperatures at any time from September through June, and for rain in all months of the year. Clouds and fog can roll in quickly, hiding landmarks. The formation of a lenticular cloud over Rainier is a sure sign that there will be rain within 24 hours.

Visiting Mount Rainier, you may find clear blue cloudless skies or you may not even be able to see the mountain for the clouds or fog, which can last for days. What to do if the weather gods aren't giving you that glorious light and you can't even see The Mountain? Pray for a break and in the meantime take advantage of the nice soft light to work on waterfalls, wildlife, wildflower close-ups, and forest scenes. Don't despair in "bad" weather, my very first large print sale was a photo taken during an afternoon of dim light, fog, and constant rain along Nisqually Vista Trail.

Corn lily or False Hellebore

Mount Rainier is considered an active, rather than dormant or extinct, volcano, meaning that there is a definite possibility that it could erupt again, but for visitors, large unexpected flows of rock, mud, and debris, known to geologists as lahars, are a much greater threat and more likely to occur than a volcanic eruption. Stay alert in river valleys, and if you hear a loud rumbling noise or see a rapid rise in river level, get to higher ground immediately. Longmire, as well as the campgrounds at Cougar Rock, Ohanapecosh, and White River are all in potential flood zones.

The popularity of Mount Rainier means that it can be overrun with hordes of visitors on summer weekends. The parking lot at Paradise fills early and there is a constant procession of hikers on the trails. If at all possible, make your own visit mid-week and you'll have a much more enjoyable experience. But even on busy summer days at the height of wildflower season, if you hit the trail at dawn or linger until sunset you'll probably find only a few other dedicated photographers sharing the sweet light.

Where to be at those times of gorgeous light at the beginning and end of the day? Here are a few suggestions for sunset:
- The Mountain from Longmire Meadow, Ricksecker Point, Glacier View, Gobblers Knob, Tolmie Peak, Eunice Lake, and Spray Park
- The Tatoosh Range from Alta Vista or Skyline Trail, or Inspiration Point.
- Pinnacle Peak from the pullout just west of Reflection Lakes

And for sunrise:
- Mount Rainier reflected in Reflection, Bench, or Upper Tipsoo Lake
- Alpenglow or the first rays of light hitting the summit from any vantage point at Sunrise, or from Longmire in winter
- The panoramic view over the Cascades from Sunrise Point lookout

When to go? If you're primarily concerned with views of Mount Rainier itself, August, September, and into October generally have the best weather. The prime wildflower season is very dependent on what the preceding spring weather was like, but Paradise usually hits its peak the first week of August, Tipsoo about the

same time, and Sunrise a week or so before that. Spray Park can be excellent in mid-August. Just as the wildflowers fade, the huckleberry and mountain ash start turning shades of yellow, orange and crimson, with the best fall color occurring in late September and early October. Vine maple in the lowland forests starts to turn even earlier, in late August. Mid-winter is wondrous at Paradise, particularly right after a storm has blanketed everything with fresh snow and pristine landscapes are just minutes from the parking area via snowshoes or cross-country skis.

What's your plan? To help you figure it out, whether you've got a day or a week, here's a guide to driving distances and times:

Seattle to Paradise via WA-706	99 miles	2.5 hours
Seattle to Sunrise via WA-410 and Enumclaw	96 miles	2 hours
Yakima to Ohanapecosh	71 miles	1.5 hours
Portland-Vancouver to the Nisqually Entrance	145 miles	3 hours
Nisqually entrance to Longmire	7 miles	15 minutes
Longmire to Cougar Rock Campground	2.1 miles	4 minutes
Longmire to Christine Falls (MP 10)	4.2 miles	
Longmire to Ricksecker Viewpoint Loop	6.2 miles	13 minutes
Longmire to Narada Falls	8.3 miles	
Longmire to Stevens Canyon Road Junction	9.0 miles	18 minutes
Longmire to Jackson Visitor Center	12.0 miles	25 minutes
Longmire to Inspiration Point	9.5 miles	
Reflection Lakes	10.5 miles	20 minutes
Bench Lake/Snow Lake Trailhead	11.9 miles	
Martha Falls view (MP 5.5)	14.5 miles	
Box Canyon (MP 8.5)	17.7 miles	35 minutes
Backbone Ridge viewpoint	22.2 miles	
Grove of the Patriarchs	27.9 miles	50 minutes
National Park Entrance Station	28.0 miles	
WA-123 junction	28.2 miles	
Ohanapecosh Visitor Center	29.9 miles	55 minutes
MRNP boundary, WA-123	31.0 miles	
Paradise to Ohanapecosh via Stevens Canyon Rd	23 miles	45 minutes
Ohanapecosh to Sunrise/White River turnoff	17 miles	30 minutes
Sunrise/White River turnoff to Sunrise	15 miles	45 minutes

Milepost markers start at 0 at the Nisqually Entrance, and then again at the junction of Paradise Road and Stevens Canyon Road heading east to Ohanapecosh and Sunrise. On the east side, MP 0 on Washington Highway 123 is at the junction with US Highway 12.

Nisqually Entrance – Longmire

For visitors coming from western Washington and Oregon, the most common point of access to Mount Rainier National Park is at the southwest corner via Washington Highway 706. Immediately past the entry station the road enters a spectacular old-growth forest for the beginning of what has been described as one of the most beautiful drives in the world, winding through a forest of giant Douglas-fir, western hemlock, and western red-cedar. Some of these massive trees are more than 8 feet in diameter, 200 feet high, and over 800 years old. Moss-covered bigleaf maple, vine maple, and dogwood seek the light filtering through the forest canopy. The understory is a wonderfully diverse mix of shrubs, wildflowers, and ferns.

About a mile from the park entrance is the turn for West Side Road. At one time there was a plan for a driveable route from here to the Mowich Lake area in the northwest corner of the park but only about ten miles of road was actually built. Due to several washouts, slides, and mudflows in recent years, the road now ends after just three miles. From the end of the road, trails lead to Indian Henrys Hunting Ground and Gobblers Knob, both of which offer spectacular views of the west face of Mount Rainier for hardy hikers. See the section on Westside Viewpoints at the end of this chapter for more on these hikes.

A couple of miles past the turn for Westside Road is the bridge for Kautz Creek, and, if the weather is clear, the first good view of Mount Rainier itself. A recent flood here caused Kautz Creek to cut a new channel just a little east of the bridge. There's a nice picnic area here, good interpretive displays, and a trail that follows the creek and then climbs to a junction with the Wonderland Trail at Indian Henrys Hunting Ground.

Not far beyond Kautz Creek is a pullout and trailhead, on the left at MP5, for Twin Firs Trail. This easy, 0.4-mile loop offers a good introduction to the old-growth forest ecosystem. It's a pleasant hike, but there's much better photo potential around Ohanapecosh in the southeast corner of the park if you're looking for really nice forest photos.

Continuing east, the road briefly skirts the glacier-fed Nisqually River. Depending on the time of year, the river can be a wide, raging torrent or a narrow stream with the wider rocky riverbed littered with trees uprooted from the eroded banks. Red alder and cottonwood trees along the river join the bigleaf maple in the forest for some nice color in autumn.

In 1870, pioneer James Longmire was a member of a party that made the first confirmed successful summit climb of Mount Rainier, and when he returned for another climbing trip in 1883 he discovered a mineral spring in a beautiful meadow. The next year, he began developing Longmire Medical Springs resort. The famous naturalist John Muir stayed at Longmire's hotel when he came to climb Mount Rainier in 1888 (Camp Muir above Paradise is named for him, and Muir was one of the first to suggest national park status for Rainier).

Today, the Longmire area is a National Historic District that includes a visitor

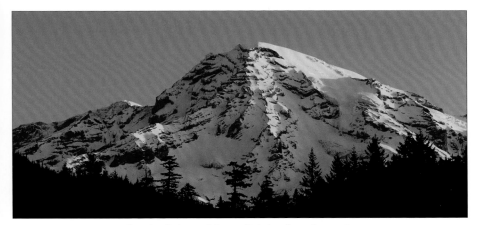

Sunrise light on Mount Rainier from Longmire

center, museum, trails, store, and the National Park Inn. If you're going to be doing any backcountry hiking and camping, stop at the Wilderness Information Center in the historic park headquarters building for permits. The little museum has some nice exhibits on the history, geology, and ecology of the area; it's also a good place to find out about current road and weather conditions in the park. Some photographers report mixed results when asking the rangers here about best locations for wildflowers or fall color, but I've received good information from those on duty at the museum on several occasions. The National Park Inn is the only accommodation in the park open during the winter, and it's a really nice place to stay.

Just across the road from the museum and inn, a path leads to Longmire meadow and a great view of Mount Rainier. On my first visit to the park years ago, I walked out to the meadow and was presented with a postcard-perfect scene: deer browsing in a meadow of wildflowers and snow-capped Mount Rainier looming directly behind. Trail of the Shadows, an easy 0.7-mile hike loops around the meadow and passes the historic mineral springs and a log cabin on the old Longmire homestead. On the west side of the meadow is the junction for Rampart Ridge Trail, a moderately strenuous 4.5-mile loop that goes to the top of a ridge overlooking the Longmire area.

On the east side of Longmire Village, Eagle Peak Saddle Trail begins 50 yards beyond the Nisqually River Suspension Bridge. The trail is somewhat strenuous, gaining 2,950 feet of elevation in 3.6 miles as it climbs steeply through old-growth forest to a great view of Mount Rainier.

Traveling beyond Longmire on the main road through the park, you'll come to the entrance for Cougar Rock Campground in 2 miles. A great place to camp while you work the park, it's also very popular and without reservations the chances of finding an available campsite on summer weekends are dicey. If possible, visit mid-week anyway, just to avoid the crowds in the parking areas and on the more popular trails.

As noted earlier, the road beyond Longmire is closed at night in winter. The sign on the gate says that it opens at 8 AM; the actual opening can be quite a bit earlier, and sometimes later, but in any case not early enough, most unfortunately, to be in place for sunrise views of Rainier or the Tatoosh Range.

Photo advice: The view to the summit of Mount Rainier from Longmire is almost due north. In mid-summer the mountain is only edge-lit at sunrise and sunset, but at other times of the year there is good potential for alpenglow. Mid-morning to mid-afternoon on sunny days, the light is too flat for good photography, but it's a striking scene. In addition to the view from Longmire Meadow, try a telephoto shot of the summit from the parking lot behind National Park Inn.

Getting there: Longmire is 6.5 miles from the Nisqually entrance, about a 15-minute drive if you don't stop along the way.

Nearby location: Wonderland Trail heads northeast from Longmire, following the milky Nisqually River for 2 miles where, shortly after a trail junction at Cougar Rock Campground, it crosses a bridge and turns to follow Paradise River. Carter Falls is visible at 3.3 miles, Madcap Falls in another 0.3 mile.

Comet Falls & Van Trump Park

The trail to Comet Falls and Van Trump Park is one of the most popular hikes at Mount Rainier, and for good reason. The path leads through thick old-growth forest and across open rockslides to 320-foot Comet Falls, perhaps the most spectacular waterfall in Mount Rainier National Park. Climbing through more forest, the trail reaches the broad meadows of Van Trump Park. What photographer can resist a mass of deep blue and fragrant lupine as a foreground with the majestic mountain summit looming above? Throw in some grazing deer or perhaps a couple of mountain goats on the higher slopes for an extra bonus. Visiting in autumn? Fields of huckleberry make this an excellent fall color destination as well.

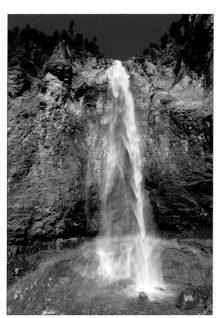

Comet Falls

You'll have to earn the rewards of this hike, however. The trail climbs rather steeply at first, with a 1,200-foot elevation gain in 2 miles to reach the falls, and another mile and 1,000-foot gain to arrive at Van Trump Park. You'll probably want to continue hiking another mile or so through the meadows and up

to Mildred Point for the best views. Mount Saint Helens is visible above the Tatoosh Range to the south, Mount Adams to the southeast, and to the north the Kautz and Van Trump Glaciers accent the upper slopes of Mount Rainier itself. Early summer hikers may have to scramble across rockslides and ford Van Trump Creek. During wildflower season the swarms of flies can be a challenge, even with a generous dousing of bug repellent.

Soon after starting the hike, the trail crosses Van Trump Creek just above Christine Falls (see next section). With good water flow, the view is quite dramatic as the creek surges and drops and carves its way through the bedrock and into a number of bowl-like plunge pools. Just before reaching Comet Falls, the trail crosses a bridge with a good view upstream of a triple waterfall. Comet Falls gets all the glory, but Van Trump Falls is quite beautiful in its own right. Look for pikas and marmots on the rocky open slopes along the way. Most likely you'll hear their high-pitched squeals and squeaks before you catch sight of them. One might think that the two animals are competing for the same limited food supply, but their diets are distinct, with pikas almost exclusively eating grass while the marmots prefer to dine on wildflower blossoms.

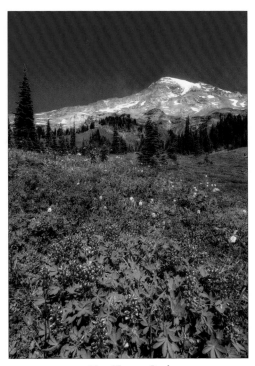

Van Trump Park

Photo advice: Comet Falls faces southeast to east, and on sunny days is directly lit from mid-morning to early afternoon. There's a nice rainbow across the lower part of the main falls when the sun hits the spray just above the plunge pool. Van Trump Falls faces west and works best in the afternoon or on an overcast day. At Van Trump Park, the best light on Mount Rainier's glaciers is late afternoon until sunset.

Getting there: The trailhead is 4.4 miles east of Longmire. The parking area is not large, and due to the popularity of the hike is often full from mid-morning until late in the day.

Time required: Allow at least three hours if only visiting Comet Falls and at least a couple more for the round-trip hike to Van Trump Park. There is a good chance you'll want to linger longer in the meadows if conditions are just right. Don't forget to pack your flashlight, just in case.

Christine Falls & Roadside Viewpoints

Just past milepost 10, look for a parking area on the south side of the road for views of Christine Falls, a very pretty waterfall visible from the bridge across Van Trump Creek. If you miss the first parking area, there is another on the other side of the bridge. Walk down the short path to a viewpoint with excellent

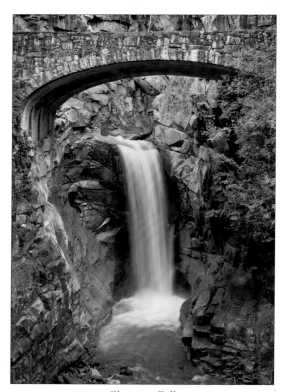

Christine Falls

placement for a photograph of the 40-foot high falls. Use the rockwork bridge to frame the waterfalls, or use a longer focal length lens to just focus on the falls themselves. This shot isn't going to work midday in sunshine due to the extreme contrast, but will be great on overcast days; alternatively try it early in morning or late in the afternoon when surrounding ridges block the direct sun.

Continuing toward Paradise and the eastern part of the park, the road soon crosses another, much larger bridge, this one over the Nisqually River. The view up river to the Nisqually Glacier and the summit of Mount Rainier is impressive. In the 1830's the terminus of the glacier was ¼ mile below the location of the present-day bridge. In the 15+ years that I've been visiting the park, Nisqually Glacier has shrunk very noticeably, as have most of the other glaciers in the Cascades. Late summer visitors see a rather small amount of water, but the size of the riverbed gives a clue to the power of water as it rushes down the mountain during the height of snowmelt, coursing its way to the lowlands and eventually emptying into the Puget Sound at Nisqually National Wildlife Refuge.

Ricksecker Point on the one-mile loop at the top of the grade above glacier-carved Nisqually River Valley is named in honor of Eugene Ricksecker, the designer of the wonderfully scenic road to Paradise. There are good views of Mount Rainier almost due north, the Tatoosh Range to the south and east, and down the river valley to cone-shaped Tumtum Peak in the southwest. The view of Mount Rainier is better from the back of the parking area at the second

viewpoint than it is from the rock wall at the first viewpoint. Late afternoon to sunset light on the peaks can be beautiful here, as shown in the first photo in this chapter.

Narada Falls

Fed by melting snowfields, the crystal clear Paradise River slides down a rocky river bed and then suddenly plunges 160 feet over a wall of dark andesite lava. It is one of the most popular, and most photographed, waterfalls on Mount Rainier. From the parking area, a short (0.2-mile) trail leads to a couple of good viewpoints. The trail is paved, but the 200-foot descent is a bit steep and if icy can be treacherously slippery. During summer the verdant slope is a good place to photograph the large, showy, white flowers of cow parsnip. When the river is running full, the falls are a wide torrent and there is a lot of spray coming up from the plunge pool. In winter, the falls freeze and become a wall of icicles popular with ice climbers. The rock walls around the parking area are a great place to appreciate the work of the CCC crews that built many of the historic structures in the park in the 1930s.

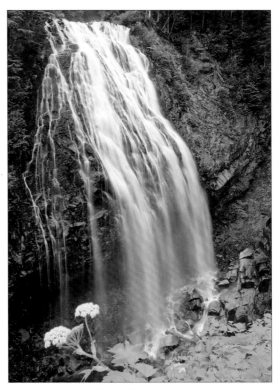

Narada Falls & cow parsnip

Photo advice: The waterfall faces more or less south and gets direct light from a couple of hours after sunrise until early afternoon. If the sun is out, there will likely be a rainbow near the base of the falls.

Getting there: The parking area is 8.3 miles beyond Longmire if coming from the west, or 0.7 mile below the junction with Paradise Road if traveling from the east via Stevens Canyon.

Time required: Half an hour is probably sufficient for a good waterfall photo.

Nearby location: For more waterfall photography, hike the Wonderland Trail from either the Narada Falls parking lot or the trailhead opposite Cougar Rock Campground to Carter Falls and Madcap Falls.

Paradise

The primary destination for most visitors to Mount Rainier National Park, at least in mid- to late-summer, is the Paradise area, and with good reason. When the acres and acres of sloping meadows burst into bloom the scene is truly and memorably spectacular. The area got its name when James Longmire's daughter-in-law Martha first saw these flower-strewn meadows and exclaimed, "This must be what Paradise is like."

John Muir declared the Paradise meadows the most superb subalpine gardens he had ever seen, and in 1898 wrote:

...above the forests there is a zone of the loveliest flowers, fifty miles in circuit and nearly two miles wide, so closely planted and luxuriant that it seems as if Nature, glad to make an open space between woods so dense and ice so deep, were economizing the precious ground, and trying to see how many of her darlings she can get together in one mountain wreath—daisies, anemones, geraniums, columbines, erythroniums, larkspurs, etc., among which we wade knee-deep and waist-deep, the bright corollas in myriads touching petal to petal.

Paradise became so popular in the 1920s-1930s that it was overrun with tourists who trampled what they came to marvel at, camping and parking their cars on the meadows. At one point there was even a golf course in Paradise Valley. Soon after Mount Rainier became a national park, protections began to be put in place; although there are still hordes of tourists on occasion, the Paradise meadows have been preserved for future generations to enjoy. Try wading through the flowers now as Muir did and the park rangers and volunteers (or Meadow Police as one photographer friend calls them) will be on you in no time. The peak of the wildflower season at Paradise, and other areas of Mount Rainier at similar elevation, is late July to early August; the weather during the previous month or two will determine if the bloom is early or late. The first week in August is usually a good bet if you're planning a trip far in advance. At the height of the season, the meadows will be filled with a colorful smorgasbord of lupine, paintbrush, heather, bear grass, aster, elephant head, pasqueflower, and daisy.

For close-ups of the flowers, just about any of the trails that radiate out from the Henry M. Jackson Visitor Center at Paradise will yield great rewards, although this varies by year and by seasonal stages of blooming. I recommend stopping at the Visitor Center to pick up a copy of their free handout "Paradise Area Trails" that shows the location and distances of all the trails in the area. If you're trying to find an area with a mass of color, park rangers can point out on the map specific places where there have been recent reports of good flowering.

Nisqually Vista Trail is an easy 1.2-mile loop through forest and small meadows to a cliff-side view of Nisqually Glacier. In early summer the open areas are carpeted with delicate white avalanche lilies. The trail passes tiny Fairy Pool, sometimes surrounded by lupine and magenta paintbrush.

Another popular and easy walk is the beginning of Skyline Trail heading east

from the visitor center for 0.5 mile to Myrtle Falls and Edith Creek. The paved path is suitable for wheelchairs (with help), and strollers. The view of the creek and Mount Rainier from the bridge above the falls is a photographer's favorite. In years past it was possible to get right down to the creek for the sweeping wide-angle view, but so many photographers tried for that shot that the creekside environment was being destroyed and the Park Service now prohibits getting off the trail. Below the bridge, a short spur trail leads to a view of 70-foot Myrtle Falls, a good subject for the soft light of overcast conditions or else very early or late in the day when there is no direct sunlight on the scene.

Alta Vista Trail gets a bit more strenuous with a 600-foot elevation gain, but as the name suggests, the high viewpoint at the top of the trail affords splendid views all around. On a clear day, Mount Saint Helens and Mount Adams are visible beyond the craggy Tatoosh Range. This trail can also be one of the best for fields of colorful wildflowers in summer and a mass of crimson and orange huckleberry in autumn. It's possible to get some good compositions along this trail with wildflowers in the foreground leading up to the snowy summit of Mount Rainier, although I personally prefer the angle of view a little further east from either Skyline Trail or Lakes Trail. Look

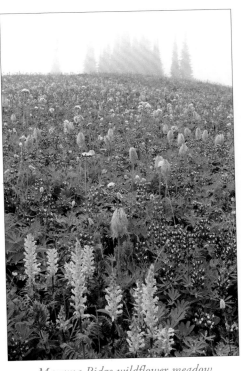

Mazama Ridge wildflower meadow

for hoary marmots munching on lupine flowers right next to the trail.

In the 'not-to-be-missed' category is the Skyline Trail, a 5.5-mile loop that climbs 1,700 feet to Panorama Point for truly wondrous views up to the glaciers of Mount Rainier and out over Paradise Meadows to the Tatoosh Range and beyond. I recommend doing the loop in a counter-clockwise direction, starting as mentioned above for Myrtle Falls. The trail continues eastward on a contour across the sloping meadows for 0.5 mile to the junction with 4th Crossing Trail, then climbs Mazama Ridge to the junction with Lakes Trail in another 0.4 mile. The trail soon turns north and climbs steadily for a couple of miles to reach Panorama Point. If there is a good wildflower bloom you'll probably spend a good deal of time on this section of the trail, composing sweeping vistas with the flowers leading to the snow-capped mountain summit or back to the Tatoosh Range. The view is particularly good at the Stevens-Van Trump Historical

Overleaf: Skyline Trail meadows & the Tatoosh Range

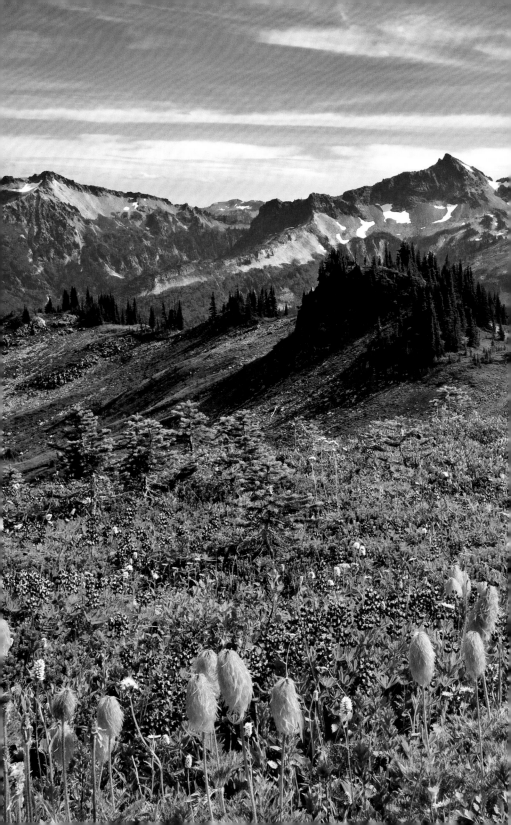

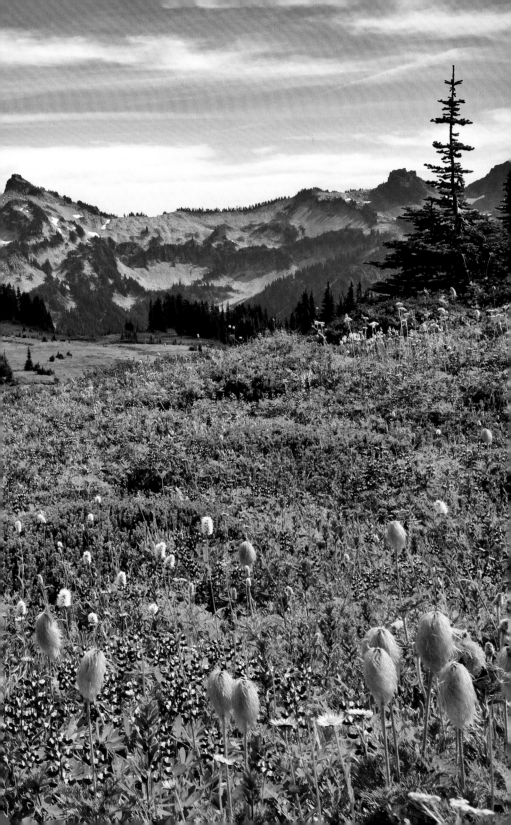

Monument, a stone structure commemorating the first recorded summit climb of Mount Rainier. Once at Panorama Point, the incredible view to the south is the perfect opportunity to make a series of photos with the idea of stitching them together for a panoramic format image. The jagged Tatoosh peaks are the immediate attention getter, but look farther, on a clear day, to peaks in the Goat Rocks Wilderness, Mount Adams, and Mount Saint Helens. From here, the trail climbs a bit more, then turns south to head back towards Jackson Visitor Center, reaching the trailhead in about two miles. The return trip offers options of a short side trip to Glacier Vista for a superb view of Nisqually Glacier or additional hiking on Deadhorse Creek Trail and Alta Vista Trail.

Lakes Trail on Mazama Ridge consistently has some of the best wildflower displays, and the meadows here are one of the best places to try for the iconic photo of Mount Rainier with a mass of colorful blossoms in the foreground. To get to Lakes Trail, head east from the visitor center trailheads on Skyline Trail for 1.4 miles and turn right at the trail junction at the top of Mazama Ridge. Alternatively, start from the top of the loop on Paradise Valley Road and hike up 4th Crossing Trail for 0.3 mile along Paradise River until it meets Skyline Trail. Turn right and continue 0.4 mile to the junction with Lakes Trail on the crest of Mazama Ridge. Head south on Lakes Trail as it descends gradually for about a mile. There are large open meadows and small pockets of flowers between stands of subalpine fir trees. As with the higher Paradise meadows, glacier lilies and avalanche lilies spring up here in profusion when the snow melts away in mid-July,

Paintbrush & pond, Nisqually Vista Trail

to be followed by masses of deep blue lupine accented with paintbrush, bistort, aster, and many more. Huckleberry patches make this a prime area for fall color, too.

Paradise River, just above Paradise Valley Road, is another oft-photographed subject in this area. From the road, start up 4th Crossing Trail and you'll immediately see some possibilities for photo compositions. In late summer yellow monkey-flower and fuchsia-colored Lewis' monkey-flower add brilliant color in the rocky riverbed. Exposures of 1/4 second to 2 seconds will give the silky flow effect on the water. I sometimes like to play with shutter speeds of around 1/8 to 1/15 second, which doesn't freeze the action but can give some very interesting results with the flow and any spray. The effect will vary from moment to moment, so it's great to be able to quickly check the LCD on digital cameras.

No matter which trail you take, please stay on the path. There are plenty of great photos to be made that don't require trampling the flowers, and even stepping on what appears to be bare dirt in a meadow can damage the delicate ecology of the meadows. Admittedly, it's really tempting sometimes to just take a few steps off trail in hopes of finding a better composition, but consider that every step into the meadow squashes an average of 20 plants, and even if a plant survives the weight of your footstep, its growth may be stunted for years.

Wildflower season isn't the only good time to visit Paradise. The autumn palette of reds, yellows, and oranges provides striking foregrounds for photos of Mount Rainier's summit at places along the Alta Vista, Skyline, and Lakes Trail. Paradise gets huge amounts of snow every year, and a pair of cross-country skis or snowshoes will give you access to fantastic winter scenes.

Paradise Valley in winter

Photo advice: When your aim is to shoot close-ups of the flowers, try to be there early in morning when the air is likely to be still, and when there will be fewer people on the trails. For sweeping landscapes that include the summit of Rainier or the Tatoosh Range, both early morning and late afternoon light can be good. Mid-morning to mid-afternoon on sunny days can at first appear glorious to the eye but the light is flat on the mountain and too contrasty on foreground foliage. If the weather is overcast, foggy or rainy, turn your attention to flower close-ups and tightly framed waterfall images.

Getting there: The way to Paradise is well signed whether approaching from the Nisqually park entrance or the Steven's Canyon entrance. If you're staying at Longmire or Cougar Rock campground, it is a 30-minute drive to the Jackson Visitor Center parking lot.

Time required: Because the meadows are directly adjacent to the parking area, visitor center, and Paradise Inn, it is possible to get a few decent photos here in about an hour, but it's really better to plan for at least half a day, no matter what the season. To allow plenty of time for photos, plan on at least 5 hours for the Skyline Trail loop and 4 hours for the Lakes Trail if the wildflowers are good.

Nearby location: The picnic area just below Jackson Visitor Center is a good place to spot black-tailed deer and, if you're lucky, red fox. You might also see a fox at the lower end of Paradise Valley Road, but in recent times that area has been signed for no stopping—most likely because tourists were feeding the fox.

Inspiration Point & Pinnacle Peak

The view from Inspiration Point, now a large, well-marked lookout along the road, inspired renowned naturalist John Muir to climb Mount Rainier. Even if you don't aspire to bag the summit, the view here is definitely inspirational. Look up to The Mountain, down to the Nisqually Valley and across to the multiple peaks of the Tatoosh Range.

A little further up the road, a small pullout is a convenient place to stop for a great view of the Tatoosh's Pinnacle Peak. Late afternoon and sunset light really brings out the reddish-brown tones of this aptly named volcanic peak.

Rock climbers aim for the jagged summit of Pinnacle Peak, while photographers and hikers scramble up the Pinnacle Peak Trail for some of the very best views of the south side of Mount Rainier. For all but experienced climbers, the trail ends in the saddle area between Pinnacle Peak and Plummer Peak, where a tarn reflects Rainier's summit in summer and colorful huckleberry bushes make a great foreground in autumn. At 2.5 miles round-trip, the trail is not long, but with a 1,050-foot elevation gain it is steep enough to be somewhat strenuous. Look for pikas and marmots along with way.

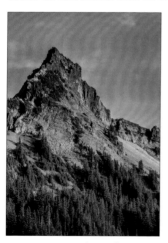

Pinnacle Peak

Photo advice: Even if sunset is not happening at the summit of Mount Rainier, there can be good light at that time for the views of the Tatoosh peaks, and haze in the Nisqually Valley can make for a very nice, moody telephoto composition with stacked mountain ridges fading into the distance. For the best photos of Mount Rainier itself, head up Pinnacle Peak Saddle Trail before dawn to catch the sun's first rays hitting the iconic summit.

Getting there: Inspiration Point is 0.4 miles from the junction with Paradise Valley Road on the Stevens Canyon Road; the Pinnacle Peak view pullout is half a mile beyond that. Trailhead for Pinnacle Peak Saddle Trail is across the road from the Reflection Lakes parking area.

Time required: Unless the light and conditions are exceptional, 10-15 minutes will do the trick at the roadside viewpoints. Allow about 3 hours or more for the Pinnacle Saddle hike.

Reflection Lakes

The image of Mount Rainier mirrored in the glassy surface of Reflection Lake may be the single most photographed view in the national park. It's practically a requirement if you are a photographer. Okay, that's pushing it a little, but almost every photographer who visits Mount Rainier tries for this shot.

There are actually two Reflection Lakes, right next to each other. Most everyone wants to get close to the water's edge for the best reflection, but access to the shoreline is limited, and the vast majority of photos are taken along the few yards of shoreline at the east end of the parking area next to the larger, more westerly lake. Unfortunately that means a lot of human impact on the foliage in this area. It astounds me to see photographers trampling a bunch of plants in order to line up their shot just so with one particular plant that is blooming. Please be careful

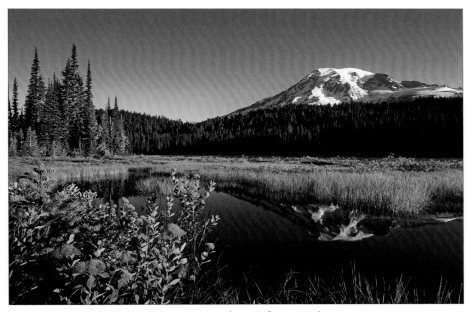

Mount Rainier from Reflection Lake

where you walk, kneel, and lay your camera backpack so that there will be flowers the next time you visit—and so that the Park Service doesn't cordon off the whole shoreline and prevent all of us from getting this photo in the future.

Standard practice is to arrive at Reflection Lakes at the crack of dawn. Most of the time the best light is not when the sun first hits the mountain summit, but it's a very good idea to arrive that early, figure out your composition and get set up so that when the light is just right you're ready. In mid-summer the sun rises far enough to the north that the mountain is only edge lit right at sunrise, and the trees on the far side of the lake form a dark, featureless horizontal band. If you're

lucky, you'll be there on a day when there's surface fog on the water, which both breaks up that dark band of trees and adds a little something extra to the scene.

Reflection Lakes is a great place to meet and talk with other photographers. Several times I've met very accomplished pros there, and on one recent visit Art Wolfe was hanging out at the lake chatting with all the photographers there in between trips to check on a remote camera he'd set up nearby.

Photo advice: There aren't a lot of wildflowers at Reflection Lakes, but those that are there are usually best around the first of August. Many photographers like Reflection Lakes even better in late September and early October when the huckleberry and ash show of their fall colors.

Getting there: From Longmire travel east on the Paradise road for 9 miles, turn right onto Stevens Canyon Road and proceed for 1 mile (it's about a 25-minute drive). From the Stevens Canyon entrance, drive west for 17 miles.

Time required: The photos are only steps from the parking area, so the amount of time you spend here really only depends on how much you want to work the scene.

Nearby location: Bench Lake is also great for a reflection of The Mountain early in the morning, and more than likely you'll be the only one there. It's a fairly easy 0.7-mile hike, and you can get a two-fer here: from the shore looking east for the sunrise over the lake, then pivot around to get the early light hitting the top of Mount Rainier. Autumn is especially nice thanks to the huckleberry and ash surrounding the lake. The trail continues for 0.5 miles to reach Snow Lake, which has nice views of Unicorn Peak, but not Rainier. Look for the trailhead on the south side of the road 1.5 miles east of Reflection Lakes, at the top of Stevens Canyon.

Stevens Canyon

Stevens Canyon may not have any of the iconic views of Mount Rainier, but it is a very scenic drive with several interesting photo stops along the way. In autumn, the south-facing slopes are ablaze with color from masses of huckleberry and vine maple. The canyon is named for Hazard Stevens, who along with P. B. Van Trump made the first documented summit climb of Mount Rainier.

For travelers coming from the west, soon after Reflection Lakes the road passes a view of Louise Lake and then drops through a hairpin turn, crosses Stevens Creek and then turns east, hugging the canyon wall. At milepost 5.5 a convenient wide spot on the shoulder of the road is a good place to stop for a view of Martha Falls. Unicorn Creek comes out of Snow Lake just above and plunges in several segments from a glacier-carved hanging valley to join Stevens Creek. From the road, it's possible to get a nice, if somewhat distant view of a 150-foot drop. Those who hike the Wonderland Trail get a close-up view of a shorter plunge from the pool at the base of the waterfall. It's a 0.6-mile hike from the trailhead below the

big loop turn. At Box Canyon the Muddy Fork of the Cowlitz River has cut a very narrow trough through a glacier-carved valley, creating a gorge 180 feet deep yet only 10-15 feet wide. On the north side of the road, a short trail leads to views of the river from the edge of the chasm, but perhaps the best view is from the middle of the bridge just west of the parking area. On clear days, the distinctive hump of Mount Adams can be seen in the distance to the south.

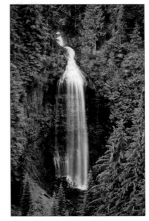

Photo advice: Martha Falls faces north and only gets direct sun in mid-day during the summer. From the roadside pullout, a 200-300mm lens pulls in the main visible section of the waterfall quite nicely. A polarizer will both cut any haze and bring down your shutter speed enough to get the smooth flow effect on the water. Box Canyon is an interesting sight, but a challenge to get anything more than a documentary shot, and even for that works only with soft overcast light.

Getting there: The Martha Falls viewpoint is 4 miles east of Reflection Lakes, and Box Canyon is 3 miles

Martha Falls

further east at MP 8.5. If traveling from the east, Box Canyon is 10 miles west of the Stevens Canyon Entrance to the park.

Time required: If not electing the hikes, both of these locations can be captured adequately from the roadside viewpoints in 10-15 minutes.

Nearby location: A long pullout at the end of Backbone Ridge, MP 13) affords an impressive view of Mount Rainier's summit looking northwest over Stevens Canyon. Mount Adams can be seen in the distance to the south.

Grove of the Patriarchs & Ohanapecosh

In the southeast corner of Mount Rainier National Park, near the Stevens Canyon entrance and Ohanapecosh campground and visitor center, the Grove of the Patriarchs Trail leads to a prime example of lowland old-growth forest. This stand of giant Douglas-fir, western red-cedar, and western hemlock includes some trees more than 1,000 years old and 8-10 feet in diameter at chest height. The understory includes moss-covered nurse logs and ferns, salmonberry, vanilla leaf, and other shade-tolerant shrubs and wildflowers. From the parking area the easy 1.5-mile round-trip trail follows the Ohanapecosh River, then crosses a bridge to reach the Grove of the Patriarchs on an island in the river. A 0.5-mile loop on the island, much of it on boardwalk, circles some of the densest forest. With its massive, 300-foot tall trees, the grove is quite reminiscent of the redwoods on California's north coast.

The Ohanapecosh Visitor Center, open late May (Memorial Day weekend) through early October, has some very nice interpretive displays on forest ecology

and the history of the area, including some hands-on stuff for kids. An easy 0.5-mile loop nature trail leads to hot springs, where steaming water gurgles out of the ground and runs downslope to the Ohanapecosh River. The hot springs are not very photogenic, but it's a pleasant walk and placards along the way serve to identify the flora.

Silver Falls can be reached from the visitor center and campground by continuing on the trail that goes to the hot springs, or drive to the unsigned trailhead on Highway 123 immediately south of the Stevens Canyon Entrance. From the highway trailhead, it's 0.3 miles to descend to the falls, with a good photo vantage about halfway down. From the visitor center and campground, it's a nice 2.5-mile loop, up one side of the Ohanapecosh River and down the other.

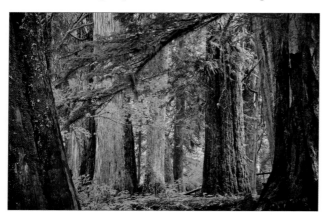

Grove of the Patriarchs

Deer Creek Falls is also just a short hike from the highway. This segmented waterfall slides over smooth, sandy-colored bedrock, with a couple of emerald pools where the flow pauses on its descent to meet Chinook Creek. The trail is a nice duff-and-dirt path, with a good, if somewhat treacherous, vantage point about 0.2 mile down from the highway trailhead.

Serious waterfall lovers may want to hike the 10-mile long Eastside Trail that parallels WA-123 and passes several falls where tributaries join Chinook Creek and the Ohanapecosh River. Access this trail at the Stevens Canyon Entrance, Tipsoo Lake or from the Deer Creek Trail.

Photo advice: Since you don't really want a bright, sunny day when shooting waterfalls or forest understory, this is a good area to go to when views of the mountain are poor or non-existent due to clouds, fog or rain. A polarizing filter will bring out verdant greens in the forest and help in getting shutter speeds down to the range necessary for a smooth, flowing effect with waterfalls.

Getting there: Grove of the Patriarchs is about a quarter mile west of the Stevens Canyon entrance at WA-123. The Ohanapecosh Visitor Center and campground is 2 miles south of the park entrance. Traveling from the west, it's about a one-hour drive from Longmire to Ohanapecosh if you only make very brief stops along the way. Note that Stevens Canyon Road and the Ohanapecosh area are closed in winter. The trail for Deer Creek Falls is signed as the Owyhigh Lakes Trail near MP 12 on WA-123, half a mile south of the bridge that crosses Deer Creek; park at a wide spot across the road immediately south of the trailhead.

Time required: Allow an hour or more for Grove of the Patriarchs, perhaps half an hour each for Silver Falls and Deer Creek Falls.

Nearby location: Gas, food, coffee, and wi-fi (what else do you need?) are available in the town of Packwood, 12 miles south of Ohanapecosh.

Tipsoo Lake & Naches Peak Loop Trail

On the eastern border of the park at Chinook Pass, the Tipsoo Lake and Naches Peak Loop Trail is another favorite for photographers and hikers. It's also high on everyone's list of best places for wildflowers. Tipsoo is a very pretty little high mountain lake with nice views of Mount Rainier. In spring the lake is surrounded by a green meadow with colorful lupine, paintbrush, spirea, and other wildflowers. Come autumn, the fall color is great thanks to thickets of huckleberry bushes. A 0.5-mile path circles the lake, and it's possible to get a nice reflection of Mount Rainier from the northeast corner of the lake, although the view is partially obscured by trees. A somewhat better view that encompasses the lake and the mountain can be had from the roadside parking area just above the lake on Highway 410.

For really grand views of Mount Rainier, some of the best in the park, hike the 4-mile Naches Peak Loop Trail. It's a relatively easy walk, with 500 feet of elevation gain but no really steep or challenging sections.

From the parking lot for Tipsoo Lake, start walking toward the lake but turn left at the first trail junction and head north, up through a meadow. In spring this hillside is covered with lupine, paintbrush, corn lily, and tall aster. The trail soon comes to a junction with the Pacific Crest Trail, and a footbridge over the highway. Continuing on the trail as it bends its way around the northeast flank of Naches Peak, you'll pass the boundary sign for the William O. Douglas Wilderness, then leave the forest for more open areas of wildflowers and a beautiful little alpine tarn. The meadow under the rock wall on the north side of the peak remains lush even after the flowering season has mostly past on the sunnier east and south sides.

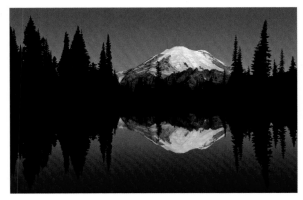

Upper Tipsoo Lake & Mt. Rainier at dawn

In early August the bench meadow on the southeast side of Naches Peak is filled with a good variety of blooming wildflowers, enticing photographers to pull out the close-up gear and spend some time getting intimate with the lovely blossoms. From here the trail soon turns west, with the PCT splitting off and

heading south to the Dewey Lakes basin. In summer you may hear the whump-whump of blue grouse coming up from the valley below, or bugling elk in the fall. Rounding a rocky bend on the south flank of the peak, Mount Rainier suddenly appears in an open area of huckleberry, corn lily, and mountain ash. More mountain views lie ahead as the trail descends on the west side of Naches Peak, passing tiny Upper Tipsoo Lake just before reaching the highway and returning to the parking area.

Photo advice: Peak of the wildflower season here is around the same time as at Paradise, with glacier lilies popping up as the snow melts in late July, soon followed by a multitude of lupine, paintbrush, pasqueflower, and others. A few blooms persist into late August even as the huckleberry and mountain ash begin to add crimson and gold to the scene. This hike is best done in the morning because the views of Mount Rainier will be strongly backlit later in the day. If you're serious about getting the very best photos I recommend that you do it counterclockwise, and that you start at dawn. This means that you'll have to keep looking back over your shoulder for the views of Mount Rainier, but the views are early in the hike this way and this is an excellent place to catch the first rays of sun hitting the mountain's peak.

Getting there: Tipsoo Lake is located on WA-410, 3 miles east of the junction with WA-123 at Cayuse Pass. The drive from either White River Campground or the Stevens Canyon Entrance takes about 20 minutes.

Time required: Plan on about three hours to do the Naches Peak Loop Trail, even more if conditions are great and wildflowers at peak.

Sunrise

Getting my gear ready to hit the trail, I was parked next to a couple of women who had just arrived for some sightseeing. One of them turns to the other and says, in all seriousness, "Do you think we need the camera for anything?" With a view of majestic Mount Rainier on one side and a sloping meadow of wildflowers on the other, I found it rather difficult not to make a comment.

Sunrise is one of the most spectacular and strikingly beautiful areas in Mount Rainier National Park. It is an awesome place to be at sunrise, whether photographing The Mountain or just watching as the sun first hits the summit. And, like Paradise, it is excellent for wildflowers in the summer, with peak season usually late July. At 6,400 feet, the elevation here is higher than at Paradise, but because Sunrise has more porous soil and receives less snow and rain the bloom is a week or two earlier.

As you drive up the road to Sunrise (only open from early July to late October), you'll first come to Sunrise Point, with truly awesome panoramic views to the north, east, and south for many miles. You won't find a great view of Mount Rainier's summit itself from here, but if you've already got that shot,

this too would be an awesome place to shoot at sunrise, silhouetting the jagged Cascade peaks against the dawn sky or catching the first rays of the sun cresting the mountains.

About a half mile before the end of the road and the large parking lot at the Sunrise Visitor Center, a small pullout on the south side of the road is a convenient place to park for a fantastic view of Mount Rainier rising above the White

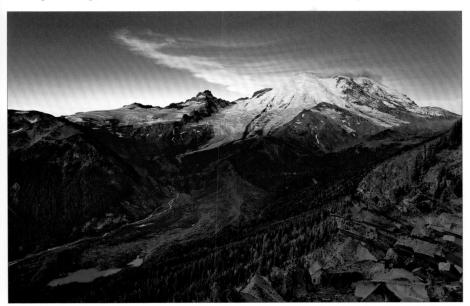

Mount Rainier & Glacier Basin from Sunrise Rim Trail

River Valley. It makes a great panoramic shot, or pull in a little tighter to feature just the summit of the mountain.

Another good view of the glaciated summit is from the Sourdough Nature Trail that starts at the picnic area on the north side of the Visitor Center and goes up through Yakima Park, a large open meadow on the slope leading up to Sourdough Ridge. (High, open meadows in the Cascade mountains are often called parks). Remember to stay on the established pathways; off-trail travel is prohibited.

If you can arrange a shuttle, take the Dege Peak trail from Sunrise Point, following the Sourdough Ridge trail toward Sunrise. The panorama from Dege Peak is limitless and the one-way 3-mile hike keeps The Mountain view always in front of you.

A short walk from the south side of the parking lot at Sunrise leads to Emmons Vista lookout for a wonderful view of Rainier and the White River valley, carved over eons by the massive Emmons Glacier. The view gets even better if you head west from Emmons Vista on Sunrise Rim Trail. The trail passes Shadow Lake and Sunrise Camp (backpacker camping only), then makes a short but steep

climb, reaching Glacier Overlook in 1.5 miles. The rock-walled lookout is a great vantage point for getting sunrise on the mountain photos, and can work well at sunset, too, when clouds swirling around the summit light up.

Berkeley Park is one of the classic hikes of Mount Rainier National Park, and considered by some to be one of the best places in the Pacific Northwest to see and photograph wildflowers. The moderately strenuous hike is 7 miles round trip, with 1,200 feet of elevation gain. The trail is almost entirely in open terrain, so make sure to use sun protection and bring plenty of water. More than likely you'll want bug protection as well while in the meadows. The north flank of Mount Rainier is visible for most of the hike, but to my mind the large, barren ridge of Burroughs Mountain makes it difficult to find a pleasing composition. Berkeley Park is not the place to capture a field of flowers with Rainier in the background, but it is certainly an enjoyable and worthwhile hike.

To reach the wildflower meadows of Berkeley Park, start on the paved path next to the rest rooms on the north side of the parking lot and hike up through Yakima Park for 0.4 mile to the junction with Sourdough Ridge Trail. Head

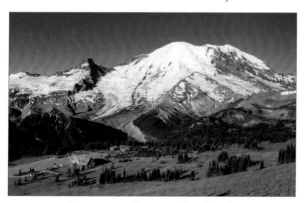

Sunrise vista from Sourdough Ridge

west along the ridge for 1.1 miles to Frozen Lake, then continue west on Wonderland Trail for 0.7 mile. Turn north on Northern Loop Trail at the top of Berkeley Park, following the trail down through open meadows of wildflowers. Brilliant yellow monkey-flower and Lewis' monkey-flower, with its masses of bright pink blossoms, thrive in the moist environment of Lodi Creek even after the lupine and paintbrush have faded in the drier meadows. If you really want to work Berkeley Park, there is a backpacker camp 1.5 miles down the trail. On the way back, you can vary the route by staying on Wonderland Trail at the Frozen Lake junction, then pick up the old road that goes from Sunrise Camp to the visitor center.

Sunrise Visitor Center has some interesting historical and geological displays and is staffed by rangers and volunteers who can offer advice about trail conditions and current best areas for wildflowers. The garden directly in front is planted with native species, conveniently tagged with names for identifying the most common wildflowers. Sunrise Day Lodge has a restaurant/snack bar and gift shop, but no overnight accommodations. Overnight parking is not allowed at Sunrise except for those with backcountry camping permits.

Photo advice: In planning your trip, aim to be at the roadside viewpoint at sunrise, and then move to the Yakima Park area and find your angle while waiting for the sun to crest the ridge just to the east. When the weather is clear it's

reat to be at the viewpoint well before sunrise as the view of Mount Rainier at rst light is wondrous—the white of the snow-covered mountain appears to glow gainst the deep blue pre-dawn sky. A graduated neutral density filter really helps ith the sunrise and sunset landscapes, bringing the range of contrast between ark foregrounds and the bright tones of sky and glacier into something manage-ble by sensors and film.

etting there: From the east side of the park on WA-410, turn at the sign for he White River Entrance. Four miles past the entry station, turn right and head p this road for 11 miles to where it ends in a large parking lot at Sunrise Visitor enter and Day Lodge. If you're camping at White River Campground, allow 0 minutes for the drive up to Sunrise. Plan on 1½ to 2 hours if driving from ongmire or Paradise.

ime required: A minimum of a half-day is needed to make the drive worthwhile nd have time for photography. Allow 4+ hours for the Berkeley Park hike.

earby location: Just south of the turn for the White River Entrance on /A-410 is a rock-walled viewpoint that looks out over the White River valley nd up to the summit of Mount Rainier. White River Campground can be noisy nd busy all summer, but unless you're backpacking it's the only place to camp hat's reasonably close to Sunrise.

Carbon River

At the very northwestern tip of Mount Rainier National Park, glacier-fed arbon River runs through dense temperate rainforest that receives more precipi-tion than any other area in the park. Heavy, repeated flooding in the past few ears has severely damaged Carbon River Road, forcing closure of the road right t the national park boundary. Due to a combination of budget constraints and he likelihood that there will be more flooding in the near future, the road will emain closed to motor vehicle traffic indefinitely.

Hikers and bicyclists are still welcome on Carbon River Road, and Ipsut Creek ampground, 5 miles from the park entrance, remains open. Backcountry camp-g permits are required, and available at the entry ranger station. The 0.5-mile ainforest Nature Trail at the ranger station loops through a prime example of ld-growth temperate rainforest where mosses and ferns thrive beneath giant estern hemlock and red-cedar trees.

Half a mile beyond Ipsut Creek Campground is the junction with the ountain-encircling Wonderland Trail. Heading southeast for 3.5 miles on Vonderland Trail will take you to the snout of Carbon Glacier, one of the largest nd lowest-elevation glaciers in the contiguous United States.

Waterfall fans have the option of several side trails in the Carbon River-Ipsut reek area, including Ipsut Falls, Chenuis Falls, and, on the way to Green Lake, anger Falls. All are easy hikes through dense lowland forest.

A fantastic hike for backpacking photographers is the 17-mile loop starting at Ipsut Creek and taking Wonderland Trail to the Spray Park Trail and picking up the Wonderland Trail again at Mowich Lake to return via Ipsut Pass. A back-country camping permit is required for this hike, and must be secured in person at the Carbon River Ranger Station during business hours. See the Mowich Lake-Spray Park section for more on this area.

Photo advice: As in any forest situation, overcast light works best. A polarizing filter helps bring out the rich greens of the foliage, but turned to maximum polarization it can sometimes make the scene look artificial and lifeless.

Getting there: From the south Puget Sound area, travel WA-167 and WA-410 towards the town of Buckley, then head south on WA-165 through the historic coal mining towns of Wilkeson and Carbonado. Follow the signs, staying left at the fork soon after crossing the bridge over the Carbon River.

Time required: If planning on doing anything more than the nature trail at the park boundary, consider this a half-day trip at the very least.

Spray Park & Mowich Lake

Without hesitation, I recommend a summer visit to meadows of Spray Park for some of the best views of Mount Rainier in the entire park. Acres and acres of flower-strewn meadows with reflective tarns in rocky moraines are backed up by the very photogenic northwest face of magnificent Mount Rainier.

The trail to Spray Park is a moderately strenuous 7 miles out and back, with an elevation gain of 1,600 feet. Add another half mile for a side trip to Spray Falls. From the trailhead at Mowich Lake, the path switchbacks down 0.2-mile to a junction with the Wonderland Trail, then slopes more gently on a contour around the ridge of Hessong Rock. At 2 miles, look for the short spur trail to Spray Falls, a 280-foot drop where Spray Creek fans out while plunging over a cliff and then tumbles down a bouldery slope. The west-facing waterfall gets direct light in the afternoon, so sunny days can be a photographic challenge due to the extreme contrast. As the name of the falls suggests, spray can also be an issue for photographers.

Back on the main trail, a series of steep switchbacks climbs to Spray Park, reaching the first open meadows in another 0.8 mile. If you've planned your trip for good weather, or if you just get lucky, the views of Mount Rainier from these meadows are positively stunning. White avalanche lilies and yellow glacier lilies pop up here as the snow melts in early- to mid-July. The show really starts in late July when masses of subalpine lupine form blankets of blue, accented by the orange, red, and magenta varieties of Indian paintbrush and the bright whites of bistort and valerian. It's tempting to stop at the first good clump of flowers, but the views get even better as the trail continues for half a mile or so on a more gentle climb. The rocky ridge separating Spray Park from Seattle Park

is a good turnaround point. Mid-summer isn't the only good time to visit Spray Park. In late September, look for autumn colors in the meadows and the mirrored reflection of Mount Rainier in the little subalpine tarns.

Rainier reflections are also a good possibility with a hike to Eunice Lake, as is a spectacular mountaintop view from the old fire lookout at Tolmie Peak. The first 2.5 miles from Mowich Lake to Eunice Lake is fairly easy, climbing gently through forest on the Wonderland Trail as far as Ipsut Pass. To the top of Tolmie gets a bit more strenuous, with a continual and somewhat steep climb for about a mile beyond Eunice Lake. If you're really ambitious, set out on this hike at oh dark thirty to capture sunrise light raking the ridges and glaciers of Tahoma.

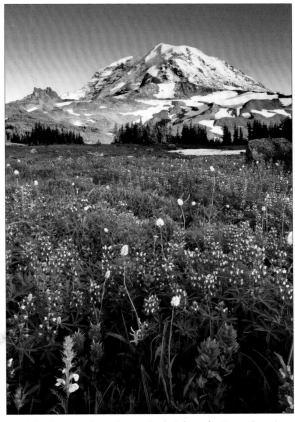

Mt. Rainier from Spray Park (photo by Don Geyer)

Mowich Lake, the largest lake in Mount Rainier National Park, is a scintillating jewel, deep cerulean blue in the center, fading to aquamarine with touches of jade in shallow spots along the shore. Somewhat surprisingly, there doesn't seem to be a trail that circles the lake, although even if there was a path along the northwest shore, the view towards Mount Rainier from Mowich Lake is mostly blocked by the high ridge of Hessong Rock.

During mid-summer, Spray Park gets lots of visitors, so if possible plan a mid-week trip to avoid the crowds. Backcountry camping in Spray Park is now prohibited, in an attempt to lessen the impacts on the sensitive meadow habitat. There is a walk-in only camping area at Mowich Lake; if you've got a van or truck camper, don't let the rangers catch you sleeping in it or they will tell you to drive back out to the park boundary for an overnight stay. Trailers and large RVs are not advised due to lack of parking and turnaround space. The Park Service tries to have the Mowich area open for the 4th of July weekend; depending on weather the road closes for the season in mid- to late October. Don't forget that lakes and meadows mean mosquitos.

As mentioned in the section on Carbon River, the 17-mile loop from Mowich Lake to Spray Park and returning via Ipsut Creek and Ipsut Pass on the Wonderland Trail is a fantastically scenic backpack trip. Adding the 3.6-mile round-trip to Tolmie Peak and 2.5-mile side trip to the snout of Carbon Glacier makes it even better.

Photo advice: Photographing Spray Falls or close-ups of wildflowers will work on overcast days, but a white sky behind Mount Rainier, or worse yet not even be able to see it due to fog is no good, so watch the weather and try to plan your visit for a day with interesting skies. Late afternoon to sunset light on this northwest-facing flank of Rainier is magical.

Getting there: From the south Puget Sound area, travel WA-167 and WA-410 towards the town of Buckley, then head south on WA-165 through the historic mining towns of Wilkeson and Carbonado. Follow the signs, staying right at the fork soon after crossing the bridge over the Carbon River to stay on WA-165 until it dead-ends at Mowich Lake in about 17 miles. The gravel road can be bumpy due to some washboard sections but is fine for passenger cars.

Time required: Some Seattle photographers buzz down here in the afternoon, shoot at Spray Park until sunset then hike out in the dark and drive home, but the spectacular scenery here really demands at least a full day.

Wonderland Trail

In 2009, Backpacker Magazine named Wonderland Trail the best loop hike in the entire U.S. National Park system. This 93-mile circumnavigation of Mount Rainier traverses dense old-growth forest, roaring rivers and burbling creeks, wildflower meadows, alpine ridges, and icy permanent snow fields. Waterfalls, wildlife, wildflowers, crystal clear lakes and, of course, fabulous views of The Mountain, will quickly fill digital camera memory cards.

Originally blazed by the Mountaineers hiking group in 1915, Wonderland Trail is a strenuous trek, with an overall elevation gain of 20,000 feet. Fastpackers can do the whole circuit in a week or less, but photographers need a minimum of a couple of weeks to allow for shooting time and hiking some of the side trails. The hiking season is mid-July through September, and hikers need to be prepared for extremes of weather. Camping is allowed only in designated sites, and only with a backcountry permit, obtainable at the visitor centers and ranger stations. Basic supplies are available in the store at Longmire; a very limited selection is available at Paradise and Sunrise.

A description of the complete circuit is beyond the scope of this book, but sections of the trail are described for the Spray Park, Carbon River, Sunrise, Stevens Canyon, and Longmire areas. For those interested in extensive hiking on the trail, Bette Filley's book *Discovering the Wonders of Wonderland Trail: Encircling Mount Rainier* is a comprehensive guide.

Westside Viewpoints: Gobblers Knob & Glacier View Lookout

Sometimes the best view of The Mountain is not from a close vantage point such as Paradise or Yakima Park. To appreciate the immensity of this stratovolcano from its 14,411-foot summit to its base in old-growth forests, you have to stand back at a distance. Two options stand out for photographing the dramatic west face of The Mountain. Both provide superb panoramas and sunset viewpoints.

Along the southwestern boundary of the park, Gobblers Knob offers an unobstructed view of two vertical miles of The Mountain, from the snout of the Tahoma Glacier to the summit's outer rim. The three summits of Mount Rainier: Liberty Cap, Columbia Crest, and Point Success punctuate the sky. Aptly named Sunset Amphitheater, beneath Liberty Cap, catches the brilliant rays of the setting sun.

Reaching Gobblers Knob requires a round trip of 12.5 miles hiking. From the Nisqually Entrance on WA-706, drive 1 mile eastward and turn left onto the

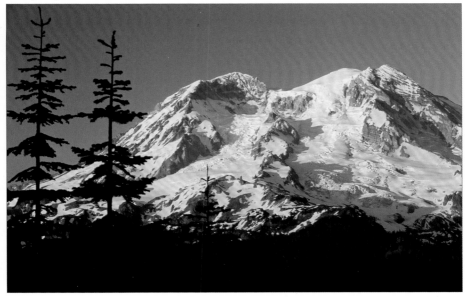

The Mountain from Glacier View (photo by Ron Warfield)

Westside Road. Proceed 3.3 miles to park at the base of Mount Wow, a good place to watch for mountain goats. Walk (or ride a mountain bike) 3.7 miles on the road to the Round Pass Trailhead.

From the trailhead, it is only .9 mile to Lake George where there is a fine backcountry campsite. Grab a backcountry camping permit at the Hiker Information Center at Longmire if you plan to spend the night here after capturing the sunset from Gobblers Knob. Walk around the right-hand shore of Lake George for some nice views of Mount Rainier reflected in the forest-rimmed lake.

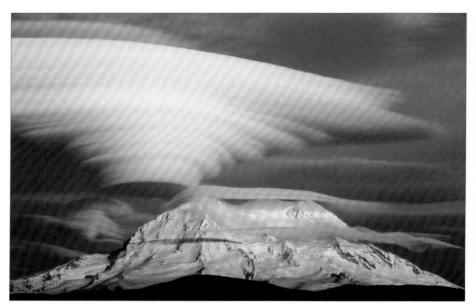

Stacked lenticular cloud over Mount Rainier (photo by Ron Warfield)

The trail climbs 1,300 feet in 1.5 miles from Lake George to Gobblers Knob. Enjoy the horizon on all sides from the old fire lookout tower. Mount Rainier dominates one side, but other Cascade stratovolcanoes also offer visual rewards.

Just outside the western boundary of the park lies perhaps the quintessential west side balcony view of Mount Rainier. Protected from clearcutters' saws within the Glacier View Wilderness, the old fire lookout site atop Glacier View Lookout gives photographers a 360 degree view. The Olympic Mountains bound the western horizon, and the snow-covered summits of Mount Adams and Mount Saint Helens stand to the south. But, the awesome western flank of The Mountain fills the eastern view from this quiet mountaintop. Don't worry about fighting the crowds at this location. Even on days when thousands of visitors throng Paradise, you'll likely have this exquisite mountaintop view to yourself.

To reach Glacier View, drive west 3.3 miles on WA-706 from the Nisqually Entrance to Copper Creek Road (FR-59) and turn right. Drive up the gravel roadway 7.6 miles to an outstanding view of Mount Rainier. If you're pressed for time, this could be your turnaround point. Otherwise, drive another 1.5 miles to the parking area and trailhead. From the car park, a short trail climbs eastward to intersect with Forest Service Trail #267 and heads northward (left) along a ridge. The ridgeline offers several viewpoints of Mount Rainier, framed by hemlock, Alaska yellow cedar, and subalpine fir as you climb 800 feet in 2.5 miles to a saddle where the trail splits. Take the left fork 0.3 mile to the 5,400-foot summit of the Glacier View Lookout. Be sure to take supper and a headlamp. Darkness descends quickly when the last sunset colors fade from The Mountain.

❖ ❖ ❖

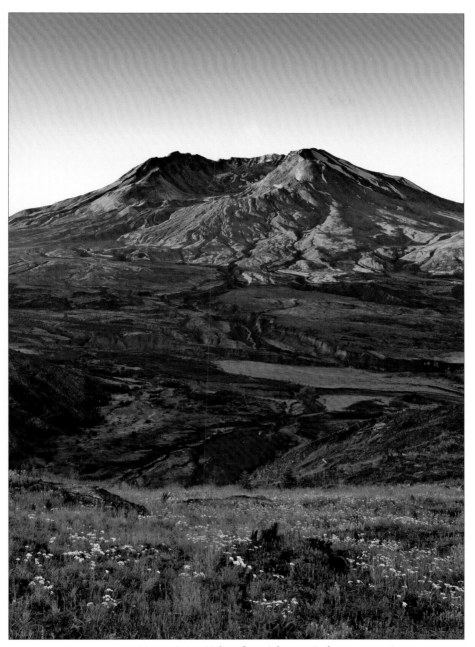

Mount Saint Helens from Johnston Ridge

Chapter 10

MOUNT SAINT HELENS

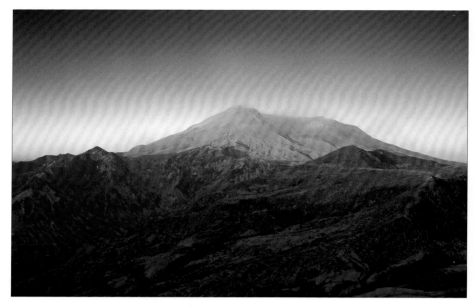

Mount Saint Helens from Smith Creek Viewpoint

MT. SAINT HELENS NATIONAL MONUMENT

On May 18, 1980, a sleeping volcano came to life with an explosion that literally blew the top off one of the highest peaks in the Cascade Mountains. Tons of volcanic ash blew miles into the sky and flowed down from the crater like a fast moving avalanche. Trees in hundreds of square miles of forest were blown down or blasted clean of leaves and branches.

In the years since the big eruption, some areas of forest have started to recover, but the devastated landscape near the blast site remains dramatically desolate looking. A minor eruption in 2004, and continuing frequent small plumes of steam and ash fall are reminders that Mount Saint Helens is still very much an active volcano.

The Klickitat Indians that lived in southwestern Washington called this magnificent mountain Loo-Wit, and visited the slopes in summer and fall to harvest berries, roots, and medicinal plants. Early in the twentieth century, campgrounds and lodges around the lakes, rivers, and meadows were favorite family recreation areas for many Washingtonians. The vegetation is starting to return now, and some lakes have re-opened for recreational use, but there are no lodges or campgrounds within Mount Saint Helens National Volcanic Monument. Road access is limited, and traveling between the three major visitor areas on the northwest, east, and southern sides of Mount Saint Helens requires a lot of driving and at least a day of time in each.

If your time at Mount Saint Helens is limited, I recommend that you visit the part of the Monument accessed by State Highway 504, also known as Spirit Lake Memorial Highway. Stop at the Mount Saint Helens Visitor Center at Silver Lake for a great introduction, and then head directly for the Johnston Ridge Observatory viewing area at the end of Spirit Lake Highway, 51 miles from I-5.

If you're not in a hurry, stop at each of the visitor centers along Highway 504 on the way to Johnston Ridge, each with its own perspective on the history and geology of the area. Note that hours at all but the Silver Lake visitor center are very limited in winter, and Johnston Ridge is inaccessible from November to early May.

There are also some excellent views of Mount Saint Helens to be found on the east side of the National Monument. With more time to explore, plan on a day on the east side with a sunrise shoot from Windy Ridge area and hikes to Norway Pass, Spirit Lake, and the Pumice Plain.

Spirit Lake Highway

Five miles east of Interstate 5 along State Highway 504 is the Mount Saint Helens Visitor Center at Silver Lake. With excellent displays it is a great introduction to the whole Mount Saint Helens experience and the knowledgeable staff can give you the latest on conditions in the national monument. Seaquest State Park campground just across the highway is a good base if you're camping or RVing.

Driving east on Highway 504 you'll come to Hoffstadt Bluffs Visitor Center at milepost 27 and then the Forest Learning Center after six more miles, each focusing on a different aspect of Mount Saint Helens, effects of the eruption, and the ecology of the surrounding area.

Just as you actually enter the National Monument you'll come to Elk Rock Viewpoint, with a great panoramic vista of Mount Saint Helens, the Toutle River Valley, and forested ridges to the east and north. Most of the area on either side of the highway was salvage logged after the big blast, and note the replanting in some places with a monoculture of noble fir. A few miles further on the highway is Castle Lake Viewpoint, with an even better view. If you're visiting in winter, these viewpoints may be as far as you can get if there has been recent heavy snowfall.

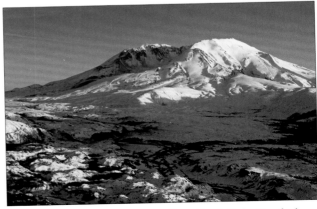

Mt. Saint Helens in winter from Castle Lake Overlook

Photo advice: Look for a wide spot on the highway shoulder just beyond the turn for Castle Lake Viewpoint to pull over for another great view of the volcano. All of these viewpoints are best with late afternoon to sunset light; the volcanic peak silhouetted at sunrise is also a possibility.

Getting there: Travel I-5 to Exit 49 at Castle Rock and head east on WA-504, following the signs for Mount Saint Helens.

Time required: The drive from I-5 to Coldwater Ridge on Spirit Lake Highway is about one hour plus stops at visitor centers and viewpoints.

Coldwater Ridge

For many years Highway 504 ended at Coldwater Ridge, which was the location for the main visitor center for Mount Saint Helens National Volcanic Monument. Soon after Johnston Ridge Observatory opened, budget constraints forced the closure of Coldwater Ridge Visitor Center. This was really a shame, not just because of the loss of some excellent interpretive exhibits and a great view of the mountain, but it provided a destination with warmth and services in winter. Fortunately, thanks largely to volunteer efforts, the facility is once again in use, reincarnated as the Mount St. Helens Science and Learning Center at Coldwater. It is not a full visitor center and hours are limited, but certainly worth a stop to check it out. In winter, Highway 504 is closed beyond Coldwater.

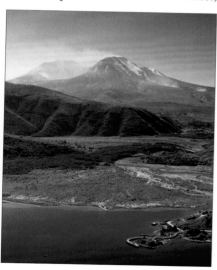

Coldwater Lake

Photo advice: The view of Mount Saint Helens from the deck at the Science and Learning Center, while not quite as good as the view from Johnston Ridge, is very good. Best light is in late afternoon. The terrain nearby is a good place to get photos showing the ecological recovery in the blast zone.

Getting there: Drive WA-504 east from I-5 for 43 miles.

Time required: Half an hour is plenty for the standard view of the crater, but you may want to spend a lot more time if there is activity at the Science and Learning Center.

Nearby location: Birth of a Lake Trail is an easy, wheelchair accessible half-mile loop at the southwest side of Coldwater Lake. It's not a great place for landscape photography but worth the short walk to take in the scene. The lake didn't even exist prior to the eruption and was formed when an avalanche of rock dammed a stream in what had been a forested valley.

Johnston Ridge

The closest and best easily accessible views of the crater, lava dome, and blast zone are from the visitor center and trails at the Johnston Ridge Observatory at the end of State Highway 504. Summer time means thousands of visitors per day to this viewpoint, but on a recent trip there were only a couple of other photographers in the area at sunset and I was the only person there at sunrise the

following morning. Waiting for the light, it was delightful to hear, first the low, tentative howl and then the yip, yip, yip of a family of coyotes down in the Toutle River valley. Minutes after the sun hit the ridge, a hummingbird buzzed by, pausing briefly to check me out on his way to the sumertime wildflowers on nearby slopes.

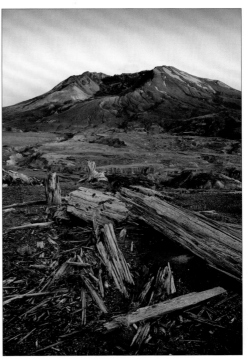

View from Loowit Viewpoint

The view of Mount Saint Helens right from the observatory deck is excellent, but hike the quarter-mile Eruption Trail to the top of the hill next to the observatory for a little more elevation; interpretive plaques along the way explain the natural history of the area. I like the view a little further east, taking Boundary Trail #1 as it follows the ridgeline for about 2 miles to a point where there's a direct look south to the lava dome in the center of the crater as well as a clear view of the Toutle River course below. You can con-
tinue on Boundary Trail #1 for another half mile to the junction with Truman Trail, which will take you down into the valley and then options for a longer hike to Loowit Falls or east to Spirit Lake and Windy Ridge.

Loowit Viewpoint, just west of Johnston Ridge Observatory, is also an excellent view of the volcano, with the possibility of getting some of the blasted and downed tree trunks in the foreground. Scattered clumps of lupine and paintbrush will provide spots of color in summer. There is a parking lot at Loowit, or walk half a mile west from the observatory on Boundary Trail #1.

The Johnston Ridge Observatory Visitor Center is open daily 10:00am to 6:00pm from about mid-May through the end of October. From November to early May the road is closed from either Coldwater Ridge or Coldwater Lake.

Photo advice: In mid-summer the sun's azimuth is far enough north that there

is interesting light on Mount Saint Helens at both sunrise and sunset from Johnston Ridge. In spring and fall the mountain is heavily back or side-lit; that kind of lighting can be great for people portraits, but rarely works for mountains. As at most locations, shooting at dawn and dusk can result in outstanding photos. Peak wildflower bloom here, as well as most other areas surrounding the volcano, ranges from early July to early August.

Getting there: Follow WA-504 all the way to its end, 52 miles from Castle Rock on I-5 or 9 miles beyond Coldwater Ridge. The drive from Castle Rock to Johnston Ridge takes about 1.25 hours without stops.

Time required: Plan several hours for a sunrise or sunset shoot with time for the visitor center and to explore nearby trail views. At the very least allow an hour just to see the highlights once you arrive at the parking area.

Northeast Side of Mount St. Helens

While the major visitor centers and most visitor facilities are on the west side of Mount Saint Helens, the east side provides additional great opportunities for photography. Forest Service Roads 99 and 25 provide access to views of Spirit Lake and the vast area of forest blown down by the blast of the 1980 eruption. These routes are generally open from Memorial Day until snow blocks the roads. Keep in mind also that there are no stores, services or gas between Randle and Cougar on this side of Mount Saint Helens, nor is there cell phone reception in much of the area. Backpackers need to note that a permit is required for any backcountry camping, and they're only available during business hours at Forest Service ranger stations and the Mount Saint Helens visitor centers.

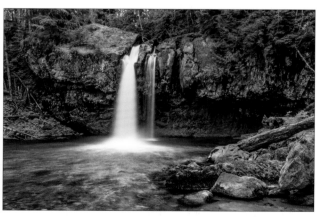

Iron Creek Falls

The USFS maintains a very nice developed campground at Iron Creek, and it's the only one for miles around. There is a quarter-mile nature trail in old-growth forest within the campground. Several miles south, Iron Creek Falls is a very short walk just off FR-25. The north facing 38-foot waterfall drops into a nice pool, and is in the shade both early in the morning and late in the afternoon. In spring and early summer, the creek shoots out over the cliff, almost in an arc; when water levels drop in later summer the creek drops more directly into the pool.

Several developed lookout points on Forest Road 99 afford views of Mount Saint Helens, Spirit Lake, and the surrounding blast zone. The Smith Creek Viewpoint has a very nice panoramic vista and is a good place to be at sunrise, both for the first light hitting Mount Saint Helens and for shooting the sunrise itself, with 12,281-foot high Mount Adams to the east as another dramatic focal point. Nearby Donnybrook Viewpoint has the best view of Spirit Lake, which is still partially choked with logs that have been floating on the surface for over 30 years. Both of these view-points are located at about milepost 15 on Forest Road 99. At the end of FR-99, a stair-step trail leads to a panoramic vista from the top of Windy Ridge. The viewpoint has a great view of Pumice Plain and Spirit Lake, but it's not a great location for photographing Mount Saint Helens itself because the southern part of the ridge interrupts the view of the volcano.

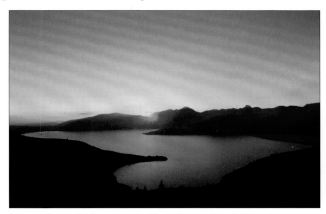

Spirit Lake at sunset from Donnybrook Viewpoint

Photo advice: The views of Mount Saint Helens from this side are all looking south to southwest and are going to be backlit after early morning, although around the summer solstice the sun sets far enough north to get some good light on the volcano. Being here for sunrise light is definitely worth the long drive in the dark. Hazy and overcast days don't work here at all.

Getting There: If coming from the north, travel WA-12 to Randle and then head south on WA-131, which becomes FR-25, for 20 miles. Turn right on FR-99, a mile past Iron Creek Falls, and follow the winding road into the Blast Zone to the viewpoints. Windy Ridge is about 16 miles from the junction with FR-25. If coming from the south, travel east from Woodland on WA-503, continuing east as the route becomes FR-90 near Cougar. Turn north on FR-25 and drive 25 miles to reach FR-99. Note that FR-25 and the other roads on the east side of the National Monument are closed due to snow in winter.

Time Required: Considering the drive to get here and time both for photography and learning about Mount Saint Helens and the eruption from the numerous interpretive sites and viewpoints, plan for at least a full day to visit this area.

Nearby Location: There are several other points of interest along this route, and also driving north on FR-26, that are worth exploring, particularly in wildflower season when you can juxtapose the new growth of flowers with the long-dead tree trunks in the blast zone.

Norway Pass

A very pleasant two-mile hike leads to one of the nicest views in all of Mount Saint Helens National Monument. Starting from the signed trailhead on FR-26 for Boundary Trail #1, the hike is about 4.5 miles round-trip, and although it's not overly strenuous, the first mile is a bit steep, gaining about 800 feet in elevation. It is a very popular hike, so count on lots of trail activity on summer weekends.

Climbing steadily in the first mile or so, it is mind boggling trying to image the power of the eruption, which was over seven miles away from this point and behind a fairly high ridge, and yet all the trees here and even further north and east were totally flattened. The views just keep getting better, with Mount Adams over Meta Lake to the east and Mount Rainier to the north. The real reason to do this hike, however, is the scene to the south from Norway Pass, a wonderful view over Spirit Lake to Mount Saint Helens. Continue on the trail, passing a junction to the left for Independence Pass, reaching Norway Pass about 2.2 miles from the trailhead. Downed trees, barkless and bleached silver by years of sun, make good foreground elements for landscape photos, highlighted by wildflowers in summer and huckleberry in early autumn.

There are sounds to compliment the sights here. You're likely to be buzzed by mosquitoes in summer, and perhaps hummingbirds, too. You might also hear the low whump-whump of grouse or the high-pitched squeal of bugling elk.

Photo advice: A sunrise shoot here is highly recommended. Don your headlamp pre-dawn and head up the trail while it's still dark. The early light will hit Mount Saint Helens beautifully. Sunset and dusk can also be excellent. Layer blending or HDR-type processing may be necessary to capture the range between shaded foreground, snow-capped mountain, and open sky. Norway Pass isn't thick with wildflowers, but there is a good assortment, with peak blossom time in late July and early August.

Getting there: If coming from the north, travel WA-12 to Randle and then head south on WA-131, which becomes FR-25, for 20 miles. Turn right on FR-99 and continue south for 9.2 miles, turning right on FR-26 to reach the trailhead in another mile. If coming from the south, travel east from Woodland on WA-503, continuing east as the route becomes FR-90 near Cougar. Turn north on FR-25 and drive 25 miles to reach FR-99. Note that FR-25 and the other roads on the east side of Mount Saint Helens are closed due to snow in winter.

Time required: Allow at least four hours so that you have plenty of time to explore and find just the right composition.

Nearby location: Walk south from Norway Pass on Independence Pass Trail for more views to the south. After following this route for 2.0 miles to Crater Viewpoint, you can loop back, in another 2.3 miles, on Boundary Trail.

Right: Mount Saint Helens from Norway Pass

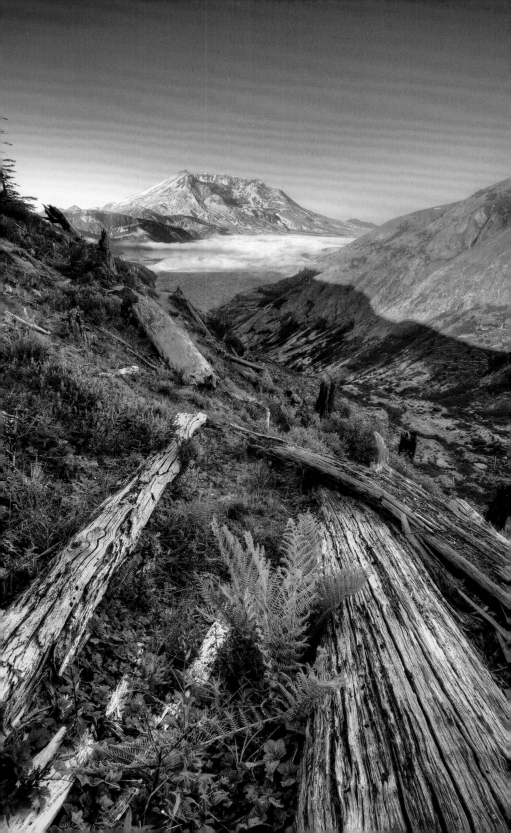

Pumice Plain & Loowit Falls

Short of a summit climb from the south side, the closest you can get to the crater of Mount Saint Helens, is a hike across the Pumice Plain from Windy Ridge. As the name implies, the ground here is a large expanse of gravelly pumice. This gently sloping field isn't all that attractive as a photo subject most of the time, but in mid summer a purple carpet of low-lying lupine and penstemon covers large swaths of the plain.

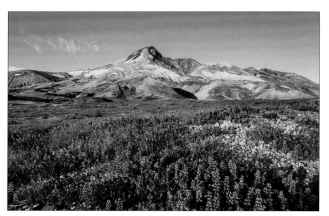

Lupine & penstemon on the Pumice Plain

The trail to Pumice Plain starts at the southern side of Windy Ridge Viewpoint parking area. It's not a difficult trail, as the ups and downs are mostly at a gentle grade. There are actually several trail options once you reach the plain, and you'll likely want to wander some looking for the best compositions, so count on a round-trip hike of about 10 miles. The route is treeless, and may get quite warm on summer days, so pack plenty of water; because there is a good reason why Windy Ridge got its name, it is a good idea to bring a light jacket, too.

From the trailhead, start walking on an old road on the eastern side of Windy Ridge, signed as Truman Trail. In about one mile you'll come around a bend to an incredible view of Mount Saint Helens—the crater and dome, with a mini-crater within the dome, are clearly visible and appear quite close. A little further on the trail, you'll see Pumice Plain and the purple carpet.

At 1.8 miles, continue past the junction with Abraham Trail to reach another junction at 2.2 miles. Truman Trail continues to the right, heading northwest and down the sloping plain toward Spirit Lake. Take the left fork for Windy Trail, which goes west across Pumice Plain and through the fields of flowers. Go right at then next junction at 1.1 miles and continue for another 1.5 miles to reach Loowit Falls. The trails are well marked with signs and cairns. At Loowit Falls, melted snow water plunges 186 feet into a narrow chasm. The landscape here, just below the open crater of Mount Saint Helens, is almost moon-like—just barren pumice, ash, and lava.

Make a loop trip by heading south from the falls on Loowit Trail, then turn right on Truman Trail to get back to Windy Ridge. There may be lots of flowers along Truman Trail, but the view of the crater is mostly blocked by a low ridge.

Photo advice: Mid-July to early August is best for the wildflowers. If you begin your walk pre-dawn, you'll get some great sunrise light on Mount Saint Helens from the trail at the south end of Windy Ridge. Early morning is also preferable for the flowers as the winds are generally lacking at that time. The terrain around Loowit Falls is very unstable and you can't get very close, so bring a moderate tele-zoom.

Getting there: Follow the directions above for the Northeast Side, driving FR-99 to its end at the large parking area at Windy Ridge Viewpoint.

Time required: Plan on most of a day if doing the complete loop around Pumice Plain and to Loowit Falls.

South Side of Mount St. Helens

The area to the south of Mount Saint Helens didn't receive a cataclysmic blast like the north side did, but it has been repeatedly covered with lava and mud flows from previous eruptions. With the exception of the Lahar Viewpoint, the views of Mount Saint Helens itself are not as good as those from the Johnston Ridge area and from the trails and viewpoints on the east side, but there are some sites that are certainly worth visiting.

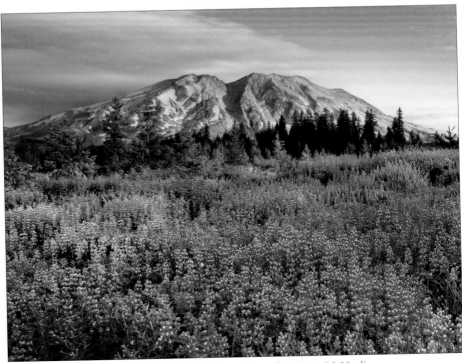

Lupine at Lahar Viewpont (photo by Kevin McNeal)

At Lava Canyon, a 3.3-mile round-trip trail follows the course that the Muddy River has cut through layers of lava over the centuries. When Saint Helens erupted in 1980, a massive mudflow, or lahar, scoured the canyon. The trail, which can be treacherously slippery when wet, includes a suspension bridge and a set of metal ladders to ascend/descend steep cliffs. There are several waterfalls in the canyon, but the views are rather distant.

Ape Cave is the most visited area on the south side of Mount Saint Helens. The cave is actually a lava tube, and at almost 2.5 miles long it is the third longest lava tube on the North American continent. If you plan to visit the cave, dress warmly and bring two flashlights.

Lahar Viewpoint offers a very nice view of the south side of Mount Saint Helens, looking right up into the notch that has resulted from glacial runoff and the lahar that scoured Lava Canyon. In spring and early summer, a broad, open area that was just barren ash a few years ago now sprouts an assortment of colorful wildflowers.

Note that the access roads to these areas may be snow-covered in autumn and FR-83 is closed in winter, re-opening at the end of May.

Photo advice: The vista from Lahar Viewpoint is looking almost due north, so is going to have very nice light in early morning and late afternoon; mid-morning to mid-afternoon the light is quite flat and not great for photography.

Getting there: From I-5 at Woodland, travel east for 32 miles on WA-503, Lewis River Road, to the northeast end of Yale Lake and continue east another 3 miles as the designation changes to FR-90. For Ape Cave: about a mile after reaching the dam at Swift Reservoir, turn left on FR-83, travel 1.7 miles and make a left onto FR-8303 and go another 2.2 miles to Ape Cave. For Lahar Viewpoint and Lava Canyon, proceed as above, but instead of turning on FR-8303, continue on FR-83 for 10 miles to the trailhead at the end of the road.

Time required: Count on several hours to a full day to visit these areas as they involve some slow, winding roads.

❖ ❖ ❖

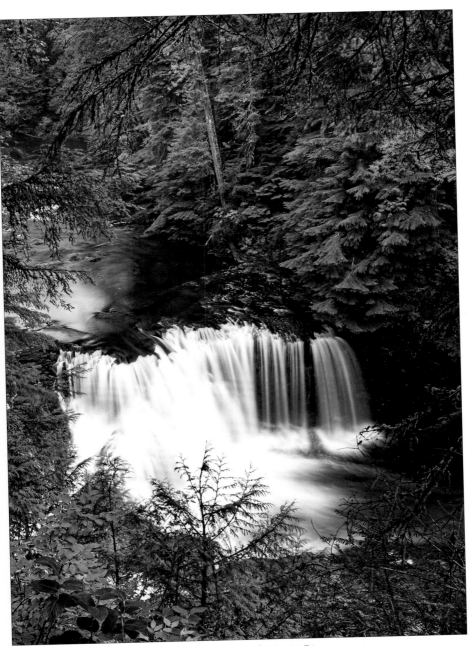

Taitnapum Falls on the Lewis River

Chapter 11

SOUTHERN CASCADES

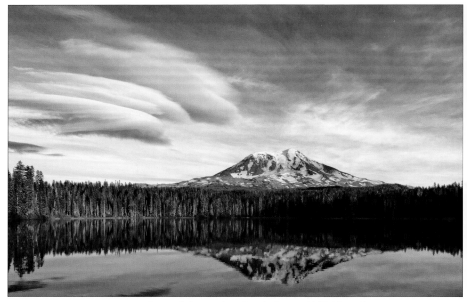

Mount Adams & lenticular clouds from Takhlakh Lake

SOUTHERN CASCADE MOUNTAINS

While the North Cascades largely appear to be a jumble of jagged peaks stretching as far as the eye can see from any particular vantage point, the southern half of the range in Washington is dominated by three massive volcanoes: Mount Rainier, Mount Saint Helens, and Mount Adams. The landscape surrounding these peaks was largely formed by lava and mud flows and is now predominately covered with dense coniferous forest.

Most of the territory covered in this chapter falls under the jurisdiction of Gifford Pinchot National Forest, including several Wilderness areas and Mount Saint Helens National Volcanic Monument. The Gifford Pinchot is named after the first Chief of the U. S. National Forest Service, who is quoted as saying "Conservation is the foresighted utilization, preservation and/or renewal of forests, waters, lands and minerals, for the greatest good of the greatest number for the longest time." An early and active conservationist, Pinchot was way ahead of his time in promoting sustainable uses of our natural resources.

The southern Cascades offer a wealth of opportunities for nature photography, with wonderful wildflower displays, a bunch of easily accessible waterfalls, fantastic fall foliage, and of course those two big, beautiful mountains.

A couple of locations on the periphery of the southern Cascades are covered elsewhere in this book. See the Southwest chapter for Silver Star Mountain and the Columbia River Gorge chapter for Conboy National Wildlife Refuge.

Goat Rocks Wilderness

Long recognized for its outstanding scenic and recreational value, much of the Goat Rocks territory received federal protection as a Primitive Area in 1931, more than 30 years prior to the passage of the Wilderness Act. Now encompassing 105,600 acres, the mountainous terrain, formed from a large, long extinct volcano, is an alpine wonderland. As one might guess, it was named for the large number of mountain goats that inhabit the area.

Quite a bit of the Wilderness lies above timber line, providing fantastic views over alpine meadows to craggy peaks and, depending on location, vistas of Mount Adams and Mount Rainier. Many miles of trails traverse Goat Rocks, including a nice stretch of the Pacific Crest Trail. Higher elevation trails are often snowbound until July and the snow can return again as early as September. Covered in the following two sections are a couple of low elevation, easy access trails that will get you into the Goat Rocks Wilderness on a dayhike.

For backpacking photographers, there are several very good destinations, including Conrad Meadows, Cispus Basin, and Bear Creek Mountain, but the best option is the Snowgrass Flat - Goat Lake Loop. This is a very popular, and therefore busy, trail, and with good reason. Those that venture this way will find outstanding wildflower meadows and panoramic vistas, including good looks at Rainier and Adams.

It's possible to do Snowgrass Flat as an 8-mile round-trip dayhike, but it will be much more rewarding to do a multi-day hike, making a 13-mile loop that goes to Snowgrass Flat, continues on to Goat Lake and returns via Goat Ridge. This moderately strenuous route gains about 2,590 feet in elevation. Remember that meadows mean mosquitoes, so bring plenty of bug repellent or wait until September when the mossies are gone.

Photo advice: Prime time for wildflowers in the alpine meadows is early to mid-August. A polarizing filter can be great for the vistas but rotating the filter for maximum polarization when at alpine elevations can result in blue skies going too dark and using one with a wide angle lens causes uneven sky tones.

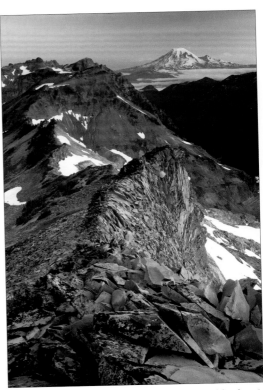

Goat Rocks & Mt. Adams (David M. Cobb photo)

Getting there: For the Snowgrass Flat-Goat Lake Loop, travel two miles west of Packwood on US-12 and then turn south on FR-21, Johnson Creek Road. Drive 15.5 miles and fork left onto FR-2150, signed for Chambers Lake. In another 3 miles, shortly before reaching Chambers Lake, make a right onto FR-2150-040 and almost immediately right again on FR-2150-405. Look for the Berry Patch trailhead sign at the end of this short spur road.

Time required: A 2-4 day backpack trip will give you time to really enjoy and take advantage of all there is to see and photograph on the Goat Rocks trails.

Packwood Lake

An easy 4-mile walk on a nearly level trail leads to Packwood Lake, a popular destination for summer camping. It's not a particularly great photo destination, with the trail and the lake shore being almost entirely forested, but the view of the lake with Agnes Island and Johnson Peak in the Goat Rocks is quite nice. The trail continues for another mile to the east end of the lake, where you can look back to a view of Mount Rainier. Goat Rocks Wilderness surrounds the east end of Packwood Lake, although the lake itself is not within the official Wilderness.

Photo advice: The view of the island and Johnson Peak is looking southeast from the western end of the lake, and gets very nice late afternoon light. If you're there when the sunset light is good on the mountains and there are good clouds above but the lake is choppy, try a long exposure – ten seconds or even more – to smooth out the water.

Getting there: Drive US-12 to the east end of the town of Packwood, then turn southeast on FR-1262. Continue for 6 miles to a parking area at the trailhead.

Time required: Packwood Lake makes a nice, leisurely dayhike, with time for lunch and maybe even a swim.

Walupt Lake & Nannie Ridge

If you're a Washington resident looking for an overnight trip with maybe a little fishing or just relaxed camping mixed with a good hike and some serious photo potential, here's an excellent location to consider.

Walupt Lake is an attractive little body of water nestled in the mountains with a notch opening to the east that makes it a good option for sunrise sky reflected on glassy water. The very pleasant USFS campground at Walupt Lake gets pretty busy in the summer, but visit here in the weeks after Labor Day until the campground closes for the winter and you might have the whole place to yourself. And as is typical around Cascades lakes and meadows, the mosquitoes and biting flies can be a real bother from June through July and into August, but by September they are usually gone.

A hike along Nannie Ridge offers great views of stately Mount Adams and

meadows full of wildflowers in the summer. From the trailhead at the east end of the Walupt Lake Campground, a moderately strenuous 9-mile out-and-back hike climbs 2,000 feet in elevation. The first couple of miles are kind of an uphill trudge through an uninspiring forest via a series of switchbacks. The hoped-for views finally arrive at about 2.5 miles, with a grand view of Mount Adams from a rock outcropping that makes the whole climb worthwhile.

At 3.3 miles, a delightful tarn will tempt you to tarry with its surrounding flowers and backpackers campsite. As nice as it is, press on as the trail drops and passes below some steep cliffs on Nannie Ridge.

The trail continues north, crossing several steeply sloping east-facing meadows. Midsummer wildflowers include the usual lupine, paintbrush, arnica, aster, columbine, and corn lily. From late summer to early autumn, huckleberries ripen, with leaves turning crimson. The bright reds of mountain ash berries and leaves add to the fall color. As you cross the steep, open meadow at about 3.8 miles, look back south for a nice view of Mount Adams.

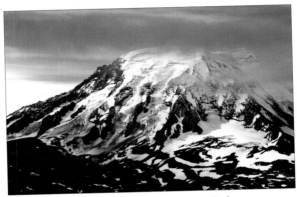

Mount Adams from Nannie Ridge

Following the contour of the ridge, the trail finally arrives, 4.5 miles from the trailhead, at lovely Sheep Lake. A what point does a tarn become a lake? This one is either a large tarn or a small lake, and the setting is sublime, with the shallow little lake surrounded by wildflower-strewn meadows. The jagged peaks of Goat Rocks appear above the lake to the north. Immediately beyond Sheep Lake is the junction with the Pacific Crest Trail, and the several lake-view campsites are popular with PCT hikers. Pick your way a few feet from the campsite at the southeast end of the lake for a view through the trees of Mount Adams. For a better view of this very photogenic peak, scramble up the knoll just to the south of Sheep Lake.

From here, head back the way you came to Walupt Lake, or take the PCT and follow it south through forest to Walupt Creek Trail and back to the campground for a 12-mile loop.

Photo advice: Plan to arrive at Walupt Lake Campground in the afternoon and scout a location at the west end of the lake for a sunrise shoot. Right after sunrise, head up the Nannie Ridge trail to get morning light on Mount Adams. If you don't mind hiking in the dark, sunrise light or sunset alpenglow on Mount Adams can be awesome from the viewpoint at 2.5 miles.

Getting there: Travel US-12 to Randle and turn south on WA-131. In one mile, go left onto Cispus River Road, which becomes FR-23. Follow this road

southeast for 17.6 miles, then turn onto FR-21; travel another 12.6 miles to FR-2160, which dead ends in 4.5 miles at Walupt Lake Campground. FR-21 from Packwood is a shorter route by several miles, but it's all washboard gravel, whereas all but a few miles of the route from Randle is paved.

Time required: If just going to get the photo of Mount Adams from the first viewpoint, four hours from trailhead to return is probably sufficient. If it's wild-flower season and you're headed to Sheep Lake, plan for a whole day to give yourself time for views, wildflowers, and just enjoying being out in nature.

Nearby location: The drive on FR-23 and FR-21 along the Cispus River winds through beautiful forest with enough maple to provide some nice fall color.

Mount Adams

Pahto, as it was known to the native Yakama and Klickitat people, may not be as famous as its nearby volcanic cousins Mount Rainier and Mount Saint Helens, but this majestic mountain sure doesn't lack when it comes to fantastic photo opportunities.

Mount Adams, technically a stratovolcano and considered potentially active by geologists, is the second highest mountain in the Pacific Northwest, rising to 12,326 feet. The glaciated peak is the most prominent feature in the landscape from many viewpoints for miles around in all directions.

A network of forest service roads and many miles of trail, including a section of the Pacific Crest Trail, provide access to a vast territory on the west side of Mount Adams. The eastern slopes of Mount Adams lie within the Yakama Indian Reservation and general public access is limited to the Mount Adams Recreation Area on the southeast side of the mountain.

The remainder of this chapter details the best and most accessible locations for photography in the immediate vicinity of Mount Adams and areas to the west and southwest in Gifford Pinchot National Forest, one of the jewels of our national forest system.

Adams Creek Meadows

Killen Creek Trail starts off as rather a drudge, a steady uphill trek on a dusty trail through uninspiring forest. But if you like wildflower meadows and splendid mountain views, this is a winner. Plan on something between 6 and 8 miles round-trip for an out-and-back hike, with 1,500 feet or more of elevation gain.

The trail, which parallels but never meets Killen Creek, finally breaks out of the forest at 2.6 miles, with the summit of Mount Adams as backdrop for a broad, open meadow. Soon after snowmelt, glacier and avalanche lilies carpet the meadow, to be followed by the usual lupine, bistort, valerian, and paintbrush as the season progresses. There is a fine backpackers campsite right on the edge of

the meadow, with the East Fork Adams Creek providing a nearby water source.

Continuing up the trail, you'll encounter pocket meadows and more glimpses of Mount Adams. Look behind you, too, for views of Mount Rainier to the north. At 3.1 miles, the path intersects the Pacific Crest Trail. There are more wildflower meadows, interspersed with lava flows, straight ahead and to the left or right along the PCT. I recommend heading west for the better angle on Mount Adams. Before reaching Divide Camp Trail and the main fork of Adams Creek at 4.1 miles, you'll find a meadow with a view looking straight up the massive glacier that graces the northwest face of Mount Adams. Retrace your steps from here, or take Divide Camp Trail down to FR-2329 to make a 9.5-mile loop.

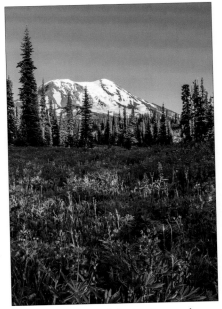

On my early-mid August hike, the early blooming wildflowers were gone and the more colorful species like lupine and paintbrush were just starting to appear. Mosquitoes weren't too bad, but the flies swarmed me as soon as I stopped moving. I recommend the slathering method of applying bug repellent rather than the spritz.

Mount Adams & lupine in meadow

Photo advice: Peak wildflower bloom is late July through late August. You'll probably want a neutral density grad filter for meadow+mountain scenes, or bracket exposures for extended dynamic range processing.

Getting there: See the directions below for Takhlakh Lake. Continue north on FR-2329 past the turnoff for Takhlakh Lake to reach the trailhead in 6 miles. If you come to Killen Creek Campground you've gone a bit too far.

Time required: If possible do this hike as an overnight backpack instead of a dayhike, to take advantage of the glorious sunset light on Mount Adams.

Takhlakh Lake

One of these days I'm going to hit it right and come away with a killer shot of Mount Adams reflected in the glassy waters of this beautiful little lake just as the sunset light turns the glaciated peak all pink and gold. Didn't happen in the first four trips I made there, but the potential is so good I'm going to keep trying.

Probably the only reason this isn't a more well known and popular shooting location is that it's a long drive from any metro area, and getting there requires miles of bone-jarring, car-rattling washboard gravel. The road may be trying, but

the scenery along the way makes up for it. Many miles of forest, including old-growth, "managed forests", and some tantalizing views of Mount Adams.

Part of the attraction here is that there's a really nice campground right on

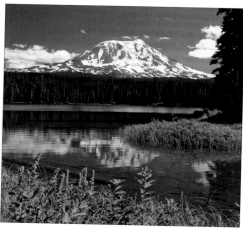

the lake. Great views are just steps away from your tent or RV. The lake is for non-motorized boats only, so it's great for a relaxing canoe or kayak paddle. Depending on snow, the campground may open as early as mid-June and stay open until the end of October.

Takhlakh Loop Trail circles the lake on an easy, 1-mile path along the lake shore and through forest. If you're visiting around mid- to late-August you'll get the bonus of delicious ripe fruit of the plentiful huckleberry bushes. Later still, the leaves of the berry bushes turn beautiful shades of red for some very nice fall color.

Takhlakh Lake & Mount Adams

Photo advice: The view from the day use area and boat launch will tempt you, but it's a rather static composition looking straight across the lake and with a tree line paralleling ridges and waterline. Follow the paths through the campground to find a slightly different angle and maybe some foreground interest.

Getting there: If coming from the Puget Sound area, travel I-5 south to US-12 at Exit 68 and head east to Randle. Turn south on WA-131, then take the left fork onto FR-23 in 1 mile. Go about 32 miles to FR-2329. Turn left and go 1.5 miles to the signed turn for Takhlakh Lake Campground. If coming from the Vancouver-Portland area, you can head east from I-5 at Woodland, taking WA-503 to Cougar and then FR-90 to where it meets FR-23; go north for 4.2 miles to the junction with FR-2329, then 1.5 miles to the lake. A scenic alternative for those coming from the south is to travel the Columbia River Gorge east and then turn north on WA-141 to Trout Lake. At the Y junction in as you enter town, take the right fork, head north for 1 mile to another Y junction and take the left fork onto FR-23; from there, continue north on FR-23 for about 25 miles to the lake.

Time required: Once at the lake, it's just a few minutes walk along the shore to find a vantage point; how much time for photography will depend a lot on weather and light.

Nearby location: Take the trail to the south side of the lake to connect with a trail to Takh Takh Meadows for a 3-mile round-trip hike, or drive to the meadows by following FR-2329 from the campground entrance for about a mile towards Horseshoe Lake. It's a beautiful meadow, although you have to work it from the edges as the trail doesn't go out into the meadow itself.

Council Bluff

Want an easy hike that leads to one of the best views in the southern Cascades? It's all uphill to the top of this bluff overlooking Council Lake, but there are only a couple of steep sections as the trail gains about 900 feet of elevation in reaching the summit at 5,180 feet. The reward is a fantastic panoramic view that sweeps from Mount Rainier in the north to Mount Hood in the south. In between, the jagged peaks of the Goat Rocks are on the horizon to the northwest, and handsome Mount Adams is practically in your face to the east. Look behind you through the trees to spot the flattened summit of Mount Saint Helens over the ridges to the west.

Start at the far end of the Council Lake Campground where the sign says "Boundary Trail 1". Boundary Trail is actually an old road, and the trailhead sign says it is open for hiking, mountain biking, and off-road motorcycling. If possible, avoid hitting this area on summer weekends, when the trail and campground are favorite playgrounds for the noisy dirt bike riders. Follow the old road on a steady climb for about 0.7 mile and look for a short spur trail at the end of a switchback that leads to an excellent view of Mount Adams with Council Lake surrounded by forest directly below.

Continue up the road until it ends, about a mile from the campground. Boundary Trail continues straight ahead, but turn right and go through a nar-row wooden gate onto the summit trail. The broad, flat top of Council Bluff is reached after a total 1.4-mile from the trailhead.

Nothing remains of a fire lookout that sat here from 1932-1960, but the location would be an wonderful spot for an overnight time-lapse photo shoot, giving you the opportunity to shoot Mount Adams at both sunset and sunrise without having to hike in

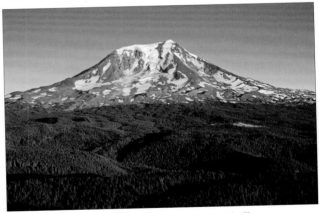

Mount Adams from Council Bluff

the dark. Barring that, bring your flashlight so you can stay for the alpenglow. The trail is generally hikeable from mid-June through October.

Photo advice: Mount Adams is backlit from sunrise through mid-morning; the light on the mountain is very flat mid-day and gorgeous just before sunset.

Getting there: Travel FR-23 from Randle about 35 miles, or from Trout Lake for 20 miles to the junction with FR-2334. Turn west at the sign for Council Lake, go about a mile and then turn right on the road to Council Lake Campground, reached in 0.2 mile. The trailhead is at the top of the campground loop road.

Time required: Three hours will give you enough time for the hike and some photography at the viewpoints. You may want to pack a picnic and linger, or a tent and stay overnight.

Bird Creek Meadows

It doesn't seem to matter which side of Mount Adams you're on, the massive mound looks good from all around. The favorite view from the south has to be from Bird Creek Meadows, where a wonderful hike takes you past waterfalls and through wildflower-strewn meadows to a cliffside view that sweeps over Hellroaring Canyon and up Mazama Glacier to the 12,276-foot summit of Mount Adams. From the meadows themselves, the views of Mount Adams are very good, and while the wildflowers are the main attraction here for many, and the combination is hard to beat.

There are several options for hiking here, all dayhikes as backcountry camping is not allowed. The route suggested below is about 6 miles round-trip, on a relatively easy trail with only 900 feet of elevation gain. Bird Creek Meadows is in the Yakama Nation Mount Adams Recreation Area, and you'll have to pick up a $5 per car permit at the fee box before starting your hike. From the

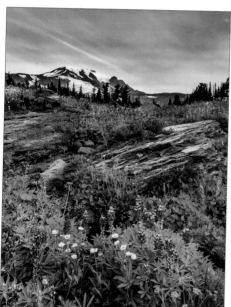

Mt. Adams from Bird Creek Meadows

trailhead parking area at Bird Lake, walk west beyond the administration building on Bird Creek Trail. In just a few minutes you'll first hear and then see Bird Creek tumbling down the mountain and shortly thereafter the trail crosses Crooked Creek. At the peak of wildflower season, the creek is bordered by a profusion of lupine, orange paintbrush, valerian, arnica, monkey-flower, and more.

The trail is mostly easy-walking dirt and duff, with a steady but not steep climb. Crooked Creek Falls appears at the 1 mile point on the trail. The creek drops over a cliff, then tumbles over basalt boulders before cutting its way through the meadow flowers. The waterfall faces southeast, so catches morning light and is in shade late in the afternoon.

At 1.4 miles you'll come to the junction with Round The Mountain Trail. Turn left for a 1.6-mile out-and-back detour for some great meadows and Mount Adams views. If taking this option,

hike west for 0.4 mile then south for another 0.4 mile on Snipes Mountain Trail. Return the same way you came. At the junction with Crooked Creek Trail, head east on Round The Mountain Trail for 0.7 mile, then turn left on Trail of the Flowers. After 0.3 mile, take another left and hike uphill for about half a mile to Hellroaring Viewpoint for a spectacular view. The trail alternates between forest and meadow, with the view of Mount Adams getting better as you climb. There are a couple of nice meadow areas that are great for flowers+mountain landscapes. At the viewpoint, Hellroaring Canyon lies directly below, carved eons ago by Mazama Glacier. Look carefully and you might spot mountain goats in the canyon or on the slopes. Look up for a splendid view of the summit of Mount Adams.

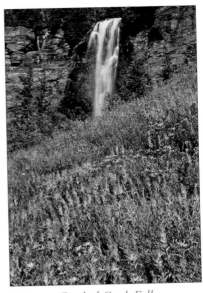

Crooked Creek Falls

Heading back down from the viewpoint, turn left on Trail of the Flowers, and circle down to Bird Creek Meadows Picnic Area and the junction with Round The Mountain Trail. More gorgeous meadows here, and still more excellent views of Mount Adams. If you're a backpacker you'll sure wish camping was allowed here. Turn right at the junction and reach another trail junction in 0.1 mile. From here you can continue west and then go back down the way you came past Crooked Creek Falls, or make a loop by turning south on this trail for a 0.7 mile hike to Bluff Lake, then another 0.5 mile back to the trailhead at Bird Lake. On the way, more forest, more meadows, more creek, more waterfalls. The popularity of this hike is well-deserved.

Photo advice: Prime time for the wildflowers is the late July through early August, with, as always, variation due to elevation and spring-summer weather history. Mount Adams lies northwest of the meadows on the way to Hellroaring Viewpoint, so the mountain would be backlit at sunset and get great light at sunrise. To really work this location, I recommend an overnight camp at Bird Lake Campground. Do the hike as described above, both for photography and to scout a sunrise location. In the morning, head out at O-dark-thirty with your headlamp, taking the trail from Bird Lake to Bluff Lake and then up for the quickest route to the picnic area and Hellroaring Viewpoint.

Getting there: Note: the road to Bird Creek Meadows is open only from July through the end of September. Depending on whether you like driving gnarly roads or not, getting to Bird Creek Meadows is either a pain or a lot of fun. A high clearance vehicle is highly recommended, although a passenger car can make it if driven with care. Start by getting yourself to Trout Lake, and make a stop

there at the Ranger Station to inquire about road conditions and pick up a map. At the Y junction in Trout Lake, set your trip odometer and take FR-23 heading north on the east side of the gas station. Take the right fork onto FR-80 at 1.1 miles, following the sign for Mount Adams Recreation Area. Right fork again at 1.4 miles onto FR-82. A few miles further the road turns to gravel at another junction. Follow the signs to stay on FR-82 for Bird Creek Meadows. At 10.2 miles, turn left onto FR-8290, also signed. The rough road soon gets rougher; it's narrow, rutted, and very dusty. At 14.7 miles you'll arrive at Mirror Lake, and just beyond the lake a large intersection. A sign says Bird Creek Meadows is straight ahead, and there is a trailhead in that direction, but for the trail route outlined above, turn left at the sign and go one more mile to the Crooked Creek Falls trailhead parking area on the south side of Bird Lake. The permit box may be at the Mirror Lake junction or at Bird Lake.

Time required: If you do this hike in wildflower season and make the round-trip in less than 5 hours you're moving too fast and not taking enough time to both photograph and enjoy the beauty.

Nearby location: There are several little lakes in this area, with convenient campgrounds, but unfortunately none have a very good view of Mount Adams

Lewis River Waterfalls

From headwaters high on the western slope of Mount Adams, the Lewis River drops through a series of waterfalls before hitting a trio of reservoir dams on its way to meet the Columbia River near Woodland. In combination with the East Fork Lewis River, the two drainages vie with Mount Rainier for the highest concentration of waterfalls in the state of Washington.

Waterfalls on the East Fork Lewis River are covered in Chapter 4. The largest and best known of the falls on the main Lewis River are easy to get to and several of them are excellent photo locations.

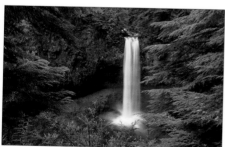

Big Creek Falls

We'll approach them from west to east, starting at Woodland on I-5 and following Lewis River Road, WA-503, past Lake Merwin, Yale Lake and Swift Reservoir. Each of these bodies of water is the result of dams built on the Lewis River. All are popular recreation areas for boaters and fishermen, and while pleasant enough to look at in passing, don't offer great photo opportunities. The waterfalls begin just east of Swift Reservoir, where Lewis River Road changes designation from WA-530 to FR-90 near the town of Cougar.

First up on this route is Curly Creek Falls. Roadside signs, maps, and guidebooks all point out Curly Creek Falls, such that you'd think it was a big deal.

I've been there twice, enjoyed the easy 0.4-mile hike to the designated viewpoint, but come away without even getting the camera out of the pack. Guidebooks say that a waterfall drops through a natural arch, which sounds awesome, but the view is obscured by brush and trees, and, according to waterfall expert Bryan Swan at waterfallsnorthwest.com, apparently some recent geologic event changed the course of the creek and water now only flows through the arch at times of high runoff and the creek is dry by the end of July. Both times I've been there, which have been in early autumn, there has been no water flowing through the arch. Swan also describes bushwhacking to a better viewpoint. If you go and find something good, let me know, okay?

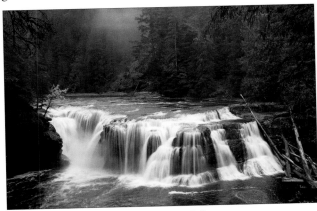

Lower Lewis Falls

Big Creek Falls is a few miles further up FR-90, which continues to follow the Lewis River as it turns northward. There is a good view of this 115-foot tall waterfall at the end of a 0.1-mile barrier-free trail. The waterfall pool is somewhat obscured by trees, but overall scene is quite nice. The surrounding forest is lush and thick, with some of the Douglas-fir trees reaching six feet in diameter.

The triumvirate of Lower, Middle, and Upper Lewis Falls makes a nice day-trip destination, or go for an overnight stay at the Lower Falls Recreation Area campground. This is a popular summer recreation area, good for family camp-outs, with several swimming holes along the river. You can do a series of very short, easy hikes from several trailheads, or one longer hike that takes in all three waterfalls. Good views can be had right from the trail at these falls, although some photographers like to do a bit of scrambling to get right down to a river level view. The surrounding vegetation is the typical verdant lower west Cascades forest of fir, hemlock, and cedar towering over an understory of salal, Oregon grape, elderberry, and fern.

At Lower Lewis River Falls, the water drops over a 35-foot cliff spanning the width of the river. Across the face of the drop, the falls vary from a straight plunge to tumbling cascades to a rushing chute, so you have a choice of a wide shot to encompass the whole waterfall, or work on capturing just a segment of the falls with a telephoto lens. Lower Falls is just 0.25 mile from the Day Use Area parking lot on an easy, barrier-free path. As with Middle and Upper Falls, this waterfall faces west and is in the shade in the morning, making good photos possible even on clear, sunny days if you're there early in the day. The Lower Falls Recreation Area Campground is quite nice, and while it is officially closed from

fall through spring, a couple of campsites outside the gates remain accessible all year round.

Middle Lewis Falls is 1.7 miles upriver from Lower Falls along the Lewis River Trail. The river drops 30 vertical feet over the course of a 100 yard slide. Not the greatest for photography, but dedicated waterfall lovers will want to check it out. You might also want to follow the signs for the 0.5-mile loop side trail to Copper Creek Falls.

The trailhead for Upper Lewis River Falls is at a parking area just where FR-90 crosses Quartz Creek. Look for the sign for Lewis River Trail #31. Head west from this trailhead for an easy 0.5 mile walk to the falls. If you're opting for the longer hike that takes in all three waterfalls, this trail access is 3 miles up river from Lower Falls. On the way to Upper Falls, the trail passes Taitnapum Falls, with a view from the top as the river drops 20-25 feet across a broad precipice. A little ways up the trail you'll look down to the top of Upper Lewis River Falls. A sign points the way to Upper Falls Viewpoint. A short but steep trail leads to a view that's nice to the eye but not particularly good for a camera angle. Scrambling a bit here will get you a better composition. Similar to Lower Falls, the river drops about 35 feet over a broad slab of dark bedrock. Continuing west on the main trail will yield another filtered view before the path angles away from the river. Upper Lewis River Falls needs decent streamflow for photography. In summer the river just slides down the bedrock to one side; in spring and after fall rains, the water rushes widely and wildly over the basalt rock of the riverbed.

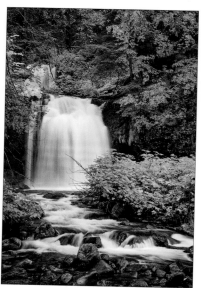

Twin Falls

Higher up on the Lewis River Road, Twin Falls Creek makes a couple of drops, 20+ feet each, into small bowls just before the creek joins Lewis River. The falls are pretty, but the view is from across the Lewis River and only the lower tier is plainly visible. The waterfalls face northwest, and are entirely in the shade in the morning. The falls, and a small developed campground, are 0.3 mile off of FR-90 on a short spur road signed for Twin Falls Camp.

Photo advice: As with most waterfall locations in the Pacific Northwest, streamflow is going to be highest from April to June, and the forest foliage will be at its lushest at the same time. However, the Lewis River itself is a good-sized stream and heavy flow isn't necessarily the best for photos, plus it tends to generate a lot of spray. The Lewis River area is also a good Autumn destination, with a fair amount of bigleaf maple and vine maple providing some nice fall color from late October to early November.

Getting there: From the Puget Sound or Portland area, drive I-5 to Exit 21 at Woodland, then east on WA-503. Just past the town of Yale, continue east on WA-503 Spur towards Cougar, and stay on this road as it becomes FR-90, Lewis River Road. At the east end of Swift Reservoir, cross over Eagle Cliff Bridge, check your odometer and continue to follow FR-90. The turn for Curly Creek Falls is 5 miles beyond the bridge, Big Creek Falls is 8.8 miles, Lower Lewis River Falls is 14 miles and Twin Falls is 26.4 miles. The junction with FR-23 is just a few short miles up river. Those coming from the Portland-Vancouver area, can make a very scenic loop trip, especially in autumn, by taking FR-23 to Trout Lake, then WA-141 to the Columbia River Gorge.

Time required: The Lewis River waterfalls make a very nice all-day trip, giving you plenty of time to really enjoy the short walks and really work the falls.

Nearby location: Look for a very pretty, multi-tiered waterfall on Big Spring Creek just off FR-23 immediately south of the junction with FR-90.

Indian Heaven Wilderness

In 1984, the U.S. Congress gave official Wilderness designation to a portion of Gifford Pinchot National Forest as a measure of protection to an area long known as Indian Heaven. Native people have been using this territory for thousands of years, and continue to do so today, for hunting, fishing, and collecting huckleberries. A portion of the Sawtooth Berry Fields on the north side of Indian Heaven are reserved by treaty for berry harvesting solely by Native Americans.

The Wilderness area encompasses over 20,000 acres of subalpine forest and meadow, and includes over 100 lakes. The Pacific Crest Trail bisects the wilderness, which also contains many more miles of trails. Forest Service roads encircle the wilderness and there are campgrounds, both developed and primitive throughout the area.

The meadows of Indian Heaven Wilderness can be wonderful for wildflower seekers, but as renowned trail guide gurus Ira Spring and Harvey Manning point out, soon after the snow clears in early July, Indian Heaven might be more appropriately called Mosquito Heaven. On the other hand, in September when the huckleberries ripen and later in autumn when

Vine maple in autumn

the vine maple leaves turn brilliant in super-saturated reds, oranges, and yellows; this is a wonderful area to explore and photograph.

Indian Heaven Loop Trail

The most popular hike in the Indian Heaven Wilderness, and one with very good photo potential, circles Bird Mountain by making a 7-mile loop using Cultus Creek Trail, Pacific Crest Trail, and Indian Heaven Trail. All the sources I used to research this hike proposed a clockwise route on this loop trail. All also noted that the hiked ended with a steep descent. My own preference is to opt for the more gradual descent whenever possible (easier on my well-worn knees), and I don't mind doing a steep uphill at the beginning of a hike when I'm fresh. As I found out, either direction entails a good climb to start and ends with an almost equally steep descent. If you choose the counter-clockwise circuit, you'll get the best of the hike towards the end, whereas going clockwise gets to the good stuff sooner but the second half of the hike is somewhat anti-climactic.

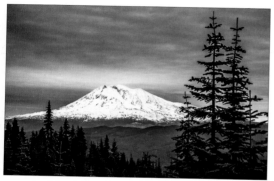

Mt. Adams from Cultus Creek Trail

If you're here just as a photo excursion, looking for grand views of Mount Adams, you might opt to start in the clockwise direction but just do the first third of the hike, with Deep Lake as the turn around point. If, on the other hand, you're here for a nice dayhike that combines the Adams views, wildflower or fall color opportunities and a nice stroll on the PCT , do the whole loop. Since I did the loop in the counter-clockwise direction, that's how I'll describe it.

Park at the trailhead for Indian Heaven Trail that is at the back of Cultus Creek Campground, then walk back to FR-24 to the trailhead for Cultus Creek Trail #108. The walk through the campground makes for a nice muscle-loosening stretch after the drive to get here. Sign in at the Wilderness Permit box, then start the hike. Right from the start it's a steady and fairly steep climb. At one mile up the trail you'll catch a fairly decent view of Mount Adams through the trees, but keep climbing until, at 1.6 miles, you see a spur trail on the right. This leads, in less than 50 feet, to a quite nice view of the mountain. You might find a nice composition using the tall, thin fir trees to frame the scene, but don't linger too long here, as the view is definitely better further on the trail.

Just past that spur trail, the trail reaches a saddle and then begins a gentle descent, reaching the Pacific Crest Trail at 1.8 miles. Stay to the left at the junction, and follow the PCT south, passing a number of little lakes and bogs along the way. At 3.3 miles, turn left at the junction for Indian Heaven Trail #33. The trail now contours around the south side of Bird Mountain, skirting the shores of Clear Lake and Cultus Lake. A scant 0.3 mile round-trip side trail leads to pretty little Deep Lake. Just over a mile beyond Deep Lake the trail comes to

an opening on a ridge with a clear view to the east of Mount Adams and, on a clear day, Mount Rainier to the north. The trail descends somewhat steeply from here, losing about 1,000 feet in elevation, before reaching the trailhead at Cultus Creek Campground in another 1.1 miles.

Photo advice: For the very best photo conditions, get to Cultus Creek Campground around mid-morning, set up camp, then do the hike in the afternoon, aiming to arrive at the ridge viewpoint just before the light gets golden.

Getting there: From Trout Lake, head west on WA-141 for 8 miles to Petersen Prairie Campground, then take FR-24 for another 8 miles to Cultus Creek Campground. If coming from the Wind River drainage or Lewis River waterfalls, pick up CO-30 and follow it north to the top of the Indian Heaven Berry Fields, then turn south and drive 4.2 miles on a rough gravel section of FR-24 to the campground.

Time required: I did this loop in about 5.5 hours, with time to explore, photograph, and stop for lunch at Clear Lake. It is certainly possible to do it in less time, or take even more.

Nearby location: For some excellent fall color in mid-October, and a very interesting geological feature, visit Natural Bridge Interpretive Site, about halfway between Trout Lake and Cultus Creek Campground. From Trout Lake, head west on WA-141, which becomes FR-24, for about 6.5 miles and start looking for a sign pointing the way to Natural Bridge. If coming from Cultus Creek, travel east on FR-24 for 0.8 mile from Peterson Prairie Campground at the junction with FR-60. At the sign, go south on FR-041 for 0.5 mile, then right at another sign to reach the Interpretive Site parking area in another 0.3 mile. A very short hike through

Natural Bridge

dense forest leads to a partially collapsed lava tube. Two sections of roof remain, forming natural bridges in what is now a mile-long mini canyon. Vine maple is thick in the area, with foliage ranging from yellow to crimson in autumn.

Trout Lake

The little town of Trout Lake is gateway to a whole bunch of outstanding scenic locations and recreational opportunities. It provides a convenient place to get supplies and gas, there are a couple of small inns for lodging and a county park offers an option for those who like to camp. The USFS folks at the Mount Adams Ranger District office can give you up to date info on road and trail conditions as well as suggest best places for fall color or spring wildflowers.

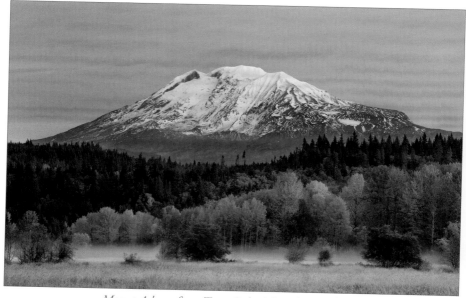

Mount Adams from Trout Lake (photo by Jesse Estes)

For a beautiful view of Mount Adams, particularly in autumn, go 0.1 mile west of the ranger station on WA-141 and turn north on Lake Road. The road ends in 0.6 mile with a clear view of Trout Lake Creek, marshy wetlands, and Mount Adams. In spring and fall, this is a good location for sunrise light on the mountain, whereas in summer the sun rises too far to the north. On autumn days you're likely to hear the wonderfully eerie bugling of elk. At the end of the road, Lake Trail runs north into the Trout Lake Natural Area Preserve. For another access to the NAP and an excellent view of Mount Adams, backtrack to the ranger station, head west again on WA-141 for 0.8 mile, turn north on FR-88, Trout Lake Creek Road, and go 1.3 miles to reach a signed entrance to Trout Lake Natural Area Preserve. If you're out shooting in this area in autumn, be sure to wear some blaze orange so that you're not mistaken for an elk or deer.

West of Trout Lake, a network of Forest Service roads are great for exploring, especially in autumn when the vine maple and huckleberry turn wonderful shades of red, orange, and yellow. FR-60, the westward extension of WA-141, is very good for fall color, as are the subsidiary forest roads to the north and south.

Photo advice: Peak of the fall color in this area is generally mid- to late October. The vine maple can be particularly vibrant around here, so much so that you'll have to be careful when shooting digital that you don't clip the yellows and reds. Watch the channels on your camera's histogram, and if shooting JPEG, set the color mode to normal instead of Vivid or Landscape.

Getting there: From the Portland-Vancouver metro area, head east into the Columbia River Gorge on WA-14. Just across the Columbia from the town of Hood River, turn north on WA-141 or WA-141-ALT. Continue on this highway

for 21 miles to the gas station at the Y junction with Mount Adams Road. Fork left and stay on WA-141 for Ranger Station, general store, and Guler County Park Campground. If coming from the north, you can find your way to Trout Lake with a good map and depending on your starting point, following FR-25, FR-90, FR-88 or FR-23—for the most part good, paved roads. Those northern routes do travel through some remote country however, and might not be advisable in winter with snow at the higher elevations.

Time required: The view of Mount Adams from the end of Lake Road doesn't require more a few feet of walking, so won't require much time to check it out. If conditions are good and the light is right, you'll want to spend an hour or so.

Nearby location: A short, easy walk through thick forest leads to Langfield Falls, where Mosquito Creek falls about 60 feet in a veil formation. At times of heavy stream flow, the waterfall spreads over a bulging chunk of charcoal gray rock. In drier times, the waterfall divides, with almost all the water flowing to one side. Heavy spray and downed logs in the pool below the falls can be a challenge here but dedicated waterfall lovers will want to work this one. To get to Langfield Falls, travel west on WA-141 for 1.5 miles from the Y junction in Trout Lake (passing the ranger station), then north on FR-88 for 12.8 miles to Tire Junction. Look for the trailhead sign on FR-88 about 0.1-mile north of the junction. The trail from the parking area to falls viewpoint is less than a quarter mile.

Wind River Waterfalls

Two waterfalls in the Wind River drainage are worthwhile photo destinations, each accessible via an easy and pleasant hike. The WaterfallsNorthwest website lists an even dozen waterfalls named Falls Creek Falls. This one, in the south-central part of Gifford Pinchot National Forest, is a real beaut and well worth the drive and hike to get to it. Falls Creek drops more than 200 feet in three tiers, although it's nigh impossible to see all three at once. From the trailhead for Lower Falls Creek Trail #152, it's a relatively easy 1.7-mile hike along the creek to get to the falls. There is a good view of the plunging lower and fanning middle tiers from the end of the trail.

Panther Creek Falls requires only a very short hike to reach a platform with a quite nice view of the upper tier of an unusual segmented waterfall Look carefully and you'll find something of a path down to the bottom of the falls and the lower tier, but getting there requires a near-vertical scramble—not advised unless you're experienced in off-trail travel. Interestingly, the location for these very attractive falls is not shown in the DeLorme or Benchmark atlases, nor on the maps in National Geographic's Topo! program.

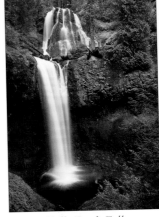

Falls Creek Falls

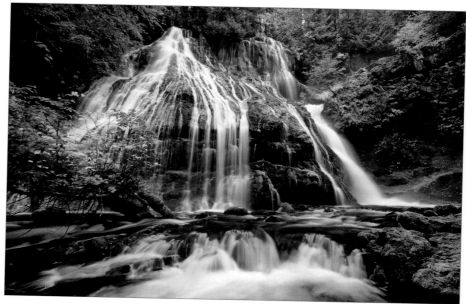

Panther Creek Falls (photo by Steffen Synnatschke)

Photo advice: A fairly wide-angle lens is required at both of these sets of falls to take in the whole view. If the weather forecast is for sunshine, plan on being at these falls early in the morning while they're still in shade. At times of high runoff in spring there's likely to be a lot of spray. Autumn in this part of the Gifford Pinchot National Forest is beautiful and you'll find a bit of fall color to enliven photographs of these waterfalls.

Getting there: To get to Panther Creek Falls from the Columbia River Gorge, take WA-14 to Carson, then head north on Wind River Road, which becomes FR-30. After 5.8 miles, turn east onto Old State Road, then almost immediately turn left onto Panther Creek Road, FR-65. In about 7.5 miles look for a large gravel parking area. Walk across the road and look for an unmarked trail about 100 feet back down the hill. Follow the trail for about 500 feet to reach the viewing platform. For Falls Creek Falls, continue past the turn for Panther Creek for 9.5 miles (about 15.3 miles north of Carson) to FR-3062, signed for Falls Creek. Turn east and in 2 miles go right onto FR-3062-057 and follow the signs to Lower Falls Creek Trail, reached in another 0.75 mile. If you're coming from the north on FR-30, the turn to Falls Creek is about 12 miles south of the junction of FR-30 and Curly Creek Road.

❖ ❖ ❖

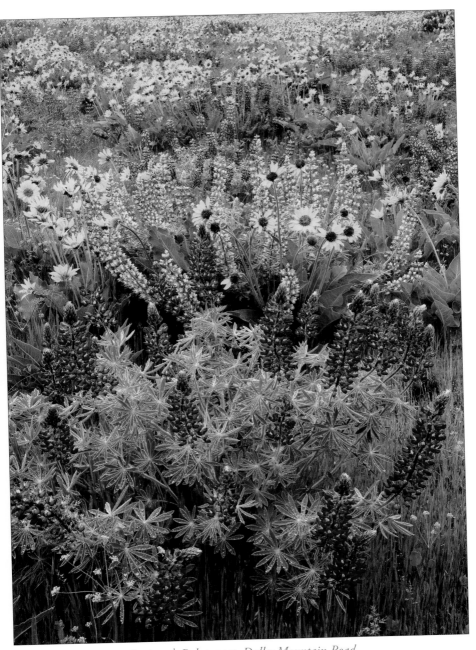

Lupine & Balsamroot, Dalles Mountain Road

Chapter 12

COLUMBIA RIVER GORGE

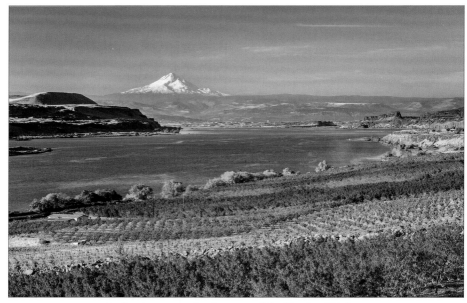

Orchards, vineyards, & view to Mt. Hood at Wishram

COLUMBIA RIVER GORGE

An ancient Columbia River was already flowing to the ocean 40 million years ago when a series of volcanic eruptions began that deposited layer after layer of basalt lava, ash, and mud over most of what is now eastern Washington and northeastern Oregon, forming the Columbia Plateau. Despite continued upheavals and the formation of the Cascade Mountains, the river continued to cut through the basalt, finding its way to the Pacific Ocean. It was a vastly different terrain than what we see today, however. At the end of the last Ice Age, giant Missoula Lake had formed in Montana and Idaho, and when its dam burst about 15,000 years ago, a wall of water up to 1,200 feet high poured out, scoured a large part of the Columbia Plateau and broadened the ancient river route. It's hard to comprehend such a cataclysmic event, but geologists now think that this flooding occurred repeatedly during a time period of a few thousand years and refer to the events as the Missoula Floods.

The Columbia River Gorge has served as a transportation corridor since the beginning of human habitation in the Pacific Northwest. Archeological digs have found evidence that Native Americans have occupied the Celilo area, a major salmon fishing site, for more than 10,000 years, and there is evidence that there were major regular trading encampments at the present-day Horsethief Lake site. Lewis and Clark ran their canoes through treacherous rapids on a wild Columbia River on their way to the Pacific, to be followed half a century later by the Oregon Trail pioneers who had to choose between the risky river route and

a rugged overland toll road on the south side of Mount Hood. The river today remains a major transportation route, with barge traffic passing through a series of locks built as part of hydropower dams, Interstate Highway 84 on the Oregon side, and busy railroad tracks running on both sides of the river.

The Gorge has long been recognized for its outstanding scenic beauty, and in 1986 Congress established the Columbia Gorge National Scenic Area. This special designation encompasses the stretch of the river, and varying amounts of land to either side of it, from the eastern edge of the Portland-Vancouver metro area upstream almost to the point where US Highway 97 crosses the river.

The Oregon side of the Columbia River Gorge gets more play in the travel press, largely due to the presence of the numerous waterfalls and the stretch of historic highway, but the Washington side is also extremely scenic. And the nice thing is, there are a lot more places to pull off the road for photography on the Lewis & Clark Highway (WA-14), than there are on I-84 on the Oregon side. The locations listed here are from west to east, starting in Vancouver.

Cape Horn

Leaving the suburbs of Vancouver, the Lewis & Clark Highway skirts the north shore of the Columbia River as it passes the plains and ponds at Staggerwald National Wildlife Refuge. Views of the river disappear as the road enters forest and climbs in elevation, until suddenly rounding the bend at Cape Horn, where a roadside pullout offers a superb view of the mighty river and The Gorge.

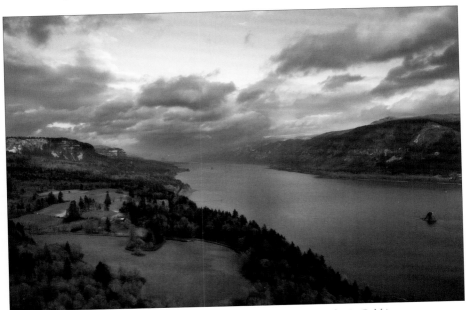

Columbia River from Cape Horn (photo by David M. Cobb)

For even better views, hike the Cape Horn Trail, an 8-mile moderately strenuous loop that rises to viewpoints 1,200 feet above the river and then drops right to its shore. The trail starts with a gentle climb through thick forest, reaching Pioneer Point and a panoramic view of the Gorge in 1.2 miles. The trail passes a couple more viewpoints then drops below a ridge as it continues west. In spring there are lots of wildflowers along the trail and on the steep hillsides at the viewpoints. The trail briefly joins an old, well-graded road, and then goes uphill to the left on another old road. Follow this path for about 0.3 mile to paved Strunk Road, turn left and walk the short distance to where the pavement ends at a fence. Turn south on the better of two gravel lanes, which looks like a private drive but leads to USFS property and an incredible view of the Gorge. Use extreme caution here as the drop-off is extreme and the trail can be slippery. The trail continues south through forest and another very good viewpoint, then descends to WA-14. After crossing the Lewis & Clark Highway, the trail drops down to the Columbia River, passing behind a waterfall before meeting Cape Horn Landing Road. Follow this road back up to the parking area at Salmon Falls Road. The section of the trail below the highway is closed from January 1 to July 1 to protect sensitive peregrine falcon habitat. If visiting during that time, turn around at the viewpoint just below Strunk Road because walking along the highway is extremely dangerous—there is absolutely no shoulder in a stretch along the cliff and there is a lot of fast moving traffic that includes large trucks.

Photo advice: There is potential here for great sunrise over the river photos, particularly during summer months, as the view is almost directly east from the viewpoints, otherwise mid-afternoon light on a day with little haze will work for a good daytime shot.

Getting there: From I-5 or I-205 in Vancouver, travel east on WA-14 to MP 25 for the roadside viewpoint. Continue another mile to Salmon Falls Road, turn left and immediately make a right into the Park & Ride lot. The trailhead is just across Salmon Falls Road from the parking lot.

Time required: Cape Horn Trail makes a very nice half-day hike. If your time is limited, the views from the highway pullout are quite good and require just a few minutes.

Beacon Rock State Park

Standing as a sentinel near the western end of the Columbia Gorge, the 848-foot tall Beacon Rock is a distinctive landmark. According to some authorities, it is the second largest freestanding monolith in the world, surpassed only by the Rock of Gibraltar. It's a pretty impressive chunk of andesite rock, the core of an ancient volcano left when ice-age floods in the Columbia Basin eroded away softer material. Lewis and Clark stopped at Beacon Rock in 1805, noting that it marked the eastern extent of ocean tide influence in the Columbia River.

The state park includes 5,100 acres of forest and river shoreline, a summer-only campground and several miles of hiking trails. A mile-long switchbacking trail leads to the top of the rock, with 360° panoramic views at the summit. It's a fairly easy hike thanks to historic ironwork bridges and stairs built into the steep-sided tower of rock.

Another easy trail leads to a couple of very nice waterfalls. The first, Hardy Falls, is reached by hiking 1.3 miles up the Hamilton Mountain Trail. Take the short spur trail to the right for the best view. It's just another 0.1 mile up the main trail to Rodney Falls. Hardy Falls is the larger of the two and is quite impressive with good spring flow, but the view from the developed lookout is somewhat obstructed. Rodney Falls is more interesting and is easily photographed from a viewpoint at the base of the main falls or from the footbridge below where the falls cascade over a rocky slope. At times of high water the spray and wind from the falls often preclude photography at the upper viewpoint.

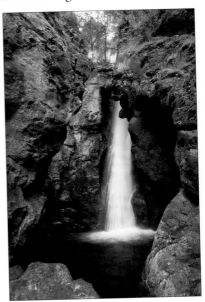

For a more strenuous hike, and the reward of outstanding views of Mount Hood and the Gorge, continue on Hamilton Mountain Trail. It's a steep climb, gaining 2,000 feet in elevation to reach the summit, and round-trip distance, including the waterfalls, is 9 miles. Wildflowers are abundant from mid-April to mid-May, both on the forest floor and in open meadows near the top of Hamilton Mountain.

Photo advice: There's an okay partial view of Beacon Rock itself from the picnic area, but the best views are from the shoreline or even across the river from the Oregon side, and in early morning light. Views from the top of the rock are better later in the day. The waterfalls work best with the soft light of an overcast day and the good stream flow in late spring or early summer.

Rodney Falls Pool of Winds

Getting there: The entrance to the state park is at MP 35 on WA-14. Traveling from the Oregon side of the river, or further east in the Gorge, it's about 7 miles west of Bridge of the Gods at Cascade Locks.

Time required: Either the waterfall trail or the route to the top of Beacon Rock can be done in an hour or two.

Nearby location: The visitor's complex at Bonneville Dam has some good views of the generators inside the powerhouse, as well as a look at migrating salmon as they work their way up river. There are also good exhibits on the history and technology of Bonneville, and guided tours are available every day. Entrance to the visitor area is located at MP 39 on WA-14.

Dog Mountain

The first time I hiked Dog Mountain Trail was in early spring after a winter of not near enough activity. I decided the mountain got its name because, unless you are in pretty good shape, you'll be dog-tired after doing this hike. It is, however, one of the premier hikes in the Pacific Northwest, both for the outstanding views of the Columbia River Gorge and for fantastic spring wildflower displays. Pick a day with a suitable weather forecast in late April or early May, load up the photo pack, and aim to get an early morning start so the winds will,

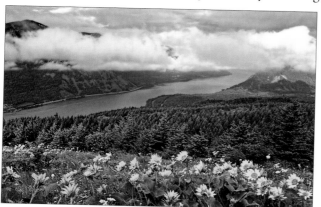

Balsamroot & view downriver from Dog Mountain

hopefully, be calm when you reach the flowers. It is a 7-mile round-trip jaunt, with an elevation gain of 2,750 feet. I highly recommend taking a set of hiking poles, or pick up a couple of wooden sticks left at the trailhead by previous hikers. Unless you've got the knees of a twenty-something runner, you'll be glad to have them for the downhill return trip. You'll also want to pack plenty of water, keep an eye out for poison oak and rattlesnakes, and to check yourself for ticks after the hike.

The trail begins to climb steeply in forest as soon as it leaves the parking area, reaching a junction in 0.5 mile. Take the right fork, as it has more forest openings for wildflowers and a good viewpoint at about 1.5 miles. The trails rejoin near the 3-mile point, just before an open knoll at 2,500-foot elevation. In spring, the slopes here are a mass of brilliant yellow arrowleaf balsamroot, punctuated by deep blue lupine and red paintbrush. It's hard to say which is more breathtaking—the floral display or the views down the Columbia River and across the Gorge to Starvation Creek Falls. This is the prime area for the flowers, but after working here continue the climb for another half mile to reach the top of Dog Mountain at 2,920 feet where the views are even more spectacular—a panorama from Hood River to distant Mount Hood and nearby Wind Mountain.

For the return hike, backtrack from the summit 0.1 mile to a junction and follow the trail west towards Augspurger Mountain. At 1.1 miles, turn south on Augspurger Mountain Trail for a 2.7-mile walk back to the trailhead. This route is much more gradual, and easier on the knees, than returning on the steep Dog Mountain Trail.

Photo advice: This is a very popular trail, perhaps second only to Multnomah Falls in the Gorge, so visiting early on a weekday, particularly during wildflower season, is advised. Flowers bloom from early April through June, with peak from late April to mid-May. There is quite a bit of variation in peak flower time from low elevation to the top of the mountain.

Getting there: The trailhead is at the east end of a large parking area on WA-14 between MP 53 and 54, about 12 miles east of Bridge of the Gods.

Time required: Allow at least half a day for the hike and plenty of time for photos if you're visiting during wildflower season.

Nearby location: Dog Creek Falls is an attractive 20-foot high waterfall just off WA-14. Look for an unsigned parking area on the north side of the road just west of MP 56 (about 6 miles east of Carson). It's a short walk up the creek to views of the falls and pool. Framing the falls with the oak trees on the side of the creek on the way might work better than getting right up to the falls, particularly if the oaks are showing autumn color.

Coyote Wall Trail

The dramatic sheer cliff and extensive views up and down the Columbia River make this trail a favorite for year-round hiking and landscape photography. Springtime bunches of balsamroot, lupine, and other wildflowers dotting the extensive sloping meadow make the trail even more enticing. The hike is 5.8 miles round-trip, gaining 1,520 feet in elevation on a steady, gentle climb.

From the trailhead just off Highway 14, head east on the old abandoned roadway for 0.7 mile. Turn uphill at the "Forest Visitors" sign, keeping left at the several junctions with secondary trails and mountain bike routes. Go left when you reach the old dirt road, and follow this route as it climbs and crosses open meadow. This area is popular with mountain bikers, and there are quite a few side trails, but it's

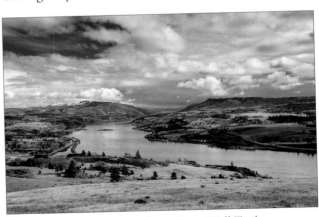

Gorgeous view from Coyote Wall Trail

fairly easy to determine the main route up the hill. At 1.6 miles from the trailhead, the path comes to a fence and makes a sharp left, following the fence line west almost to the edge of Coyote Wall, a sheer basalt cliff. From here, the

trail more or less follows the cliff edge, climbing for about a mile until it reaches forest at the top of the meadow. There are some great views looking across the meadow to the Gorge, and over the cliff edge. On the return, turn left at the junction just below the fence line, and follow the trail as it winds down to the old road in 1.1 miles, passing a pretty little waterfall and creek on the way.

Photo advice: As elsewhere in the Gorge, early mornings are usually best for photographing flowers because the winds are calm. For general landscapes, late afternoon sun raking the meadow works really well.

Getting there: Travel WA-14 to Courtney Road, about 4.5 miles east of Bingen and just west of MP 70. The parking area is immediately above the highway, with an obvious trailhead sign and gate across Courtney Road..

Time required: Plan on about three hours for the hike, and considerably more if it's wildflower season and conditions are good.

Nearby location: For a great view of Mount Hood, turn north on Cook-Underwood Road (CR-41) where it meets WA-14 on the east side of White Salmon River. The road climbs and then turns west to follow a bluff overlooking the Columbia River. Houses and private property block access most of the way, but there are a couple of spots with views to Hood River Valley and majestic Mount Hood. The view is especially good in summer when the sun is at its northernmost at sunrise and sunset and there's a good chance for getting alpenglow on the snow-capped summit.

Catherine Creek

One of the first places winter-weary Northwest photographers head for in early spring is Catherine Creek. This eastern section of the Columbia River Gorge starts to warm up much earlier than locations west of Hood River and the first blooms begin to appear in February. Purple grass widows start to pop up in March, blue camas join the show in mid-April, with arrowleaf balsamroot adding bright yellow blossoms in early May. Other photographer favorites include lupine, larkspur, and shooting star. Catherine Creek is not an area with glorious carpets of color, but more the place to work on close-ups of individual flowers.

There are several options for hiking in the Catherine Creek area. On the south side of Old Highway 8, a paved wheelchair-accessible trail makes an extensive loop through an undulating grassy plain with pockets of black oak, ponderosa pine, and an assortment of wildflowers.

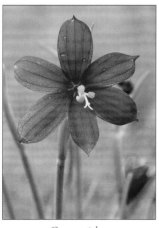

Grass widow

Another trail starts at an iron gate on the north side of the highway and angles off to the right towards Catherine Creek. In April and early May look for the delicate pink bitterroot blossoms that appear to be growing almost out of bare rock at the beginning of the trail. Meriwether Lewis was the first to provide a scientific description of bitterroot and noted that the bulbs were an important food source for the native peoples of the northwest.

Continue on the easy-walking trail towards the northeast as it drops down to a little canyon and, after 0.3 mile, take the right fork and cross the creek. Pay attention and keep to the center of the trail because poison oak and poison ivy are rampant here. In warmer months, it's a good idea to keep an eye out for rattlesnakes, too. The trail soon leads to

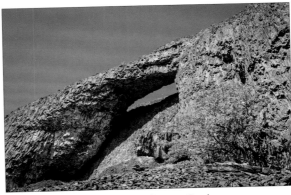
Arch at Catherine Creek

an old wooden corral under spreading Oregon white oak and ponderosa pine trees. Look to the east here to find a natural arch at the top of the basalt lava canyon wall. You can scramble up the talus slope to the base of the arch, but you'll have to pick your way carefully through poison oak to get there.

Turning around here will make it an easy 1-mile round-trip hike, but the trail continues up the Catherine Creek drainage and there is a nice meadow area under the big power line at 0.8 mile. If you're interested in continuing beyond that, find your way up to the plateau to the east and follow a faint trail south to the edge of the canyon and a look down through the rock arch.

Photo advice: It's often very windy here in the Gorge but it's usually calm first thing in the morning so get an early start if you've come for the wildflowers. From below, the rock arch is better with afternoon sun on a blue-sky day.

Getting there: Traveling WA-14 about 5 miles east of Bingen, turn north on Old Hwy No. 8 at the west end of Rowland Lake, just before MP 71. Travel this road for 1.3 miles to an obvious parking area on the north side of the road; there's a port-a-potty on the south side of the road at the trailhead.

Time required: One hour is sufficient for a quick walk to the arch and a circuit of the lower trail, but allow much more time if you're planning to work the flowers or do a more extensive hike.

Nearby location: Chamberlain Lake Rest Area on Highway 14 has great views of the Columbia River Gorge, particularly looking up-river from the east side of the rest area. Look for the large, spreading tree over a picnic table; it turns brilliant yellow-orange in autumn, framing the view.

Klickitat Trail

Running thirty miles on the old railroad corridor between the towns of Lyle and Goldendale, this popular graveled trail follows the Klickitat River from where it meets the Columbia at Lyle, upstream into a scenic valley, then turns to follow a tributary in Swale Canyon. The habitat changes from oak and ponderosa forest along the Klickitat to arid sagebrush hills along seasonal Swale Creek.

For a really nice view that includes Mount Hood as well as the river, canyon, and trail, follow Highway 142 north from Lyle for 1.6 miles to the Fisher Hill Bridge. Park just beyond the bridge and find the trail access on the west side of the river. Walk north for about a mile, checking the view behind you until Mount Hood appears. You might want to scramble up the hillside a bit for more elevation, but watch out for poison oak and rattlesnakes. The rocky gorge at Fisher Hill Bridge is a tribal fishing area.

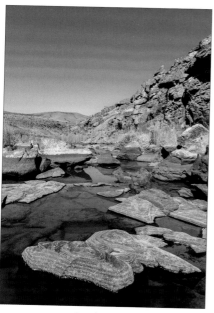

Swale Creek

The other end of the trail, at the Harms Road trailhead, is in completely different terrain. The trail, some of it over old railroad trestles, follows Swale Creek from open sagebrush plain into a narrow canyon. It's a great place for listening to meadowlarks while photographing spring wildflowers. The Trail is mostly level and easy walking, and is also suitable for mountain bikes.

Photo advice: Early morning is best in the Swale Creek area, whereas the river and Mount Hood view north of Fisher Hill Bridge are better in the afternoon.

Getting there: Travel WA-14 to the town of Lyle and look for the main trailhead parking area just off the highway on the east side of the Klickitat River, or drive up WA-142 along the river. To reach the Harms Road trailhead from Lyle, turn north on Centerville Highway and travel this pleasant country road for 14.5 miles and turn left on Harms Road. The trailhead is on the left in 0.5 mile.

Time required: At least a couple of hours are needed here for some hiking and finding good compositions.

Nearby locations: In some years, the fields along Harms Road to the north of the trailhead are filled with bright yellow arrowleaf balsamroot in April and May. After reaching a rise in a couple of miles, there are views with snow-capped Mount Adams in the distance. It's possible to do a loop drive back to the Klickitat River by going left at the junction of Harms Road and Horseshoe Road, which

drops down to the river at Wahkiacus. Further northe, there is some very nice fall color in the oak trees along the Klickitat River further north, particularly in the area of Stinson Flat Campground. Take WA-142 from either Lyle or Goldendale, turn north on the Glenwood-Goldendale Road and follow it for several miles to where it drops into the deep canyon of the Klickitat.

Conboy Lake National Wildlife Refuge

This 6,500-acre wildlife refuge is not in, or even really close to, the Columbia River Gorge, but it's included in this chapter because it is generally reached by first traveling through the Gorge. A combination of forest, grassland, wetland, and lake habitat provide homes for quite a few species of birds and mammals, including sandhill crane, bald eagle, migratory waterfowl, elk, and deer. Conboy Lake was mostly drained by early settlers looking to increase the amount of land at Camas Prairie for farming and ranching, and is now almost entirely just a seasonal marsh. The wildlife refuge was established in 1964 to protect remaining wildlife habitat. Today it is one of only two nesting places for sandhill cranes in Washington, and it also home to the endangered Oregon spotted frog.

Starting at refuge headquarters, Willard Springs Trail is an easy 2-mile loop along the west shore of the old lake bed; it offers wildlife watching and views of Mount Adams to the north. Early spring is crane nesting season, as well as wildflower time. This is the only part of the refuge that is open for public use (except for some limited hunting and fishing access). Driving the roads that crisscross Camas Prairie—through the refuge and adjacent to it—you're likely to spot elk and deer in the fields, classic old barns, and some great views of Mount Adams. Perhaps the biggest attraction at Conboy for most photographers are

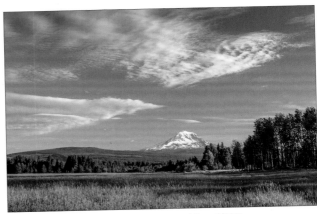

Mt. Adams from Conboy NWR

the aspen and cottonwood trees in the area that make for great fall color landscapes, particularly when combined with snow-capped Mount Adams.

Photo advice: Whether you're here for the wildlife or the views of Mount Adams, sunrise to early AM is the best time to visit this area. Peak of fall color around Conboy Lake and the Klickitat River (see Nearby Location below) is mid- to late-October.

Getting there: If coming from further west in the Columbia River Gorge, take WA-141ALT north from Underwood, continuing on WA-141 for about 8 miles to BZ Corner. Fork to the right on Glenwood Road and go about 8 miles and make a left on Laurel Rd. Drive 3.5 miles north to Trout Lake-Glenwood Road and turn right on that road, go about 1 mile and make a right turn at the signed entrance to refuge headquarters. If coming from the Klickitat Trail area in the previous section, follow WA-142 northeast towards Goldendale until the road rises up from the river canyon to a broad valley. Turn north on Glenwood-Goldendale Road and continue on this scenic road as it drops down to the Klickitat River and then climbs again to Camas Prairie and the town of Glenwood. Continue west and then southwest on Trout Lake Highway for about 6 miles to refuge headquarters.

Time required: Since it takes a bit of a drive to get here, plan on making it at least a half-day trip.

Nearby location: As mentioned in the previous section, there are some very scenic areas along the Klickitat River to the southeast; taking this route makes for a good loop trip. The Bird Creek Meadows area of Mount Adams is not far from Glenwood as the crow flies, but the road is reported to be in very poor condition—a challenge even for high-clearance 4WD. See the Southern Cascades chapter for information about Bird Creek Meadows.

Dalles Mountain Road

If you're looking for a carpet of color during spring wildflower bloom, Dalles Mountain Road is one of the very best places to find it in the entire Pacific Northwest. The undulating south-facing slopes rising above the Columbia River get lots of early spring sunshine, and in a good year acres and acres of rolling hills are blanketed with bright yellow arrowleaf balsamroot and deep blue lupine.

On clear, sunny days you can shoot upslope with the rounded hills against the sky, or downslope with the Columbia River and Mount Hood in the distance.

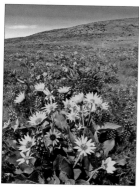

Balsamroot & lupine

The main area of interest to photographers is the old Dalles Mountain Ranch lands, now part of Columbia Hills State Park. The hills are rather dry and barren-looking much of the year, but several of the old ranch buildings provide good 'weathered wood' photo subjects and make this place worth visiting at times other than the April-May wildflower season.

Note that as you head up the road from Highway 14, the land to either side is private property. There is usually a great display of balsamroot and lupine around a ranch corral 1.6 miles up the road. Shoot right from the fence for some great compositions without trespassing. Continue up the road for another

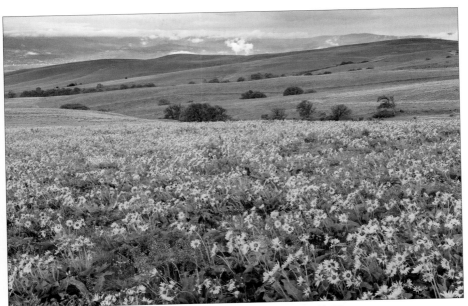

Dalles Mountain Road, Columbia Hills SP

couple of miles to state park lands and the old ranch buildings. The slopes just beyond the old barn are usually quite productive and you can wander at will among the flowers. Keep an eye out for rattlesnakes and be sure to check yourself for ticks when you return to your vehicle. About a mile further east on the road is a picnic area and interpretive kiosk; from there, you have great views of the Columbia River, and even Mount Hood on clear days. When the bloom is at peak, this is a truly wonderful place to spend a morning shooting pictures while listening to the meadowlarks.

Photo advice: As in most of the eastern part of the Columbia Gorge, it's often windy here; best bet for calm is right at sunrise, and the light is gorgeous then, too. If you're there on a windy day, try playing with long exposures for impressionistic images. The balsamroot peaks in late April, and then lupine takes over to become the dominant bloom through mid-May.

Getting there: From the junction of WA-14 and US-197, head east on WA-14 for 0.9 mile then turn left on Dalles Mountain Road and continue up this well-graded gravel road.

Time required: At the height of wildflower season, plan on spending no less than several hours here.

Nearby location: For more opportunities to shoot wildflowers, follow the road north of the ranch buildings, up past a private residence, and to the gate at the edge of the Columbia Hills Natural Area Preserve. Panoramic views of the hills and south to Mount Hood are available from a couple of places along the road leading to the top of Stacker Butte.

Horsethief Lake Petroglyphs

The southern section of Columbia Hills State Park bordering the Columbia River at Horsethief Lake is an area that was of immense importance to the Native American people. Tribes from all over the Pacific Northwest and east to the Great Plains converged here for yearly trading events. Historians and archeologists have found evidence that as many as 10,000 people camped in the area during these times. The Native Americans left no permanent structures, but they did leave hundreds of petroglyphs and pictographs on the basalt cliffs along the river. The vast majority of these antiquities were drowned when the Columbia was dammed, but a few petroglyphs were saved when the chunks of lava they were

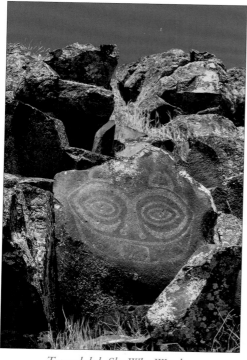

Tsagaglalal, She Who Watches

carved into were removed from their original locations. Some of these petroglyphs have now been placed on display, in a largely natural looking environment, near the campground at Horsethief Lake.

In addition, there is a section of the park where a good number of petroglyphs and pictographs remain in their natural state in an area above present day river levels. Among these is the striking Tsagaglalal ("She Who Watches"), a petroglyph depicting a woman watching over the Columbia River from a basalt cliff; it is probably the most famous petroglyph in the Pacific Northwest. This area can only be visited with a guide during official tours that are given at 10 AM on Fridays and Saturdays from April to October. Reservations are required and often fill up 2-3 weeks in advance, so reserve early by calling the State Park *(see Appendix)*. There are occasionally no-shows, so you might get lucky and be able join a tour if arriving without a reservation.

Note that the Horsethief Lake section of Columbia Hills State Park that includes the rock art and a nice little campground is only open from April through October.

Photo advice: The petroglyph display faces east so gets morning light, but the shallow carvings show up best on sunny days about mid-morning when the sun is high enough to cast shadows. Late in the day, they are in shade and don't photograph well. She Who Watches faces south and gets decent light during the

tour; most visitors try to get as close as possible but the perspective might be better by backing up and using a short telephoto.

Getting there: The entrance to the park is at MP 85 on WA-14, the Lewis & Clark Highway, about 1.5 miles east of the junction with US-197.

Time required: Half an hour is sufficient to view and photograph the installed petroglyphs in the open viewing area; allow 2-3 hours if taking the guided tour.

Maryhill

Three attractions in the Maryhill area where US Highway 97 crosses the Columbia River aren't really nature photo locations, but, depending on your interests, may be worth a stop.

Maryhill Vineyards sits on a bluff overlooking the river, and the tasting room patio is a great place to sit and enjoy the view with a glass of wine and picnic lunch. The vineyards themselves are most attractive in autumn when the grape vines show some fall color, and can be photographed both from the deck of the winery and from the edge of the highway a bit to the west.

Maryhill Museum of Art is home to a world-class collection of paintings, sculpture and Native American antiquities. The castle-like museum was originally meant to be the home of Sam Hill, who was the driving force behind the construction of the Columbia Gorge Highway. Maryhill's 6,000 acres are a landscaped oasis in an otherwise arid terrain, with peacocks strutting amongst sculptures in the gardens. The museum is open March 15 through November 15.

A couple of miles to the east of Maryhill Museum is Stonehenge Memorial, constructed by Sam Hill as the nation's first World War I Memorial. This interesting rock and concrete structure was intended to be a replica of England's ancient Stonehenge, and while there is some resemblance, Hill was unaware of the astronomical orientation of the original site. Personally, I find it a fascinating oddity, a view reinforced on one early morning visit when a lone bagpiper in full kilt regalia was parading around the inner circle of columns.

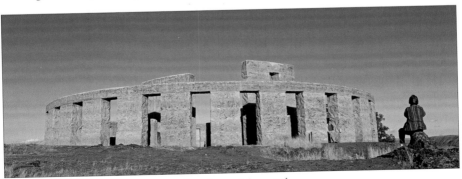

Stonehenge Memorial

Photo advice: A good sky is necessary when shooting Stonehenge—either sunny blue, dramatic stormy gray, or sunrise/sunset clouds. There are good views of the Columbia River from each of these Maryhill locations. Grape vines in the vineyards turn a beautiful golden yellow around mid-October.

Getting there: The entrance to the Stonehenge Memorial is about 1 mile east of the junction of WA-14 and US-97. Maryhill Museum is located on WA-14 about 2 miles west of US-97. Maryhill Vineyards is on WA-14 about 3 miles east of US-97 and 14 miles east of US-197.

Time required: Half an hour should be sufficient for Stonehenge. Time needed for the museum and winery will depend on your interest.

Nearby Location: Cascade Cliffs Vineyards, a few miles west of Maryhill Vineyards, has a view of Mount Hood that is really nice, with the autumn color of grape vines and cottonwood trees.

Oregon Waterfalls & Wildflowers

Traveling both sides of the Columbia River through the Gorge makes a wonderful loop trip. Myriad waterfalls and miles of hiking trails are the biggest attraction on the Oregon side. Conditions are optimal for photography in spring when the new foliage is vibrant green and good stream flow livens the waterfalls. Autumn is also excellent, with fall color usually peaking around the end of October. Towards the east end of the Gorge, the wildflowers put on a spectacular display at the Nature Conservancy's Tom McCall Preserve at Rowena, with the showy balsamroot and lupine generally at prime in mid- to late-April.

For more detailed information on these areas, please see *Photographing Oregon* in the same series.

❖ ❖ ❖

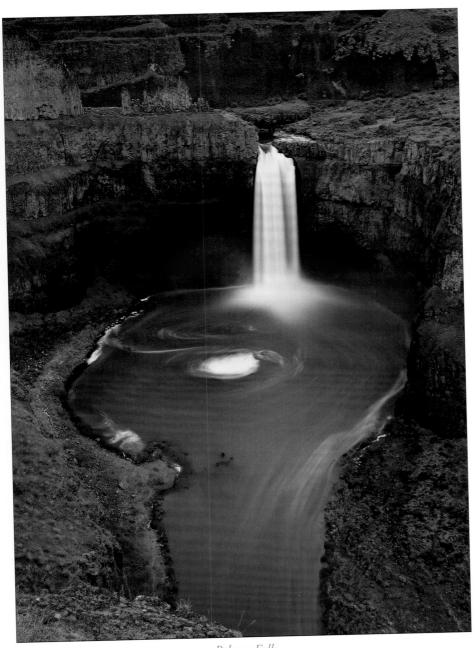

Palouse Falls

Chapter 13

SOUTHEAST WASHINGTON

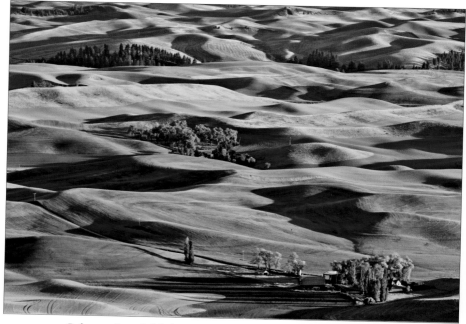

Palouse wheat fields from Steptoe Butte (photo by Laurent Martrès)

SOUTHEAST WASHINGTON

Much of Washington east of the Cascade Mountains either is or was arid desert, the terrain of which, somewhat ironically, has been shaped by the flow of water. More than 40 million years ago, the Columbia River flowed across the Pacific Northwest, seeking outlet in the Pacific Ocean even before the Cascade Mountains were formed. Starting about 16 million years ago, successive volcanic eruptions poured layer after layer of basalt lava across a huge swath of land, changing the course of the Columbia and covering much of what is now Oregon, Washington and Idaho. These flows lasted for perhaps 10 million years, forming what we now call the Columbia Plateau.

Then came the Ice Ages, burying lands to the north and east in snow. When the Ice Ages ended, a massive lake formed in the area of present-day Montana, until a combination of pressure and rising temperatures caused ice dams to break, releasing massive amounts of water that flooded west seeking outlet in the Pacific Ocean. Along the way, the water scoured surface soil and carved canyons through the layers of basalt, resulting in the rugged terrain of the Columbia Basin. Just as the land had been built by successful flows of lava, it was sculpted by repeated flows of what geologists call the Missoula Floods.

The unique landscape merits unique names, with "channeled scablands" referring to areas where the scouring and erosion created valleys and canyons on the

Columbia plateau. The larger and deeper of these canyons in central eastern Washington are referred to as coulees.

The very southeast corner of Washington largely escaped the wrath of the Missoula Floods, however, leaving the gently undulating Palouse area with deep, rich loess soil that makes it one of the most productive wheat growing regions in the world. The Blue Mountains, formed by uplifting of the plateau lava, also escaped the effects of the floods.

Over eons of time, the Columbia Basin developed as a shrub-steppe ecosystem. Several species of sagebrush and grasses became the dominant vegetation, covering the harsh, arid landscape. In modern times, large portions of the sagebrush steppe have been dramatically altered due to the dams and irrigation projects of the 1950's that allowed eastern Washington to become a major agricultural producer.

While many people look at the sagebrush steppe and see wasteland, this part of the state actually has a lot to offer photographers. It is a wonderland of wildflowers, wildlife, wheat fields, and wide-open spaces, spread out over a vast area of fascinating geology.

Yakima Valley

Blessed with good soil and plentiful water from extensive irrigation projects, the Yakima Valley is one of the world's top agricultural areas producing a large variety of fresh fruits and vegetables, as well as award-winning wines. The region also boasts of its warmer, drier climate compared to western Washington. Approaching the city on I-82, a freeway sign proclaims "Welcome to Yakima, the Palm Springs of Washington". That may be a bit of a stretch, but there is plenty here to attract visitors.

Most of the attraction of this area, for nature photographers, is in the Cascade Mountains to the west or the desert areas to the east. Right in town, the Yakima Area Arboretum, together with the adjoining Sherman Memorial Park and Yakima Greenway offer good opportunities for close-ups and botanical studies. The Arboretum

Yakima Arboretum

includes a very nice rose garden, and many of the trees in the park complex turn beautiful shades of yellow, orange, and red in autumn. Nearby Yakima Sportsman State Park is also good for fall color.

For those who like to combine photography with a bit of wine tasting, several of the vineyards in the Yakima Valley and south to Red Mountain are quite scenic. The rows of wine grape vines are especially photogenic in autumn when the leaves turn yellow, orange, and red. Recommended for scenic views are Hyatt Vineyards, Covey Run, and Porteus in the northern part of the valley, and Kiona Vineyards and Terra Blanca on Red Mountain at the east end of the valley, almost to the Tri-Cities. Wine Country tour maps are available throughout the valley, and most of the route is well signed. Traveling through the valley, you might want to also check out the Yakama National Cultural Center and the many murals in Toppenish, and, just for kicks, the dinosaur statues in Granger.

Photo advice: Apple orchards and fresh produce stands can also be good photo subjects from summer through fall harvest

Getting there: To get to the Yakima Area Arboretum, Sherman Park, and Yakima Sportsman Park from I-82/US-97, take Exit 34 at East Knob Hill Blvd, head east on WA-24 for a short distance and turn left at the first road after crossing the Yakima River.

Oak Creek Wildlife Area

Spread over 42,700 acres of ridges, canyons, and riparian areas about 15 miles northwest of Yakima, the Oak Creek Wildlife Area is home to healthy populations of Rocky Mountain elk, California bighorn sheep, and mule deer, as well as smaller mammals, upland birds, and a variety of raptors. The State of Washington started acquiring the land in the 1940's in order to provide a home for the large herd of elk that were impacting farmers and ranchers. In the fall, the area is open to big game hunters.

During winter months the Washington Department of Fish and Wildlife operates feeding stations in the area, which have become popular visitor attractions and provide good opportunities for photographers to get photos of the elk and sheep. The elk have become accustomed to the setting and the proximity of people, and a huge herd comes out of the surrounding hills for the daily feeding. At the elk feeding station, it's easy to shoot over or through the fence, or you can opt for a ride in the back of a truck on a tour run by volunteers.

At the sheep station, photography is a bit more of a challenge: you'll have to carefully shoot through the chain link fence. The sheep are also a lot more wary than the elk, and may not come down to the feeding area if they see or hear a dog among the visitors. Look for golden and bald eagles above the steep slopes of Cleman Mountain.

Rocky Mountain Elk

There are two more elk feeding stations along Cowiche Mill Road to the south, and this pristine shrub-steppe habitat along Cowiche Creek is also good for wildflower photography starting in April.

Photo advice: Plan to arrive ahead of actual feeding time (approximately 9:30 AM) to catch the elk as they come down out of the hills. Once feeding starts they're so jammed together it can be difficult to get a clean portrait of an individual elk.

Getting there: From I-82 in Yakima head west on US-12 towards White Pass. The elk feeding area is just off the highway about 2 miles west of the junction with WA-410. To get to the sheep feeding station, turn north at WA-410 and make an immediate right on Old Naches Highway, then travel east for about a mile until you see the fenced feeding station.

Time required: Half an hour is probably enough to get a few good shots of the elk. Longer and a good bit of patience may be necessary for the sheep.

Nearby location: Another elk feeding station is located near Wenas Lake, several miles north of Naches.

Yakima River Canyon

Traveling north from Yakima to Ellensburg, State Route 821 winds for twenty miles along the Yakima River through a beautiful canyon. As the road drops down to river level, canyon walls reveal the layers of basalt from successive lava flows that are typical of Columbia Basin topography. River access and camping are available at the Roza, Big Pines, and Umtanum Recreation Areas. Cottonwood trees among the ponderosa pine add some nice color in autumn.

A suspension bridge at the Umtanum Recreation Area gives hikers access to the Wenas Wildlife Area, with trails leading into Umtanum Canyon and up to Umtanum Ridge. The canyon trail makes a pleasant hike, passing an old homestead and apple orchard as it follows Umtanum Creek. The canyon is home to a variety of wildlife, including bald eagles, coyote, bighorn sheep, mule deer, and Rocky Mountain elk or wapiti, as the native people of the area call them. The trail is accessible year-round, while wildflowers

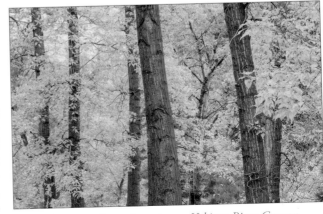

Cottonwood trees in autumn, Yakima River Canyon

and lush foliage make the area especially attractive in spring. Mid-October is also very nice, with leaves on the tall black cottonwood trees a bright yellow.

To hike to the top of Umtanum Ridge, take the left fork at the trail junction just over the bridge. This route involves a climb through a steep side canyon, gaining over 2,000 feet in elevation by the time it reaches the ridge. If you're not up for that strenuous of a hike, see the next section for a trail that offers an easier downhill stroll from the top of the ridge.

As always in this type of central Washington habitat, take care in warmer months not to startle the rattlesnakes while you're ambling about, and do an après-hike check to see if any ticks are trying to hitch a ride home with you.

Getting there: From I-90 at Ellensburg, take Exit 109 and head south on Canyon Road, WA-821. The road passes farm and ranch land for a bit before entering the canyon. From the Yakima area, travel northeast on I-82/US-97 to Exit 26, Firing Center Road. Turn left, pass under the freeway, and follow WA-821 as it curves north and becomes Canyon Road. The road passes through a few miles of farmland before meeting and then paralleling the Yakima River as it enters the canyon.

Time required: Allow a couple of hours if just making a leisurely drive between Yakima and Ellensburg, or make it a day trip exploring the canyon and photographing wildflowers or fall color.

Wenas Wildlife Area – Umtanum Ridge

Formerly part of the L. T. Murray State Wildlife Recreation Area, this 125,000-acre parcel lies between Yakima and Ellensburg, bordered by the Yakima River on the east and backing up to the Cascade Mountains in the west. The arid desert landscape is dominated by sagebrush-covered slopes, in some places punctuated with cactus and elsewhere with pine. The territory is rich in wildlife, with sizeable herds of Rocky Mountain elk, bighorn sheep, and mule deer and is managed by the Washington Department of Fish & Wildlife.

Just a few hours drive from urban centers in western Washington, the Wenas Wildlife Area is an early spring favorite for those seeking to escape the winter wet and gray. Warmer, drier weather isn't the only attraction—the hills, ridges, and canyons are awash with wildflowers, with a good variety of species found as the season progresses from March through June.

The eastern portion of Wenas Wildlife Area is dominated by Umtanum Ridge, a long, sloping, sage-covered ridge that separates the Yakima and Kittitas Valleys of central Washington, and offers several options for the hiker-photographer.

The Yakima Skyline Rim Trail offers a great combination of desert wildflower habitat and expansive vistas. From the trailhead, you can follow the official path up a broad ravine, or ramble and climb the open slopes, both of which bring you to the steep rim of the Yakima River Canyon in a couple of miles. From there, the trail follows the rim both north and south for several miles. On clear

days, the views of the Cascades to the west include the distinctive peaks of Mount Adams and Mount Rainier.

Umtanum Creek flows from the Cascade foothills through a pretty canyon, providing a moist ribbon of oasis in the desert landscape. A trail through the riparian habitat in Umtanum Canyon reaches Umtanum Creek Falls in a little over a mile, where the water tumbles over basalt in a 40-foot drop to a bowl-shaped pool. Adding interest to this hike is the transition from lowland forest with pines and firs on the canyon floor at the trailhead, to open high desert dominated by sagebrush in the area of the waterfall.

A trip to Umtanum Ridge involves driving a fair bit of rough road, fording a creek and then a somewhat steep section that may require 4WD if it's wet. Once on top of the ridge, you can do as much or as little hiking and wandering across the broad slope as you want. A marked trail follows the route of an old wagon road down the crest of the ridge for about five miles. From late spring through early summer you'll find a nice variety of blooming wildflowers, including balsamroot, phlox, and a couple of species most people don't associate with the Pacific Northwest—hedgehog and prickly pear cactus.

When hiking in this area, keep in mind that the wildlife includes rattlesnakes and ticks, and that you'll want to bring plenty of water and sunscreen. Backpackers can camp on the ridge, near the canyon rim or down by the Yakima River.

Photo advice: Best bet for the most wildflowers is the month of May, although even then you're more likely to find bright spots of color in the arid landscape rather than masses of blooms.

Getting there: For the Yakima Rim Trail, take I-82 Exit 26, Firing Center Road. Head west for 0.7 mile, then turn left on Harrison Rd (WA-823). Continue west for 2 miles and turn right on North Wenas Rd. When the road makes a "Y" at 2.8 miles, take the right fork, Gibson Rd, for 0.3 mile and turn right on Buffalo Rd. The road heads straight east then makes a sharp right turn at the last ranch property. Look for an open gate on the left almost immediately after the turn, and travel the dirt road for 1.5 miles to trailhead parking.

To reach the trailhead for Umtanum Creek Falls, travel I-90 to Ellensburg and take Exit 109, Canyon Rd. Head north for about half a mile and then turn left on Umtanum Road. Follow this road for a total of 10 miles as it changes from pavement to gravel and from Umtanum Road to N. Wenas Road, and look for the parking area where the road makes a tight turn from south to northwest.

To get to Umtanum Ridge, travel I-90 to Ellensburg and take Exit 109, Canyon Rd. Head north for about half a mile and then turn left on Umtanum Road. After 5 miles, turn south on Durr Road. Follow this

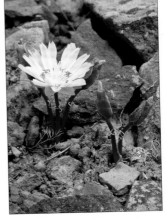

Blossoming Bitterroot

historic wagon route, rough and steep in places, for 4 miles down to the bottom of Umtanum Canyon and ford the creek. The road climbs up out of the canyon, again rough and steep in places, to reach the trailhead on top of Umtanum Ridge in 3.2 miles. If the creek is swollen with spring runoff or the road is muddy from rain, the journey may be a bit of a challenge for a 2WD passenger car.

Time required: From just about anywhere other than Ellensburg or Yakima, visiting this area means planning for a full day trip.

Nearby location: For a "fall color in the desert" excursion, try Black Canyon on the southeast side of Umtanum Ridge. A mile up an old road from the trailhead a nice grove of cottonwood and aspen trees surrounds an old log cabin. Aim for early October for the best color. Other reasons to visit: Herds of elk, lots of raptors and upland birds, and in spring, a good variety of wildflowers on the hillsides. To get there, follow the directions above for either Umtanum Ridge or Yakima Skyline, but continue on North Wenas Road into Wenas Valley. Turn north into Black Canyon about 2 miles west of Wenas Lake and travel 0.8 mile to the trailhead parking area.

Gingko Petrified Forest

The shrub-steppe habitat of much of central Washington appears to be mostly grass and sagebrush covered lava, but during the Miocene Age millions of years ago, this particular area was a forest of deciduous and coniferous trees. Lava flows that swept across the inland Pacific Northwest buried the forest, mineralizing the trees and turning wood to rock. Fossilized remains of gingko trees, one of the world's oldest tree species, as well as spruce, Douglas-fir, maples, and more can be seen at the two sections of the Gingko Petrified Forest State Park.

Some beautiful examples of petrified logs have been placed around a CCC-built interpretive center on a bluff overlooking the Wanapum Lake section of the Columbia River. There is also a nice display of petroglyphs etched into columns of basalt lava eons ago by Native Americans who lived in this region. For further exploration, there are several miles of backcountry trails just north of the Interpretive Center leading to excellent views of the Columbia River and across the rugged landscape of the state park. The hike is particularly rewarding during the spring wildflower season when you're likely to find a good variety of species, including the photogenic balsamroot, bitterroot, and larkspur.

A short distance to the west is the Gingko Petrified Forest Interpretive Trails section of the state park. An easy half-mile paved loop trail showcases some examples of petrified logs. Unfortunately, due to vandalism and theft, the logs are now encased in concrete boxes with iron gratings or heavy steel mesh over them, making good photos almost impossible. Despite this, it's definitely worth doing the short hike, or taking the longer 3-mile loop. The harsh landscape is dotted with wildflowers in spring, and it's always pleasant to just saunter, enjoy the peace and quiet and listen to the meadowlarks.

Photo advice: Rather than trying for photos of whole petrified logs, look for macro images of textures, patterns, and designs on the specimens at the Interpretive Center. On bright, sunny days you can use a hat or your body to shade the small subject area to eliminate harsh shadows.

Getting there: On I-90 where it crosses the Columbia River, take Exit 136 for Huntzinger Road on the west side of the river and go north on the old Vantage Highway. For the Interpretive Center, travel 1 mile then turn right on Recreation Road (Old US Hwy 10) and continue 0.8 mile to the park entrance. For the Interpretive Trails area, continue west on Vantage Highway another 1.5 miles to the trailhead parking lot and ranger residence.

Petrified wood detail

Time required: The short loop at the Interpretive Trails section of the park can be done in about 20 minutes; allow a couple of hours to do the longer 3-mile loop. The backcountry trails make a nice half or whole day outing.

Nearby location: The Old Vantage Highway between Ellensburg and Vantage is a scenic route paralleling I-90 and is a good place to look for wildflowers in early spring. Phlox, yellow bells, and sagebrush violets are among the early bloomers, appearing at the end of March. From mid- to late-April the showy balsamroot blossoms on hillsides all over central and eastern Washington.

Crab Creek Wildlife Area

From its origin in the Potholes basin, Crab Creek flows 163 miles to empty into the Columbia River, giving it claim to title of longest ephemeral stream in North America. Together with several small lakes and wetlands found along its length, it is important wildlife habitat. The area attracts a big variety of birds, including large flocks of migrating sandhill cranes. For photographers with more interest in landscapes than wildlife, this is also an area rich with photogenic geological features.

At Crab Creek Wildlife Area, the stream flows through Crab Creek Coulee, one of the canyons carved through layers of lava by the massive Missoula Floods at the end of the last Ice Age. Immediately to the south, the long lump of Saddle Mountain rises from the sagebrush-steppe desert.

The old Milwaukee Railroad right-of-way, part of the 300-mile long John Wayne Pioneer Trail, runs parallel to the creek for much of its length at the base of Saddle Mountain and can be accessed near the town of Beverly. To more quickly get to the areas with better photo potential, drive to a trailhead parking area on Crab Creek Road, about 9 miles east of the junction with WA-243. Find

the trail heading north to the railroad grade, walk west on the roadbed to enjoy ponds and marshes surrounded by cattails and rushes. If you're up for some cross-country hiking, head north further into Crab Creek Coulee where the basalt cliffs are colored by lichens and the rusty hues evident of a rich deposit of iron in the lava. In some places, erosion has carved the volcanic rock into pinnacles and columns.

Photo advice: No need to wait for wildflower season to visit this area. The creek, wetlands, and surrounding geological features make this a good excursion even in winter. A dusting of snow on Saddle Mountain or frost on the marsh vegetation adds to the photo possibilities.

Getting there: From east or west, travel I-90 to its Columbia River crossing at Vantage, then turn south on WA-26. After about a mile, continue south on WA-243 and go 7.5 miles to Crab Creek Road. Turn left and follow this road east, reaching the boundary for the wildlife area and the Beverly Dunes ORV area in a couple of miles. Continue for a total of 9.2 miles from the junction with WA-243 to reach a parking area at the base of Saddle Mountain.

Time required: Plan on at least two hours, plus drive time to the trailhead.

Nearby location: The sand dunes at Beverly Dunes ORV Site, along Crab Creek Road east of Beverly, have some photo potential after a period of high winds but before the off-road vehicles return. The same applies at Saddle Mountain ORV Site just off WA-243 on the southeast flank of Saddle Mountain.

Ancient Lakes

The trail to this group of three of pothole lakes in a basalt-rimmed basin just east of the Columbia River is another favorite springtime hike for Seattleites looking for warmer, drier weather after months of grey winter days. Part of the Quincy Wildlife Area, managed by the Washington Department of Fish & Wildlife, it is good, if not great, for desert wildflowers in spring. Unique to the lakes in this area is the sizeable waterfall that drops from the canyon wall into Ancient Lake.

There are several trails and old jeep tracks meandering through this basin, but the most direct route will get you to the base of the waterfall in 2.5 miles of easy walking. Starting at the trailhead parking area, the mostly level trail on hard-packed sand begins by crossing open sagebrush plain on an old jeep road. At 0.3 mile, take the left fork onto a single-track trail that soon runs right at the base of the north canyon wall. At 1.5 miles the trail ascends a slight rise and from the grassy plain on top Ancient Lake comes into view. The trail soon splits, and while the more direct route to the waterfall lies to the left of the lake, the trail is better and easier if you stay to the right and go around the lake counter-clockwise.

About halfway around the lake you'll get your first look at the waterfall at the far end of Ancient Lake, and you'll pass a couple of campsites favored by

backpackers for views of lake, waterfall, and looking west, sunsets over the distant Cascade Mountains. Just before reaching the falls, you'll have to scramble over a section of chunky basalt scree at the base of the canyon wall. The waterfall is a series of drops totaling about 100 feet; given the desert setting it's rather impressive. The waterfall and lakes here are fed by runoff from the fields above, and it's likely that the water contains agricultural chemicals, so drinking is not advised. Return via the same trail, taking time to enjoy views of the canyon walls and two more small lakes.

Photo advice: If your main objective is the waterfall, try for an overcast or cloudy day so that the light at the falls won't be too contrasty and you can get slow enough shutter speeds with the help of a neutral density filter to achieve the silky look in the water. Late afternoon sun works best for the lakes and canyon walls. Mid- to late April and into May is best for wildflowers.

Getting there: From I-90 at Vantage on the Columbia River, drive northeast for 12 miles to Exit 149 at George, then continue north on WA-281 for 10 miles to Quincy. Travel west on WA-28 for 4.8 miles and turn south on U NW

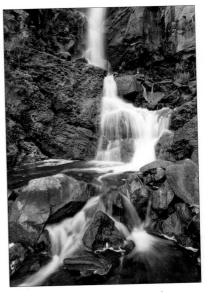

Waterfall at Ancient Lakes

Road, (also known as Whitetrail Road). In one mile, turn west on 9 NW Road, which turns south in about 3 miles and then becomes gravel. The road ends at the trailhead in 6.9 miles.

Time required: Hiking to the waterfall and back, with time for photography at the falls, requires 3 hours, maybe a little more.

Beezley Hills & Moses Coulee

In 1998 The Nature Conservancy began acquiring property in the arid lands of central Washington, putting together a preserve that now totals over 30,000 acres. Combined with adjacent BLM and state lands, this area is one of the largest intact tracts of the shrub-steppe ecosystem in Washington. While the hills and coulee are two distinct landforms, I've combined them here due to their proximity, and they can easily be visited on the same trip.

Beezley Hills is a vast expanse of gently undulating sagebrush-covered hills rising above the Columbia Basin. Much of the year, the hills appear as an almost uniform wash of muted earth tones, but in spring this is one of the premier places in eastern Washington for wildflower lovers. Arrowleaf balsamroot and lupine—perennial photographer's favorites—are there of course, but also less

common species like bitterroot, white sulphur lupine and, most unusual for the Pacific Northwest, hedgehog cactus. The gentle slopes make easy walking and a 3-mile loop trail, starting on a ridge near the summit of the tallest hill, provides plenty of opportunity for close-up shots of the flowers, as well as expansive views of the surrounding terrain. It's tempting to just take off cross-country here, but use care: despite its tough appearance, the fragile soil crust of the shrub-steppe is easily damaged, so stay on the trail as much as possible.

Beezley Hills (photo by Alan Bauer)

Immediately to the north of Beezley Hills and contrasting greatly is the dramatic topography of Moses Coulee. The scenery here is just as dramatic as the better-known Grand Coulee to the north, but sees far fewer visitors. It's a wonderful place to study the geology of the Columbia Plateau in an area first formed by massive lava flows and then carved by catastrophic floods at the end of the last Ice Age. Creeks run through some of the deep basalt canyons, with photo-worthy waterfalls at the BLM Douglas Creek area and at Dutch Henry Falls near Jameson Lake.

Central Washington locations like these are popular in early spring with residents from the western part of the state looking to escape the dreary skies and drizzle of the Puget Sound winter. I find these places just as enjoyable in autumn, when the bright yellow rabbitbrush punctuates the otherwise drab sage landscape, and when you're likely to have an entire ridge or canyon to yourself for quiet contemplation.

Photo advice: Prime time for wildflowers at Beezley Hills is late April through early May. On sunny days, it's a good idea to bring a reflector and/or diffuser to lessen the contrast while shooting close-ups of the wildflowers. For overall scenics, you'll almost certainly want to be working at sunrise or sunset to catch the light just raking the landscape. For autumn visits, the rabbitbrush and snow buckwheat bloom from early September to mid-October.

Getting there: To get to Beezley Hills from the town of Quincy, turn north on Road P NW just east of the junction of WA-28 and WA-281, and travel 4 miles up the gravel road to the top of Monument Hill. The trailhead is on the east side of the road just below the communications towers. There are several places

to access Moses Coulee. For the south Douglas Creek area, travel east and south on WA-28 from Wenatchee for about 15 miles and turn northeast on Palisades Road, at the mouth of Moses Coulee. When the road turns east after about 12 miles, look for Wagon Road, the access to several ranches in this narrow canyon. Follow Wagon Road up a rather steep, rocky grade to enter the Douglas Creek canyon. You may not need 4WD here, but some ground clearance is required—a low-slung Mini isn't going to make it. The road ends at a washout in about 1.5 miles, where there are a couple of spots suitable for backcountry camping, and trails down to creek and waterfall. To enter Douglas Creek canyon from the north, travel US-2 from the Columbia River eastward past the community of Douglas to Road H, turn south and drive for 6.4 miles. For Dutch Henry Falls, take US-2 from either the Columbia River area or Coulee City and turn north on Jameson Lake Road; it's 4 miles to the falls and 6 to the lake. If you've got a copy of the Benchmark atlas you can easily find your way between Beezley Hills and the different sections of Moses Coulee.

Time required: If you live, or are visiting from, anywhere outside of central Washington, plan on a full day for a nice leisurely exploration of this area.

Potholes – Columbia National Wildlife Refuge

Wildlife guidebooks told me that the Potholes area, between Othello and Moses Lake, is a prime place to see sandhill cranes, white pelicans, and all manner of waterfowl. Maps I looked at are marked with wildlife areas and refuges, sand dunes, and a plethora of lakes. I knew I had to go there.

What I found is a fascinating desert landscape. In the 1950's, the Columbia River Reclamation irrigation project flooded thousands of acres of a vast area of low-lying sand dunes, creating Potholes Reservoir and areas of wetlands in what had been arid desert. There are still sand dunes around the lake, although they're not the tall, ridged dunes that make for dramatic photographs. The sand here is dark, finely ground basalt, and the dunes are mostly low hills, with the most accessible ones being popular with ORV fans.

Potholes State Park, like many Washington State Parks, is largely a big, open, mowed grass campground. It is however, a good place to photograph sunrises over Potholes Reservoir, and makes a good base for exploring the area if you prefer campgrounds over motels.

Immediately to the south of Potholes Reservoir are many tiny lakes, mostly formed by water seeping from the large reservoir and filling depressions in the lava landscape. Dramatic basalt cliffs rise above some of the lakes, and the whole area is a prime example of the channeled scablands formed by the great Missoula Floods of the last Ice Age. Most of this territory is either part of the state-managed Seep Lakes Wildlife Area or the Columbia National Wildlife Refuge, both of which are primarily concerned with habitat for birds. Some of the lakes are also popular with fishermen.

Like many other wildlife areas in southeast Washington, the Potholes is a good place to find spring wildflowers. Large clumps of bright yellow balsamroot appear on plains and wherever they can find sufficient dirt to establish roots on basalt cliffs. Spreading phlox, evening primrose, and penstemon are also common.

A network of roads leads to many of the pothole lakes. For a nice loop drive through the area, look for the Columbia National Wildlife Refuge sign on WA-262 west of O'Sullivan Dam at the very southeast corner of Potholes

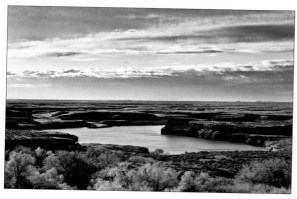

Lower Goose Lake

Reservoir. Turn south on the well-graded gravel road, and travel 1.1 miles to the turn for Soda Lake. There is a designated campground at this popular fishing lake, but it's very open and can be quite windy. Returning to the main road, continue south a short distance to the parking lot trailhead for Frog Lake. The basalt cliffs here are beautiful with sunrise light hitting them, particularly when the balsamroot are blooming.

Take a look at Upper Goose Lake, then return to the main road and travel south to the junction with McManamon Road.

Heading west, the road passes a spur to Hutchinson Lake Canoe Area, then swings north. Look for the roadside viewpoint at Drumheller Channels National Natural Landmark. The lookout here gives a nice elevated view of rugged channeled scablands terrain. The view is mostly looking east, so will be strongly backlit early in the morning. Continue north on McManamon Road a short distance until it turns and becomes 12 SE, then turn right on H SE. Heading north, look for the sign to Lower Goose Lake. The road drops down to a boat ramp, and primitive camping here puts you in a good position for sunrise over the lake and some excellent bird watching. To return to Potholes Reservoir, go back up to H SE and head north until the road reaches WA-262 at the lake.

For an easy and very scenic hike, drive to the parking area across the street from Mar Don Resort on WA-262 and look for the trailhead sign for Blythe Lake and Chukar Lake. The trail begins on a gated dirt road on the west side of the parking area, next to MarDon's storage yard. The trail reaches the western side of Corral Lake, then continues east for about 1.5 miles to Blythe and Chukar Lakes. There are some beautiful basalt cliff formations above the trail on the south side of the lakes. Blythe Lake is one of the better places to spot birds, including the sandhill cranes that visit in March during their annual migration. Climb to the plateau above Chukar Lake for a great view of the lake and surrounding sagebrush-steppe terrain. Keep an eye out for rattlesnakes, and be sure to do the tick check after your hike.

Huge numbers of migratory birds, including Canada geese, swans, and a variety of ducks, are found on this part of the Pacific Flyway each spring. In March and April, a flock of 200 or more white pelicans stops at Potholes Reservoir before heading to their breeding grounds in British Columbia. They return in late July and August, and stay through September before migrating south to the Gulf States and Mexico. One of the best places to see the big white birds is near O'Sullivan Dam in the southwest corner of the reservoir where it enters Lind Coulee. Sandhill cranes pass through the area in early spring, stopping to rest and feed in the wetlands and in the farmland north of Othello. Photo and birding tours are offered during the Othello Sandhill Crane Festival that takes place annually in late March or early April.

Photo advice: Desert light can be extremely harsh from very soon after sunrise until late afternoon, so it's best to scout locations during mid-day and be in place for the sunrise and sunset light. Prime time for wildflowers is late April through May. Autumn is also a beautiful time here, with bright yellow rabbitbrush blooming amidst the silvery sage.

Getting there: Travel I-90 to Moses Lake from Seattle or Spokane. At Exit 179, head southeast on WA-17, then west of WA-262 to the south side of Potholes Reservoir. Alternatively, from the west, take I-90 to Vantage, cross the Columbia River, and then take Exit 137 for WA-26. Travel east for 25 miles, then north on WA-262, reaching Potholes Reservoir at Mar Don Resort in about 14 miles.

Time required: A full day, or an afternoon-to-sunset shoot and dawn to early morning photography the next day.

Nearby location: Birders will want to check out the ponds of Winchester Wasteway and Frenchman Hills. Look for the fishing access signs along Dodson Road, which runs between I-90 and WA-26 west of Potholes Reservoir.

Hanford Reach National Monument

There is some irony in the fact that the only remaining stretch of free-flowing Columbia River in the United States remains that way because the huge Hanford nuclear project of World War II placed the area off limits and prevented the construction of yet another dam on the once mighty river. Plutonium reactors, now in the process of being dismantled, produced material for atomic bombs, including the one dropped on Nagasaki, Japan in 1945. The Department of Energy is now engaged in a long-term effort to clean up the Hanford site and eliminate the radiation danger.

Dramatic ivory-white cliffs rising 400 feet above the Columbia River are the main photographic reason to visit this area, but it's also a good place for wildlife viewing and spring wildflowers. Summertime brings blazing temperatures and the necessity to be extra vigilant concerning rattlesnakes on the trail. Autumn is actually a nice time to visit, as temperatures are moderate and the predominantly

brown, gray, and tan of the desert flora is punctuated with the bright yellow of blossoming rabbitbrush.

The Wahluke Unit of Saddle Mountain National Wildlife Refuge provides access to the Hanford Reach and the White Bluffs from the refuge entry road on Highway 24 southwest of Othello. A trail near the White Bluff Boat Launch

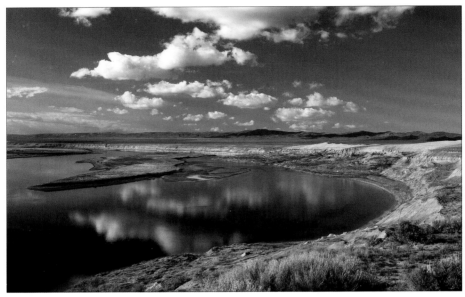

White Bluffs at Hanford Reach (photo by Alan Bauer)

leads up a gentle slope for about 0.7 mile to a great view looking north along the bluffs and northwest over the Columbia River. The bluffs are composed of soft, chalk-like caliche, which crumbles and slides easily, so don't get too close to the edge. The trail continues to the top of the bluff and then follows along the cliff, leading to some good-sized sand dunes about 4 miles from the trailhead.

Photo advice: A great time to shoot the white bluffs is immediately before sunset, but the sign at the gate says that it gets locked (automatically) at sunset. In a phone call to refuge headquarters, I was told that the gate doesn't lock exactly at sunset and that there should be enough time to shoot the bluffs with late light and still make it out before the gate locks. Allow 1.5 hours from the sand pinnacle to exit at WA-24, and at least 45 minutes from the north bluffs viewpoint. At the pinnacle, you'll probably want a very wide-angle lens; same for the north bluffs viewpoint, or do a series of views to stitch into a panorama.

Getting there: Check any roadmap for the huge chunk of land labeled U.S. Department of Energy Hanford Site, and from whichever direction you're coming from, navigate to WA-24 immediately north of the big loop of the Columbia River at Hanford. At Milepost 63, turn south on the gravel road with the sign for Wahluke National Wildlife Refuge. Pass through the solar-powered gate, drive 4

miles to an intersection, turn right, and continue for 1.3 miles to a small parking area next to a grove of cottonwood trees, just before the boat launch. Several faint trails lead towards the bluffs, with the main trail becoming increasingly more distinct.

Time required: From either Yakima or the Tri-Cities, make this at least a half-day trip to allow time for the drive and the minimum hikes.

Nearby location: Drive up Wahluke Slope to the top of Saddle Mountain for panoramic views of the area. Look for the access road on WA-24 at MP 61.

McNary National Wildlife Refuge

Another important stop for migratory birds on the Pacific Flyway, this 15,000-acre refuge includes wetlands, riparian habitat, uplands, and farmland managed for the benefit of wildlife. The main portion of the refuge lies just south of the confluence of the Columbia and Snake Rivers; adjacent habitat to the east and west is designated as State Wildlife Area. In the winter, thousands of Canada geese and a variety of ducks seek shelter in the ponds and marshes on either side of US-12. More than half of the mallard ducks on the Pacific Flyway spend the winter in this part of the Columbia Basin. White pelicans are also found here, with greatest numbers in late summer.

An easy-walking 2-mile trail loops around part of Burbank Slough, and a wheelchair accessible blind is available for those who want to spend time watching and photographing the birds. The environmental education center at refuge headquarters is also worth a visit. In addition to the trail, there are about 20 miles of roads in the refuge open to the public, so you can use your vehicle as a mobile blind for wildlife photography. As with most wildlife refuges, visiting hours are sunrise to sunset.

Photo advice: Best time for seeing the birds, as well as for photography, is early and late in the day. Even without the birds, the ponds have great potential for sunrise landscapes.

Getting there: From Pasco in the Tri-Cities area, travel southwest on US-12 for 6 miles, crossing the Snake River just before reaching the refuge. Look for the sign at Maple Street pointing the way to refuge headquarters, where maps of area roads and trails are available.

Time required: A couple of hours will be enough time for a leisurely walk on the nature trail and for checking out the visitor center.

Nearby location: Umatilla National Wildlife Refuge, another important wetland and waterfowl habitat, borders the Columbia River for 18 miles on both the Oregon and Washington sides of the river. Get there by taking WA-14 west from I-82 to Paterson, then south to the slough at the refuge sign.

Wallula Gap

Just south of its confluence with the Snake River, the Columbia squeezes through Wallula Gap, a narrow channel between high basalt formations. This gap was the only outlet for the massive and repeated Missoula Floods, as torrents of water forced their way across the Washington landscape on there way to the Pacific Ocean. The Lewis and Clark Expedition passed through the gap in October 1805 as they headed downriver after camping at the confluence of the Snake and Columbia Rivers.

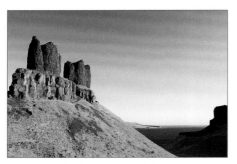

The Sisters at Wallula Gap

A photogenic pair of basalt rock formations, geologically termed scab residuals and more familiarly named The Sisters, appear almost as sentinels overlooking Wallula Gap. According to an old Cayuse Indian legend, the twin pillars were formed when trickster Coyote turned two sisters into stone.

Photo advice: The Sisters get good light at both sunset and early in the morning. It's possible to hike right to the base of the pillars, but you might like the view better from a slight distance to the east.

Getting there: Look for the landmark sign on the east side US-730 just south of Wallula Junction on US-12, and just north of the Oregon state line.

Time required: A half hour to an hour should be plenty of time.

Palouse Falls State Park

On the way to Palouse Falls, it's hard to tell that there is even a river flowing through the scablands terrain, much less one of Washington's most impressive waterfalls. But then, reaching the end of the road at the state park, all of a sudden there it is—the Palouse River spilling out of a narrow gorge cut in the black basalt and making a spectacular 185' plunge into a circular bowl. The river continues its course in a deep canyon, flowing south to meet the Snake River.

The view from the lookout point right at the campground picnic area is quite good, looking directly across the canyon to the falls. On sunny days, the contrast between whitewater and dark basalt cliffs can be extreme, and in summer a dark shadow cuts across the falls until late afternoon; from late fall until early spring, the shadow is gone by late morning. Dramatic late afternoon to dusk views are possible by taking the trail heading north from the parking area, which leads to edge-of-the-rim views of the west-facing falls with the river winding away to the south. Use extreme caution out on the edge of the canyon—it's a long, steep drop if you slip or the rock crumbles beneath you.

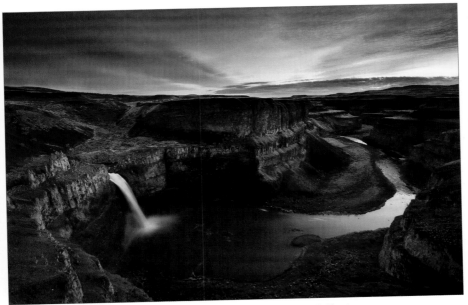

Palouse Falls at dusk (photo by Chip Phillips)

The trail continues upriver to Upper Palouse Falls. It's a particularly rewarding hike in spring when the shrub-steppe foliage is at its greenest and wildflowers abound: balsamroot, lupine, desert parsley, and death camas among the more prominent flowers, with peak bloom from late April to mid-May. Spring is also best for the falls, when there's a good flow in the river.

Yellow-bellied marmots make their home on the rocky cliffs near the picnic area and official viewpoint. A number of reptiles like the area, too, including rattlesnakes. Hikers should check for ticks after taking the trail upriver.

Photo advice: The view from the rim north of the parking area that includes the falls and the view downriver requires a very wide angle lens—18mm on full-frame camera or 12mm on a 1.5x crop camera just barely gets it all in. From the official viewpoint, a slightly wide to normal will do. An exposure of around 30 seconds will show the swirling water in the pool at the base of the falls.

Getting there: Heading east from Othello or west from the Palouse wheat country, travel WA-26 to the town of Washtucna. Turn south and go 6 miles on WA-260, then east on WA-261 for about 9 miles to the sign for the State Park. It's another 2.4 miles to the viewpoint at the end of the road. If coming from the south, WA-261 meets US-12 about 15 miles north of Dayton. From the junction, it is 20.5 miles to the park entrance.

Time required: If you're constrained for time, like on the way to or from the Palouse wheat fields, you can make some nice mid-day photos of the falls in about half an hour. With more time, plan on spending the afternoon and working until dusk.

Nearby location: If you like shooting peeling paint, weathered wood, rusty metal, and funky old buildings, take your time going through the little towns like Starbuck, south of Palouse Falls on WA-261.

Walla Walla to Clarkston

Highway 12 follows the route of the Lewis and Clark Expedition from the Columbia River just north of the Oregon border to Clarkston on the Idaho state line. The highway roughly parallels the Snake River, but only meets it a few miles west of Clarkston. Lewis and Clark traveled overland here because the Snake River was too treacherous to run in their canoes in this territory, but nowadays the river is more a series of lakes due to dams built for irrigation and hydroelectric power generation.

Walla Walla has a very nice, revitalized downtown area and is home to Whitman College. Nearby Whitman Mission and Fort Walla Walla are great stops for history buffs and offer some fair photo possibilities in the way of Oregon Trail era buildings and monuments. Walla Walla has also become one of the premier wine producing areas in Washington.

The small towns of Dayton, Waitsburg, and Pomeroy are stereotypical farming communities, with old buildings and lovely Craftsmen and Victorian style houses in residential areas that look like they could be the inspiration for a Norman Rockwell painting. The historic county courthouses in Dayton and Pomeroy are especially noteworthy.

This is grain-growing country, with vast fields of wheat, barley, and peas covering low rolling hills. Emerald green in early summer, turning to shimmering gold just before harvest at the end of July or beginning of August. Some fields are planted in rapeseed (the source of canola oil) and are a solid mass of bright yellow in early June. The grain storage buildings and silos throughout the area also make great subjects for photography.

Photo advice: While the rolling hills of wheat and barley and peas look good to the eye in mid-day light, they need the low angled sun of early morning and late afternoon to produce really good photoraphs.

Fields Spring State Park – Blue Mountains

Little known and tucked way down in the southeast corner of Washington, Fields Spring State Park is a year-round delight for outdoors people in general and photographers in particular. The 792-acre park sits at the top of 4500-foot high Puffer Butte in the rugged and remote Blue Mountains. Several miles of trails travel through old-growth forest and across grassy meadows, making for great hiking in spring, summer, and fall, and becoming enticing snowshoe and cross-country ski routes in winter.

Wildflowers abound here in spring and summer, with the peak bloom in May and June. Huckleberries provide juicy treats along the trail in late summer and color in the landscape during autumn. Western larch trees provide some great fall color when the needles of this deciduous conifer turn bright yellow.

The Puffer Butte Trail is an easy 3-mile loop that takes you through a forest of Ponderosa pine and Douglas-fir trees and up to a large grassy meadow overlooking the Grande Ronde River. The trail begins at a large parking area in the campground with a gradual but continual climb through a forest of mostly young Douglas-fir trees. At junctions with other trails, follow the signs or blue diamond markings on the trees. A short side trail marked "Summit" at the 1.0-mile point will take you to the peak of Puffer Butte, but the only view is of more of the same forest you're already walking through.

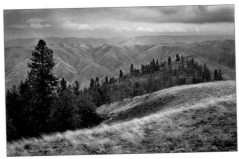

Meadow & Blue Mountains

Continue for another 0.2 miles to the large, open, grassy meadow with expansive views to the south and west of the Blue Mountains. A large, weather-tight shelter sits at the edge of the meadow, providing welcome haven if you're caught in a sudden thunderstorm. The shelter is equipped with wood-burning stove, tables, and beds, and can be rented by the night; tent camping is also allowed behind the shelter.

Established paths through the sloping meadow enable close-up views of the myriad wildflowers without trampling the delicate meadow. There are a good number of species that bloom here, so you'll find something in bloom from late April through late August. Among the showier plants are arrowleaf balsamroot, skyrockets, phlox, Indian paintbrush, and woolly sunflower. Hike downslope far enough and you'll be able to see, far below, the Grande Ronde River, the boundary between Washington and Oregon in this corner of the state.

To complete the loop hike, look for the trail and "Lodge" sign on the east side of the meadow, not far below the shelter. This will lead you back down into forest to Puffer Butte Lodge, where you can return to the trailhead by walking the road to the campground, or find the Spotted Bear Trail by walking across a grassy area between the lodge and cabins. This will shortly lead to a gravel road and then back to Puffer Butte Trail and the trailhead.

Photo advice: Landscape photos of the meadow and view of Blue Mountains from the top of Puffer Butte will be best in sunrise light or with the golden light just before sunset. A great plan would be to hike to the meadow area in mid-afternoon, shoot until sunset and camp at the shelter so that you're already on location at sunrise.

Getting there: From Clarkston, head south on WA-129 for 25 miles, passing through Asotin and Anatone (population 38 people, 20 dogs, 17 cats and 11 horses). The park entrance is located a little south of MP 14.

Time required: Allow at least 3 hours to hike the Puffer Butte loop trail and make a few photos, plus 45 minutes each way for the drive from/to Clarkston.

Nearby location: Continuing south on WA-129 you'll find some excellent views of the Blue Mountains. It's a very winding road, and steep in sections, so use plenty of caution and lower gears on the descent to the Grand Ronde River, which marks the Washington-Oregon border. Turnouts at MP 9 and MP 7 have good views. Autumn brings some very nice fall color along the Grand Ronde and in spring the grassy areas breaking up the forested slopes are dotted with bright yellow balsamroot and deep blue lupine. Montgomery Ridge Road, about halfway between Anatone and Fields Spring State Park, is reported to be good for wildflowers in mid-May.

Hells Canyon

From its headwaters in Yellowstone National Park, the Snake River flows across southern Idaho, then turns north, carving the deepest river gorge in North America at Hells Canyon before turning west again to join the Columbia River in the Tri-Cities area of southeast Washington. Like the Channeled Scablands, Hells Canyon is a remnant of the last ice age, when huge floods sculpted the landscape of the Pacific Northwest. In the middle of the Hells Canyon National Recreation Area, where the Snake River delineates the boundary between Idaho and Oregon, the gorge is over a mile deep. Just north of the Washington-Oregon state line, the steep cliffs of the canyon drop away and the river widens and smooths out as it flows into the Lewis-Clark Valley.

No roads lead into Hells Canyon from Washington, and going on foot requires pretty serious backpacking. The easiest way to experience this rugged and remote country is to take one of the jet boat tours offered by Beamer's Hells Canyon Tours or another of the outfitters based in Clarkston and Lewiston. These day-long excursions travel up the Wild & Scenic Snake River deep into Hells Canyon, with the opportunity to photograph the dramatic canyon walls, ancient petroglyphs, and with a little luck, bighorn sheep and other wildlife.

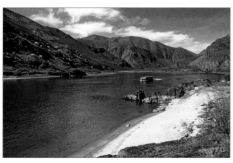

Hells Canyon at Cougar Bar

At the northern section of Hells Canyon, the only real road that reaches the river is at Pittsburg Landing in Idaho, reached by traveling south from Lewiston on US-95 to the town of White Bird, then west to the river on a long, winding backcountry gravel road. The section of the Snake from Pittsburg Landing upstream to Hells Canyon Dam is officially designated as a Wild and Scenic River.

On the Oregon side of the canyon, the only place you can drive to on the rim and see all the way down to the Snake River is at Hat Point Lookout, reached by traveling east from the town of Joseph, crossing the Imnaha River and climbing to the rim, also on a long and winding road.

Photo advice: April and May are good months to visit Hells Canyon, as the sparse vegetation is at its greenest and wildflowers like lupine and balsamroot are blooming.

Getting there: Clarkston is at the very southeast corner of Washington, with sister city Lewiston across the Snake River in Idaho.

Time required: The half-day tours offered by Beamer's take place mid-day, so with some planning you could do an early morning shoot in the Palouse country near Uniontown, take the tour, and be back in the wheat fields for sunset light.

The Palouse

With good reason, hundreds of photographers make their way to The Palouse every year. In early June undulating hills are covered in fields of wheat, barley, and peas, resulting in a patchwork of verdant greens. Deep loess soils make the Palouse the most fertile wheat growing area in the country. Towards the end of July the fields have turned golden and ready for harvest. Classic wooden barns are scattered throughout the area. Dramatic clouds and golden sunsets are frequent in the big, open sky country of southeastern Washington.

The best place to see and photograph the Palouse fields is Steptoe Butte. A spiraling road leads to the top of this natural landmark, with outstanding views of the rolling hills of farm country in all directions from a summit that rises 1,000 feet above the surrounding fields. On clear days, the sweeping panorama includes the jagged peaks of the Bitterroot Mountains in Idaho and the rounded Blue Mountains on

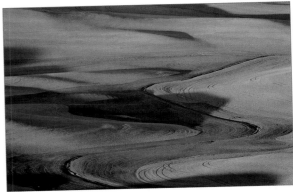

Palouse wheat fields in early June

the Washington-Oregon border. Given some decent light, it's hard to go wrong here. Being at the top for sunrise is a great way to start the day and the brief, low-angled golden light rakes the hills beautifully. Late afternoon to sunset is even better. There's often some haze in the air, making the light even more golden, and the sweet light seems to last longer at the end of the day than it does at dawn. Most people head directly for the top of the butte, but some of the best photo views are from a short distance below the summit, where the road winds around

the south and west sides of the mountain. Lower on the western slopes, spring wildflowers make a great foreground interest in wide-angle landscape compositions. The lower elevation views may also work better on days when there is a lot of haze in the air.

In early June, when the crop fields are most verdant, you'll likely find quite a few other photographers on Steptoe Butte, including groups in photo workshops. There is plenty of room for all, and the camaraderie can be enjoyable. To get to Steptoe Butte travel Highway 195 to the town of Steptoe and turn east on Scholz Road; make a left on Hume Road and go north to the signed turn for Steptoe Butte State Park in a total of 6 miles. The park road spirals to the top of the butte in 3.1 miles.

The views from Kamiak Butte, another island rising from the surrounding sea of fields, are much more limited than those from Steptoe Butte, but it is definitely worth visiting. Pine Ridge Trail, an easy 3.5-mile loop through forest and open areas includes the 3,641-foot summit, where clumps of bright yellow balsamroot and orange-red paintbrush color the hillsides in May. There is a very nice campground at Kamiak Butte, which would make for a great base for photo explorations of the area, except for the fact that the gate is locked until 7 am, meaning the only option for sunrise shooting is from Kamiak. The turn to Kamiak Butte County Park is about 3 miles south of the town of Palouse via WA-27. From Colfax on US-195, travel east on WA-272 to Clear Creek Road, then south for 8 miles, turning to the park entrance just before reaching WA-27. The park sometimes closes in late summer due to the high fire hazard.

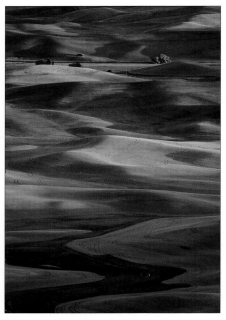

View from Steptoe Butte

Of course not all the views are from the buttes. Wandering the back roads with an eye out for pleasing compositions of the rolling hills can be very rewarding, especially when dramatic skies appear early and late in the day. Some farmers include rapeseed, used to produce canola oil, in their crop rotation. When the rapeseed blooms in May and June, it often forms a solid carpet of brilliant yellow covering the fields.

Wonderful wooden barns, both abandoned and very much in use, are found throughout the Palouse. A bright red barn on the northeast side of Steptoe Butte is a regular stop on the photo tour circuit. The farmer appears to be very photographer-friendly, and if you're lucky his horses will be hanging around the barn for additional photo interest. To get to this one, start at the entrance to

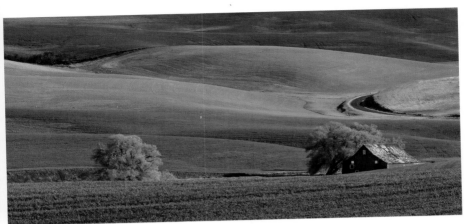

Palouse barn (photo by Jack Graham)

Steptoe Butte State Park, head north on Hume Road for 4.7 miles to the corner of Martin Road.

A very photogenic and unique round barn is located on Old Moscow Road east of Pullman. Head south on WA-270 from downtown Pullman (follow the signs for WSU), turn right on Bishop Blvd, left onto SE Johnson Rd and then take the first left at Old Moscow Road and go 2 miles; the barn is across a field on the south side of the road.

Glenwood Road, not far south of Steptoe Butte, is good for both fields and barns. Head south from Steptoe town on US-195 for 0.8 mile, turn east on Dry Creek Road for another 0.8 mile, then south on Glenwood. In another mile, you'll see an old barn on the east side of the road (best with afternoon light), and less than a mile further south a faded red barn on the west side of the road (good for morning light). If you're heading for Kamiak Butte, continue on Glenwood Road to WA-272, then jog east to Clear Creek Road.

West of Steptoe, there are several nice barns along Highway 23, including a round one near the town of Ewan. Getting good photos of these barns can be a challenge due to cluttered surroundings. An old abandoned house on Sunset Road, north of Steptoe and a little west of US-195, works well in afternoon light. WA-272 between the towns of Colfax and Palouse is quite scenic, but as on the other major roads in the Palouse, it can be difficult to find a place to safely pull off the pavement.

For further exploration, drive Highway 27, the Palouse Scenic Byway, between Pullman and Tekoa, and take the time to wander farm roads on either side of the highway.

A photo visit to Palouse country wouldn't be complete without a stop at the Dahmen Barn in Uniontown. Once a rundown dairy barn, the property was donated to the Uniontown community by the Dahmen family and has been renovated and turned into a thriving art center. The white barn is quite photogenic, but the bigger attraction here for most photographers is the distinctive

Overleaf: The town of Steptoe, viewed from the top of Steptoe Butte

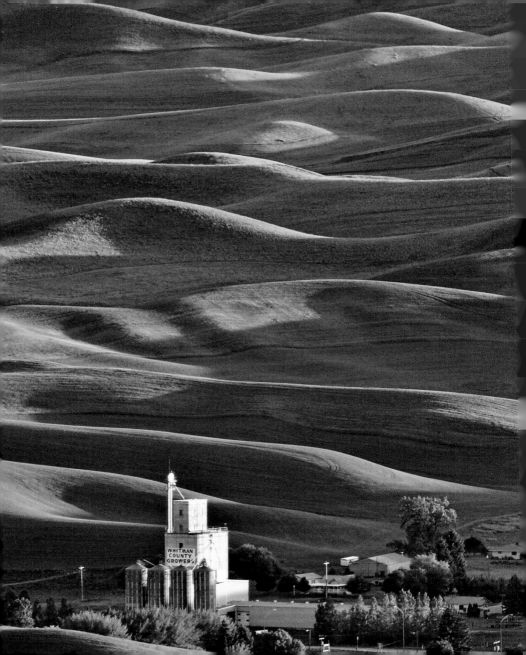

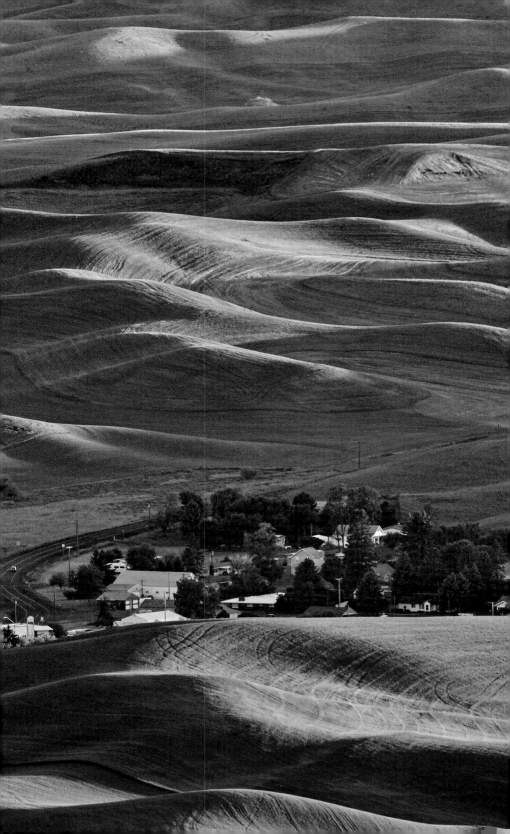

fence constructed with a thousand iron wheels from various farm machines. The barn and fence are right next to Highway 195 on the north side of Uniontown,

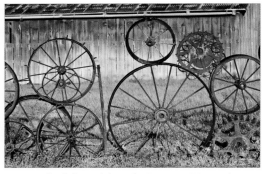

Wheel fence (photo by Laurent Martrès)

16 miles south of Pullman or 16 miles north of Lewiston. In the middle of Uniontown, two blocks west of US-195, the classic brick exterior and the columns-and-arches interior of St. Boniface Catholic Church are also excellent photo subjects. Just south of Uniontown is another classic wooden barn, set just west of the highway in a wheat field. Morning light works well for the two barns; the wheel fence is fun to shoot at any time of day in just about any lighting conditions.

Photo advice: The view from Steptoe Butte really invites shooting composite panoramas, but it also works really well for extractive landscapes, using a telephoto lens to focus on a limited part of the scene. Using a polarizer with a normal to telephoto lens, can really help by giving the greens or golden yellows of the wheat a more saturated look. The best time to photograph the wheat varies each year depending on spring weather, but the end of the first week in June is typically the best for green fields. Go at the end of July or beginning of August for golden grain at harvest time. On days when the haze seems to deaden the views from Steptoe Butte, shoot it anyway and try increasing contrast when digitally processing your files.

Getting there: From the Seattle/Puget Sound area and central Washington, head east on I-90 to the town of Sprague (34 miles west of Spokane), then head south on WA-23 for 43 miles to the town of Steptoe. From Spokane, head south on US-195; you'll be in Palouse country in about 35 miles, soon after passing through the town of Rosalia.

Time required: While it is possible to get some good photos in just an hour or two from Steptoe Butte, I highly recommend staying at least one night in the area, allowing for a late afternoon to sunset shoot plus a sunrise and early morning light the next day. If you really want to work the Palouse, there's plenty in this area to keep you occupied for 4-7 days of shooting.

Nearby location: The town of Palouse has some nice old brick buildings with a lot of character, and places like Oakesdale and Colfax offer scenes of classic Americana. Exploring these places in mid-day after a morning shoot and while waiting for the great afternoon light on the fields can be a lot of fun.

❖ ❖ ❖

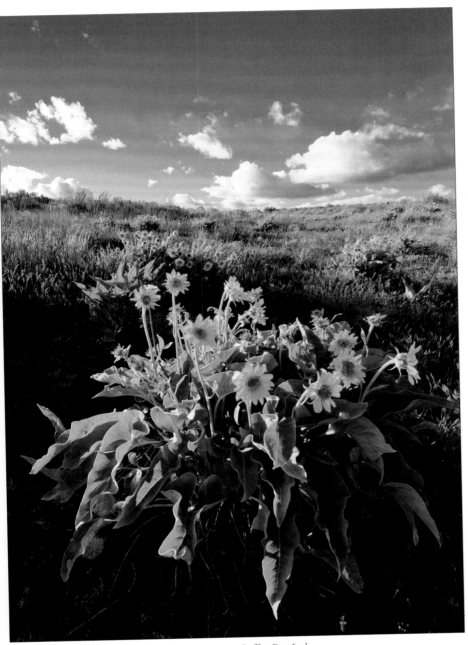

Balsamroot at Coffee Pot Lake

Chapter 14

NORTHEAST WASHINGTON

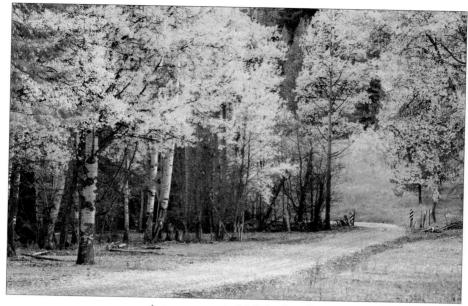

Autumn aspen in Mill Creek Valley

NORTHEAST WASHINGTON

The northeastern quadrant of Washington is a diverse mix of sagebrush desert, irrigated farmland, erosion-carved coulees, and weathered mountains, with the dam-tamed Columbia River snaking its way west and south from its origins in Canada. Outside of the city of Spokane, this section of the state is little known even by most Washingtonians. Nature and landscape photo opportunities abound, especially during the spring wildflower bloom in the desert and rolling meadows of the Okanogan Highlands. In autumn western larch, aspen, and cottonwood trees are golden on the slopes and in the valleys of the Kettle Range and the Selkirk Mountains.

The northernmost part of eastern Washington is a series of mountains, starting with the gentle hills of the Okanogan Highlands on the west, becoming higher and more rugged in the central Kettle River Range. East of the Columbia River, the Selkirk Mountains are sometimes considered the westernmost range of the Rockies, but they are actually part of the Columbia Mountains, extending into Idaho and British Columbia. They are geologically older than the Rockies, and much older than the Cascade Mountains to the west.

These mountains form the northern border of the Columbia Basin, a vast area of ancient lava flows sculpted by massive floods through which the Columbia and Snake Rivers have carved their way. Between seventeen and thirteen million years ago, successive lava flows covered the entire region with layers of basalt that in some places is more than two miles thick. Towards the end of the last Ice Age,

a large ice dam formed in what is now Montana, forming massive Lake Missoula. This glacial lake contained more water than Lake Ontario and Lake Erie combined. When the ice dam broke, a towering mass of water burst through, flowing at a speed close to a mile a minute and at a rate ten times the combined flow of all the rivers in the world. This incredible force swept westward, scouring the surface soil and cutting deep canyons or coulees into the layers of Columbia basalt. This mind boggling event was also the creator of some great photo features in eastern Washington.

The Colville Indian Reservation makes up a large chunk of the territory of northeast Washington, bordered by the Columbia River on the south and east and extending to US Highway 97 in the west. Descendants of twelve aboriginal tribes live on the reservation, among them members of Chief Joseph's Band of Nez Perce, whose ancestors made a 1,700-mile trek to the reservation after being evicted from their native lands in Montana and Idaho. As elsewhere in the country, the history of the Native Americans on the reservation is a long and sad tale of forced relocations and broken treaties.

Spokane

Washington's second largest city was established in the late 1800's, first as a fur trading post and later as the center of grain operations and lumber mills for eastern Washington and western Idaho, earning its moniker of Capitol of the Inland Northwest. Historically known for its warm hospitality and boasting of plenty of sunshine, Spokane has done an admirable job of preserving a vibrant core downtown area and neighborhoods of historic houses. I-90 connects the city with Seattle in a 275-mile, 4-hour drive.

The Spokane River runs through 100-acre Riverfront Park before dropping 130 feet in a series of cascades that are a tumultuous, roaring mass of whitewater during the spring and early summer runoff. The park itself was created out of former industrial and railroad land that was redeveloped for Expo '74, and several of the world fair's attractions and features remain. Late afternoon light is generally the best for park features like the old clock tower; better still is twilight time when city lights briefly balance with the evening sky. At Spokane Falls, the water tumbles over dark basalt lava, making for very contrasty subject matter and a location that is totally backlit until about noon when seen from the vantage point of the

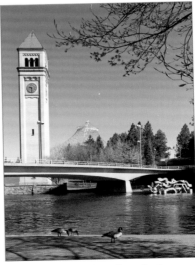

Spokane Riverfront Park

park footbridge or the Monroe Street bridge.

While you're exploring downtown Spokane, check out the work of a couple of Washington's premier nature and landscape photographers: Charles Gurche's photos are on display at the Community Building at 35 W. Main Street, and Chip Phillips' images are at Brick Wall Gallery, 530 W. Main Ave.

Manito Park Gardens

Located in the South Hill neighborhood of Spokane, Manito Park is the city's garden showplace and a treasure trove for nature photographers at virtually any time of year. The 90-acre park includes five landscaped gardens and a pond frequented by ducks, geese, and swans. In spring and summer there is a profusion of flowers blooming at the Rose Garden, the Joel E. Ferris Perennial Garden, and in the formal Renaissance style Duncan Garden. The Nishinomiya Japanese Garden with its central koi pond has showy azaleas and rhododendrons in spring and in autumn the maples provide a variety of fall color. Come winter, photographers can continue to work with the exotic flora in the Gaiser Conservatory.

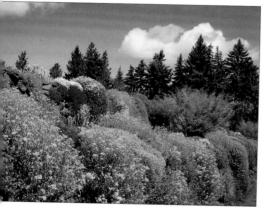

Manito Park Gardens

There is no entry fee to the gardens, and no restrictions on tripods.

Photo advice: Overall landscape photos of the Rose Garden and Duncan Garden can work well on sunny days, but for flower close-ups and shooting in the Japanese Garden the soft light of overcast weather is preferable. A collapsible diffuser/reflector is also very helpful for the flower studies. Flowers bloom in the formal and perennial gardens from May through October and in the Rose Garden from June through September.

Getting there: From Riverfront Park in downtown Spokane, head south on Stevens Avenue. Bear to the right when the road splits at 9th Avenue and continue south as it becomes Grove Street and then Bernard Avenue at 14th Avenue. Turn left at Shoshone Place for the Japanese Garden or at 21st Avenue to reach the main garden areas.

Time required: It's possible to do a quick tour of the main garden areas in about an hour, but plan on at least two or three hours to do any serious work with the flowers.

Nearby location: Finch Arboretum in southwest Spokane is a botanical collection of trees and shrubs spread over 65 acres of wooded hills along Garden Springs Creek. Visit April-May for a good variety of flowering species and in

October for some colorful trees. The arboretum is open year round from dawn to dusk. To get to the arboretum from downtown Spokane, go west of Second Avenue to Sunset Highway and continue west past Government Way and look for the sign at F Street.

Riverside State Park

Of the several units of Riverside State Park, the two with the most interest for nature photographers are the Bowl & Pitcher Area and the Little Spokane River Natural Area. At the former, the Spokane River flows between huge basalt boulders, including the Bowl & Pitcher formation for which the area is named. While the rock formations are very interesting, it is a challenge to make really nice landscape photos here. The boulders are a dark gray form of chunky lava, and the north-south orientation of the river canyon at this location means they're never lit by the nice golden light of sunrise and sunset. Still, the Bowl & Pitcher area is a very pleasant place to visit, and the miles of well-maintained trails pass through shady forest and over rocky outcrops on the way to views of the river.

The Bowl & Pitcher formation is located about 100 yards downstream from the suspension bridge. It takes a little imagination to discern the pitcher because the part of the formation that looked like a handle has fallen off, but there's nothing that even remotely looks like a bowl and no explanation to be found for the naming. A panoramic viewpoint on the canyon rim can be reached by heading upstream on the trail from the bridge. In spring and early summer, balsamroot, lupine, and other wildflowers show their color in the understory of the ponderosa pine forest.

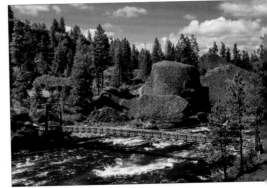

Spokane River at Bowl & Pitcher Area

The Little Spokane River Natural Area preserves a riparian habitat little changed from the early 1800's when trappers plied the river in canoes. It's still a great place for a quiet canoe paddle, and an easy 3.5-mile round-trip hike on a trail through ponderosa pine forest, wetlands, and meadows lets hikers experience the same pristine environment. Bright yellow iris, balsamroot, lupine, and camas are among the wildflowers found along the trail in May and June, and groves of aspen and cottonwood make this a good area for fall color landscapes. There is a blue heron rookery in the riverside cottonwood trees. The pictographs at the Indian Painted Rocks site, adjacent to the trailhead parking area, are interesting but somewhat faded and photo angles are limited by the metal fence erected to protect the site from vandalism.

Getting there: For the Bowl & Pitcher area, take I-90 take Exit 280 (Maple Street) and go north across the Spokane River, turning left at the second stop light onto Maxwell. Follow Maxwell, which becomes Pettit Drive, then Downriver Drive. Turn left on Aubrey L. White Parkway at the park entrance and continue for two miles down river to the Bowl & Pitcher day-use area and campground. To get to the Little Spokane Natural Area, take I-90 Exit 280, cross the Maple Street Bridge and continue north for about 4 miles. Turn left on Francis Avenue, go 1 mile and turn right on Indian Trail Road. Continue north for about 5 miles as the road becomes Rutter Parkway. The trailhead and painted rocks area is just past the Little Spokane River bridge.

Time required: The Bowl & Pitcher area is a 20-minute drive from downtown Spokane. An hour at the park will give you time for the short hike to the Bowl & Pitcher formation. There is a very nice picnic area and campground if you want to stay longer. Plan on a couple of hours at the Little Spokane Area to do the hike and view the pictographs.

Mount Spokane

This southernmost peak in the Selkirk Mountains is a year-round popular recreation area. Area residents flock to the ski area in the winter and head to the higher elevations of the mountain to hike and camp in summer. Mount Spokane State Park is Washington's largest state park, and the first to be established east of

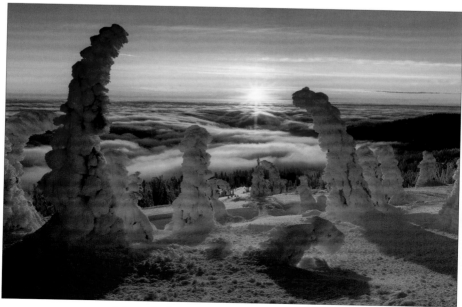

Mount Spokane winter (photo by Chip Phillips)

the Cascade Mountains. The heavily forested park features stands of old-growth trees, with western larch in the conifer mix for some autumn color. On a clear day, the view from the 5,883-foot summit extends across the Idaho panhandle to Montana.

With 300 inches of snow each year, this is a great place for winter scenic photography. A pair of snowshoes or cross-country skis will get you to pristine snowfields and ice-clad trees. Summit views at sunrise and sunset are particularly awesome in winter. The groomed ski and snowshoe trails provide a network of many miles of trail for hiking and mountain biking in summer.

Photo advice: Winter scenics are usually best right after a storm hits, when the snow is fresh and trees heavily laden.

Getting there: From Spokane, head north on US-2 to WA-206, continue for 15 miles to the State Park entrance.

Nearby location: The orchards and farms at Green Bluff are quite scenic and a number of the growers have banded together to encourage visitors. Photographers will especially want to visit during the spring orchard bloom and during fall harvest time. Green Bluff is about 15 minutes north of Spokane on Mount Spokane Road just east of US-2.

Turnbull National Wildlife Refuge

Established in 1937 to protect breeding and nesting grounds for migratory birds and other wildlife, this refuge—situated at the eastern edge of the Columbia Basin—has an attractive mix of forest and wetland habitat.

The landscape was formed by the glacial floods at the end of the last ice age, but there is quite a bit of difference between Turnbull and the more arid Channeled Scablands west of here. Rather than potholes in rocky canyons, this refuge—at least the part of it that is open to the public—is mostly lakes and ponds set in a forest of Ponderosa pine trees. Grassy open meadows and stands of aspen trees are also found in several places. In addition to the waterfowl and waterbirds that visit or reside on the refuge, wildlife photographers will have the opportunity to capture deer, elk, moose, coyote, and a variety of smaller mammals.

A 5.5-mile auto tour route makes a loop through the publicly accessible part of the refuge and provides plenty of views of both landscape and wildlife. Unlike the auto routes at many wildlife refuges, visitors are not restricted to their vehicles (this one is also open to hiking and bicycling), so it's possible to get out and work the landscape at a number of locations along the route. There are also short, easy hiking trails—some wheelchair accessible—at several points in the loop, providing better views of meadows, marshes, and lakes. The Kepple Peninsula Interpretive Trail, about halfway around the loop, is very good as it includes forest, meadow, and wetland habitats and good views of Kepple Lake. From late April to June the grassland meadow is an excellent place to view and photograph

wildflowers; the camas, prairie shooting stars and western blue iris are among the more photogenic species.

Bright yellow arrowleaf balsamroot, a photographer's springtime favorite in the northwest, highlights the understory of ponderosa pine forest that cov-

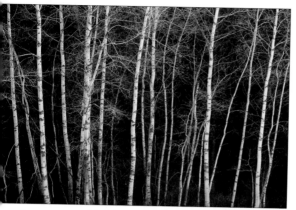

ers much of the refuge. They're usually at their best here in early May. Groves of aspen trees along the entrance drive, the auto tour route and at the south end of Pine Lake are great for color in the fall or close-ups of their white-barked trunks at other times of the year. More landscape, wildflower, and wildlife photo opportunities are available along the hiker-only Bluebird Trail, an easy 3-mile round-trip path that leads from refuge HQ to Kepple Lake.

Aspen trees at Turnbull National Wildlife Refuge

Photo advice: Late afternoon light is optimum for landscape photography at several locations, including the Pine Lake Trail and to catch backlight on the aspens in autumn. Early morning would be preferable for working the wildflowers in spring. Wildlife photographers will want to visit during the migratory periods of mid-March to mid-May and September through November. The refuge is open daily from dawn until dusk.

Getting there: From I-90/US-395, take WA-904 to the town of Cheney. Turn south on Mound Street, which becomes Cheney Plaza Road. Continue south 4 miles to the signed entrance for the refuge.

Time required: As a stop on the way between Spokane and the Palouse wheat fields, you can do the loop auto route in about half an hour. For seriously working the wildflowers in spring, or if you're going to capture the waterfowl and other wildlife, plan on at least half a day.

Nearby location: Fishtrap Lake, southwest of Turnbull NWR and not far of I-90, is very good for wildflowers from May to mid-June. A trail starting at the old Miller Ranch area travels through BLM-managed channeled scablands featuring sagebrush steppe, wetlands, and rocky canyons. The nearby town of Sprague has some great old buildings and a lot full of farm trucks from a bygone era.

Twin Lakes & Coffeepot Lake

In the heart of the Channeled Scablands, a series of coulee lakes connected by Lake Creek are managed for wildlife habitat and recreation by the Bureau of Land Management. These small lakes, bound by walls of rugged basalt, make

good landscape subjects, particularly on days with dramatic skies full of cumulous clouds. In springtime, this is one of the best places to find and photograph wildflowers in the eastern Washington sagebrush-steppe desert.

On the plateau above Twin Lakes, you can wander any of a number of old jeep tracks, now off-limits to vehicles, in search of wildflower photos. The showy arrowleaf balsamroot appear in late April, with lupine (white as well as the more familiar blue) not far behind. Phlox, in various shades of pink and lavender, and several yellow asters are also found up here. Even without the wildflowers, the song of meadowlarks in the upland sage, red-winged blackbirds in the lakeside cattails and geese honking on their approach will make you glad to be here.

Starting at the camping area at Twin Lakes, a trail crosses Lake Creek and heads northeast to a grove of aspen trees, great in autumn for close-ups of brilliant backlit leaves or as a backdrop to landscape photos of the lake. Around the marshy area near the aspens, look for common camas and water buttercups in late April and early May. The trail climbs to open sagebrush plain, continues east and then north to a trailhead at Reiber Road, and then continues in a loop across the arid plains and back down to the campground.

Coffeepot Lake offers similar geology, wildflowers, and wildlife, as well as another lakeside campground (and trout fishing for the anglers). There are no established trails here, but primitive tracks and game trails lead to some nice landscape views of the lake and wildflowers set among the basalt formations and at the base of the canyon cliffs.

At both lakes, good numbers of waterfowl are present during migratory periods. You're likely to see deer early and late in the day, and you'll hear coyote yipping at night. Watch carefully for rattlesnakes in warmer months, and be sure to check for ticks after your wanders, they're *really* common out here.

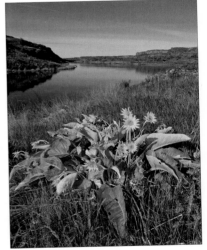

Balsamroot, Twin Lakes

Photo advice: : There is good sunset potential at south Twin Lake, from the north end of the lake at the camping area, and the late afternoon sun lights the basalt walls of the coulee nicely. Early morning, however, is a better bet for calm winds when the lake surface is more likely to be glassy and the wildflowers aren't waving in the breeze.

Getting there: From Spokane, drive west on US-2 to Davenport, then south on WA-28 to Harrington; from central and western Washington, go east on I-90 to Exit 231, then north on Harrington-Tokia Road. In Harrington, turn west on Coffee Pot Road and travel 14 miles to Highline Road. To get to Twin Lakes, turn north on Highline and drive 1.4 miles to the BLM sign for Twin Lakes, then another 1.9 miles to the campground between the two lakes. To get

to Coffeepot Lake, continue past Highline Road for 1.1 miles, turn at the BLM sign and proceed 0.3 miles to the lake. The lake access roads are a bit rutted but not enough to be a problem for passenger cars under normal conditions.

Time required: The drive from Spokane is about 1.5 hours each way, and you'll want 2-3 hours to wander the plateau and/or hike the trails at the lakes.

Nearby location: Just after you turn north on Highline Road heading for Twin Lakes, there are several old, very weathered, and somewhat photogenic ranch buildings. They are on private property, fenced, and with prominent No Trespassing signs, but shootable from the road.

Dry Falls

One of the outstanding geological features of the channeled scablands, Dry Falls is located at the head of the Lower Grand Coulee. As the name suggests, water no longer runs over these falls, but it is the site of what was probably the greatest waterfall that has ever existed (for comparison, Niagara Falls is one-tenth the size of Dry Falls). Towards the end of the last ice age, the great Missoula Floods channeled water through the Upper Grand Coulee and over this 3.5-mile long, 400-foot high cliff at something like 65 miles per hour. Geologists speculate that the water flow at the falls may have been ten times the current flow of all the rivers in the world combined.

The cliff-side overlook at the Dry Falls Interpretive Center on WA-17 provides a great view of the falls and the canyon created by the floods. As the sign there notes, the falls actually started 20 miles to the south but kept moving upstream due to the tremendous erosive power of the flow.

Dry Falls, Lower Grand Coulee

Photo advice: The view from the overlook is looking just about due east, so an early morning shoot is not going to work very well here; mid-day light is typically very contrasty and harsh. Late afternoon light works well from late autumn to early spring when the sun's path is more to the south. To go beyond the ordinary, try sunrise or dusk photos with a strong, hard-edged graduated neutral density filter and/or multiple exposures to blend for an HDR-type treatment in post-processing.

Getting there: The visitor center is 7 miles south of Coulee City on WA-17.

Time required: Fifteen minutes to a half hour is enough for a mid-afternoon photo and a look at the visitor center information.

Nearby location: If you're traveling this way in spring, look for some very nice patches of balsamroot and other wildflowers at the base of the Lower Grand Coulee cliffs along WA-17 at about MP 85 between Blue Lake and Lenore Lake.

Steamboat Rock State Park

Once an island in the Columbia River, Steamboat Rock is a massive chunk of columnar basalt that rises a thousand feet above present day Banks Lake in the Grand Coulee region of north central Washington. Banks Lake was created as part of the U. S. Bureau of Reclamation project to provide irrigation water to turn sagebrush desert into productive agricultural land. An easily recognized

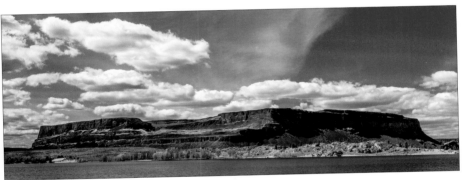

Steamboat Rock, Banks Lake

landmark for centuries, Steamboat Rock is the central feature of its namesake state park, popular with residents and visitors for boating, swimming, and fishing. The butte and surrounding territory also make a great location for nature photography. In addition to the striking geological features characteristic of the channeled scablands, the gray-green sagebrush landscape comes alive with color during the spring wildflower season, and there are some nice pockets of fall color thanks to aspen and poplar trees.

At any season, there are fantastic views of Banks Lake and the Grand Coulee from the top of Steamboat Rock A 4-mile round-trip hike leads from the main campground and day-use area to the top of the butte. The trail does become rocky and steep as it heads up through a slot in the basalt, and you'll need to watch your footing on the loose rock, but the views from the top are worth the effort. In mid-April you'll find balsamroot and desert shooting star, followed by lupine, larkspur, and bitterroot in May. At any time of year you'll likely to spot a herd of resident mule deer, and if you're lucky a coyote or bald eagle.

Northeast of Steamboat Rock, a trail into Northrup Canyon offers a pleasant hike to an old homestead. Abandoned buildings remain at the head of a grassy field, surrounded by steep canyon walls. Some of the cliffs are columnar basalt painted with yellow, orange, and green lichen, and the colors are nicely enhanced by the early morning and late afternoon light. Small groves of aspen occur at

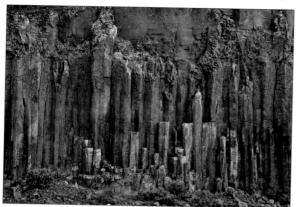

Columnar basalt, Steamboat Rock

several places along the 2-mile long mostly level path from trailhead to homestead and clumps of wildflowers appear amongst the sagebrush in the drier areas. The surrounding forest, largely ponderosa and lodgepole pine, is said to be the last remaining native forest in Grant County. The tall trees provide roosting for around 200 bald eagles that frequent Banks Lake in the winter. For those wanting a longer hike, the trail continues up a narrow canyon to Northrup Lake, or you can hike the historic wagon road that goes up to the canyon rim and to views of Banks Lake and Steamboat Rock.

In early spring, runoff from Devils Creek courses through Whitney Canyon and then drops 360 feet over a sheer basalt rock face at Martin Falls, visible from the highway at milepost 17. Due to the arid climate in this part of Washington, the creek usually dries up by late April.

Summer brings plenty of mosquitoes and temperatures in the nineties or more to this area. Autumn and early spring daytime temps are ideal, but it can drop into the twenties at night. Watch out for rattlesnakes while hiking, and be sure to check for ticks at the end of the day. Best time to visit is mid-April to mid-May for wildflowers and late September through October for fall color.

Photo advice: Early morning light works best for overall views of Steamboat Rock from pull-outs along the highway. Scenics from the top of the butte looking south over Banks Lake are great with the golden light of either sunrise or sunset. Late afternoon light is best for both the old buildings and the basalt cliffs in Northrup Canyon.

Getting there: From western or central Washington, drive US-2 or WA-17 to Coulee City, then take WA-155 north for 16 miles to the park entrance. From Spokane, drive west on US-2 to Wilbur, then northwest on WA-174 to Grand Coulee, and turn south on WA-155 to reach the main park entrance in about 13 miles. The turn to Northrup Canyon is at MP 18, about 3 miles northeast of the main campground and recreation area entrance on WA-155.

Time required: If you're just passing by on the way to another destination, you

can get a pretty decent shot of Steamboat Rock itself from several pullouts on WA-155. For the hike to the top of Steamboat Rock or the Northrup Canyon hike allow about 3 hours.

Nearby location: Grand Coulee Dam may only be a nature photo subject in the sense of how dams have affected the natural environment, but if you're in the area and haven't seen it before you'll almost certainly want to check it out. The huge concrete face of the dam looks north and for much of the year the sun never directly hits it, but there's a good overview of the dam and lake from Crown Point Lookout on the north side of the town of Coulee Dam. In summer a nighttime laser light show is projected on the face of the dam.

Okanogan Highlands

North of the Columbia River coulee country are the Okanogan Valley, which extends into British Columbia, and the Okanogan Highlands, a series of mountain ranges which extend north into British Columbia and east into Idaho. The Columbia River cuts through these ancient mountains, with present day Lake Roosevelt running north south between the Kettle River Range and the Selkirk Mountains.

Leaving the sagebrush and orchard land of Okanogan Valley, Washington Highway 20 turns east to traverse the Highlands. Desert sage gives way first to Ponderosa pine and then, with increasing elevation to a predominantly Douglas-fir forest. Along the Sanpoil River near the town of Republic, there are some tall, stately, cottonwood trees and small groves of aspen that turn beautiful shades of yellow and gold in autumn.

The western part of the Okanogan Highlands is Washington's most extensive mining area, with some gold mines dating back to the late 1800's; a few old buildings still stand in ghost towns scattered throughout the mountains and valleys.

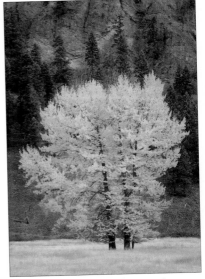

Cottonwood, Sanpoil River Canyon

Photo advice: Drive a few miles south of Republic on WA-21 for some great old abandoned farm buildings, and in mid-October, colorful cottonwoods and aspens in the valley and western larch trees on the hillsides.

Nearby location: Chief Joseph, the legendary leader of the Nez Perce people, lived his last days on the Colville Indian Reservation. Thinking that the Chief Joseph Memorial marked on state maps must be worth visiting given the chief's

importance in U.S. history, I drove to the reservation town of Nespelem. I was disappointed to find only a simple marker, but have since come to understand that Joseph's burial site is sacred to the Nez Perce, and that they, like most Native American peoples, honor their dead differently than Anglo-American culture. If you wish to pay your respects to the chief, do so with sensitivity to the customs of his people.

Kettle River Range

Whether starting from the west at Republic or the east at Lake Roosevelt, Washington Highway 20, climbs quickly to Sherman Pass, which at 5,575 feet elevation is Washington's highest winter maintained pass. The Sherman

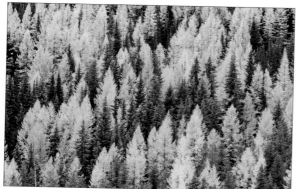

Western larch at Sherman Pass

Pass National Scenic Byway cuts through Colville National Forest following what was once a route of major importance for Native Americans from the coast to the Rockies. The Kettle Range is thickly forested with Douglas-fir, ponderosa pine, and, to the delight of photographers, western larch. The needles of this deciduous conifer, like its close relatives the Tamarack larch and subalpine larch, turn to a bright golden yellow in autumn.

Traveling on Highway 20 from the west, watch for a paved pullout just beyond MP 316. There's a great view looking west over the valley and distant mountains. Kettle Crest, the summit of Sherman Pass, is at MP 320. There is a nice picnic area and campground here with a short nature trail and interpretive signs. Just below the picnic area the highway makes a big looping turn; a wide pullout at the bend is another great place for photographs of the larch lighting up the hillsides of Sherman Peak and Scalawag Ridge. There's more autumn color from aspen and cottonwood trees as the highway continues east following Sherman Creek.

Photo advice: Prime time for catching the larch in autumn color is usually around mid-October. A polarizing filter will help bring in bringing out the best color, but it's best to back off a bit from full polarization so as not to have the scene look unnaturally flat. Catch them back-lit for the most visual impact.

Getting there: To get to the Sherman Pass Scenic Byway, travel east on WA-20 from Omak and the Okanogan Valley. From Spokane, head north on US-395 to Kettle Falls, then west on WA-20. From the Columbia Basin, WA-21 bisects the Colville Reservation and meets WA-20 at Republic.

Nearby location: Copper Butte Trail, which can be accessed from either Kettle Crest Trail or via FR-2040 west of Sherman Pass, crosses meadows that are probably the best wildflower locations on the western slopes of the Kettle Range. Just over the crest, Wapaloosie Mountain Trail is similarly great for east slope flowers. Early May is prime for east-facing slopes, a little later for the west slopes.

Selkirk Mountains

East of the Columbia River in northern Washington and extending eastward into Idaho, the Selkirk Mountains are made up of the oldest sedimentary and metamorphic rock in the state. This northeast corner of Washington is considered part of the Canadian Rocky Mountain Ecoregion. The mountains are more rounded than the jagged Cascades, and include 8,000-foot peaks as well as deep, narrow valleys. It's remote and rugged country, with probably a greater diversity of large mammals than anywhere else in the state. Deer, elk, black bear, mountain goat, bighorn sheep are found in a number of locations in Washington, and here they're joined by moose, grizzly bear, gray wolf, and the extremely rare mountain caribou. The thick forest is primarily Douglas-fir at lower elevations, with western hemlock, western red cedar, and grand fir becoming more widespread higher up; subalpine fir and whitebark pine occur at the highest elevations. Perhaps of more interest to nature photographers, the valleys, riversides, and lakeshores contain wonderful stands of cottonwood and aspen for brilliant autumn color.

Northeast Washington isn't particularly known for waterfalls, but there are a couple easily accessed by visitors to the area. Meyers Falls in the city of Kettle Falls (turn south on Juniper Street from WA-20/US-395) is an attractive sliding waterfall, although it is a challenge to make a good photographic composition due to the very restricted viewpoint. Crystal Falls State Park is located 14 miles east of Colville on WA-20. A short walk leads to an excellent view of the Little Pend Oreille River as it drops 60-80 feet in two fanned tiers. Crystal Falls faces west, so catches afternoon sun light and is entirely in the shade early in the morning. This is a good waterfall to work both tight shots to zero in on just a portion of the whitewater and wider views to take in more of the surroundings a give a sense of scale to the falls.

The Little Pend Oreille Lakes are little jewels at the head of the river of the same name. A quick visit and you'll know why this is a popular

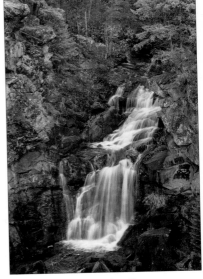

Crystal Falls

area for vacation cabins and summer camping. Each of the lakes is scenic, but Frater Lake and Lake Leo are probably the best bets for nature photography. A system of trails around the lakes is used year round for hiking, mountain biking, snowshoeing, and cross-country skiing. There is lots of nice fall color around here thanks to a heavy concentration of western larch trees in the forest. Even more good fall color can be found by driving west from Lake Gillette on South Fork Mill Creek Road. This road, gravel part of the way but easy driving, winds through valleys all the way back to Colville. Along the way are several very nice groves of aspen trees and mountain hillsides above Mill Creek Valley are covered with western larch trees; there are some particularly nice autumn views about 5 miles in. If you're visiting in spring and looking for wildflowers, turn north on FR-7018 (7.7 miles from WA-20) and drive a couple of miles on good gravel road to Bestrom Meadows. Tiger Meadows, northwest of the Little Pend Oreille Lakes at about MP 385 on WA-20, is also a good bet for spring flowers, and has lots of larch and aspen around it for fall color.

The North Pend Oreille National Scenic Byway starts at the junction of WA-20 and WA-31 and follows the Pend Oreille River north to the Canadian Border. This little known corner of the state just begs for days of leisurely exploring rivers, lakes, and trails in the Colville National Forest and the Salmo-Priest Wilderness. Wildlife enthusiasts will want to visit the mountain goat viewing area on Boundary Road just north of the town of Metaline and the bighorn sheep viewing area near Noisy Creek Campground at Sullivan Lake. Rocky Mountain elk, white-tailed deer, and mule deer are also frequently seen in these areas. Remember to wear bright clothing when you're tramping the woods during hunting season.

Still more scenic driving awaits those who follow the Pend Oreille River south on WA-20. There's very good fall color from aspen and cottonwood along the river near the towns of Usk and Cusick in the Kalispel Valley, and in spring camas flowers are a mass of blue. Look for bald eagles and osprey along the river, and in February and March the flocks of tundra swans that pass through the area on their annual migration.

Photo advice: If you're interested in fall color, plan a trip for mid-October and check with the USFS district ranger stations in Kettle Falls, Colville or Newport for updates on conditions.

Getting there: From Spokane, head north on US-395, ideally making a loop trip with WA-20 and US-2. If coming from the west, continue east from Lake Roosevelt on WA-20.

Nearby location: The International Selkirk Loop is a driving tour route that loops around the Selkirks through Washington, British Columbia, and Idaho.

❖ ❖ ❖

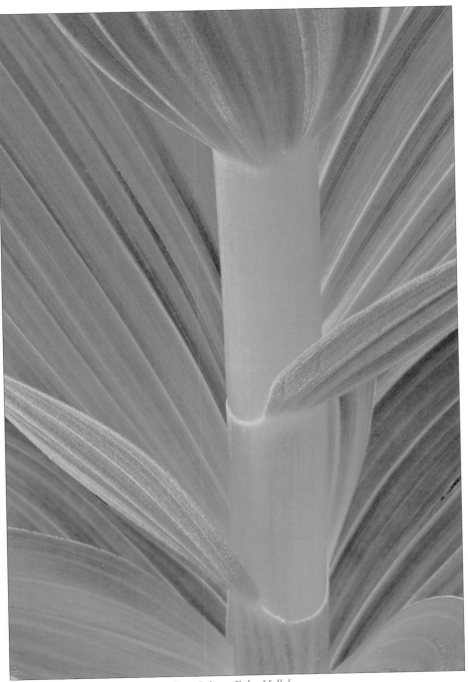

Corn Lily or False Hellebore

APPENDIX

Bibliography – Guidebooks

A great many guidebooks cover hiking, camping, wildlife, flora and travel in Washington and the Pacific Northwest. Below is a selection of guides that I'm familiar with. What I always take with me: the Benchmark Atlas, *Cascade Olympic Natural History* (comprehensive and enjoyable to read), and whichever of the hiking guides published by The Mountaineers is appropriate for my trip.

100 Classic Hikes in Washington by Ira Spring and Harvey Manning, published by The Mountaineers Books, ISBN 978-0898865868

100 Hikes in Washington's Alpine Lakes by Vicky Spring, Ira Spring and Harvey Manning, published by The Mountaineers, ISBN 978-0898863062

100 Hikes in Northwest Oregon and Southwest Washington by William Sullivan, published by Navillus Press, ISBN 978-00967783070

Backpacking Washington by Craig Romano, published by The Mountaineers Books, ISBN 978-1594851100

Backpacking Washington by Douglas Lorain, published by Wilderness Press, ISBN 978-0899974231

Best Desert Hikes: Washington by Alan Bauer and Dan A. Nelson, published by The Mountaineers Books, ISBN 978-0898865370

Best Wildflower Hikes: Washington by Art Kruckeberg, Karen Sykes and Craig Romano with photos by Ira Spring, published by The Mountaineers Books, ISBN 978-0898869644

Cascade Olympic Natural History by Daniel Mathews, published by Raven Editions, ISBN 978-0962078217

Day Hiking Central Cascades by Craig Romano, photography by Alan Bauer, published by The Mountaineers Books, ISBN 978-1594850943

Day Hiking Columbia River Gorge by Craig Romano, published by The Mountaineers Books, ISBN 978-1594853685

Day Hiking Mount Rainier by Dan A. Nelson, photography by Alan Bauer, published by The Mountaineers Books, ISBN 978-594850608

Day Hiking North Cascades by Craig Romano, published by The Mountaineers Books, ISBN 978-1594850486

Day Hiking South Cascades by Dan A. Nelson, photography by Alan Bauer, published by The Mountaineers Books, ISBN 978-1594850455

Going Wild in Washington and Oregon by Susan Ewing, published by Alaska Northwest Books, ISBN 978-0882404264

Hiking Olympic National Park by Erik Molvar, a Falcon Guide published by Morris Book Publishing, ISBN 978-0762741199

Mount Rainier by Don Geyer, published by Hancock House Publishers, ISBN 978-0888395979

Plants of the Pacific Northwest Coast by Jim Pojar and Andy MacKinnon, published by Lone Pine Publishing, ISBN 978-1551055305

Sagebrush Country: A Wildflower Sanctuary by Ronald J. Taylor, published by Mountain Press Publishing, ISBN 978-0878422807

Seasonal Guide to the Natural Year by James Luther Davis, published by Fulcrum Publishing, ISBN 978-1555911973

The Photographers Guide to the Puget Sound & Northwest Washington by Rob Barbee, published by The Countryman Press, ISBN 978-0881507560

The San Juan Islands: Into the 21st Century by Joann Roe, published by Caxton Press, ISBN 978-0870045042

Travelers Guide to the Lewis & Clark Trail by Julie Fanselow, published by Falcon Press, ISBN 978-0762744374

Washington Atlas & Gazetteer published by DeLorme Publishing, ISBN 978-0899333298

Washington Road & Recreation Atlas published by Benchmark Maps, ISBN 978-0929591988

Washington's Best Wildflower Hikes text and photography by Charles Gurche, published by Westcliffe Publishers, ISBN 978-1565794405

Waterfall Lover's Guide: Pacific Northwest by Gregory A. Plumb, published by The Mountaineers Books, ISBN 978-0898869118

Wildflowers of the Pacific Northwest by Mark Turner & Phyllis Gustafson, published by Timber Press, ISBN 978-0881927450

Bibliography – Photo Books

Here are a few large format books about Washington with great photography for ideas and inspiration.

Backroads of Washington text by Diana Fairbanks, photography by Mike Sedum, published by Voyageur Press, ISBN 978-0896586437

Mount Rainier National Park by Ron Warfield, published by Sierra Press, ISBN 978-1580710671

Mount Rainier National Park Impressions photography by Charles Gurche, published by Farcountry Press, ISBN 978-1560372400

Olympic National Park Impressions photography by James Randklev, published by Farcountry Press, ISBN 978-1560372035

Our Washington text and photography by George and Rhonda Ostertag, published by Voyageur Press, ISBN 978-0760329207

San Juan Islands Impressions photography by Charles Gurche, published by Farcountry Press, ISBN 978-1560373827

Washington text by Ruth Kirk, photography by John Marshall, published by Graphic Arts Books, ISBN 978-0932575647

Washington: The Spirit of the Land photography by Terry Donnelly and Mary Liz Austin, text by Linda Mapes, published by Voyageur Press, ISBN 978-0896580138

Helpful Websites

- Waterfalls Northwest - www.waterfallsnorthwest.com
- The Photographer's Ephemeris - www.photoephemeris.com
- Washington Trails Association - www.wta.org
- Northwest Hikers - www.nwhiker.com
- Portland Hikers - www.portlandhikers.org
- Trails Northwest - www.trailsnw.com
- Nature Photographers Network - www.naturephotographers.net
- Green Trails Maps - www.greentrailsmaps.com
- My Topo (maps) - www.mytopo.com
- Google Maps - www.maps.google.com
- Photograph America - www.photographamerica.com
- Pacific Northwest Wildflowers - www.pnwflowers.com

Government Agencies & Visitor Organizations

- Washington Discover Pass 866-320-9933 www.discoverpass.wa.gov
- Washington State Parks 360-902-8844 www.parks.wa.gov
- Washington State Ferries 888-808-7977 www.wsdot.wa.gov/ferries
- Washington State Highways 360-705-7000 www.wsdot.wa.gov/traffic
- Washington Dept. of Fish & Wildlife 360-902-2200 www.wdfw.wa.gov
- Mount Rainier National Park 360-569-6575 www.nps.gov/mora
- Olympic National Park 360-565-3130 www.www.nps.gov/olym
- North Cascades National Park 360-854-7200 www.nps.gov/noca
- Mount Saint Helens NVM 360-449-7800 www.fs.usda.gov/mountsthelens
- Mount Baker-Snoqualmie National Forest 206-470-4060 www.fs.usda.gov/mbs
- Okanogan-Wenatchee National Forest 509-664-9200 www.fs.usda.gov/okawen
- Gifford Pinchot National Forest 360-891-5000 www.fs.usda.gov/giffordpinchot
- Colville National Forest 509-684-7000 www.fs.usda.gov/colville
- Olympic National Forest 360-956-2402 www.fs.usda.gov/olympic
- Columbia Gorge Nat'l Scenic Area 541-308-1700 www.fs.usda.gov/main/crgnsa
- National Weather Service, Western Region www.wrh.noaa.gov
- NOAA Tide Charts - www.tidesandcurrents.noaa.gov/tide_predictions
- Washington's official visitor info website - www.experiencewa.com
- Mount Rainier 877-270-7155 www.visitrainier.com
- Olympic Peninsula 800-942-4042 www.olympicpeninsula.org
- San Juan Islands 888-468-3701 www.visitsanjuans.com
- Seattle 866-732-2695 www.visitseattle.org

For additional resources, including links to the above, visit
www.GregVaughn.com/photographingwashington/resources

INDEX

A
Adams Creek Meadows 230
Agate Beach, Lopez Island 107
Alki Point 62
Alpine Lakes Wilderness - Enchantments 167
Alpine Lakes Wilderness - South 172
American Camp, San Juan Island 94
Anacortes 119
Ancient Lakes 270
Ape Cave, Mt. Saint Helens NP 224
Artist Point 129

B
Bainbridge Island 80
Baker Lake 136
Battle Ground Lake SP 49
Beacon Rock SP 248
Beezley Hills 271
Bellevue Botanical Garden 69
Bellingham 125
Bench Lake, Mt. Rainier NP 200
Beverly Dunes 270
Big Creek Falls 237
Blewett Pass 171
Blind Bay, Shaw Island 104
Bloedel Reserve 80
Blue Mountains 280
Blythe Lake 274
Boeing Museum of Flight 69
Bowl & Pitcher 293
Bridal Veil Falls 160
Browns Point Lighthouse 73

C
Cama Beach State Park 114
Cama Beach SP 114
Cape Alava, Olympic NP 30
Cape Disappointment SP 44
Cape Flattery 32
Cape Horn 247
Carbon River, Mt. Rainier NP 207
Cascade Falls, Orcas Island 98
Cascade Pass Trail 142
Catherine Creek 252
Cattle Point, San Juan Island 95
Cedar Creek Grist Mill 50
Chain Lakes 130
Channeled Scablands 296
Christine Falls, Mt. Rainier NP 190
Chuckanut Drive 124
Clarkston 280
Cle Ulum 173
Coffeepot Lake 296

Colfax 284
Columbia Hills SP 257
Columbia NWR 273
Columbia River 260
Columbia River Gorge 246
Comet Falls, Mt. Rainer NP 188
Conboy Lake NWR 255
Coyote Wall Trail 251
Crystal Falls SP 303
Cutthroat Lake 149

D
Dalles Mountain Road 256
Dash Point SP 72
Deception Pass SP 116
Deer Harbor, Orcas Island 101
Deer Park 38
Diablo Lake 145
Dog Creek Falls 251
Dog Mountain 250
Dry Falls 298
Dungeness NWR 39

E
East Fork Lewis River Waterfalls 51
Eastsound, Orcas Island 97
Ebey's Landing 116
Elwha River, Olympic NP 36
Emmons Vista, Mt. Rainier NP 205
English Camp, San Juan Island 90

F
Fairhaven District 126
Fay Bainbridge Park 82
Fidalgo Island 118
Fields Spring SP 280
Finch Arboretum 292
Fisherman Bay Preserve 106
Fort Casey SP 115
Fort Columbia SP 45
Fort Nisqually 73
Fort Vancouver NHS 47
Fort Worden SP 40
Friday Harbor, San Juan Island 88

G
Gaiser Conservatory 292
Gifford Pinchot NF 226
Gig Harbor 63
Gingko Petrified Forest 268
Glacier View Lookout, Mt. Rainier NP 211
Goat Rocks Wilderness 227
Gobblers Knob 211

Gold Creek Pond 175
Grand Coulee Dam 301
Grays Harbor 42
Grove of the Patriarchs, Mt. Rainier NP 201

H
Hamilton Mountain Trail 249
Hanford Reach NM 275
Heather Pass 146
Hellroaring Viewpoint 235
Hells Canyon 282
Hidden Lake 163
High Divide Trail, Olympic NP 34
Hobuck Beach 32
Hoh Rainforest, Olympic NP 27
Hood Canal 40
Horsethief Lake Petroglyphs 258
Hulda Klager Lilac Gardens 48
Hurricane Ridge, Olympic NP 36

I
Iceberg Point, Lopez Island 108
Icicle Creek 166
Indian Heaven Loop Trail 240
Inspiration Point 198
International Selkirk Loop 304
Irely Lake Trail, Olympic NP 24

J
Julia Butler Hansen NWR 45

K
Kamiak Butte 284
Kerry Park 61
Kettle River Range 302
Kitsap Memorial SP 82
Kitsap Peninsula 82
Klickitat Trail 254

L
Lahar Viewpoint, Mt. Saint Helens 224
Lake Chelan 153
Lake Crescent, Olympic NP 35
Lake Quinault 23
Lake Serene 160
Lakes Trail 196
Lake Viviane 169
Lake Wenatchee 163
Langfield Falls 243
La Push 29
Larrabee State Park 124
Lava Canyon, Mt. Saint Helens 224
Leavenworth Area 165
Lewis & Clark State Park 54
Lewis River Waterfalls 236

Lime Kiln Point SP 92
Little Pend Oreille 303
Little Spokane River NA 293
Longmire, Mt. Rainier NP 186
Loowit Falls, Mt. Saint Helens 222
Lopez Island 104
Lower Lewis River Falls 237
Lucia Falls 51

M
Mackaye Harbor, Lopez Island 107
Madison Falls 36
Makah Indian Reservation 31
Manito Park 292
Maple Pass 146
Martha Falls, Mt. Rainier NP 201
Marymere Falls, Olympic NP 35
Mazama Ridge, Mt. Rainier NP 196
McNary NWR 277
Methow Valley 150
Meyers Falls 303
Mima Mounds NAR 55
Moran SP 97
Moses Coulee 271
Moulton Falls 51
Mount Adams 217
Mountain Lake 98
Mountain Loop Highway 139
Mount Baker Highway 128
Mount Constitution, Orcas Island 98
Mount Finlayson, San Juan Island 96
Mount Olympus, Olympic NP 22
Mount Rainier NP 180
Mount Saint Helens NVM 214
Mount Shuksan 129
Mount Si 175
Mount Spokane 294
Mowich Lake 208
Mukilteo Lighthouse 113
Museum of Glass 73

N
Nannie Ridge 228
Narada Falls, Mt. Rainier NP 191
Natches Trail, Mt. Rainier NP 203
Neah Bay 32
Nishinomiya Japanese Garden 292
Nisqually NWR 75
Nooksack Falls 133
North Cascades Highway 135
North Cascades NP 128
North Head Lighthouse 44
North Pend Oreille NSB 304
Northrup Canyon 300
Northwest Trek 49
Norway Pass, Mt. St. Helens NP 220

O

Oak Creek Wildlife Area 264
Obstruction Pass SP 100
Odlin County Park, Lopez Island 105
Ohanapecosh, Mt. Rainier NP 201
Okanogan Highlands 301
Olallie SP 176
Olympia 76
Olympic Sculpture Garden 60
Orcas Island 96
Otis Perkins Day Park 106
Ozette Triangle, Olympic NP 30

P

Packwood Lake 228
Palouse Country 283
Palouse Falls SP 278
Panther Creek Falls 243
Paradise, Mt. Rainier NP 192
Park Butte Trail 137
Patterson Mountain 152
Pearson Air Museum 48
Pelindaba Lavender Farm 93
Peshastin Pinnacles SP 166
Picture Lake, Mt. Shuksan 129
Pike Place Market 60
Pinnacle Peak, Mt. Rainier NP 198
Pioneer Square 62
Point Defiance Park 73
Point No Point Lighthouse 84
Point of Arches, Olympic NP 30
Point Robinson Lighthouse 79
Port Angeles 39
Port Stanley 106
Port Townsend 40
Potholes 273
Poulsbo 82
Prusik Peak 169
Ptarmigan Ridge 130
Puget Sound 58
Pumice Plain, Mt. St. Helens 222

Q

Quartermaster Harbor 79
Quinault River Ranger Station 24

R

Railroad Grade, Mt. Baker 138
Rainbow Falls SP 55
Reflection Lake, Mt. Rainier NP 199
Rhododendron Species Garden 64
Rialto Beach, Olympic NP 28
Ridgefield NWR 46
Riverside SP 293
Roche Harbor, San Juan Island 89

Rockport SP 139
Roozengaarde Tulips 122
Rosario Strait 100
Roslyn 174
Ross Lake NRA 144
Ruben Tarte CP 90
Ruby Beach, Olympic NP 26
Rustic Falls 98

S

Saddle Mountain NWR 276
Sahale Arm 142
Salish Sea 86
Saltwater SP 72
Sand Point 30
San Juan County Park 91
San Juan Island 88
San Juan Islands 86
San Juan Islands NM 95
Sauk Mountain 138
Sauk River Valley 139
Scenic Beach SP 82
Seattle 59
Second Beach, Olympic NP 28
Sehome Hill Arboretum 125
Selkirk Mountains 303
Sequim 39
Shark Reef Sanctuary 106
Shaw Island 103
Sherman Memorial Park 263
Shi Shi Beach, Olympic NP 30
Silver Star Mountain 52
Skagit River 140
Skagit River Bald Eagle NA 140
Skagit River Valley 138
Skagit Valley Tulip Farms 122
Skagit Wildlife Area 120
Skykomish River 158
Skyline Divide Trail 134
Snoqualmie Falls 177
Snoqualmie Pass 174
Snowgrass Flat 227
Sol Duc Falls, Olympic NP 32
Spencer Spit SP, Lopez Island 105
Spray Park, Mt. Rainier NP 208
Squak Mountain SP 70
Staggerwald NWR 247
Stehekin 153
Steptoe Butte 283
Stevens Canyon, Mt. Rainier NP 200
Stevens Pass 162
Stimpson Family Preserve 125
Stonehenge Memorial 259
Storm King Ranger Station 35
Strait of Juan de Fuca 58

Stuart Lake 170
Summit Lake 98
Sunrise, Mt. Rainier NP 204
Sunrise Rock 98
Suquamish Museum 83

T
Takhlakh Lake 231
Tatoosh Range 193
The Enchantments 167
Thompson Ridge 152
Tipsoo Lake, Mt. Rainier NP 203
Tom McCall Preserve 260
Tronsen Ridge 171
Trout Lake 241
Tsagaglalal petroglyph 258
Tuck & Robin Lakes 172
Tulip Town 122
Tumwater Canyon 164
Tumwater Falls 77
Turnbull NWR 295
Turtleback Mountain Preserve 102
Twin Falls, Lewis River 238
Twin Falls, Snoqualmie River 176
Twin Lakes 296
Twisp River Road 152

U
Umatilla NWR 277
Umtanum Ridge 266
Union Bay Natural Area 67
Uniontown 285
Upper Lewis River Falls 238
Upright Channel Picnic Area 105

V
Van Lierop Bulb Farm 74
Van Trump Park, Mt. Rainier NP 188
Vashon Island 68

W
Waikiki Beach 44
Wallace Falls 159
Walupt Lake 228
Wapaloosie Mountain Trail 303
Washington Park Arboretum 66
Washington Pass 148
Washington State Capitol 76
Watmough Bay Preserve 109
Wenas Wildlife Area 266
Westcott Bay 89
West Point Lighthouse 64
Westport Light SP 42
Westside Preserve Viewpoint 93
Whatcom Falls Park 125

Whidbey Island 115
White Beach Bay 101
Willapa Bay 42
Winchester Mountain Lookout 133
Winslow 80
Winthrop 150
Wolf Haven International 48
Wolf Tree Nature Trail 64
Wonderland Trail, Mt. Rainier NP 210
Woodland Park Rose Garden 66
Woodland Park Zoo 65
W. W. Seymour Botanical Conservatory 73
Westport Light State Park 125
Westside Preserve Viewpoint
Whale Museum 99
Whatcom Falls Park 46
Whidbey Island 115
White Beach Bay 133
Willapa Bay 64
Winchester Mountain Lookout 201

Y
Yakima Area Arboretum 263
Yakima Greenway 263
Yakima River Canyon 265
Yakima Skyline Rim Trail 266
Yakima Sportsman SP 263
Yakima Valley 263
Yellow Aster Butte 131

RATINGS

The ratings on the following pages are intended to give you further information about the locations discussed in the book and to help you make comparisons and choices when planning your photographic journeys in Washington. Obviously, the ratings alone don't tell the whole story about a location and should be used only in conjunction with the chapter text.

Using a scale of 1 to 5, the ratings are assigned according to four different criteria: overall interest of a location (based mostly on its value as a scenic attraction), the location's photographic potential (can you make great images there?), and the level of difficulty in getting to the location, either on foot or by vehicle. In many cases, photographic potential and scenic value vary greatly depending on season, and these ratings are based on the peak time of the year for the specific location. Keep in mind that the trail ratings are based on normal, dry weather conditions; times and difficulty may be very different before trails are cleared in spring or early summer, or when storms hit in early autumn.

Note especially that Road Difficulty ratings are for normal, dry conditions. Driving conditions can change dramatically during or after a rain or a snowstorm. Some forest and desert roads have deep mud holes in winter and spring. When a road was last maintained also has a huge impact on its condition: a washboard gravel forest or desert road can be torture on driver and vehicle and can really slow you down. Always check current road conditions with local authorities before you leave. In my experience, the high school girl at the local fast food stop hasn't been down the road you need to know about, but the folks at the regional National Park, Forest Service and BLM ranger stations have good, current information and are happy to share it with you.

Rating	Scenic Value
–	Of no particular interest
♥	Mildly interesting, visit if nearby and/or time permitting
♥♥	Scenic location, worthy of a visit
♥♥♥	Very interesting, scenic or original location
♥♥♥♥	Remarkably scenic or rewarding location, a highlight
♥♥♥♥♥	World-class location, absolutely tops

Rating	Photographic Interest
–	Of no particular photographic interest
♦	Worthy of a quick photo
♦♦	Good photo opportunity
♦♦♦	Good photographic potential and scenic subjects
♦♦♦♦	Outstanding photographic potential, highly original or scenic subjects
♦♦♦♦♦	World-class photographic location, "photographer's dream"

Rating	Road Difficulty
–	Paved road, accessible to all normal-size vehicles
▲	Dirt road accessible without difficulty by passenger car (under normal conditions)
▲▲	Minor obstacles, accessible by passenger car with caution (under good conditions)
▲▲▲	High-clearance required, but no major difficulty
▲▲▲▲	High-clearance 4WD required, some obstacles, no real danger
▲▲▲▲▲	High-clearance 4WD required, some risk to vehicle & passengers, experienced drivers only

Rating	Trail Difficulty
–	No or very little walking (close to parking area)
♠	Easy short walk (<= 1h r/t), for everybody
♠♠	Moderate (1 to 3h r/t) with no major difficulty or short hike with some minor difficulties
♠♠♠	Moderate to strenuous (3 to 6h r/t) and/or difficulties (elevation gain, difficult terrain, some risks)
♠♠♠♠	Strenuous (> 6h r/t) and/or globally difficult (elevation gain, difficult off-trail terrain, obstacles, risks)
♠♠♠♠♠	Backpacking required or for extremely fit dayhikers

Location	Page	Scenic Value	Photogr. Interest	Road Difficulty	Tra Diffic
2 Olympic Peninsula					
Lake Quinault	21	♥♥♥	♦♦	–	♣
Ruby Beach	23	♥♥♥	♦♦♦♦	–	♣
Hoh Rainforest	26	♥♥♥♥♥	♦♦♦♦	–	♣
Second Beach & Rialto Beach	27	♥♥♥♥♥	♦♦♦♦♦	–	♣
Cape Alava	28	♥♥	♦♦	–	♣♣♣
Shi Shi Beach & Point of Arches	30	♥♥♥♥♥	♦♦♦♦♦	–	♣♣
Sol Duc Falls	32	♥♥♥♥	♦♦♦♦	–	♣♣
High Divide Trail	34	♥♥♥♥	♦♦♦♦	–	♣♣♣♣♣
Lake Crescent & Marymere Falls	35	♥♥	♦	–	♣
Elwha River & Madison Falls	36	♥	♦	–	–
Hurricane Ridge	36	♥♥♥♥	♦♦♦♦	–	♣
Deer Park	38	♥	♦	♠♠	♣
Tongue Point and Dungeness Wildlife Refuge	39	♥♥	♦	–	♣♣♣
Port Townsend	40	♥♥♥	♦♦♦	–	♣
3 Southwest Washington					
Cape Disappointment State Park	44	♥♥♥♥	♦♦♦	–	♣♣
Lower Columbia River	45	♥	♦	–	–
Ridgefield National Wildlife Refuge	46	♥♥	♦♦	♠	♣
Fort Vancouver National Historic Site	47	♥♥	♦	–	–
I-5 Corridor – Southern Lowlands	48	♥	♦	–	♣
Battle Ground Lake State Park	49	♥♥	♦	–	–
Cedar Creek Grist Mill	49	♥♥	♦♦♦	–	–
East Fork Lewis River Waterfalls	51	♥♥	♦♦♦	–	♣
Silver Star Mountain	52	♥♥♥	♦♦♦	♠♠	♣♣♣
Lewis and Clark State Park	54	♥	♦	–	♣
Rainbow Falls State Park	55	♥	–	–	–
Mima Mounds	55	♥	♦	–	♣
4 Puget Sound					
Downtown Seattle	59	♥♥♥	♦♦♦	–	–
Kerry Park Cityscape View	61	♥♥♥♥	♦♦♦	–	–
West Seattle – Alki	62	♥♥	♦♦	–	–
Rizal Bridge City View	63	♥	♦♦	–	–
Discovery Park & West Point Lighthouse	64	♥♥	♦♦	–	♣♣
Woodland Park Zoo	65	♥♥	♦♦	–	♣
Washington Park Arboretum & Japanese Garden	66	♥♥♥♥	♦♦♦	–	♣
Kubota Japanese Garden	68	♥♥	♦♦	–	♣
Bellevue Botanical Garden	69	♥♥	♦	–	♣
Cougar Mountain Regional Wildland Park	70	♥	♦	–	♣♣
Weyerhaeuser Bonsai & Rhododendron Gardens	71	♥♥	♦♦	–	♣
Saltwater and Dash Point State Parks	72	♥	–	–	♣
Tacoma	73	♥♥♥	♦♦♦	–	–
Nisqually National Wildlife Refuge	75	♥♥	♦	–	♣♣
Olympia – State Capitol	76	♥♥	♦♦	–	–
Tumwater Falls	77	♥	–	–	♣
Gig Harbor	78	♥♥♥	♦♦	–	–
Vashon Island	79	♥♥♥	♦♦♦	–	♣
Bainbridge Island	80	♥♥	♦♦♦	–	♣
Poulsbo	82	♥♥	♦	–	–
Port Gamble	83	♥	♦	–	–
Point No Point Lighthouse	84	♥♥	♦♦	–	–
5 San Juan Islands					
Friday Harbor	88	♥♥♥♥	♦♦♦	–	–
Roche Harbor – Westcott Bay	89	♥♥	♦♦♦	–	–
English Camp	90	♥♥♥	♦♦	–	♣
San Juan County Park	91	♥	–	–	–
Lime Kiln Point State Park	92	♥♥♥	♦♦♦	–	♣
Pelindada Lavender Farm	93	♥	♦	–	–
American Camp	94	♥♥	♦	–	♣

Location	Page	Scenic Value	Photogr. Interest	Road Difficulty	Trail Difficulty
Cattle Point	95	♥♥♥	♦♦	–	♣
Eastsound	97	♥♥♥	♦	–	–
Moran State Park	97	♥♥♥♥♥	♦♦♦♦	–	♣♣
Eastern Orcas	99	♥♥♥♥	♦	–	–
Western Orcas	101	♥♥♥	♦	–	–
Turtleback Mountain Preserve	102	♥♥♥	♦♦♦	–	♣♣♣
Shaw Island	103	♥♥♥	♦	–	–
Odlin County Park	105	♥	–	–	–
Spencer Spit State Park	105	♥♥	♦	–	♣
Fisherman Bay Preserve	106	♥♥	♦♦	♠	♣
Shark Reef Sanctuary	106	♥♥	♦♦♦	–	♣
Mackaye Harbor & Agate Beach	107	♥♥	♦	–	–
Iceberg Point	108	♥♥♥	♦♦	–	♣♣
Watmough Bay Preserve & Point Colville	109	♥♥♥	♦♦♦	♠	♣
Northwest Washington					
Mukilteo Lighthouse	113	♥♥	♦♦	–	–
Camano Island State Park	114	♥♥	♦	–	♣
Whidbey Island	115	♥♥♥	♦♦	–	♣
Deception Pass State Park	116	♥♥♥♥	♦♦♦♦	–	♣
Fidalgo Island	118	♥♥♥	♦♦♦	–	♣
Skagit Wildlife Area	120	♥	♦♦♦♦	–	–
Skagit Valley Tulip Farms	122	♥♥♥♥	♦♦♦♦	–	–
Chuckanut Drive & Larrabee State Park	124	♥♥♥	♦♦♦	–	♣
Bellingham	125	♥♥	♦♦	–	♣
Northern Cascades					
Mount Shuksan & Artist Point	129	♥♥♥♥♥	♦♦♦♦♦	–	♣♣
Yellow Aster Butte	131	♥♥♥♥	♦♦♦	♠	♣♣♣
Nooksack Falls	133	♥♥♥	♦	–	♣
Skyline Divide Trail	134	♥♥♥♥	♦♦♦♦	♠	♣♣♣
North Cascades Highway	135	♥♥♥♥	♦♦	–	–
Baker Lake	136	♥♥	♦♦	♠	–
Park Butte Trail	137	♥♥♥♥	♦♦♦♦	♠♠	♣♣♣
Sauk Mountain	138	♥♥♥♥	♦♦♦	♠♠	♣♣♣
Mountain Loop Highway & Sauk River Valley	139	♥♥	♦♦	♠♠	♣
Skagit River Bald Eagles	140	♥♥♥	♦♦	–	–
Cascade Pass	142	♥♥♥♥♥	♦♦♦♦♦	♠♠	♣♣♣♣
Ross Lake National Recreation Area	144	♥♥♥♥	♦	–	–
Maple Pass – Heather Pass Loop Trail	146	♥♥♥♥	♦♦♦	–	♣♣♣
Blue Lake	148	♥♥	♦♦	–	♣
Washington Pass	148	♥♥♥♥	♦♦♦	–	♣
Methow Valley	150	♥♥♥	♦♦♦	–	–
Patterson Mountain – Thompson Ridge	152	♥♥♥	♦♦♦	♠	♣
Lake Chelan - Stehekin	153	♥♥♥♥	♦♦♦	–	♣
Central Cascades					
Stevens Pass - U.S. Highway 2	158	♥♥♥♥	♦♦	–	–
Wallace Falls	159	♥♥	♦♦	–	♣♣
Lake Serene - Bridal Veil Falls	160	♥♥♥	♦♦	♠	♣♣♣
Deception Falls	162	♥	♦	–	♣
Lake Wenatchee & Hidden Lake	163	♥♥	♦♦	♠	♣
Tumwater Canyon	164	♥♥♥♥	♦♦♦	–	♣
Leavenworth	165	♥♥♥	♦♦♦	–	♣
Alpine Lakes Wilderness – The Enchantments	167	♥♥♥♥♥	♦♦♦♦♦	♠♠	♣♣♣♣♣
Blewett Pass	171	♥♥♥	♦♦♦	–	♣
Alpine Lakes Wilderness – South	172	♥♥♥♥	♦♦♦♦	♠	♣♣♣♣♣
Snoqualmie Pass	174	♥♥♥	♦♦	–	♣♣♣
Franklin Falls	175	♥♥	♦♦	–	♣♣
Twin Falls – Olallie State Park	176	♥♥	♦♦♦	–	♣♣
Snoqualmie Falls	177	♥♥♥♥	♦	–	♣

Location	Page	Scenic Value	Photogr. Interest	Road Difficulty	Tra Diffic
9 Mount Rainier					
Nisqually Entrance – Longmire	186	♥♥♥	♦♦	–	♣
Comet Falls & Van Tump Park	188	♥♥♥	♦♦♦	–	♣♣♣
Christine Falls & Roadside Viewpoints	190	♥♥	♦♦	–	–
Narada Falls	191	♥♥	♦♦	–	♣
Paradise	192	♥♥♥♥♥	♦♦♦♦♦	–	♣♣
Inspiration Point & Pinnacle Peak	198	♥♥	♦♦♦	–	–
Reflection Lakes	199	♥♥♥♥	♦♦♦♦	–	–
Stevens Canyon	200	♥♥	♦	–	–
Grove of the Patriarchs & Ohanapecosh	201	♥♥♥	♦♦	–	♣
Tipsoo Lake & Naches Peak Loop Trail	203	♥♥♥♥	♦♦♦	–	♣♣
Sunrise	204	♥♥♥♥	♦♦♦♦	–	♣♣
Carbon River	207	♥♥	♦♦	♠	♣
Spray Park & Mowich Lake	208	♥♥♥♥	♦♦♦♦♦	♠	♣♣♣
Wonderland Trail	210	♥♥♥♥♥	♦♦♦♦	–	♣♣♣♣
Westside Viewpoints: Gobblers Knob & Glacier View	211	♥♥♥♥	♦♦♦♦	♠	♣♣♣
10 Mount Saint Helens					
Spirit Lake Highway	215	♥♥♥	♦♦	–	–
Coldwater Ridge	216	♥♥♥	♦♦	–	–
Johnston Ridge	217	♥♥♥♥	♦♦♦	–	♣
Northeast Side of Mount St. Helens	218	♥♥♥	♦♦♦	–	♣
Norway Pass	220	♥♥♥	♦♦♦	–	♣♣♣
Pumice Plain & Loowit Falls	222	♥♥♥	♦♦	–	♣♣♣
South Side of Mount St. Helens	223	♥♥	♦♦	♠	♣
11 Southern Cascades					
Goat Rocks Wilderness	227	♥♥♥	♦♦♦	♠	♣♣♣♣
Packwood Lake	228	♥♥	♦	♠	♣♣
Walupt Lake & Nannie Ridge	228	♥♥♥	♦♦	♠	♣♣♣
Adams Creek Meadows	230	♥♥♥	♦♦♦	♠♠	♣♣♣
Takhlakh Lake	231	♥♥♥♥	♦♦♦	♠♠	♣♣
Council Bluff	233	♥♥	♦♦	♠♠	♣♣
Bird Creek Meadows	234	♥♥♥	♦♦♦	♠♠	♣♣
Lewis River Waterfalls	236	♥♥♥	♦♦♦	–	♣
Indian Heaven Wilderness	239	♥♥	♦♦	♠	♣
Indian Heaven Loop Trail	240	♥♥♥	♦♦♦	♠	♣♣♣
Trout Lake	241	♥♥	♦♦♦	–	♣
Wind River Waterfalls	243	♥♥♥	♦♦♦	–	♣
12 Columbia River Gorge					
Cape Horn	247	♥♥♥	♦♦♦	–	♣♣♣
Beacon Rock State Park	248	♥♥♥	♦♦♦	–	♣♣
Dog Mountain	250	♥♥♥♥	♦♦♦♦	–	♣♣♣
Coyote Wall Trail	251	♥♥	♦♦	–	♣♣
Catherine Creek	252	♥♥♥	♦♦	–	♣
Klickitat Trail	254	♥♥	♦	♠	♣♣
Conboy Lake National Wildlife Refuge	255	♥♥	♦♦♦	–	♣
Dalles Mountain Road	256	♥♥♥♥	♦♦♦♦♦	♠	♣
Horsethief Lake Petroglyphs	258	♥♥♥	♦♦	–	♣
Maryhill	259	♥♥♥	♦	–	♣
Oregon Waterfalls & Wildflowers	260	♥♥♥♥♥	♦♦♦♦♦	–	♣
13 Southeast Washington					
Yakima Valley	263	♥	♦♦	–	♣
Oak Creek Wildlife Area	264	♥♥	♦♦	–	–
Yakima River Canyon	265	♥♥	♦♦	–	♣♣
Wenas Wildlife Area - Umtanum Ridge	266	♥♥	♦♦	♠♠	♣♣
Gingko Petrified Forest	268	♥	♦	–	♣
Crab Creek Wildlife Area	269	♥♥	♦	♠	♣
Ancient Lakes	270	♥♥	♦	♠	♣♣♣
Beezley Hills and Moses Coulee	271	♥♥	♦♦	♠	♣
Potholes - Columbia National Wildlife Refuge	273	♥♥♥	♦♦	♠	♣

Location	Page	Scenic Value	Photogr. Interest	Road Difficulty	Trail Difficulty
Hanford Reach National Monument	275	♥♥	♦♦	♠	♣♣
MacNary National Wildlife Refuge	277	♥	♦♦	–	♣
Wallula Gap	278	♥	♦	♠	♣
Palouse Falls State Park	278	♥♥♥	♦♦♦♦	♠	♣
Walla Walla to Clarkston	280	♥♥♥	♦♦	–	–
Fields Spring State Park – Blue Mountains	280	♥♥	♦♦♦	–	♣♣
Hells Canyon	282	♥♥♥	♦♦	–	–
The Palouse	283	♥♥♥♥	♦♦♦♦♦	♠	–
Northeast Washington					
Spokane	291	♥♥	♦	–	–
Manito Park Gardens	292	♥♥	♦♦	–	♣
Riverside State Park	293	♥♥	♦	–	♣
Mount Spokane	294	♥♥	♦♦	–	♣
Turnbull National Wildlife Refuge	295	♥♥	♦♦	♠	–
Twin Lakes & Coffeepot Lake	296	♥♥♥	♦♦	♠♠	♣
Dry Falls	298	♥♥♥	♦♦	–	–
Steamboat Rock State Park	299	♥♥♥	♦♦♦	♠	♣♣
Okanogan Highlands	301	♥♥♥	♦♦♦	♠	–
Kettle River Range	302	♥♥	♦♦♦	–	–
Selkirk Mountains	303	♥♥♥♥	♦♦♦	♠	♣

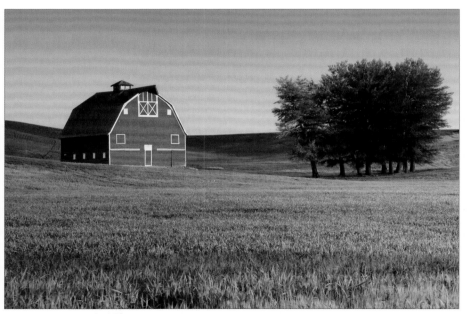

Red barn at sunrise, The Palouse (photo by Laurent Martrès)

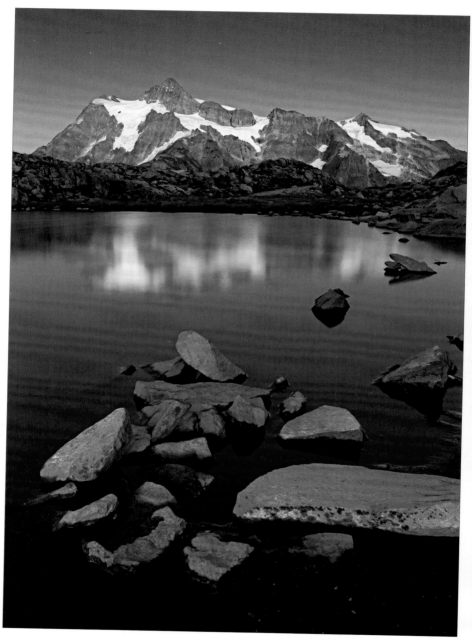

Mount Shuksan & tarn on Kuhlsan Ridge at dusk

ABOUT THE AUTHOR

Northwest resident Greg Vaughn can't imagine a more rewarding occupation than combining photography with his love of travel and nature. For over thirty years he has wandered back roads and backcountry, mountains, valleys, beaches, deserts and islands, capturing images to share the beauty of nature and the wonders of the world.

Greg's photos regularly appear in travel-oriented websites and publications such as Backpacker, VIA, National Geographic Traveler and Travel Oregon. He has worked with a number of calendar and book publishing companies and he is the sole or principal photographer for several books in the Compass American Guides series of travel handbooks. His stock photography is distributed worldwide through agents Getty Images, Alamy, and Pacific Stock.

Greg is a member of the American Society of Media Photographers (ASMP), the North American Nature Photography Association (NANPA), and the Society of American Travel Writers (SATW). His photography has won several awards, including honors from PRINT Magazine, the Hawaii Visitors Bureau and the Society of American Travel Writers.

Greg's book *Photographing Oregon* was named Best Travel Book of the Year by the Independent Book Publishers Association in 2010.

To see more of Greg's photographs, visit www.GregVaughn.com

OTHER TITLES IN THE SERIES

Photographing the Southwest: Volume 1 (2nd Ed.)
A guide to the natural landmarks of Southern Utah
by Laurent Martrès
320 pages
ISBN 978-0-916189-12-9

Photographing the Southwest: Volume 2 - Arizona (2nd Ed.)
A guide to the natural landmarks of Arizona
by Laurent Martrès
272 pages
ISBN 978-0-916189-13-6

Photographing the Southwest: Volume 3 (2nd Ed.)
A guide to the natural landmarks of Colorado & New Mexico
by Laurent Martrès
272 pages
ISBN 978-0-916189-14-3

Photographing Oregon
A guide to the natural landmarks of Oregon
by Greg Vaughn
304 pages
ISBN 978-0-916189-18-1

Photographing California Vol.1 - North
A guide to the natural landmarks of the Golden State
by Gary Crabbe
432 pages
ISBN 978-0-916189-20-4

Photographing the World
A guide to photographing 201 of the most beautiful places on Earth
by Tom Till
336 pages
ISBN 978-0-916189-22-8

Photographing
California

Vol. 2
South

Photographing California Volume 2 - South
A guide to the natural landmarks of the Golden State
by Jeff Sullivan
ISBN 978-0-916189-21-1
Available Spring 2014